GAME LEVEL DESIGN

An accompanying
CD is enclosed
inside this book

GAME LEVEL DESIGN

ED BYRNE

CHARLES RIVER MEDIA, INC.
Hingham, Massachusetts

Publisher: Jenifer Niles
Cover Design: The Printed Image
Cover Images: Ed Byrne

CHARLES RIVER MEDIA, INC.
10 Downer Avenue
Hingham, Massachusetts 02043
781-740-0400
781-740-8816 (FAX)
info@charlesriver.com
www.charlesriver.com

This book is printed on acid-free paper.

Ed Byrne. *Game Level Design.*
ISBN: 1-58450-369-6

Library of Congress Cataloging-in-Publication Data
Byrne, Edward, 1975–
 Game level design / Edward Byrne.
 p. cm.
 ISBN 1-58450-369-6 (pbk. with cd-rom : alk. paper)
 1. Computer games--Design. 2. Video games—Design. I. Title.
 QA76.76.C672B97 2005
 794.8'1536--dc22
 2004023497

Printed in the United States of America
04 7 6 5 4 3 2 First Edition

This book is dedicated to:

My parents, Terry and Cindy, who gave me everything I could ever need.

Contents

Acknowledgments

This book would not have been possible without the tremendous support from a number of individuals:

Jenifer Niles and Charles River Media for their patience, professionalism, and the opportunity to write this book in the first place.

Mathieu Bérubé, Rich Carlson, Ian Fischer, Richard "Levelord" Gray, Lee Perry, Dream Smith, Harvey Smith, and Hayden Wilkinson for graciously taking time to answer my questions and shed light into the dark corners of level design.

To my friends Neil Alphonso, Del Chafe, Jess Crable, Eric Dallaire, Crista Forest, Raphael van Leirop, R.J. Martin, Christine Miller, and everyone at GI, for their unwavering support, assistance, and advice on the book.

And most importantly, to Ciarán, Willow, and my unfailingly amazing wife, Katja.

Introduction

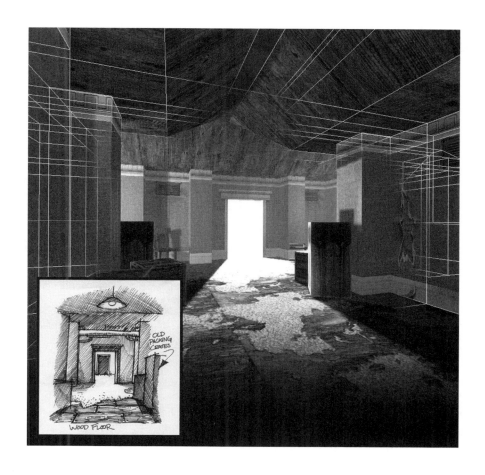

Thanks for picking up this book. Perhaps you have an interest in designing great levels for games, either as someone who wants to know how levels are made, or someone who wants to make levels professionally for commercial titles. If that's the case, you're in the right place, and it's most certainly the right time. Level design is a fast-growing and diverse part of game development. In writing this book, I have tried to convey the theory, realities, and advice I have acquired in my time as an artist, game designer, and level designer.

WHAT THIS BOOK IS ABOUT

What you won't find in this book are complex lessons or tutorials on making levels for specific games and technology. The technology that drives games evolves so quickly; much of the information would be outdated within a year or two. This book is not about architecture, game art, or scripting, either. There are countless articles, tutorials, and books available on these and other level-design related subjects in your local library and on the Internet. Instead, this book is about the *fundamentals* of level design—to help you on your way by teaching you common procedures for designing, drafting, and creating interactive environments for games. For instance, what does it mean to be a level designer on a development team? As a level designer, you will be in contact with every department on your team, and operate on the frontlines of the production process, creating game content and fixing critical problems. This book will explain what level design is, where it came from, and, most importantly, how to plan, design, and construct levels professionally for modern-day computer and video games.

WHAT THIS BOOK INCLUDES

Game Level Design includes a comprehensive look at the basic, advanced, and real-world techniques used to create game levels for hit titles. This book also contains a selection of interviews with notable level designers to provide both supporting, and alternative, views on the craft, as well as valuable information about designing levels from people working in all aspects of the games industry. In order of appearance, interviewees include the following:

- Richard "Levelord" Gray, Ritual Entertainment
- Hayden Wilkinson, Knowwonder Entertainment
- Dream Smith, Griptonite Games
- Harvey Smith, formerly of Ion Storm
- Ian Fischer, Ensemble Studios
- Lee Perry, Epic Games
- Mathieu Bérubé, Ubisoft Entertainment Inc.
- Rich Carlson, Digital Eel

Level Design Tools

Included on the companion CD-ROM are the following level design tools:

- Photoshop LE, a trial version of the industry-standard two-dimensional graphics tool
- Unreal 2 Runtime Demo, a free version of the acclaimed *Unreal* engine and level editor used to create diverse titles such as *Unreal Tournament 2003, Splinter Cell, Thief 3, Republic Commandos, Harry Potter and the Prisoner of Azkaban,* and *Lineage 2*
- Terragen, the free version of the classic shareware program that generates some of the most realistic looking skies and landscapes for use in game levels
- OpenOffice, a free and fully featured open source office suite that contains everything a level designer needs for documentation and design communication
- Textures and environments I used to create the illustrations in this book

A "GENRE AGNOSTIC" APPROACH

Although the content in the book uses many examples from popular genres such as first-person shooters (FPSs) and real-time strategy (RTS) games, the approach is designed to teach about level design as a genre- and platform-independent craft. All games need to take place in environments, and by extension, the rules of level design apply to all games to some degree.

SO WHAT ARE YOU WAITING FOR?

Level design is a unique position in game development where you can determine exactly what the player sees, hears, and feels in the game. Sound like a lot of work? It is, to be sure, but it's also a lot of fun. Game development is highly collaborative, and extremely experimental, an environment for dreamers, visionaries, and world builders. It requires determination as much as imagination, and restraint as much as it does enthusiasm. Despite the long hours, the reward of seeing your game on a store shelf, or hearing people talk about one of your levels on the street, is an incredibly fulfilling experience. If this sounds like something you want to be a part of, I hope you'll pick up this book and enjoy reading it as much as I did writing it. The game world is your oyster, level designer!

1 Introduction to Level Design

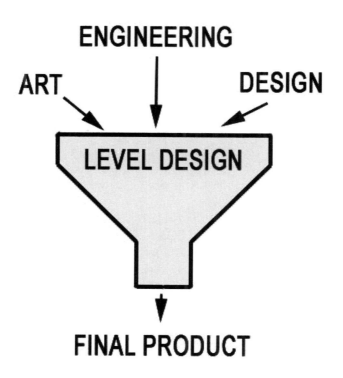

In This Chapter

- Game Design
- Level Designers
- Anatomy of Level Design
- Defining Levels
- Brief History of Levels
- Level Design Today
- Summary
- Interview with Richard "Levelord" Gray of Ritual Entertainment

One of the hardest things about being a level designer is trying to explain to people what you do. This chapter will explain what levels are, where they came from, who makes them, and what "level design" means for the production of a modern video or computer game.

GAME DESIGN

Everything that is made has a designer. A designer formulates plans for creating products from concepts. In games, the designer is the person who often conceives the original ideas, puts them on paper to present to others (in the form of a design document or rough demonstration), and supervises the transition from design to a working video game.

Being the player's advocate is the highest function of a game designer during the entire process of making a game. Simply put, this means that designers are the "eyes and ears" of the player, and represent the interests of the audience during the production. If a problem occurs in creating a game such that the player's needs are not met, the designer must find a solution. When someone on the team wants to add something he feels is really cool, it's the designer's job to evaluate the addition's potential risks, how much players will really use it, and what changes it will make to the players' experience, good or bad. In the end, we make games for the players, not for ourselves, and designers are the people on the team who must always be able to see the game through the eyes of a player, rather than through the eyes of a tired developer who knows the product inside and out.

On a day-to-day basis, game design is primarily about creating and interconnecting all the elements that make up a game—the mechanics—and creating an appealing world in which to house them. Different types of nonplayer characters (NPCs) and their behaviors, weapons, and tools that the player will use and their effects; locations; items; on-screen interfaces; mood; emotional reaction; controls;

and camera views—all these things need to be considered in the early stages of developing a game. These days, a design team handles the work of documenting and implementing design decisions. This will be discussed in a later chapter, but the size of modern games means that the days of a single designer making all the decisions are quickly coming to an end.

LEVEL DESIGNERS

When it comes to actually creating the game from these beginning elements, a specialist is needed to implement the design. This is the essence of level design—the application of the team's ideas in a playable form. A level designer is the point of convergence for programming, cinematography, audio, art, and design—all of the components of a modern computer or video game as shown in Figure 1.1. Game designers create rules and systems that form the backbone of every game, but a level designer implements them and makes them work properly. In addition, level designers carve out environments, create interesting visuals, monitor the performance of the game, make sure that technical problems are resolved before the product hits the shelves and fixes problems in the game. That's a pretty exhausting list of responsibilities. As such, level design is an extremely important role in today's production team—ultimately, the player experiences the game through a game's levels.

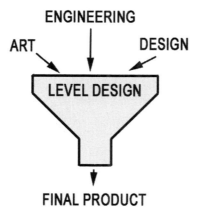

FIGURE 1.1 Art, design, and code all funnel into level design.

The level designer is an omnipotent power in the game, responsible for leading the player through the experience. However, the less the players feel the designer's presence, the more they will feel in control of their own virtual destiny. A good level

designer will create a level that is full of decisions players make. A *great* level designer will allow players to feel like they are making the right decisions, even if they really aren't. Partly, this can be through the illusion of choice—allowing the player three ways to choose that all lead to the same room, for example, is an easy way of letting the players make the surface decisions ("Which way do I go now?") while maintaining control of their ultimate destinations. This can be taken further with concepts like systemic level design where players are given a high degree of freedom in the environment, but can still be guided along a narrative path. We'll discuss the different approaches to level design flow in Chapter 5.

On a visual front, level designers use the same art of illusion to create spaces that feel much bigger than they really are. For a game like *Unreal Tournament*, this might mean creating the illusion of an underwater world outside the window of an undersea base—even though there's nothing really out there. For a title like *Need for Speed: Underground,* this could be the multitude of inaccessible but plausible side streets and landmarks seen between buildings that give players the sense they are racing through a city rather than just on a single track.

Regardless of the type of game or what platform it is for, until we work out a way to create worlds with as much rich detail and level of immersion as real life has, level designers will have to rely on the art of illusion to create believable and enjoyable game spaces.

ANATOMY OF LEVEL DESIGN

Level Design is really a composite role, bringing together several disciplines: art, design, and engineering.

Art

In the past, games could often reach critical acclaim without the need to be visually stunning. These days, to create an interesting and atmospheric environment, a level designer must have some measure of artistic or architectural sense. A level that is well balanced, fun to play, and packed full of surprises will still face player criticism if the environment is crudely built or features a lot of obviously amateur art. Likewise, an architecturally impressive map with nothing to do in it is going to cause players to complain. Balancing artistic considerations with gameplay needs is an everyday struggle for the modern level designer. Although some designers can create many of their own art assets and take the visual quality of their maps into their own hands (schedule permitting), others may have more knowledge in a specific area such as modeling, texturing, lighting, or simply taking a few primitive shapes and evoking just the right emotions and imagery in the audience.

As games get more complex and level designers are responsible for more ambitious content, many teams are adding art support staff to help shoulder the burden of creating engaging aesthetics and allowing the designers to focus on the play experience. Regardless of who makes a level's assets, however, the level designer still holds the vision of the level and will be required to lend direction and vision to his team members during production. Some of the best level designers don't have an artistic background but, rather, use books and images to help them make interesting spaces. Level design does not require an art degree by any means; however, a level designer should be able to illustrate or describe the artistic needs and aesthetic requirements of the map to his team members.

If you're reading this and despairing—don't worry. Most of what makes a good artist is imagination, and the fact that you are, or want to be, a level designer is a pretty good indication that imagination is something you possess. Learning how to use your imagination wisely is something that can be learned—many great books teach the fundamentals of architecture, lighting, texture creation, and the like, examples of which will be included in later chapters.

Design

Although the amount of pre-design that goes into a level before building starts varies, there will always be times when a level designer needs to make a design decision in the process of constructing the map. We'll talk about this later in the book, but the level designer should be able to handle the implementation of the game design to achieve the goals for that map.

After the initial placement of game elements—after you've put in your enemy's units, your traps, puzzles, powerups, and everything that the player is going to interact with, you'll need to "tune" it all. Early drafts of levels are often disjointed and unbalanced, and unacceptable to release to the public. A level designer's game intuition is vital at this stage to go through the level and polish it, tweaking parameters, editing the variables for NPCs, trying to anticipate potential problems and ultimately designing an enjoyable experience for the player.

Level designers also need to be able to spot problems as they work and report them to the designer or producer. If the game designer is the general directing the game from above, level designers are scouts, on the front line of production and able to see potential trouble up close and personal, if they just know what to look for.

Engineering

Although the gulf of knowledge between scripting a level event and actually programming game engine functionality is sizable, some aspects of level design are closer to coding than anything else. Games frequently have an internal "script" system that allows designers to access parts of the game code in a more user-friendly

manner. The means differ from project to project, and some level designers need to be more versed in their game's scripting language than do others who might use simpler or more streamlined tools for setting up in-game events or editing level elements. However, the process is still the same—level designers will invariably be called on to plan, execute, and debug special situations in a level.

As games support larger worlds and more intricate stories, many developers rely more heavily on scripting to provide a sense of realism and action to the environment, as well as to create bigger and more elaborate situations for the player. Boss battles, patrols, the behavior of certain objects when hit with a projectile or the behavior of a civilian when seeing one of the player's units—all these things are potentially scripted by the level designer. As such, any knowledge about scripting or programming can come in quite useful when making playspaces.

Another aspect of level design is technical in nature—performance. Level designers are usually expected to bear a large responsibility for how their environments run. Every game has limitations in how complex the world can be, how many moving characters can be calculated, and how many textures or lights can be displayed in a scene before the game engine is overtaxed and the performance of play degrades. This often results in loss of frame rate—the view becomes jittery and the controls become hard to use. Further problems such as objects overlapping the same space, or errors in the geometry, can cause technical problems too. In general, the performance issue is one that becomes more and more important as the project nears the final shipping date, and a level designer needs to know not only how to spot these problems in a map but also how best to deal with them—be it a workaround, remaking that part of the level, or even amputating the whole section from the map.

DEFINING LEVELS

The term *level* is synonymous with "map," "mission," or "stage" in many games. The original term *level* in games most likely comes from the early arcade machines and home game systems where the play experience was divided into increments of difficulty, called stages or levels. For instance, once the player had finished the first wave of enemies, he was considered to have finished "Level One" of however many levels of difficulty the game allowed. These levels were descendants of "Dungeon levels" in early role playing and tabletop games like *Dungeons and Dragons,* which divided the game environments—most often dungeons and subterranean structures—into vertical floors, which not only determined how deep the players were, but also gave an indication of how powerful the creatures would be. Level Five creatures were obviously going to be a much bigger challenge than mere Level Ones, being further from the surface and the safety of retreat.

A modern game level has a wide range of forms. A common example is a single *Deathmatch* or *Capture the Flag* map you might play in your favorite shooter. Or it could be a track in a racing game, or simply the maze from *PacMan*. At its most basic, a level is simply an environment for gameplay. Does a level have discernible characteristics? Well, it has physical boundaries. It has entrances and exits. It has goals, and it has a beginning and an ending—or it has many of them. A level can contain almost all the game's systems and mechanics, or it can focus on a single activity. Some levels are unique, such as a boss level. Some levels are crossed through repeatedly like the parts of the city that compose those of *Grand Theft Auto 3*.

Every game takes place in an environment, and that's what level designers must provide—putting the "ground" in playground. A level is really a container for gameplay.

BRIEF HISTORY OF LEVELS

As long as there have been games, there have been environments to play them in. Almost every culture has its version of chess, along with a board to play it on. Even in the absence of a board, players have scratched playfields in the dirt or scribbled them on paper like tic-tac-toe. Gameplay needs a vessel in which to exist. Similarly, although the craft of creating interactive environments for video games is fairly new, there is a great deal of history behind it.

Creating Pinball—The Mother of Level Design

Although the level designer position as a team role has only been around for the past 10 years or so, games have always needed play fields. In fact, the first examples of "playfield design" started back in the days when pinball was becoming a national pastime. Early versions of pinball—called bagatelle —were random affairs. The ball was entered into the playspace and found its way down through the layout of pins until it came to rest in a numbered hole. The player really didn't have much control of the ball once it was in play. Although there was some excitement watching the ball progress through the pins, it was more akin to pulling the lever on a slot machine, or watching a movie—once the initial interaction of starting the process was over, the participant could only watch helplessly as events unfolded.

When pinball designers began to add in the element of interactivity, such as the addition of flippers or the ability to guide the ball into reward-rich areas (i.e., a part of the board with a cluster of high-scoring bumpers, or triggering the release of bonus balls), the game made its move from passive to active entertainment. Much in the way that even though building a game level shares many common elements

with building a movie set or describing a location in a book, what sets it apart is interactivity—the player has the opportunity to choose and alter the flow of events to his desires. That's the "play" in gameplay.

It is interesting to note the similarity between pinball design and modern level design. Both were concerned with the funneling of an avatar—in pinball's case, the player avatar was a small metal ball—through an interactive playfield full of rewards and hazards. With each generation of pinballs, the designers had to create new variants on old favorites and develop original ideas to keep players interested. Level designers would do well to look back to the golden age of pinball because these are our real roots—the first examples of interactive environment design.

From Pinball Machines to Super Computers

As computers began to appear in universities in the 1970s, eager engineers started turning them to recreational uses, and the transition from the pinball table to video screen began. Unfortunately, the capabilities of computer-driven playfields were vastly inferior to the long-established mechanical pinball machines. In addition, the people making video games were almost always engineers and students taking a break from their real work, rather than professional game designers, so the art of playfield design had to start all over again, accounting for the new display and control methods.

In the Beginning There Was *Space War*

Widely considered the grandfather of all computer games, *Space War* was actually displayed on an oscilloscope and contained only a single planet at the center for two players to fight around against a backdrop of stars. This could be considered the first video game level. The planet was not just for decoration—it exerted gravitational influence on the players' ships and projectiles. Thought went in to creating an interesting playspace when really, if it had simply been a blank background, no one would have complained.

As games matured, their playspaces matured also. More attention was given to the way game environments looked, and the kinds of experience different environments could give the player. Care was taken to ensure the player was steadily challenged through shifts in environmental parameters. Music and audio played more important roles in both inviting players to the game and providing feedback about their performance. Gradually gameplay went from one-screen action (like *Pong* or *PacMan*) to multiscreen or scrolling environments like *Pitfall* and *Tempest,* where the player was suddenly given greater opportunity for discovery and greater freedom of movement. Playspaces became richer, and gameplay rules more complex. *Defender,* for instance, featured a rapidly changing environment, intense special effects, and audio feedback. *Defender* was one of the first games where the player was informed of things happening in another location by audio cues—when a "human"

was converted into an enemy unit, a specific sound effect played. Although the levels allowed the player to travel left and right over the landscape, randomly moving opponents of varying speeds and accuracy meant simple travel in a straight line was impossible and the experience of each stage was always slightly different. Even though the controls were fairly simple, the sheer complexity and intensity of the levels made *Defender* a favorite for hard-core arcade junkies.

Similarly, for home systems, the Atari game *Adventure* had a randomization routine that meant the player didn't know where all the necessary items in the game were each time he played. The game was laid out on a number of screen-sized rooms that the player would travel between, dodging dragons and collecting required components to beat the game. The first fledgling elements of level design were being born to the gaming world.

The Rise of Home Computing

In the 1980s, the rise of home-gaming on consoles and personal computers meant gamers were hungry for greater challenges, and developers quickly responded with more advanced level design concepts. Armed with more computing power and increased storage capacity on modern gaming machines, the basic elements of earlier genres such as moving platforms and enemies with simple, looping attack patterns were combined and evolved in different ways to create new challenges for the player. Designers strove to encourage exploration by hiding special rewards or even entire levels for discovery by the careful player. Environments became more interactive, introducing complex puzzles to block progression and produce richer and more varied gameplay to keep the player challenged. Narrative became an important focus as games suddenly came with richer back stories and character development rather than simply suggestive box art. Early text adventures, for example, relied on more complex story lines and descriptive text to keep the player engaged. A classic adventure in this style was *Planetfall,* which is widely regarded as being one of the first games to make players cry because of the death of a character.

However, as involved as these new game environments were, there still wasn't a specialized role for their creation yet. Video games were made by only a handful of people, who handled everything required—programming, art, and design. Audio expectations were low enough that the programmers often handled those aspects too. In the heyday of the video arcade in the 1980s, many games were designed, programmed, and decorated by a single person.

LEVEL DESIGN TODAY

Because of the explosive increase in complexity and in expectations of modern interactive entertainment, it's not uncommon to find production teams of 30, 50, or

even more than 100 developers working for years to complete a single title. In such an environment, work is divided up into very narrow specializations, and more often than not one of these specializations is you—the level designer.

Contemporary level designers have a considerably larger responsibility in game production today. Fortunately, they also have a much bigger palette of tools and a huge amount of support in production as well. However, levels are not simply around because they have a history. Having levels helps a game in many ways, including the following:

- Overcoming memory constraints
- Narrative chapters
- Dividing the workload

Overcoming Memory Constraints

In their earliest forms, interactive games were usually simple affairs. Earlier we mentioned that *Space War* was played using an oscilloscope to display two ships and a planet. *Pong* had variable speeds and opponent response, but the playfield never changed. Game graphics were limited by ridiculously meager computational power by today's standards, and often took place in limited or repetitive environments. Most importantly, the technology at the time meant that games needed to load into whatever memory the machine had and stay there until the game was switched off or reset. Given that available memory capacities at the dawn of the computer age were minuscule compared with today's—the need to keep games as simple as possible was a predominant concern. Later, with the introduction of portable storage media like floppy disks and tape cassettes, games expanded enormously in both size and scope, and it was impossible to load the whole thing into computer memory all at once. The concept of levels (or chapters) became more prominent as a way to break up a game into sections that would only be brought in when needed. A game that was broken into sections could be much larger than the available memory of the gaming machine. When each section was finished, it would be replaced with another section loaded from tape or disk.

Early home computers such as the Commodore 64 or Sinclair Spectrum subjected the player to long waits while stages of the game loaded from tape cassette. Thankfully, storage media can be read fast enough now that consoles and computers can quite easily load in specific parts of the game they need from the CD or DVD without the player ever knowing. However, levels have also expanded in size, often having large amounts of unique textures, decorative meshes, character models, scripted sequences, and a host of support content that makes them impossible to load other than one at a time. Thus, the original concept of breaking a game into smaller pieces—levels—is still necessary to avoid straining the processor and to allow epic-sized games to parcel themselves out into bite-sized pieces.

Narrative Chapters

Very commonly, a game's levels are set up in a narrative fashion, telling a story within a story. The player character enters the level, explores his surroundings, encountering increasing challenges and dangers along the way, until the end is reached.

Most games have some form of story or narrative that draws the players along, and many games use levels as a book would chapters—dividing the story into segments allowing story arcs, the introduction of new characters, resolution of goals, unexpected return of old enemies, and so on. In many cases, a level is like a novella—a short, self-contained story that has an introduction, a series of encounters and challenges, and a final resolution. As games start to create broader, less linear story lines, levels begin to contain many story possibilities, which we'll explore in greater depth later in Chapter 5 as emergent gameplay.

Levels encompass areas of connected gameplay and provide logical breaks between key story locations. For instance, one level of a game that uses time travel as a story element might have the players in Berlin in 1800, and the next level has players in the same city in the year 3000. Separating these two periods into levels is logical, as they can be bridged by a cinematic, scripted sequence, or a simple voice-over, to create a more dramatic transition between the two locations.

Dividing the Workload

Level design arose out of a need for specialization within game production teams. As game sales grew, the one-man shows faced new challenges in keeping up with increasing consumer demand for quality and quantity of content. To maintain constant levels of production quality, game teams began to grow in numbers. Aspects of game development that one person had done previously were gradually being done by two or three people. With larger teams, programmers who might have handled both programming and the art were being relieved by full-time professional artists. Similarly, new positions such as game designers, sound effects engineers, and character animators developed to help spread the effort of creating a computer game over a wider team of individuals, each with a narrower set of tasks.

The main advantage of creating a game in stages is that it can be built faster, and production speed can be a huge factor in gaining a publishing deal or getting a milestone out the door in time. The more you can subdivide your game into distinct levels, the more designers can work on them simultaneously. In addition, with the advent of specialized level editors and working environments, the ease of importing and exporting assets (the individual art pieces used to decorate a level— props, characters, textures, etc.) into a level has improved dramatically. This means that a level designer can be working on a map while artists, programmers, and audio engineers all work on content for it, all of which can be imported easily.

This is not to say that designers should seek to break their games into the greatest number of levels possible. Like everything, there is a point at which simply throwing more people at a problem becomes counterproductive. It does mean, however, that identifying and capitalizing on logical breaks in story, gameplay, and visual themes by separating them into levels can help reduce the risk and length of a project.

SUMMARY

This chapter covered the reason that level designers exist today. Having an idea for gameplay is one thing, putting it into practice is another. Level designers oversee the convergence of materials into the final package that players experience. Historically, level design is the extension of early forms of playfield design—from millennia back where game boards were drawn in the sand to the latest in photo-realistic game environments.

Levels have been used in games for many reasons: to allow for larger games, to separate the game experience into narrative or geological locations, and to allow the team to work on the whole game at once.

INTERVIEW WITH RICHARD "LEVELORD" GRAY OF RITUAL ENTERTAINMENT

Richard, you've been making levels for quite a while now, and on a variety of projects. How did you get started as a designer?

Like many of the old veterans, I started with *Doom*. I still remember when DEU (Doom Editing Utility) came out. I downloaded it from CompuServe. The whole time it was transferring over my 256K modem, I was thinking "This can't be for real. Nobody would let you freely create content for their proprietary game." I installed DEU, loaded up E1M1, and removed one of the walls. Run the perverted E1M1 in the game and . . . "Oh my god! I can make my own Doom levels!" I was forever hooked!

I then spent every waking hour of the next six months making four new Doom levels, which I uploaded to CompuServe's Action Forum. These caught the attention of both Q Studios, then working on *Blood* for Apogee, and Apogee themselves. I was hired as a contract level designer by Q Studios and worked for them for almost a year. I was then asked to work on *Duke Nukem* 3D full-time and came to Dallas, Texas, where I've been ever since.

\rightarrow

How has the position of the level designer changed in your opinion, as teams and budgets get bigger?

When I started, the level designer was responsible for many different tasks. These included geometry, asset placement, gameplay, player flow, lighting, balancing, scripting, and some texturing. Now, everything is far more complicated. Most of these tasks are now specialized and performed by one person or subgroup of level designers. The role of the level designer is just as important, the position just requires more people to do it, and they need to be more specialized.

It is very similar to a movie. Watch the credits in a 1930s–1950s movie. They're scrolled by in less than a minute. Now there is enough time to play two or three full songs as the thousands of people's names go by. I expect the game industry will grow in this fashion many times over in the coming years.

Conversely, do you think the quality and sophistication of level design have increased with the scope of games?

Absolutely! The quality and sophistication are incredibly evolved, and that has broadened the level designer's scope. Just reload one of your games from five years ago . . . even two years ago. It's hard to look at it and remember that it was cutting edge in its time.

Do you see any standards emerging in the design and construction of game spaces? Are there tools, or a language, common to level design?

Standards are still ephemeral. They will emerge, such as tool sets and asset pipelines, as one game becomes popular and their way of doing things is in style. For instance, the *Quake* tools were a standard for a long time. Now, many level designers are using sophisticated 3D tools such as 3D Max and Maya for almost all game engines.

When you ask about standards, I presume you mean like in the software industry where engineering disciplines are used such that individuals can bounce from one application, project, or company to another with little re-education. This sort of scale of standardization has not happened yet.

Can you impart some critical lessons you've learned in your career so far?

Yes! . . . making games is not fun-and-games, . . . it's work-and-games! 'Tis true, it's a dream job and I would not replace it with any other career. However, it is not the same as playing games at home and thinking you're the next great game designer. It is also not like sitting at home and making mods and

\rightarrow

such. It is, in fact, long hours of sometimes very tedious work. It is months, at times, of 12–14 hour days, 6–7 days a week. It is coordinating with the egos of other teammates, and meddling producers and publishers, and the press that at times can be brutal, and fellow developers. Your creative juices are most often sucked into someone else's sponge. There are heartbreaks, with months of work thrown out, never to be seen by anyone again.

For someone wanting to land a level design position today, what sort of steps should they be taking?

There are a few great ways to enter, but you MUST make sure you really want to do this. I will warn any poser of this question that simply by asking the question makes me suspicious. Even if I had not started in 1994, you would not have to tell me how to get hired today. The hunger, the true desire, would have me looking under every rock for a niche to fit in.

This is what I would do, this is what I did in 1994: Find a game you enjoy playing that allows access to level editing. Most games do. Make some levels. Play test them well! Get a Web page going to exhibit them. This is a portfolio. Get feedback from people (friends and others that have played your levels). When you think you are polished, start emailing companies and keep an eye out for job offerings.

There are also some very good schools today, if you can afford the tuition. Southern Methodist University, for instance, here in Dallas has a great program setup by many of the leading local developers.

2 Building a Simple Level

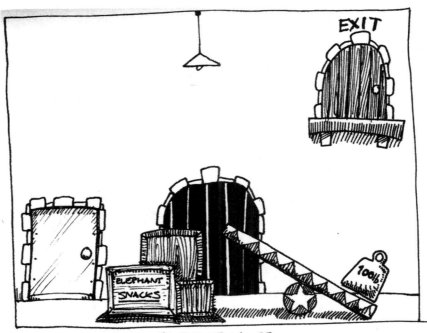

CONCEPT SKETCH - ELEPHANT HOUSE

In This Chapter

■ Level Design Building Blocks
■ What About Story?
■ Putting It All Together
■ Summary

In this chapter you will learn about the most basic and most critical components of what we call a level, then go through an example of how they are interconnected and what part they play in defining the user experience.

LEVEL DESIGN BUILDING BLOCKS

Before we go too far into the details of level design, let's consider what the basic elements in a level are. The "building blocks" we need are these:

■ Concept
■ Environment to exist in
■ Beginning
■ Ending
■ Goal
■ Challenge to overcome between the player and the goal
■ Reward
■ Way of handling failure

As simple as it may seem, those are really the only essential items for a level. Sure, it's not going to cover what might be needed for a next-generation shooter or role-playing game, but generally you won't need *new* or *different* elements for big titles, you'll just need more of everything—more goals, more challenges, and frequently more than one ending.

As an exercise, think of a game—it could be your favorite video game, board game, card game, or puzzle. Generally, you will find all these elements in it. Try to break the game you're thinking of into its component parts. If you use a video or computer game, watch for the different quantities and importance put in elements for each of the levels.

Later in the book we'll talk more about "high-level" concepts like difficulty and flow, but for now these basic components are of the most interest to us, because if

any are missing, the level will almost always be incomplete. You can have a great level with great flow, but if there's no challenge, it won't be fun at all.

In Figure 2.1, we see a screen shot from a classic *Tetris*-style puzzle game. The game is divided into rounds where the player has to interlock falling shapes to format a certain number of lines stretching from one side of the game screen to the other. In this respect, we can measure a level in this game against our checklist of basic requirements:

Concept: Find a place for the blocks or lose the level.

Environment: The active play area to the left of the game data.

Beginning: The player starts with an empty screen and a score of 0.

Ending: The level is over when the player either creates the correct number of vertical lines (success) or the blocks pile up to the top of the screen (failure).

Goal: Create a number of lines that meet the target requirement for success.

Challenge: The speed of descent, type of blocks, and number of lines needed.

Reward: The player moves to the next level, or receives a brief animated sequence.

Failure: The game ends and must be started from the beginning.

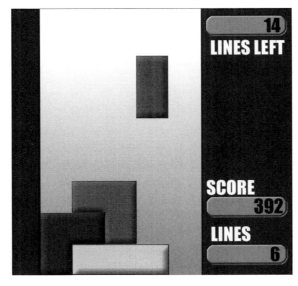

FIGURE 2.1 The level building blocks as seen in a simple puzzle game.

WHAT ABOUT STORY?

You might be thinking to yourself, "Shouldn't a game, and therefore its levels, also have a story?" Well, the simple answer is no—it's not a fundamental requirement. A story can *enhance* a level and give the players information about what they are expected to do, what they might need to avoid or seek out, and so on. However, many types of games exist without a narrative element, and leave it to the players to create a story if they really need one. Chess, for example, has elements of medieval war and politics—castles and knights and bishops on a playing field eliminating each other. However, the game can be played with colored stones, as with its ancient cousin "Go." The battlefield element simply enhances the experience, allowing the player to fantasize on some level about being a general or monarch moving forces into conflict. But the gameplay needs no such background elements to be fun.

Similarly, many levels from titles such as *Tetris, Frequency,* or *Rayman* have no inherent story other than perhaps a thin veneer given at the beginning of the game or in the manual. The gameplay is what drives games, and similarly, it is what drives the stages and levels within them. Ideally, a level will to some degree allow the *players* to create a narrative as they play, even if it's just a series of personal achievements.

Later in the book, we will look at how level designers can express narrative elements or micro-stories in their maps through the use of audio and visual suggestions, and letting the players fill in blanks with their own imaginations. A story does not need to be an epic to be entertaining.

PUTTING IT ALL TOGETHER

Now that we have a manifest of things we need to include, let's go ahead and create a simple level to demonstrate how they all work together.

Concept

For example purposes, let's say we're making a game to be played on a portable phone. The game is called *Clownhunt* and it involves the player controlling Crispy, a clown desperately trying to escape a maniacal ringmaster whose low box-office returns have sent him over the edge. The game is a puzzle game, and each level takes up one screen, presenting the player with a challenge to overcome before moving to the next screen, with each successive level being slightly harder than the one before.

The controls are simple: The player can move Crispy the Clown left and right, and make him jump while moving. This allows Crispy to leap onto low obstacles and jump to avoid small enemies that can pass underneath him. Crispy can fall from any height without injury, has unlimited energy for jumping, and has no inventory or weapons to keep track of. The game is as simple as can be.

Environment

Clownhunt is set in a circus, so all the elements should be thematic if possible. Colorful backdrops and "cartoony" graphics should be present in the environment. These become important as humorous elements to offset the grim theme of the game—the player being pursued by a murderous ringmaster.

Technically, each level takes up the maximum space allowed by the screen's display. The environment consists of a static background image, a starting point for the player, a visible exit he must reach, and whatever elements are available to help him progress in the foreground. There is no on-screen information or heads-up display (HUD) to interfere with the environment because the game doesn't require the player to keep track of lives, energy, or other game "metrics."

For our demo level, the environment will be the Elephant House. The background of the level shows several dark cages, a concrete wall, and a single light hanging from the ceiling, all of which are shown in the basic environment sketch in Figure 2.2. The sounds of elephants trumpeting plays in the background along with the game music and general effects as the player moves through the environment.

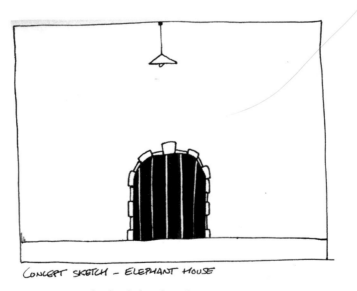

CONCEPT SKETCH - ELEPHANT HOUSE

FIGURE 2.2 The basic level environment.

Beginning

Clownhunt always begins with the player on the left edge of the screen, needing to move to the right side of the screen to exit. The entrance can be at the top, in the

middle or at the bottom of the screen, depending on the level. It is always represented as a doorway through which Crispy runs. For this level, we'll start the player at a plain wooden door next to the elephant cages at the bottom left corner of the screen (Figure 2.3).

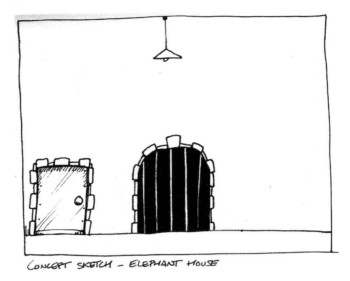

CONCEPT SKETCH - ELEPHANT HOUSE

FIGURE 2.3 The entrance added to our sketch.

Ending

We need the exit to be far enough away from the entrance to make sure the player can't reach it without overcoming some kind of challenge or obstacle. For this level, we're starting the player at the bottom left part of the level, so putting the exit high up on the right (Figure 2.4) sets the goal for the player. We'll also label it "Exit" in the level itself to make sure the player knows that's where he needs to go to move to the next stage. The area around the door will detect if Crispy is touching it and end the level successfully.

Goal

The goal of every level in *Clownhunt* is the same—reach the exit. The final level might be a showdown with the Dante, the ringmaster, but for the purposes of this chapter that doesn't matter. The important part is making sure the player has a way to reach the exit and finish the level. For our game, the goal is made clear by the story—an enemy pursuing the player makes it essential that the player keep moving. This is a narrative-driven goal, however. The Ringmaster will never actually appear

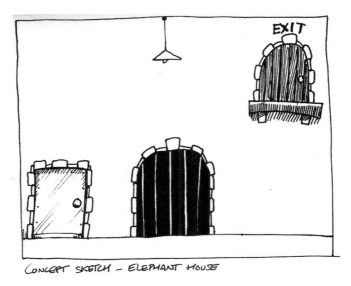

CONCEPT SKETCH - ELEPHANT HOUSE

FIGURE 2.4 The level exit added to the map.

in the level or get Crispy, no matter how long he stands idle. The advantage of a goal that can be applied to all levels is that there is no need to precede each stage with a description of the objective, or keep track of different success metrics for each map (such as enemies destroyed, coins collected, or whether a certain key has been picked up.)

Challenge

This is the key to the player actually having fun in the level. We need to come up with an obstacle to stop the player from simply reaching the exit, and provide a way for him to overcome the challenge. We also need to make sure the challenge is thematic—that it doesn't strike the player as out of place or goofy for the kind of game he is playing. This is called *dissonance,* and you will constantly need to avoid this as a level designer.

As this is a game set in a circus, having a puzzle involving a seesaw might not seem too out of place, so let's run with that idea.

The seesaw is a useful challenge for a number of reasons:

- We need a way for the player to gain height to reach the exit.
- It is immediately recognizable by most players.
- How it works is apparent just by looking at it, so we don't need to explain to the player how to use it.

So let's go ahead and put it on the floor of our level design sketch (Figure 2.5). We can make the pivot point a large circus-looking barrel and the moving part a plank so that it fits into the background.

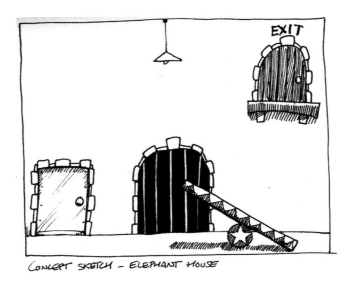

FIGURE 2.5 The challenge element added—a balance puzzle using a seesaw.

Determining the Challenge Mechanics

Now that we have the puzzle, we need to add the *mechanics* that will allow the player to interact with it. Usually, when we talk about a puzzle or challenge in a level, we can break it down into different sorts of mechanics—a mechanic is simply the functionality behind each puzzle or game element. The mechanics behind a door are simple for most games—activate a door and it will move a certain direction on one axis, usually its hinges, just as it does in real life. Players should have no reason to believe a door would behave otherwise unless they were led to believe so by prior knowledge, a prompt from a character, or a visual clue. The best gameplay mechanics are those that need no explanation, allowing the player to simply work out how to interact with them from his own observations. This makes the players feel clever and allows the designer to stay out of the picture while they play.

For our gameplay challenge, the mechanics should work like the player expects—a weight on one side of the seesaw will make that side go down and the other rise. The greater the weight, the higher the opposite side will move.

So how can the player use a seesaw to propel Crispy up to the exit platform? Obviously, he'll need something heavy to drop on the opposite side of the seesaw, which will make his side move up and give him the height needed. There are several ways we can introduce this weight to the player and allow him to interact with it, a few of which are illustrated in Figure 2.6.

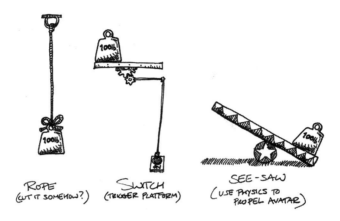

FIGURE 2.6 A suspended weight, a weight on a triggered platform, and a weight already sitting on the seesaw.

In the example, only one option will work for us. The suspended weight would work if we could shoot or throw something sharp at the rope to cut it, dropping the anvil down onto the seesaw. However, the design of *Clownhunt* doesn't allow the player avatar to be able to do anything but move from side to side and jump. Likewise, the option of having the weight on a platform triggered remotely by a lever won't work either. Obviously, Crispy doesn't have an "interact" action to use the lever. We could allow the player to simply bump into the lever to drop the weight, but then it would cause difficulties allowing the player to be on the low end of the seesaw and trigger the weight at the same time.

Putting the weight *on* the seesaw seems the most advantageous. This way the player needs to work out how to use the seesaw to throw the weight up and then use the resulting impact to propel the avatar to the exit (Figure 2.7)

Fortunately, this mechanic needs little explanation. Gravity is a known concept for players, and they can reasonably expect that if the weight goes up, it will also come down. We don't need to clue players into the puzzle ourselves—it's all self-explanatory.

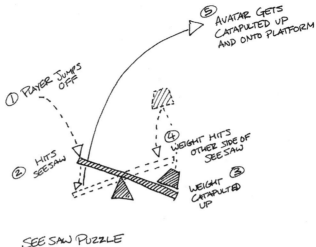

SEE SAW PUZZLE

FIGURE 2.7 Creating gameplay around the puzzle
element.

A relatively logical solution for the player right now is simply to jump on the
high part of the seesaw and wait as the opposite weight flies up and comes smash-
ing down. In real life, this might end up breaking the seesaw, or the weight may not
land where it started. However, this is an example of "game logic." Game logic is
where the player can reasonably expect that certain situations or objects will be
more predictable than might be the case in real life.

In *Andrew Rollings and Ernest Adams on Game Design,*[1] the authors explain that
knowledge gained about the game from within the game itself, is called *intrinsic*
knowledge. Conversely, knowledge applied in the game but gained from another
source, usually real life, is called *extrinsic* knowledge. In the case of the seesaw, the
player is using his extrinsic knowledge of how that object works in the real world to
tackle the problem facing him in this level.

In the case of the seesaw, most players will assume they can use it to get up to
the exit, without too many *realistic* factors to hamper their efforts. We can add fur-
ther complexity to the puzzle by requiring the player to jump on the seesaw from a
high point to propel the weight object high up. We can do this by adding a struc-
ture of some sort that allows the player to get higher than the seesaw before jump-
ing on it and creating a *rule* to allow the game to know how high to move the
weight based on how high the player jumps from.

1. Andrew Rollings and Ernest Adams. *Andrew Rollings and Ernest Adams on Game Design.* Indi-
anapolis: New Riders, 2003.

We'll talk more about scripting in later chapters, but a very simple example of level design scripting is creating simple rules for in-game objects to follow to react to the player's actions. Often, you or the game designer will give these rules to the programmers to implement when they code the object. In other instances, you will be able to implement rules like this yourself on a level object through some kind of editing language.

An example of a rule we could set for the seesaw is this:

Multiply the distance the weight goes up by the number of feet the player character falls before landing on the other end of the seesaw.

With this rule in place, the next questions is, What will the player jump from? If we assume Crispy's jump height is fairly low, then jumping onto the plank from the ground isn't ideal. We probably want to include a low platform for the player to jump onto the seesaw from. We can put in a small stack of obstacles next to the seesaw that the player can climb on top of and jump down from. At this stage, what the obstacles are isn't important, but it is critical that they are low enough for the player to jump up onto them, and stacked high enough that they offer various heights to jump from so our rule has some effect on the weight at the other end of the seesaw. For thematic reasons, however, we can make it a stack of crates with the words "Elephant Snacks" stamped on the sides, shown in Figure 2.8.

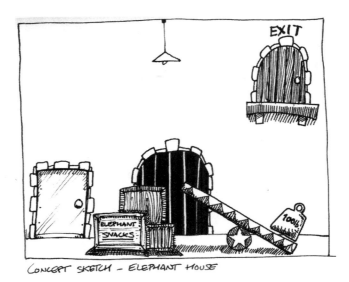

FIGURE 2.8 Crates will allow the player to gain height for his jump and propel the weight higher.

The challenge is now complete—using simulated real-world reactions, a lever in the form of a seesaw is weighted at one end. The player must work out that he needs to climb a nearby stack of boxes to jump onto the other side of the lever, catapulting the opposite weight up and sending him flying when it hits the seesaw again. Simple, easy to understand from visual observation, and effective enough to probably require more than one attempt by the player to get it right.

Reward

In this case, the main reward for completing the level is allowed to access the next one. A secondary reward will be a short victory animation of Crispy giving the player a thumbs-up before diving through the exit. For many players, the act of completion and progression is the driving force for playing a game. This is a tendency we can capitalize on for *Clownhunt* to simplify the levels and reduce the need for special case level goals.

Failure

The last critical part of the design is what to do when the player fails the challenge, or fails to complete the level. Luckily for us, all of this is handled inherently. We don't have a timer or any kind of over-arching challenge that might end the game before the player manages to finish. We don't have health, so falling from any kind of height won't end the level. There are no expendable resources or parts of the level players can waste and put themselves into a no-win situation. Falling from the stack or seesaw simply means the player has to get back on the crates and try jumping onto it again. Simply put, there is no chance of failure in this level.

This does bring up an interesting point, however, and one that you should keep in mind as long as you design experiences for other people: The more the players can blame you, the designer, for failure, the easier it will be for them to simply stop playing. If a player fails and can only blame himself, there is a greater incentive for him to try again. You should only set the players back, or force them to reload when absolutely necessary—letting them climb back up and try again, or transporting their units back to a neutral location after getting killed by an ambush, for example, is always a better option. This point will come up several times in this book because it is one of the most important rules of creating game levels.

SUMMARY

Although there may be many, many different types of game genres, almost all share the same basic requirements for the individual levels that make up the game. Knowing what these building blocks are is critical to knowing what makes a good

level. In this chapter, we covered these foundation concepts and went through the process of making a level that uses all of them for a virtual cell phone title. Some key lessons illustrated in this chapter are the following:

- The more players can complete a challenge in a level by simply interacting with it and observing the results, the better they will feel about overcoming it. If you need to resort to prompts or special mechanics to allow players to complete your puzzle, you will risk removing them from immersion of playing your level.
- Sometimes simply finishing a level can be a reward—there doesn't always need to be fireworks or an exit guardian to defeat for the player to feel like he has accomplished something.
- Try not to let the player be in a position to blame you for his failure. If you give players all the tools they need and don't impede their abilities to learn from mistakes, they will be much less frustrated with failure. Even better, eliminate the need for failure at all when you can.

3 Team Roles and the Pipeline

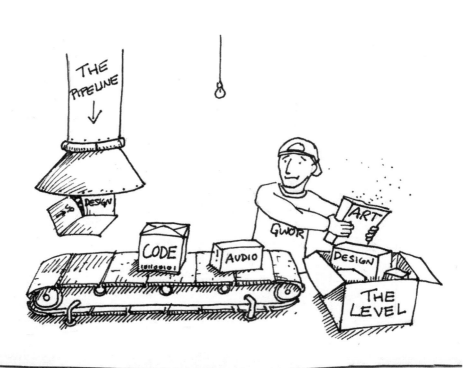

In This Chapter

■ Development Teams
■ Management
■ Design
■ Art
■ Programming
■ Audio
■ Other Development Roles
■ Team Setup
■ The Pipeline
■ The Unarguable Benefits of a Solid Pipeline
■ Pipeline and Technology
■ The Game Engine
■ The Game Editor
■ Pipeline as Defined by the Team
■ Summary
■ Interview with Hayden Wilkinson of KnowWonder Digital Mediaworks

Throughout the book, we will be referring to many different roles in, and stages of, game production. This chapter will explain in depth the major roles in a game development team, as well as describe the *pipeline,* or the way in which a game is put together. Although not all of it is critical to know when you are simply making levels on your home computer or even when making levels professionally, the more information you have about who does what, and when, the better a designer you will be. A level is made up of a huge number of pieces, and a huge effort from a large number of people. Let's look at who all those people are and what they do.

DEVELOPMENT TEAMS

You may be part of a commercial game development team, an amateur development group (also called a modification or "mod" group, creating a new game based on the engine of an existing title), or simply working at home on levels for fun. In each case, you will experience different levels of responsibility and control over your levels. Many variables affect who does what on a game team. Some companies prefer a system that includes many managers and nondevelopment staff who help keep the project running and make sure the needs of the creative team are met. Other companies seek to keep management to a minimum with only a few leads

and a single manager steering the ship. In some cases, level designers are required to create all the art they will need for their own levels, in addition to designing and building the actual environment. Some teams have level designers who design maps in high detail on paper, and hand them over to others to build. In any case, there are a few established "departments" that most game developers fit into. Let's look at the common roles that make up the modern game team.

MANAGEMENT

A team needs business-savvy people who can guide the project through the rough waters of developing a game, especially if it is a game being made for clients with very specific interests and requirements. Managers can be full-time, with little creative input into the game, but usually are somewhat involved with the look and feel of the project. The smaller the team, the more "hats" everyone has to wear to get the job done right.

Producers

Producers handle a role similar to a producer/director on a movie. They are the communication link between production team members and the higher levels in the company—the executives, owners, and so on. Producers may give creative criticism about the game, or even design parts of the game themselves. In very small teams, a producer may also have the lead design role. Producers also handle the delivery of game content to the client for review, creating "builds" or snapshots of the game in progress. In mid-sized teams, the producer usually handles meeting team needs, scheduling, resources, and making sure the demands of the client or publisher are met.

Project Managers and Assistant Producers

In a team where the producer is involved heavily in the design of the game, or where there is simply too much work dealing with day-to-day problems, project managers often take over the more mundane tasks, such as scheduling the team members, motivating them based on performance and upcoming deadlines, and handling individual requests (for new mice, graphics cards, etc.). When a team has a project manager, he or she becomes the level of management that the team deals with instead of the producer. Sometimes a project manager is called an assistant producer, but the role is often exactly the same.

Creative Director

Unlike the other managers, creative directors are often shared between teams in smaller companies, meaning that they serve as advisors, making suggestions and

helping the creative staff realize the vision of the game, but often don't create a lot of art or design themselves. Creative directors on larger projects are still part of the managerial staff, but are dedicated to the vision of a single game. Often they will produce documents and structures to make sure all the art and design staff members are working to create a unified "look and feel" to the game. Otherwise, with several strong artists on staff, each level in the game or each character could be rendered with a very different style, resulting in an unharmonious look or feel to the game.

Leads

When games require several people of the same discipline, the management may appoint *leads,* who are members of the staff that straddle the line between developers and managers. For instance, a lead programmer may still program parts of the game, but will also guide the programming team, attend management meetings to report the problems and concerns of the programming team to the producer, and help schedule and provide his team with tasks. Leads are usually individuals with experience or seniority who can be resources for members of their team when problems or questions come up. Common lead positions in the game industry are the following:

- Lead designer
- Lead programmer/engineer
- Lead artist
- Lead level designer
- Audio lead
- Lead writer
- Lead tester

DESIGN

We discussed the designer's role in Chapter 1, but only briefly. The ideas generally come from the design department of a team. If game development were like a piece of self-assembly furniture, the designers would be the instruction manual. The designers conceptualize the game and create the vision of the game world. Designers also provide the rules and systems that determine how that world works, what's possible to do and not to do within it, and the activities and encounters that the player (or players) will face. There are several commonly found roles within the design group: game designers, level designers, and system designers.

Game Designers

Before a game is designed, it is like a blank book. Game designers fill in the pages of that book to make a document that describes the game to everyone else. Generally, designers are the folks who take a seed of an idea—it might be an original game concept, or it might be a movie that is due to be released in a year—and grow that idea into a set of rules, descriptions, and examples that will provide direction to the entire team in what to create and how it will all work together. The main output of game designers is the *design document,* which is all the game's data combined into one place. Nowadays, the concept of a single document is becoming outdated, and teams are putting the game's design on internal Web sites (or *intranets*), which allows team members to find what they need more quickly using Web browsers, and edit or make comments on part of the design that they have questions about. Game designers are planners, thinkers, and writers and often have little actual art or programming game output.

Level Designers

These developers are special designers who, as we now know from Chapter 1, juggle design, art, and programming skills to create the spaces where the player will actually be playing the game. We won't go into too much detail here because most of the book explains their role and responsibility on the team. It is important to note, however, that " level design" is possibly the most ill-defined game job today. Some level designers are responsible only for the design of the gameplay, with artists taking on the task of building, decorating, and populating the map based on the designer's specific plans. A similar role, that of "scenario designer" is common in games where all of the level's art is prefabricated and designers are involved mostly in creating and scripting the complex missions of the game, especially for strategy titles like *Empire Earth* or *Warcraft 3*. Sometimes *scenario designer* refers to individuals who do everything—design, plan, build, light, populate, decorate, and polish the map all by themselves. Level designers can work under either a lead designer or a lead level designer if the team is large enough to need one.

Systems Designers

More recently, games have become complex enough that it takes a specialized designer to create the individual systems, rules, or scenarios of the game, but doesn't actually build any of the game content. For instance, a game team may have a system designer handle the way combat works in a fighting game. These designers supplement the lead designer's responsibility to work out the mechanics of the game and document them for the rest of the team. As games become more complicated and the ability for one person to adequately keep track of the design of a

game's internal structure becomes more limited, systems' designers will become more common.

ART

The art team is responsible for everything the player *sees* in a game, literally. From the install menu, to the final credits, as long as it happens on screen, the art team helped create it. This covers a huge number of skills, roles, and responsibilities, as you might imagine. Art teams are broken down into several specializations.

Modelers

As games increasingly use more complex 3D graphics, the need for people to create the myriad of people and things in the game world—to model them as 3D objects—also increases. Modelers are masters of turning out the props and characters that you will use in your maps. Modelers work either from reference, concept art, or purely from their imaginations to create 3D meshes for the game, often hundreds of them. Commonly, they will use commercial modeling programs (such as Alias|Wavefront Maya) to create their work, which is then brought into the game editor for placement in the levels.

Animators

Animators take the characters, and sometimes objects, that modelers make and give them life and motion. For instance, in most games where players can see their characters, the animator needs to create a response for each of the character's available actions. When the player presses the jump button, the avatar plays an animation of jumping into the air—an animator created this movement. Similarly, for every action in the game, the animator makes a unique animation. Sometimes a company may choose to use live motion capture, or *mo-cap*, where real actors dress in special suits that translate their movements to computers as animation data. This data still needs an artist to tune and edit the data before it can be used in the game, however. Motion capture is popular because it provides many of the subtle nuances of human movement that are hard to replicate manually. However, motion capture costs a great deal more money than a traditional computer animator does.

It's not just living things that need motion. Animators often create animations for game objects that need movement—doors that open, or trees that sway, for instance. As computer technology improves, many of what we have traditionally used as static objects in levels will begin to be animated all the time—trees, papers, curtains, grass, etc.

Texture Artists

Texture artists create the flat images (which we'll discuss more in Chapter 10) and effects, called textures or materials, that go on the surfaces of objects in the game. Very often small teams don't have unique texture artists—the modeler or animator handles the texturing of an object or character. For larger teams where the number of textures to be created is large enough, one or more texture artists are brought in to help ease the workload for the modelers.

These artists use 2D image editing programs such as Adobe Photoshop to create original art and use digital photos for the game. They also need to be well versed in the 3D applications so they can actually map the textures onto models properly, and test their work in three dimensions.

Texture artists also make the materials that level designers apply to the levels. In this case, the designers are responsible for actually applying the materials onto the level surfaces, and a great deal of communication is needed between a level designer and a texture artist to make sure exactly the right textures are made to match the needs of the level.

Special Effects Artists

Another specialized role, effects artists are all-round skilled artists who create the special effects (SFX) needed for games. Many special effects that cannot be created by simple animation use what are called *particle effects* in levels. This type of effect uses, as you might guess, small objects called particles that can be generated when needed, and destroyed after certain conditions are met. A texture or image is used for each object for its appearance in the world. Almost any kind of effect can be created with particles, and they are used extensively in games for things like billowing smoke, flickering flames, muzzle flashes from guns, waterfalls, sparks, snow and rain, falling leaves, or blood spraying from a hit location.

Many game engines feature very complicated, scriptable particle systems that allow the users to create complex and realistic effects. For this reason, effects artists tend to spend part of their time creating art and images for the particles, and the rest of their time fiddling with parameters and adjusting the properties of the effect.

Interface Artists

All games have interfaces—the layer between you and the actual game. When you start a game there is always a start screen with options that allow you to begin a new game, load an old one, choose from a selection of performance options, and so on. When you actually play the game, there are elements that aren't part of the game world that show you specific information—we call this the heads-up display (HUD), as coined by the U.S. Air Force for the kind of information overlay that fighter pilots see superimposed on their view through the cockpit canopy. In games,

the HUD usually tells the player how much health he has left, shows where he is on a small map, or displays remaining ammunition or turns that are left.

Interface artists create flat images like texture artists do, though they may often work in 3D modeling programs to create those images. Interface design is a very skilled field that uses the science of "information display" to determine what the most critical information that the player needs to know is, and how to display it in a way that is easy to see, yet won't get in the way of playing the game. Many games strive to remove the HUD completely, like Lionhead's *Black and White;* however, very few games can get away with no on-screen information other than what is shown in the level. Even a game without a HUD will still need interface art for menus, pause screens, in-game systems such as inventory and character statistics, and so forth. The work of interface artists and level designers tends to be independent and there isn't a great need for extensive communication unless each level will feature a unique style of interface art.

Concept Artists

Concept artists work during the early part of the game, mainly in pre-production where they help to visualize the look of the game—its locations, characters, objects, interface style, and so forth. Concept art is loosely done, and involves coming up with lots of ideas at first, choosing the best direction from many and refining the result in waves of concept drawings and sketches. It used to be that conceptual art was done via traditional means—pencil, pen and ink, or marker compositions. More recently, with the ease of programs such as Photoshop and Painter that can replicate all manner of artistic styles and media, concept artists often work electronically. This helps to distribute, print, adjust, and even place concept art in a game environment for evaluation quickly.

Occasionally, a concept artist will remain with a game team to help realize important visuals and game encounters, but it's rare. Most concept artists finish their work as production begins in earnest, creating a set of images and reference art for artists and level designers to work from.

PROGRAMMING

Programmers are the folks who make everything work on a fundamental level. Not only do programmers create the technology on which the game runs—the engine, the renderer, the drivers that make the hardware work—they also create the tools that other developers use to create the content for the game, as well as programming individual parts of the game, from the behavior of a squirrel to the entire artificial intelligence (AI) system controlling whole enemy fleets. Let's look at the major roles in a game-programming department.

Gameplay Programmers

This type of programmer works directly with designers and level designers to provide functionality and behavioral elements for use in the game. A programmer generally handles anything that the player needs to interact with or sees making decisions on its own. Although the visuals of an enemy archer may be handled by a modeler to make the character mesh and by an animator to give him animations for moving, readying a bow, or firing at the player, a programmer puts these things together and adds the intelligence behind the NPC that causes it to move, target the fire, die when wounded enough, or seek help when outnumbered. As a level designer, when you need a specific behavior for an existing game actor, or when you need a new actor entirely for an encounter or situation you are building in a level, you will work with most closely with a gameplay programmer.

Tools Programmers

All the tools you use when developing a level were created and coded by programmers and engineers. In game development, the quality of a project is often influenced heavily by the quality of that game's tools. Animators need tools to adjust and import their work into the game. Designers need tools to adjust the properties of the game, see specific data, and make tuning adjustments to all manner of game elements. For level designers, the most important tool is the editor, or the tools that allow designers to build, decorate, script, and test their levels. Without good tools to do all of these things efficiently and comprehensively, developers can't work at their best.

Tools programmers, then, are responsible for creating, updating, and fixing the game engine and tools used to interface with it. They may be split between game programming and working on the engine, but these programmers usually work through a game's production to make sure the team gets what it needs, as needs arise, and that new features are implemented based on the wishes of the client or team leads. Tools programmers tend to work *between* projects too, updating and refining the tools so that by the time a new game ramps up to production, the engine has been improved a great deal and is able to use advances in game technology, keeping current with the engines of competing titles.

Graphics Programmers

Modern games need eye-candy, impressive visuals that make the player want to buy the title just from seeing the screenshots on the back of the box. Some games are so visually impressive that dedicated "hard-core gamers" will actually purchase new computer hardware or game consoles just to play them. Thus, programmers who are able to get as much juice as possible from a game's technology and the hardware it will be running on, to make it as visually appealing and graphically unique as possible, are crucial.

Graphics programmers work somewhat in conjunction with level designers, providing the means for rendering visual aspects of a level such as textures and materials, lights and special effects such as *light blooms* that make the screen fuzzy around bright lights, or dynamic shadows that move around and react to the lights in a level. In general, however, the major work of graphics programmers is beneficial to the art department and is filtered to level designers through tools that allow them to use the graphics techniques properly.

Graphics programmers are also responsible to some degree for how a game performs, balancing the need for eye-candy with the need to run smoothly on most computers and not slow down from trying to process too many visual effects.

AUDIO

The audio department is responsible for the sounds and music in a game, and by extension, all the aural effects in a level. Never underestimate the importance of audio in a game level; often it is one of the most critical components of atmosphere and emotion in a game map. Two major game audio roles are commonly found, sound designers and musical composers.

Sound Designers

Much like texture artists, who use their talents to modify real-life images as well as create materials from scratch, sound designers are responsible for creating audio texture—adding authenticity and complexity to the level through the use of prerecorded or synthesized sounds as well as *Foley*—creating sound effects in a special studio from scratch (using appropriate sounding objects and surfaces) as is done for film.

Sound designers work from the documents that the design team creates. Your level documentation will be reviewed by the audio staff for suggestions and clues to what sort of sound effects or music is needed. Although you may actually specify effects that you need, skilled sound designers will generally extrapolate information from your ideas and create sounds that suit the theme, setting, and practical requirements of your map. For instance, if your real-time strategy level takes place in an arctic environment, a sound designer may decide to come up with special movement sounds for all the vehicles to play when they move over snow and over ice. The muffling effect of a heavy snowfall may inspire them to alter weapon firing sound effects a little to make them more realistic. Ambient sounds might simply be arctic winds blowing ice crystals across the plains, or the occasional creak and crack of glacial movement. Sound designers play a critical part in creating game environments and level designers should expect to interact with them a great deal during production.

Composers

Musical compositions in games—full thematic scores, momentary "stabs" of heart-pounding music, and simple background ambient music—are all put together by musical composers. The creation of game music differs less from that of cinematic composition than one might think. Game music can be anything from completely synthesized, computer-generated techno music to sweeping, symphonic background music played by full orchestras. Many games pursue traditional music over computer-aided instruments when trying to capture a cinematic or classical feeling.

Level designers often get music as an asset that they can use in the map with varying amounts of direction from the audio department. Sometimes a piece of music can be used whenever and wherever it feels suitable, but at other times (or on other projects) much of the music is written especially for specific parts of each level, like a movie score. Either way, having a fully-fledged musical composer on the team is a great asset and customized music for a level can add an amazing amount of depth and atmosphere.

OTHER DEVELOPMENT ROLES

Other common roles will also intersect with level design but aren't attached to particular departments.

Cut-Scene Artists

Cut-scenes, as we will talk about much later in the book, are simply miniature movies created within the game itself, to relate critical story information to the player, to force him to watch a situation unfold, or to give clues about an upcoming challenge.

The people who make these interludes are generally a subset of level designers, in that they work within levels as the backgrounds or sets on which the cut-scenes are "filmed." A cutscene artist does this by using special markers for game characters to move to, virtual cameras to switch views at key moments, and special animations to let the characters "act" appropriately. This is often done through a special tool in the editor, or through a scripting language that allows them command of the level environment and the characters in it.

Level designers and cut-scene artists work in conjunction with each other to create high-end interactive, and non-interactive, experience in the level.

Writers

Game writers create the narrative thread of the title, as well as handle incidental dialog (conversations between two thieves that a player might overhear, for example),

writing voice-overs for mission briefings, communications and mission failures, and all other related in-game writing. In addition, game writers often create background information for the development team, including character descriptions and histories, location information, and extra detail that helps level designers create more authentic or appropriate environments and encounters.

Writers work closely with level designers and cut-scene artists to make sure the storyline and narrative are consistent, that the player will be able to follow along with the plot and identify with the characters, and that in general the game upholds a high standard of writing quality. A team without a writer will usually fall back to a producer or lead designer filling in and creating written content, which is not always a desirable situation. The art of game writing is still evolving because games have mostly not developed full-scale cinematic storylines and in-depth characterizations. As the industry grows, however, many writers are making the transition from film writing to producing game scripts, which are very different from each other in how they are implemented. Film scripts are the end-all-be-all of the movie around which production revolves. In games, story is secondary to gameplay and, as such, the game writer needs to make constant adjustments and refinements based on what goes in, what gets cut, and what written situations are discovered to be too expensive to produce within the game engine.

Testers

Once a game starts to shape up and playable levels are being made, the testing team is brought on to identify "bugs"—problems in the game that range from graphical glitches like missing textures, to high priority "show stopper" bugs that cause the game to crash completely, or allow the player to get stuck somewhere and not progress, effectively killing his ability to progress.

Testers are dedicated souls who not only play the levels as they get made, they try their hardest to break them. In this way, after playing through a level tens, sometimes hundreds of times, the testing team identifies as many problems as it can, and the team can release a bug-free game to the public.

In very small teams, the testers may interact with the level designer directly. In most teams, however, testers will submit bug reports to a special database that the level designers access to find problems that relate to levels they are working on. In this way, the relationship between tester and designer is very close, but little direct contact is made between the two.

TEAM SETUP

Now that we have gone through all of the common members of the modern game development team, let's look at how these teams are set up to function at peak efficiency.

Every team is unique, but we can use the categories of small, medium, and large teams to show the kind of scale differences that can be found in the industry. The numbers used as examples of how many people each sized team has are current at the time this book is written; however, as time goes on these sizes are bound to increase alongside the expectations of the players and the capacity of the available technology.

Small Teams

Small development teams of one to twelve need members to "wear multiple hats" by performing more than one duty on the project. For instance, the producer may also be the designer—one person handling both scheduling the team members and running the logistical side of things while also creating the design document and working with the team to oversee the creative vision. In small teams, communication between various members is easier and fewer large-scale reviews or informational sessions are needed. Small teams can change direction, respond to problems, and rearrange the internal structure of the team more quickly if necessary. They tend not to have leads, and management falls on only a few key people. The structure of a more compact game team generally results in a "flatter" command structure (Figure 3.1)—if one really exists at all—but the scope and size of the games it can reasonably tackle are also smaller. Independent games tend to go for a reduced development group because of smaller budgets and no real publisher support. Handheld games, Web games, cell phone games, and games for younger gamers all steer toward fewer team members. Contractors often play a big part in filling out the ranks of small teams, as well as part-time developers who work on elements of the game for only a portion of the production process. In small teams, levels are often created by whoever has the time or inclination, and level designers commonly must produce large numbers of maps and create the assets for them, too.

FIGURE 3.1 An example of a small development team.

Mid-Sized Teams

The mainstay of game production is the mid-sized team. Usually, these teams are large enough that each person on a team has a single primary task, and regularly scheduled

communication makes sure everyone knows what the others are doing. Medium-sized teams tend to have small departments relating to the major areas of development—programming, art, design, audio, and management—with a lead for each (Figure 3.2). Given enough time and money, mid-sized teams can produce anything from a complex Web game to a "triple-A" chart-busting game for console or PC. Mid-sized teams also have a management layer that does not create content for the game but, rather, oversees the production process and deals with the client. Independent games with mid-sized teams generally already have a contract in place with a publishing client and so can afford to pay the large overhead that comes with substantially more developers working at one time. Sometimes contractors and part-time members are drafted in to fill out the numbers but mid-sized teams range in size from about 12 to 35 full-time employees and are the average size for most large-audience PC and console games. Level designers in medium-sized teams are often responsible for a handful of levels each, but are supported by the other departments for asset creation.

FIGURE 3.2 An example of a mid-sized team structure.

Large Teams

In rare cases, games cover a large enough scope, size, or expectation that a large team of 35 or more is needed to meet the requirements of the client, or the consumers. Large teams require the most specialization from the staff (this sized team

is often where you will find SFX artists, assistant producers, and systems designers, for example), often grouping them into smaller teams within the main production group to handle specific tasks.

Large teams require a great deal of management to organize and oversee the developers (Figure 3.3). Large teams are frequently employed in the production of high-

FIGURE 3.3 An example of a large development team setup.

budget flagship games for well-funded studios, such as *Half Life 2* or *Prince of Persia* or for massively multiplayer (MMP) titles such as *EverQuest,* which need not only a development team but also a group employed to make new content continuously, help players in the game, and create events and in-game encounters (called the "live team").

Level designers in large teams may only be responsible for one or two levels, but can expect a huge amount of work and documentation in making them. Constant communication is needed to keep everyone on the same page, and generally a level designer enjoys dedicated support from one or more artists and programmers to make sure all the content and functionality for the level are delivered.

THE PIPELINE

As we can see, a game level is really made up of many parts, all coming from different people and departments within the studio, much like a modern factory line (Figure 3.4). When the time comes to plan for how all the levels in your game are to be built, a process has to be worked out to make sure the production goes smoothly and everyone is able to work without waiting for someone else to finish first. This is called the *pipeline* and it helps define

- Which team member is responsible for doing what tasks
- The order in which those tasks must be done
- How much time those tasks will take

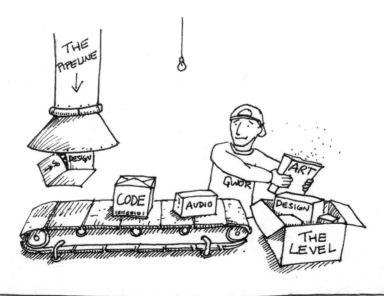

FIGURE 3.4 The level designer is the end of the factory production line.

To use the analogy of the factory floor again, there is no set production pipeline that works for everyone. A factory that makes cars will create and assemble parts in a different manner than does a factory making pies. In the same way, in the game industry each studio, each team, each genre, and each individual title will have certain demands for the production process. Conversely, when a company finds a way of making games that seems to work well in general, each following project works from that standard pipeline. Further modifications are then made based on team size, resources, engine, and platform for a particular project.

As a level designer, or a lead level designer, you may be called on to advise in how your game is made; specifically, you may be asked for input on the role of the level designer on your project, the amount of support needed, and the distribution of levels among the support teams. When in the process of building a level does the cinematic team get to work on it? When does the sound engineer get the map to see what effects he needs to make? All these questions need to be evaluated based on project resources and limitations.

THE UNARGUABLE BENEFITS OF A SOLID PIPELINE

With so many decisions being made, and very often not enough communication between developers, it is essential that the team understand the "big picture" of how everything is meant to come together and, more specifically, that each team member is clear on his role on the team. Given that most games are made with strict deadlines and release dates, the biggest enemy of the level designer is *time*. The bigger and more detailed a game is, whether it be a platform game, a shooter, or a simulation, the more help the designers will need to create the levels, and having solid pipeline allows everyone to work at the same time.

SIDEBAR

Megan's studio has set up its pipeline so that the level designer is responsible for creating the basic level, as well as adding the models and textures created by the art team as soon as they become available. During the production of the level, there is constant dialogue between Megan and her support artists about what is needed, allowing them all to work in parallel. By the time the basic geometry in the level is complete, she has all the models and textures that she needs to finish it. While she is adding models, the audio designers and game programmers are working on more specific content for her to add, and the artists move on to her next map. The pipeline determines who works on what level so the production schedule is well oiled and allows everyone to work at once.

If you are building a level, you rely on the support of others. If the model or code you need isn't done, you may be forced to sit and wait. Likewise, if an artist is sitting twiddling his thumbs because you have the map that he needs to texture, you're wasting his time. It's as simple as that, really. The worst thing for a producer or project manager is if employees cannot get their work done for any length of time, and are stuck idling as the next team deadline looms. This is the sort of thing most producers have nightmares about.

SIDEBAR

At Greg's company, the procedure is for artists to place their textures and models themselves, rather than have the level designer do it. This allows the artists to do it right the first time, but unfortunately requires that whoever is changing the level have it open on their computer, preventing anyone else from working on it. This wouldn't be a problem, except that level designers are scheduled to work on their maps until they have been finalized and reviewed by the leads before moving to the next level. Greg builds the level for a few days, and then has to pass it off to the texture artist who spends several days applying the materials he has made, and then gives it to the modeler so she can place her decorations. During this time, Greg has little to do—the next level hasn't been finalized and he is unable to access his current map for days at a time.

The level pipeline should become a solution to a puzzle. It breaks down all the elements and interdependencies of a game's levels and organizes them over time so everyone on the team can work in parallel as much as possible.

PIPELINE AND TECHNOLOGY

The technology used to make a game imposes the heavy pipeline demands—a company can often add more people or resources to a project in need, but an engine cannot be changed halfway through a project without serious repercussions. Some game technology will require more artists to create final levels, some will require a greater number of programmers, or several different types of programming talent to support the designers. Some games need fewer designers, for instance, a flight simulator where artists do most of the environment based on real-world data.

THE GAME ENGINE

The engine is what literally drives the game and allows the content to exist in a form that the player can interact with. Programmers and engineers put together the engine to work on the target platform(s) and provide the functionality that allows artists, designers, sound engineers, and other creative developers to add their work to the game. Game engines are often composed of the *renderer,* which is the main code that actually displays the visuals of the game, and the *interpreter,* which takes all the lines of code created by the game programmers and uses them to run all of the game's systems and behaviors.

THE GAME EDITOR

The editor is the tool that nonprogrammers use to either create content for the game or to import it into the game from other programs. Some editors are very basic, allowing no real preview of how a level will look or play, requiring a level designer to *compile* or *build* the map (compressing all the level information into a format that the engine can run and display in the game) frequently to see the effect of changes or additions to the environment.

On the other end of the spectrum, some editors are fully functional programs that offer features comparable to high-end 3D modeling and programming applications. UnrealEd is one such editor, and we will be reviewing it in more detail later in this book. Some game editors allow level designers a great deal of control over their maps, from scripting AI to fine-tuning the visuals of the map in real time to anticipating technical problems and either fixing them or notifying the designer when the level is built.

As one might imagine, the kind of engine and editor used will very much affect the level pipeline used by a team.

SIDEBAR

Say your team uses an engine that features a very robust scripting language that allows the designers to create almost all the gameplay they require without needing programming support. It might be decided to allow the level designers to create much of the script for their level, reducing the needs for gameplay programmers, but increasing the time needed for one designer to complete a map. Most of the programmers would then be free to move onto another project once the designers are comfortable using the existing code and scripting tools to complete their levels.

The sidebar is really just a simple example of how a game's tools and technology can drive the production process. However, many other factors will affect how your game's environments are made. The genre, the platform, the specific features of the title will all call for different processes and different pipeline components.

PIPELINE AS DEFINED BY THE TEAM

Although the tools you use to make the levels play an important role in planning, another important factor is the designers themselves. The individual skills and abilities of each designer play an important part in defining the production process. If the level design team in the sidebar example was mostly from an art background, having excellent scripting tools may not make a big difference. On the other hand, instead of needing less programming support, they might need fewer artists if they can make most of the assets they need themselves. It won't affect the time in which a level is made, but it may end up affecting the quality, or user experience. The pipeline should reflect, and respect, the various talent levels, technical leanings, and training level of the level designers as well as the other members involved in development.

SUMMARY

In this chapter, we discussed all the different types of people a level designer will need to interact with when making a game. We also learned that game teams come in different sizes, having more complex hierarchies and spreading responsibilities as teams get larger.

The concept of the level pipeline was discussed, including how it creates a smooth production process and allows level designers to work in harmony with other development departments without wasting time or facing downtime while waiting to get back into a level.

INTERVIEW WITH HAYDEN WILKINSON OF KNOWWONDER DIGITAL MEDIAWORKS

Hayden, you had been making maps long before you became a professional level designer. What attracted you to making levels, and why is it something you felt you wanted to do for a living?

True, I had been making levels for about four years previous to me becoming a professional level designer. I think what attracted me most to level design was the opportunity to be creative. With level design you have the chance to project your vision for the game in many different ways. For example, when I began constructing levels it was up to me to design the layout and the experiences the player would encounter; beyond that I would be responsible for the environment, the lighting, placement of sound effects, enemy placement, and yes, even the optimization. With so many different avenues available for me to show my creative side, I just put it in my mind that this was the job for me.

How hard was the transition from making maps on your own time, for fun, to making levels under the pressures of development—deadlines, bug fixes, client changes, and everything that goes with making games?

I don't want to say it was really hard to make the transition, but there is definitely a learning curve to contend with. For me, I felt like such a "new guy" in the business that I kicked my creativity into high gear to help make up for being so new to the development process. Sometimes this would come back to bite me, in that there were times when I would get a little too overconfident in what I was creating and would get a visit from the producer letting me know that there was not enough extra art or programming time needed for such an idea. Someone new to game development needs to keep in mind that a professional project costs money to make and that there are deadlines to keep, for the team to get paid.

As for client changes, it's just a fact of game development. Unless you end up working with a studio that supports itself without the help of a publisher, be prepared to make changes to your work on occasion. It's because so many eyes look at your levels, so many people with all of their individual ideas of what would make your hard work even better; I had a bit of a time adjusting to this. You just have to remind yourself you're working with a team now.

For me, fixing bugs is probably the most grueling part of the production cycle a level designer faces. You spend maybe 85% of the time designing, building, and putting on the finishing touches to your creations only to be faced with an inbox full of imperfection, imperfection that must be fixed before the product can make it to the game store shelf. When I was making levels in my basement for fun, I would have never caught most of these bugs, they were simply put off onto the poor guy that downloaded my levels. QA/Testers, the guys who send me all the comments on how I overlooked a collision detection problem or an out of place texture, are truly important to the development process.

\rightarrow

To sum it up, the transition from making "for fun" levels to "professional" levels requires you to understand that this is a team effort and that its going to take a lot of devotion and the ability, on your part, to accept criticism. However, the light at the end of the tunnel is seeing your work enjoyed by the people who play it.

When creating a level, what are your priorities? What elements do you begin with and how do you go from concept to design, and from design to finished map?

I have what I think is a simple set of priorities when creating a level.

First, I think it's important for me to understand what the designer wants from the level, and it's my job to maintain that vision. In maintaining that vision, one needs to know his or her limitations, those limitations being the time frame allowed to complete the level, how far can one can push the technology given to create the level, and how much room is allowed for deviation from the designer's original idea.

Second, I want the level to be unique. When the player enters a level, especially one set far into the game, it needs to be cohesive with the rest of the levels but at the same time it needs to stand out from the rest. I like to try to give the player something distinctive to remember in each level, whether it's the lighting/mood, the puzzles, or even the architecture.

My last and most important priority . . . Make it fun! This is, after all, the one thing that keeps players glued to the screen. Now, it is up to the designers and writers to create a great storyline and characters, but the level designer is the one who builds on all of that. I help create the game mechanics needed to make a level fun and challenging, the unique environments for exploring and setting the pace so the player can enjoy the all the game experiences one at a time with out feeling overloaded.

Going from design to the finished map can be somewhat complicated and riddled with many different steps. Design itself is disorganized, so it's up to us to organize all the different elements of the game in to one big ball of fun. Once I know what my priorities are, I like to go over all the concept art available to me at the time. After I have a good understanding of the environment and game mechanics that should be in the final version of the level, I start to work out a basic layout on paper and begin to bring this in to the editor I use to create game worlds. I like to work on one area at a time; I work out the geometry, the lighting, and lay down temporary gameplay elements; typically, I end up revisiting these areas to fine-tune or polish the level. In professional game design, at some point, usually before I am finished with the fine-tuning,

\rightarrow

the level goes off to the QA department for testing. When this happens I end up spending a lot of my time juggling high priority bugs and final level polish.

Often the best lessons are those hardest to learn. What sort of misconceptions did you have about level design before you joined a game studio? What are the hardest lessons about designing levels that you have learned in your history of making interactive environments?

For me, coming from the *Unreal* community, where the level building tools were so easy to learn, I had the idea that I would be given a design and I would create the level, put my own spin on it and be responsible for the whole level. In reality, you have to work with a team. Now all I do is focus on the gameplay, general look and feel of the level, and optimization. Before now, I was doing everything myself.

The hardest lessons I've learned over my years in making game environments are mostly related to performance. I can't count how many hours I've put into levels only to find out that it's not running optimally on "normal" machines (normal being what most people own). Many times I would go overboard with trying to make the environment so unique, so detailed that I was only making it hard for the player to enjoy it. There is a balance you have to find in creating levels: it needs to be fun and look great but it also needs to be playable on different machines. It took a little while and a lot of times I had to give up what I thought worked great for the environment, but in the end, it's better for the player and your game.

What are the most important elements for a good level? What are the encounters or experiences you try to include in your work?

Simply put, the most important elements to me are gameplay, storyline (not for all games), atmosphere, and cohesiveness.

Some recent games have been made that just live off of their names; these games start out with characters that you can interact with and they help to build a story line, tension, and the urge to see what happens next. After you play the game for a while, you begin to notice that the game slips off into a lull, and the gameplay becomes stale and predictable. I would like to see more games that introduce new characters and game mechanics at an easy-to-swallow pace, while allowing me the time to experiment with new weapons or powers.

While gameplay is the most important element of level design, to me, atmosphere runs a close second. This is easily my favorite part of making levels. I enjoy expanding on the designer's vision by creating worlds that reach out and grab the player and give them the chance to escape reality. I try to include

→

unforgettable areas for the player to explore; this somewhat helps the player to know where he has, and has not yet, explored in the level.

I've seen a lot of games that seem to enjoy thrusting the player off into some entirely new sequence of gameplay or into an environment that seems foreign compared to the previous levels of the game. I think the reason this happens is because the level designer does not have a clear understanding of what is needed with the level or it could also be due to the designer's vision not being consistent with the rest of the story/game. In either case, this could hurt a game, and it's the reason why I always try to understand what the level needs by collaborating with others on the team, such as the lead designer and art lead.

Who are the people you most look to for inspiration, both in the field of level design and beyond, when working on a project?

Right now in the field of level design, I would have to say that the level designers at Id, Ion Storm, Epic, and what was once Looking Glass Studios inspire me the most. Looking Glass made 1998 a good year for games by creating *Thief,* the father of all stealth games. Companies like Epic continue to set the bar high in architecture, lighting, and effects, not to mention an easy-to-use editor and a huge community of fans willing to make mods. I can always turn to these guys for inspiration.

Beyond level design but still in the realm of designing games, I like people like Yoshiki Okamoto (designer of *Time Pilot, Gyruss,* and *1942*). He had a smooth, if not seamless way of adjusting the level of difficulty while at the same time keeping the game consistent and fun to play. These games that came from those classic designers are what helped build the foundation for today's games.

Hayden, what advice can you give to the mappers and mod-makers out there who are thinking about a job in level design?

From a professional standpoint, I would have to say that creating levels has been a lot of fun for me and has taught me a lot about game development, but . . . be prepared to work hard and implement ideas you might disagree with, as well as having some of your own ideas shot down. Understand you're going to be working as part of the team; you're not a lone wolf anymore. Organization comes in handy when you're working on multiple levels and having the right communication skills is the most important advice I can give.

From an old community mapper/mod-maker view, tenacity is the answer to landing a job in the industry. Keep working away at your levels; learn all the tools needed to be a well-rounded level designer. If you can make levels really

\rightarrow

well in Max or in Unreal, try to expand your knowledge to something like Maya or maybe even brush up on your Photoshop skills. I don't think you can ever know too much about your craft.

Promote yourself . . . network, if you can, with others in the industry. Make sure you have a clean and easy-to-navigate Web page with links to your personal work and resume. Release levels to the public and encourage criticism of your work; it will help you out more than you know. I also hear a lot from others that I work with that a good level designer is up-to-date on things like current events, technology, news, entertainment, literature; all these things feed your creative mind.

4 Basic Level Design Theory

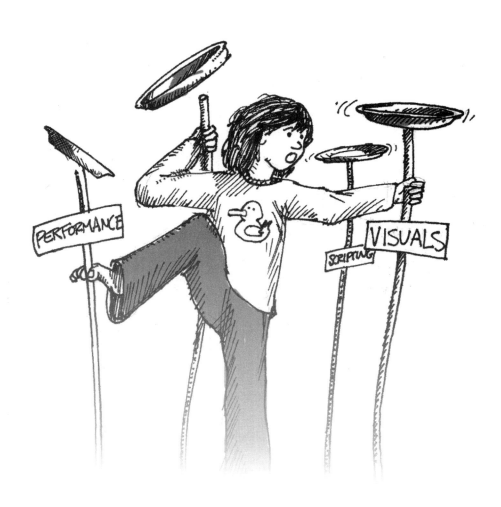

In This Chapter

In this chapter, we'll go over the "high" concepts that provide the proper foundation for most levels. These concepts are the basic theory of what it takes to create an enjoyable user experience in a level.

Designing a level is a long process, mostly because so many factors go into making an intensely enjoyable experience. A level that looks good will attract players to it, but it won't keep their interest for long if there isn't anything fun for them to do. A fun level will keep only the most dedicated players if it's set in a series of identical-looking concrete rooms, each lit by a single light bulb. A level that's far too easy, or far too hard, or where difficulty is wildly inconsistent, will not be played for long either.

The point here is that to design a good-looking, challenging, fun, bug-free interactive environment, you need to be spinning many, many "plates," making sure that all of the factors are within acceptable levels and trying not to concentrate on, or neglect, certain factors in lieu of the whole experience. A level designer needs to make sure all aspects of the level are in balance (see Figure 4.1). This chapter will deal with the beginning of the process, where you'll be making choices that will create a framework for the rest of the design and construction process. In some cases, this information will simply be given to you, in the form of an existing document or through verbal instructions by your lead designer. This is likely if you are joining a team midway through making a game, but it is uncommon that a level designer is simply given a blind set of criteria and instructions and told to go make a fun map—the two are like oil and water.

One thing to keep in mind is the balance between fun and feasibility. Many of the best levels give the feeling of epic-scaled environments or that the player is making important choices all the time. In the *Thief* series of games, for example, the player is always an unwitting participant in a struggle against evil, and the player is constantly led to understand that his actions in the world will determine the fate of

FIGURE 4.1 Level design is about spinning plates.

the world. Or, in *Dark Cloud 2,* the player must *rebuild* the world after it has been ravaged by an evil force. This illusion of power is almost always fakery. Your job is to make players feel like they are in a believable environment, encountering believable situations, and making believable choices, when really *you* are guiding them through a world that's only as big as what they can see or interact with.

It's also important at this stage to get in the habit of analyzing your decisions. The most unashamedly ambitious ideas are usually born at the beginning of preproduction, especially in group design meetings where ideas can be borne aloft on the enthusiasm of a room full of developers beginning a new project. It's important that you judge the feasibility of your choices at this point and not start out designing a level that's simply too ambitious to ever be made. This is not to say you can't be creative, but when you see a potential problem, or the possibility of a problem in a level at this stage, immediately changing it will take a lot less effort than realizing it a week before the game's alpha deadline. As a level designer, one of your responsibilities is to make sure the level is not only built, but that it plays well and doesn't slow to a crawl whenever the player walks outside. If something about your level's location or environmental settings makes you nervous, it's best to deal with it now.

WHAT MAKES THE LEVEL FUN

The beginning of a new project is an exciting moment. The game is like a blank canvas, with an initial design framework or concept in place and the first seed ideas of

your level, and you have a thousand ideas already that you want to start working on. However, tempting as it is to fire up the editor and begin building at this stage, you must resist. Before you even pick up a pencil and start sketching (which we'll cover later in Chapter 7), you'll need to address some important concepts about the foundation of your work to come. The first concept is the most important one of all. What makes a level fun to play? Although the game itself may have a lot of fun things to do, what specifically can you, as the level designer, do to make sure that the player has a great time in your map?

First, asking a game developer to define "fun" is like asking a chef to define "taste." In the end, it's such a subjective concept—there is no true definition other than what you know but cannot put into words properly. This is instinct—and as a level designer, you'll need to trust your instincts so you can deliver the kind of fun the game requires.

For instance, the fun in a first-person shooter (FPS) may simply be in successfully dodging your opponent's shots while returning fire accurately and destroying him. Much like tennis, the fun is in the give-and-take action that doesn't end until someone loses. It's the kind of fun you feel with your whole body, actually physically moving closer to the screen when in combat, or jumping when an opponent races around a corner in front of you.

On the flip side, a game like *The Sims*® is an entirely different experience for fans. Balancing the needs of their avatar, trying to maintain an optimum level of comfort, career, and environment, finally purchasing an item for their virtual home that they had wanted for ages, or manipulating the complex social relationships between characters, are all fun yet entirely different from the fun of playing a shooter.

Instead of painting a bleak picture where everything is created from experimentation and luck, there are indeed ways to determine how enjoyable and immersive a game level can be—there are universal concepts in level design that you can learn to identify and manipulate to create a fun experience for whoever your player is. In a nutshell, these key concepts are the following:

- Ergonomics
- Flow
- Rhythm
- Difficulty
- Wow Factor
- Hooks

Let's look at these concepts in detail and see what role they play in affecting the player's experience.

PLAYER ERGONOMICS—NO LEARNING BY DEATH

One thing all designers share—whether designing games or designing desk lamps—is that they must always keep the user in mind. This is especially important for level designers to remember as they get deeper in the game and begin to lose sight of the overall difficulty and scope of the game for the average player. If at any time during a game the player is able to blame the level designer for failure, rather than themselves, we've lost them. No matter how cool a level looks, no matter how bug-free or polished the gameplay, if a level contains areas or elements that cause frustration for the players, it will reduce the overall quality of the experience for them.

This concept is called player ergonomics—the act of identifying possible areas of frustration in the level and addressing them to maintain a high level of comfort for the player. Everything designed has a level of ergonomics. The book you're reading has a font size that most people can read easily, porous pages to prevent them sticking, and a spine to keep it all together. Without these elements, reading it would not be impossible, but it would be a great deal more difficult. Likewise, I'm sure you can instantly think of many examples of a game you really enjoyed that suddenly presented a challenge so hard, or a situation so unfathomable, that you put the controller down and turned off the console. This is often a case of bad player ergonomics.

An illustration of bad ergonomics is a level designer blocking some part of a map by a never-ending stream of enemies. The designer realizes that if the player exits the level before they have destroyed all three generators, the next level (escaping the powerless refinery) won't make sense. With a deadline approaching, he quickly sets up a group of spawn points near the exit to generate enemy guards. If the player tries to exit, the guards will keep reappearing and denying him exit until he either goes and destroys all of the generators or runs out of health and dies. He explains to the lead designer, "After dying a few times, the player will realize he just can't leave yet and will be forced to finish his objectives." And the lead designer replies, "At which point he will be throwing his console at the wall."

This is also a great example of a level flow coming to a grinding halt. The players may think that if they can shoot X amount of guards they'll win and be allowed to end the level. The only way they'll realize it's an impossible situation is by dying over and over again and having it dawn on them that this is a completely artificial situation designed to keep them from progressing.

Usually, this is an honest mistake. It's quite common for a game's difficulty to exceed the ability of a player at some stage during play, or for the player to do something the designer never thought possible. This is why play testing and Q&A are vitally important—without the benefit of new eyes seeing a level, the designer is at risk of committing ergonomically criminal gameplay that assumes the average player will find only mildly challenging, or creating vast and complex events that

can break at the slightest path deviation. As you gain experience as a level designer, you will gain greater ability to see your level through the player's eyes, and to anticipate or isolate spots where the player may become frustrated. However, there's no substitute for having someone else play through your work and alert you to problems that may have been invisible to you.

SIDEBAR

A great example of ergonomics is the game *ICO* for the PlayStation 2. In this game, the player cannot kill the main character without intentionally jumping over a precipice, and even then only after the main character catches himself and allows the player an opportunity to climb back up without dying. In addition, early levels of the game are in enclosed rooms—there is no way for the player to die and have to restart, while learning the controls and becoming accustomed to the game mechanics and amazing visual style. The player is eased into the controls, the gameplay, the situations that will allow him to fail at a smooth pace that, ergonomically speaking, is a great model of how a game should begin—no learning by dying and restarting ad nauseam.

Later in the game, when the player is protecting another character, he can leave her temporarily to scout ahead and solve puzzles to allow her to progress. However, she is vulnerable while the player is not around and can be attacked by creatures that appear out of the shadows around her. When this happens, the player is given an audible warning (the princess shouts in alarm) and the camera will quickly cut to her to remind the player where she is. He is then given a certain amount of time to run back and defeat the creatures. This is another great example of ergonomic design—the needs of the player are catered to, and he is given a fair chance to rectify his mistake without being punished.

Some hard and fast rules that will allow you to keep up the ergonomic quality of your level are saving and reloading, giving clues, and being aware of the player's comfort level.

Allow Players to Save and Reload

Allow the player to save frequently. If this is not allowed by the game design, place save points frequently or allow the player to recharge and restock after major encounters. Being forced to replay parts (or all) of a level multiple times before a

player can finish it is one of the biggest complaints about games. No matter how fun a level is, it will get tedious if you are forced to replay it more than a few times in a row. Don't let this happen to your players, or at least give them the chance to succeed. If they don't stop long enough to recharge their health between fights, that's their choice and they can't blame you, the designer.

Give Clues

Don't let players get lost. Try to avoid, at all costs, putting a simple maze in your map, thinking it will be challenging to the player or extend the life of your level. A maze where the player has to solve it by trial end error is an exercise in frustration, and will often simply result in the game becoming a "coaster"—the disk makes a better drink coaster than a game. A player needs access to clues and information about how to progress through a level when he is stuck. A maze that has a system the player can learn, and use to quickly find his way through is a better option; for instance, in the game *Myst* the player is shown an interactive compass that plays a sound effect at each cardinal direction. Later, in a seemingly endless maze, the player can listen to sound played at each intersection and using their knowledge of the compass sounds, determine which direction they need to go. Other ways of giving clues are characters that will sell more and more obvious hints for increasingly higher prices, or emails left on computers or notes on bodies that hint at how to progress through a puzzle or obstacle. Players are free to ignore these, but doing so relieves the designer of blame when they get stuck. A player will never accuse you of being *too* helpful, unless you are blatantly telling him how to beat each challenge before he has had a chance to work it out alone.

Be Aware of the Player's Comfort Level

This ties into the concept of level *difficulty,* which we will discuss a few sections later. However, for the player's comfort, always remember the rate at which the player is learning your game's many systems and rules. Don't suddenly dump a completely new rule on players with no warning before they've even worked out how to fire their secondary weapon or jump consistently.

An example of ergonomic oversight in this area is *Daikatana*. Although this game does have many interesting features and solid design elements, one of the things that put many gamers off was the introduction of very challenging enemies (in the form of hard-to-target flying mosquito robots) in the first level. This wasn't simply a matter of difficulty—small, fast-moving flying opponents are *always* challenging to hit when you're using a mouse or console controller to aim. Putting them in the level where the player is getting used to the controls, how the weapons handle, and how the rules of the game work is a violation of the player's "ergonomic rights."

LEVEL FLOW—KEEP THE PLAYER MOVING

Players can suffer "disconnects" in many ways—when they reach a point in the game where they are suddenly dumped back into the real world, or the fun drops to a point where it's no longer worth the time to play it. The former problems can often come about from a lapse in ergonomics. The latter problem—the game going from fun to tedious—often occurs when a level's "flow" breaks down. Flow and rhythm are deeply connected concepts, and hard to separate concretely, but we will try to do so with the next two sections.

Dissonance and the Importance of Believability

The concept of "level flow" is admittedly nebulous. There are a lot of definitions floating around, but generally, the level designer is the invisible hand guiding the player through each environment in a game, sometimes by pushing him to go through a certain doorway or defeat a particular challenge, and often by subtly pulling him along by using lighting, sound effects, item placement, and other "bread crumbs" (a term that comes from the old fairy tale of Hansel and Gretel, where two lost children left a trail of bread crumbs behind them that would guide them back home when they got lost). In either case, the more aware the player is of the level de-signer's influence, the less fun the level will be, just because it's obvious that things have been engineered to happen artificially. Naturally, a lot of game experiences are engineered by the level designer; however, the player will quickly notice if the same sort of event is recurring a lot, or will easily spot something completely out of con-text such as a stack of explosive barrels in a supermarket parking lot. This feeling that something is out of place is called *dissonance* and can be a very effective tool for cre-ating tension or creeping the player out, but only when used sparingly, which we'll discuss in later chapters. A great deal of dissonance, like a row of toilets in a kitchen, will bother the player enough to question his surroundings unless the level's theme is a dream-like or nightmarish place where reality is skewed. *Silent Hill* and its se-quels all rely on constantly having the player question the reality of his surroundings, or the creatures he is fighting, and it works brilliantly within the context of the game. However, sticking a *Silent Hill* level smack in the middle of a *Mario* game will prob-ably not be the successful juxtaposition you'd hoped for when the gaming public tries it.

Another very obvious way to create bad flow is physically blocking the player, or making him perform complex maneuvers for what should be simple tasks. A very crude example is a series of alcoves along a corridor in a shooter game, each containing a single clip of ammunition. The player will need to move into an alcove to pick up the ammo, back up or turn around and move to the next alcove, and re-peat this several times to pick up the same amount of ammunition the designer

might have allowed him if the clips were placed along the center of the corridor, or in a group in a single alcove. This doesn't seem like such a big problem in a slower-paced game, but in a furious action game, every second counts. Ask any serious *Quake 3* player—these folks will buy graphics cards for hundreds of dollars just to get an edge over their online competitors. Flow in an action game is a serious matter, and the flow of a player *through* the environment becomes much like designing a racing car—you need to think about it like aerodynamics, allowing the player to run through the map picking up items and weapons, attacking and retreating, capturing the flag, or whatever he needs to do, without having to weave in and out of pillars, stop to jump up on crates (Figure 4.2), or pause to enter a code on a door to open it. Often forcing players to perform tedious tasks in a level is simply making them jump through hoops.

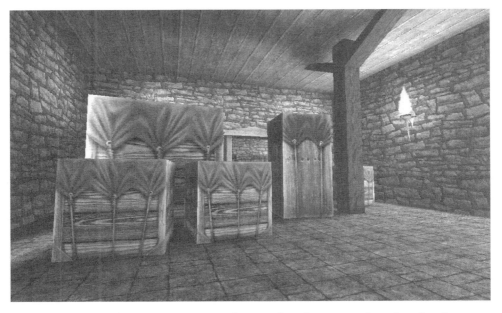

FIGURE 4.2 Stopping to jump on crates in an action shooter can be a flow-breaker.

Naturally, if you are creating a level for a platform game, players will be expecting to jump on several difficult-to-reach ledges to collect certain items. That's what they're paying for. Be aware of what *flow* means to your game, and design your level for that. Adventure games can suffer from too many irrelevant action sequences, but they also suffer from puzzle after puzzle with no break in between, for example. This is why games like *Myst* place "whimsical" items or interactive objects

in the game levels for the player to play with, allowing them a mental break between logic puzzles, and the chance to simply see something cool.

The Constant Danger of Boredom

Dissonance or jumping through too many hoops is only one occurrence that can break the flow. More commonly, it's simply a matter of the player becoming bored. Don't assume that boredom is only caused when the player *isn't* doing enough to be entertained. A player can often become bored by doing the same thing for too long, even if that thing is something we developers consider exciting. Shooting things and having them blow up is a mainstay of the gaming culture. However, very few games where players do nothing but keep their fingers on the triggers and see things explode will keep their attention for more than a few hours. Boredom can be categorized into two basic forms:

Mental boredom comes from seeing the same things, hearing the same sounds and music, or playing essentially the same gameplay repeatedly seemingly without end.

Physical boredom comes from a lack of interaction or physical movement. If players are simply watching the same 10 pixels on the screen, if they are holding down one key for minutes at a time, or are so disengaged that they become aware they're sitting in an uncomfortable chair for hours, they will become bored.

SIDEBAR

An interesting example of potential boredom can be seen in some older arcade games designed to keep players' adrenaline pumping so much that they would feel the need to keep shoving quarters in the machine to keep the experience going. For example, *Robotron,* the classic action shooter by Eugene Jarvis, dropped the player into an unwinnable situation from the start—in every level, a greater number of more powerful enemies advances on the main character. The player is forced to shoot constantly and keep moving or he will quickly find himself surrounded and ultimately out of lives.

For an arcade machine, this is a perfect formula—the game is so insanely difficult that a play session for the average player will only last a few minutes, requiring a new quarter to continue. This is great news for the arcade owner, who is emptying the coin box every night, but in reality this sort of game

→

quickly gets boring if the player can just continue to play whenever they die. Take away the risk of restarting the entire game each time you lose your lives and there becomes little point in playing it for more than an hour—there's so little variety of experience that the game cannot maintain the attention of a normal human for long enough to be worth paying $40 for.

Recently, a shareware game called *Crimsonland* brought the gameplay of *Robotron* to the modern gaming public. However, rather than simply re-creating the arcade experience, the developer included many boredom-relieving features: powerups, gaming modes, choices to be made during levels, different ways to control the main character or to aim—all these elements allowed a better flow and a bigger variety of experience—mental and physical—to the game, making it a much more viable candidate for longer play sessions.

How do we prevent a player from getting bored in a level? We drive him ahead, like a sheepdog herds a sheep—through subtle temptation, direction, and the threat of a painful bite on the rear if they don't do it right. Many times a level designer must lead the players through the environment or push them in a direction, but at all times the players must be driven or the game will become stagnant, with the player left wondering or searching for what to do next.

Ideally, players will be driven through a level by a combination of many elements. A light illuminating a doorway at the end of a corridor, a conversation overheard below them, an imminent explosion behind them, or even a simple timer ticking away in the corner of the screen (though this is dangerously close to becoming a game design stereotype, the player racing against a disembodied timer on the game's interface). In all these cases—and throughout the level—a player has to *want* to progress. Flow is created by stringing together a long a series of interesting encounters, revelations, and rewards for players. Unfortunately, it's much easier to kill the flow than create it. Laziness or neglect of "unpopular" areas of a level can often kill the flow. If both directions at a t-junction seem equally intriguing to players, you cannot punish them for picking the wrong one by simply making it a long, boring dead-end; not only is this a case of bad ergonomics, it's a serious break in the flow of the level. Forcing the player to backtrack through a level can be an interesting game element if the level has changed sufficiently in the meantime or if there are new challenges on the way back. Making both of those directions eventually lead to the same destination—perhaps with very different challenges or experiences en route—keeps the flow going. However, simply forcing the player to go from one end of the map to the other constantly, spending long minutes simply trudging through the same space every time, will surely reduce the flow to a crawl.

When we talk about flow in general game and level design, it's not just the flow between the start and end of a map. It's also the parts in between. Whether your game will use cinematics to illustrate the transitions between levels, or each level will load immediately after the next, the continuity of atmosphere and the player's sense of place must remain continuous. If the player reaches a critical goal in the center of the map, and then the next thing he knows, he's back at HQ getting briefed on the next mission, there is a significant disconnect. You might want to extend the level to have the player reach an escape point, or at the very least a cinematic showing the main character leaving the level environment bound for home.

SIDEBAR

Imagine a level in an abandoned military complex being used as a base by a local gang of werewolves. The long-dormant shapes of military robots create shadows in the gloom of the torch-lit interior in which the player can hide and snipe his unsuspecting prey on his way to the level's sole objective—activate the generator on the bottom floor of the complex. The way into the objective is a milk run, with lots of sniping and unwitting guards to run up to and dispose of with a variety of weapons.

The player reaches the generator room easily and completes the procedure to get it back on line. It hums to life, lights flicker on, and the player leaves to head back up to the exit. As he reaches the doorway, however, the screen shakes a little and the rhythmic sounds of thumping can be heard from above. That would be the sound of several long-dormant military robots warming up their Gatling guns and resuming their patrols. The player may have completed the objective successfully but the level is far from over. By completing his primary goal, he just reactivated the base's interior security systems. Though the level architecture remains the same, the player is now faced with a completely new challenge—getting out of the level will require a great deal more skill than getting in. The player's weapons are no good against the armor-clad security droids, and he must now formulate a plan of avoidance and distraction. Changing the gameplay topography of the level has changed the flow of the level and given the player a whole new reason to finish the level as quickly as possible.

Simply having players walk back through five minutes of empty corridors and the bodies of previously slain enemies is simply going to bore the player. There's no draw in progressing, and when the draw ends and the player doesn't want to move forward, the flow is dead.

RHYTHM—CREATE A ROLLER COASTER RATHER THAN A HIGHWAY

Flow controls the player's frustration, and along with rhythm, keeps players from ever feeling so disconnected or negatively jarred out of the gaming experience that they don't want to play anymore.

Rhythm is a way of expressing the pattern, frequency, and intensity of the sequences of events in a level. For linear levels in simple games, it's easy to control rhythm, but for more open-ended and organic game environments, it can be nearly impossible to exert a lot of control. However, we know that a game level is generally a series of events and experiences, regardless of whether we choose the order in which they happen or the player determines it. We have to then allow for a range of experiences to keep players interested.

In almost all forms of entertainment, the rhythm of events is used to draw the audience in, to set up expectations, and to deliver surprises. A horror novel where the protagonist simply walks through a bunch of mildly creepy corridors for the entire book without encountering a single obstacle or creature is not going to have many readers. Neither would a war drama where the hero hides in a barn for the duration of the conflict, emerging only after the armistice has been signed. In both these examples, there is a recognizable element of storytelling, but it is the *only* element throughout. To create tension—if only in the player's imagination—there has to be diversity of experience, pauses for effect, sudden and unexpected occurrences, and long, disturbing sections dripping with suspense. If the experiences are too diverse or misplaced, you will lose your audience; as a level designer, you need to have a feel for the emotional state of your player as he progresses through the map or mission and have an instinct about what would be a good direction to turn the play to keep his attention.

The most direct comparison might be to the beat of your favorite song. Chances are, it isn't a flat, repeated rhythm that doesn't change from start to finish. Drummers use flourishes, different types of drum and percussion instruments, and the occasional solo to drive the song along rhythmically. Otherwise, the song will sound flat. The same is true for games—a level designer needs to use the myriad means at his disposal to create a roller coaster of experiences to keep players on their toes. You can learn a great deal about rhythm in different media by watching movies, plays, attending classical concerts, or reading novels. A great contemporary example of the use of rhythm is the movie *Finding Nemo*. The length and positioning of scenes next to each other—the jump from action to drama, happy moments, and moments of despair—is brilliant and would show a very diverse but climbing graph of ups and downs of the user's emotional being while watching. The same pacing and focus on building the player's excitement can be used for almost any kind of game level.

In a space shooter, the player is told to investigate the disappearance of a cruise liner that has requested aid. The player is told it is a routine mission and outfitted with minimal armaments.

As players approach the first waypoint, their radio goes dead. A little further in and they begin to see pieces of wreckage fly by. When they reach the waypoint itself, there is a constellation of wreckage but no cruiser. Suddenly, a warning light flashes, indicating incoming fire, and the player is engaged by several enemy fighters. After a short battle, the fighters suddenly turn tail and retreat, and the player is able to easily finish them. The radio comes on again and a relieved cruiser captain thanks the player for saving his crew and passengers. The player heads for where the cruiser is now shown on the radar and approaches to begin escorting the cruiser home. All of a sudden, when the player is just a few kilometers away, the cruiser erupts in a massive fireball of burning gases and fuel. No sooner has the fireball formed, than a black shape glides through it—the distinctive shape of an enemy battleship bristling with guns. It's the player's turn to panic now, dodging huge pieces of speeding debris and enemy fire to take on the battleship single-handedly.

In the sidebar example, there are a few high-intensity moments punctuated by pauses in action or smaller respites. In some cases, the player is totally engaged—attacking or being attacked—but at other points, he is cautious; at others, he perhaps hovers just above boredom level for a short while. If we take all of these moments, we can probably show them more clearly as a graph as demonstrated in Figure 4.3.

FIGURE 4.3 An example rhythm graph for an average game.

Now, this is just for example. Don't try to plot the rhythm of your level in so much detail that you are afraid to change it, or it takes a week of work to complete. However, you should probably be aware of the overall rhythm of your map, and writing down the key moments and pivotal experiences in sequence to spot areas that need more work. You can do this in a "cell" diagram, as shown in Figure 4.4.

FIGURE 4.4 A cell diagram of the rhythm example showing key moments or "beats."

So, as you can see, it's quite important to determine the rhythm of your level in its infancy, where things are more organic and change is easily accomplished instead of reworking vast portions of the level geometry a month before alpha. By keeping the player on a roller coaster of experiences and interactions, you create gameplay. Without sufficient rhythm, the player is basically out for a Sunday drive. With haphazard or huge spikes in rhythm, the player may simply be exhausted by the middle of the map.

Aesthetic Rhythm

As we described at the beginning of the book, the craft of level design is not purely functional, and not always related directly to gameplay. Take care to make sure the look and mood of your level flows along with the gameplay. This is largely what we described as dissonance in the previous section—visual elements that seem out of place, but it can be subtle enough that the player isn't aware of *why* he feels the

rhythm flattening out or that he's just in a virtual environment and not a real living world, just that he does. Some commonly recurring examples of this kind of subtle break in the visual pace are drastic changes in textures, models, or lighting styles or shifts in quality.

Drastic Changes in Textures, Models, or Lighting Style

When the walls of a corridor shift from metal plating to rubber padding, you're going to notice, no matter how involved in the game you are. Subtle transitions between environmental elements can be a great way to invoke emotions in the player, and we'll go over this more in later chapters covering techniques in building levels. If handled inappropriately, however, it can also be a jarring experience for players—*even if they don't consciously realize it!* One consideration in dealing with aesthetics such as lighting and texturing is that they often affect the viewer in very subtle ways.

For example, let's say you are making a stealth-shooter. When players move through a series of caverns with a rocky texture on the walls and deep blue lighting, they will feel immersed in a damp, subterranean mood. However, if they transition suddenly to a brightly lit, red-saturated room with concrete walls, their brains will register a change in situation, even if the gameplay or the enemy type remains the same. The player will stop and think, *"Where the heck am I? I thought this was the Cavern of the Wizard Del, not a high school furnace room!"* They will begin to ask themselves what this change means—what could be the significance of red instead of blue? Does the fact that the walls are man-made give a clue to some kind of upcoming event or is it a clue that the player must change tactics? If the answer is "yes" to these questions, you've successfully given the player a warning about impending gameplay shifts, and that's an example of good ergonomics. If the answer is "no," then you've made the player stop and think for no reason, which may bring a screeching halt to the game-trance he's been in up to now, or may cause him frustration that he spent 20 minutes looking through his mission briefing for some clue about the paradigm shift, putting a big dead space in the game's rhythm graph.

Shifts in Quality

Sadly, one lingering truth in level design is that, as an iterative process, many times the designer creates different areas of a level with more or less attention. Generally, the ebb and flow of quality isn't noticeable at all by the player. Sometimes, though, if you had to rush through the last half of your map, plopping down enemies haphazardly and throwing textures on the walls like Jackson Pollock in a paint store, you may find your player actually stops playing when he notices the drastic lapse in quality compared with the first half of the level, which was brilliant.

Previously, we've covered bad flow as being a *disconnection* problem, where someone playing the level breaks out of their experience by boredom, frustration,

unease, or any sudden negative shift of emotion by an incorrectly placed element. You need to weight the design elements so that they feel right, but there's no hard and fast formula for that beyond experience and instinct. If the player is having a great time in a survival horror game, walking down darkly lit corridors one minute, suddenly to be fighting off zombie dogs another, it's a balancing act of emotions you as a designer are performing, choosing the right moments to introduce factors from your designer's deck of cards that will give the player exciting ups and downs, side-to-sides, and zigzagging changes of pace.

However, when the player begins to feel that he is not getting the real deal, or not getting the designer's attention, no amount of rhythm will save the map. It may even be made worse by pouring all your effort into the beginning of the level (this is why it's a good idea to start designing your level from anywhere but the start). Once you've tasted cheese, it's hard to go back to plain crackers. It's the same with delivering a consistent effort in your design and implementation, and making sure you don't play all your rhythm cards at the start of game.

DIFFICULTY—LET THE PLAYER WIN, NOT THE DESIGNER

The different design elements and techniques I've talked about until now—ergonomics, rhythm, and flow—are all pivotal to creating a great play experience. However, encompassing all these elements is the notion of difficulty as a level design tool.

Every game has a difficulty curve (see Figure 4.5). By extension, every level—as a point on that curve—has a level of difficulty assigned to it. Actually, we call it a *curve*, but ideally, it will be more like a wave when looked at closely. Why is this? A steady, linear progression of similar events is not really fun, even if it's steadily

FIGURE 4.5 A simple difficulty curve.

going up. A game level that simply gets harder the more you play is not delivering on what makes games so different from other mediums—interactivity and being able to respond to the individual actions of the player. Even a game like *Tetris,* which on a surface level is about a steady increase of difficulty, has random intervals where the blocks are easier to place than others.

Figure 4.6 shows a much better example of a game difficulty graph: It represents smaller areas of difficulty increase where a player is challenged more and more, finally building to a goodly test of the players' skill, at which point the graph dips again—or simply plateaus—allowing players to gain control of the level and feel like they have surpassed the skill of their opponents. This is also a good time to introduce a new game or level element to the player—a new weapon, special power, or a new type of enemy that players must now learn to use or overcome—which in turn begins a new increase in difficulty, and so on. In practice, many levels end up with a difficulty graph that looks a lot like Figure 4.7.

FIGURE 4.6 A complex difficulty wave.

Each map has to have a difficulty graph of its own that will allow for the player's improving his skills and provide suitable challenges with suitable rewards. Depending on the genre of your game, the type of level you are creating, and the sort of mechanics you have at your disposal, your own level graphs may appear quite different—but you will hardly ever have an even curve from start to finish. Just as with rhythm and flow, variations in difficulty will provide a more interesting experience for the player, if applied with care.

FIGURE 4.7 An example difficulty graph for a single level.

Ways of controlling difficulty vary from genre to genre, but some examples include the following:

Distribution of resources: The amount of ammunition in a map for certain weapons or number of health items and powerup items that give the player an extra advantage. If the player is constantly low on ammunition, he will try to conserve it, and that will make combat more challenging. If there is an excess of ammunition or health, then the player may simply be too well equipped to be challenged by an opponent.

Distribution of opposing forces and their properties: Flying or invisible enemies might be much harder to shoot than regular opponents, for instance, and a concentration of lesser opponents may still be tougher than a single major enemy. Simply adding to the number of enemies the player has to face at one time will increase difficulty, but can be countered by giving the player special abilities or items to use that will allow him to take on more enemies at once, or defeat individual enemies faster. Differences in the opponents' properties can alter the level of difficulty for the player without having to alter the *number* of opponents.

Distribution of clues: Leaving the player to work everything out himself will result in a much harder level. Leaving clues in the form of intercepted communications between enemies, emails, letters, messages from the avatar's HQ, and so forth can all ease the player's progress through the level by letting him know how to get past tough puzzles or encounters.

Player character penalties: By slowing down the player avatar when it enters water, or uneven terrain, for example, you can increase the difficulty of traversing the level and carrying out actions in these penalizing areas.

There are many, many more techniques and solutions for fine-tuning the difficulty of a level, or specific section within it.

Dynamic Difficulty Adjustment

Some games include a system where the overall difficulty graph is organic—it increases and decreases according to how the player is doing. When a level starts, it has a pre-set difficulty, as normal. However, if the player begins to fall behind the curve, and the engine detects that he has to replay sections repeatedly, it will literally drop the difficulty level by a certain degree. This will continue until the player drops further, in which case the level will make itself easier, or he actually rises *above* the curve, in which case the level will increase the difficulty at that time.

Generally, this system will plug in to certain elements of the game. It might simply adjust the hit points of the enemies, and so make the level more or less difficult by making the player's opponents tougher or easier to destroy. It may increase the *number* of enemies encountered in a specific battle, or it may increase or decrease the amount of health items in the level. The benefits of this (theoretically, that is, because few games have implemented such a system very widely) are that the player should be able to progress through the game without having to replay too much of any particular system, but because the difficulty adjustments are invisible, the player also doesn't feel inferior to the game . Whatever the case, a level designer needs to be informed of a global system like this and should be comfortable working with in and setting up maps to support dynamic difficulty.

WOW FACTOR—THE WATER COOLER MOMENTS

Gameplay is the most important part of a level, but sometimes great experiences come from other aspects of the level, such as architecture, special effects, or audio.

One of the things you'll often hear about when designing levels is the Wow factor. This intangible unit of measurement simply refers to the biggest point of impact in your level. It could be some kind of impressive architecture or landscaping. It's also known as a "water cooler moment" because people will be so impressed they'll all be talking about it around the cooler after they've played it. It could be a complex and impressive scripted event involving dozens of NPCs launching a coordinated attack on the player. It could even be a challenging mechanic or puzzle so ingenious that the player can't help but tell his friends about the next day. It simply has to leave

an impression on the player. Ideally, a level should have a few of these moments—they define a level to the player, and often to the community of gamers who play the title. It's when you hear, "What was the name of that level? It was the one where the floor collapsed and you free-fall between the skyscrapers trying to land on the alien bomber!," and the like that you realize that many games, and levels within those games, are known best for several superior moments of play. Wild situations and level locations can convey a lot of "Wow." Figure 4.8 shows a concept painting for a level set on a sinking oil rig. The tilting decks and slow demise of the level into the ocean over time is a great way to get players talking about this particular map.

FIGURE 4.8 A sinking oil rig level—a good example of the "Wow factor."

The Wow factor is the sort of thing game journalists will zero in on and rave about, and thus it's often more important to producers and marketing to have these clearly defined "moments" in a level.

An example of Wow in a game:

The player has been slogging through the cramped tunnels and water-logged chambers of a dungeon level. Until now, the only opponents have been varieties of zombies and the occasional giant rat. Suddenly, he walks through a doorway into a huge room full of bones mired in a pool of black water. The bones rise up, dripping, and begin to swirl around, in a cloud of particle effects so dense it threatens to set fire to the player's monitor. The bones swirl up into the form of a giant skull with spider's legs, and suddenly, torches flare around the walls showing row after row of spectator seating, pale faces leering at the player as the bone-monster approaches. This isn't just another dungeon chamber—it's an arena, and it looks like the player is the star attraction for this evening.

You might think that this aspect of a level is a natural occurrence. However, the Wow factor is often dictated by other channels—marketing being one of the biggest culprits. It's often good to nail down what part of the level is going to provide the biggest impact and have the relevant parties agree. The worst-case scenario is being told your level needs more "pop" three days before the game is ready to ship. Having this element designed in detail and approved from the start will help to avoid potentially troublesome rework down the road.

These concepts are all things to be considered as you first start developing your ideas for the level. Some of these may be provided for you in the design doc or level documentation. Perhaps, if your level is to feature a "boss" character or special challenge at the end you will need to work closely with the designer to accommodate a special difficulty curve. Likewise, in some instances, the pacing of your level will be dictated by the part of the game it occurs in. Later levels may feature up-tempo pacing throughout the map.

HOOKS—SETTING YOUR LEVEL APART

The "Wow" moments in a level may inspire or impress a player for a short period, but an entire level can stand out from the other maps in a game.

One of the most important factors in game design, especially from the point of having the game fly off the shelves, is to have a *hook*. A hook is some unique or must-have feature that will attract players simply because they haven't experienced

anything quite like it in a game before. Much like fish are unwilling to simply leap into a boat without actually being hooked and reeled in, players also need incentives to purchase a game (or ask that a game be purchased for them) and when it comes down to it, games within a certain genre can only differentiate themselves by the different features and experiences they offer against their competitors.

Likewise, in level design, a level's hooks are the major features that make it different—and therefore attractive—to the players of a game. Levels with good hooks are almost always the experiences that players will remember fondly or describe as the moments that defined the game for them.

A good hook can be all-encompassing "twist" that affects everything in the level. It might be a special power the player character only has for that one map, or it might be a completely different style of gameplay or environmental style.

A great example of a level hook is one of the later stages in *Dark Forces 2: Jedi Knight*, a FPS by LucasArts. In this level, the player is stuck within a spacecraft that has been crippled and is slowly plummeting down into a canyon. The level layout is already known to the player—he went through it once before in a previous mission. This time, however, the entire level is turned on its side, and gravity is no longer a constant, with walls becoming floors, corridors becoming deadly pits, and enemies moving with just as much difficulty as the player.

By taking a normal level and giving it a big twist (literally), the designer created an entirely new experience, one that took the player by surprise and introduced a slew of new challenges to overcome in that short space of game time.

In Chapter 12, we will discuss the CIA level from *Tom Clancy's Splinter Cell*, but as another example of a game hook, this level was one of only two levels in the game where the player was not allowed to kill a single person. For many players, this was a much harder mission demand, and it forced them to use stealth in a game that to that point had supported the ability to simply shoot troublesome guards and opponents. The simple fact that this level had a single, but viable hook—it was a stealth-only map—made it stand out to players as a novel experience within an already novel game.

Hooks aren't always necessary, or feasible, in game maps. However, if you think there is something you can do to create a memorable twist or to make your level stand out from the others, think about using it, or at the very least bringing it to the other designers to see if it would add something special to the game.

SUMMARY

Fun is an extremely subjective word. There's no strict formula for what makes something fun. However, a more obtainable goal is making an enjoyable level, which coupled with the overall design of the game, should lead to a lot of fun for the

player. A level designer needs to be a master of juggling many elements all at once to make a fun experience for the player.

These elements, the "high concept" factors of designing an entertaining level, were covered in the chapter:

Ergonomics: Making sure the player is not frustrated in play

Flow: Keeping the player moving through the playfield

Rhythm: Providing a spread of intensity and experience to motivate the player

Difficulty: Keeping the player challenged

Impression: Or "Wow Factor." Introducing the element of awe at key moments

Hooks: Making your level stand out to the player as different from the others

INTERVIEW WITH DREAM SMITH OF GRIPTONITE GAMES

Dream, can you explain a little about what you do and how you came to be doing it? What games have you worked on?

Well, quickly, I spent a lot of time as a kid playing games, not just video games, but chess, anything requiring the application of logic to solve a problem. Add to that a love of drama and story. These together led to film school, testing, temp work for Nintendo, and then a lucky break at Griptonite designing on Lord of the Rings.

Games I've worked on: *Return of the King, James Bond: Everything or Nothing, Lemony Snicket,* and a little help here-and-there on some others—all Game Boy Avance (GBA).

Can you explain a little about designing levels for handhelds—what are the obvious limitations for levels (screen size, memory constraints, fewer controls, etc.) and how do you design around them?

You named my toughest hurdles, but in addition, there's the age (and perceived age) of the audience, the cart size, 2D games, and the accelerated schedules to which most GBA titles are restricted. PC and next-gen consoles spend 2–5 years on a title, but every six months we are expected to complete a game. The grueling pace leaves little room for revision, which I need as a designer; though there's upside to bustle. Aside from learning efficiency tricks, I get to start on a fresh project twice a year.

\rightarrow

The biggest constraint for me is screen size and perspective. The games I'm used to playing at home are almost all in 3D. I am accustomed to thinking of gameplay in those terms, thinking of an enemy being "in proximity" when my Player Character is standing at one end of a hallway and he at the other. For a stealth game, seeing your target before he sees you is critical. In a treatment of that scenario on the GBA, the screen is so limiting that you could be right on top of the enemy as soon as he appeared on screen. So, the breadth of a single activity has to be distilled down. The grand sense of *overall* action also has to be considered. Using an action game as an example, in a classic FPS, I might see 3–4 characters shooting at me, weigh my options of which environmental object in my vicinity to duck behind, and run for cover. On the GBA screen, with four guys visible plus your avatar, it's going to be pretty crowded. Showing furniture and obstacles on top of that, and a HUD on top of *that*, and the gameplay will be cramped, and your choice of cover *forced* (the couch that's on screen, duh), since the rest of the objects in the room wouldn't be visible. I can't expect the player to know what objects lay off screen, even if they're two pixels away, even if they've seen them prior (I can't expect memorization).

A lot of these issues are handled before the level design stage: How fast will the hero move? At what perspective are your backgrounds? The one that's most defining for me is how many pixels high the hero is rendered. Player-character size will inform all the other perspective questions. And it's not a simple answer; give-or-take four pixels is a laughable height differentiation for a console character, but that's a ton of detail lost on the GBA. The flip side is that the bigger your avatar, the less screen real estate is available to show the player what is *around* him.

In designing levels themselves, I always start out constructing these long passageways connected to cavernous rooms, and there's just all this space (the artists I've worked with will attest to this, my early maps are *huge*). It's what I mentioned before about playing 3D PC games at home, and thinking about the experience of walking into a large room. In those games, I walk into the room, and I can look all the way off to the other side of the room and say, wow this room is big, and maybe see a structure all the way in the distance that has a beacon shining, and that will draw me toward it. What happens when I hop into my newly designed levels and start playing them is I'll walk into the large room and all I'll see is floor! And I'll walk and walk, and still, for way too long, it's all floor. That sense of the large room is lost, and instead there's a sense of discontinuation, of chaos, because there's no visible *form* to the area I'm in. Eventually, I'll get lucky and hit a wall, but it's not fun. So I'll go back, and apologize to the artists, and cut the map, *and this is not an exaggeration*, by

→

60–80%, and it will *still* be large enough and fun. And in the cuts, all I'm doing is looking at that long hallway, and saying, look, the experience of "*long*" here is about 60–80% shorter than I thought, because after walking down a hall *without seeing what's in front of you*, it will *seem* long.

Then there's the issue of *leading* the player. In the previous example, there's a big structure, or a beacon, sighted far in the distance. Using some *continuous* landscape feature can take the place of this far-away landmark. A heavily trodden ground texture that follows the clearest path from start to finish can clue the player in on where he's been and which way he's going. I'll maybe try to encourage exploration by trailing a few footprints out down a side corridor, and players who get lost can always wander back around and see the large trail and get their bearings. Flashing lights in sequence, bodies left in the wake of a fleeing monster, a river flowing through the level, there are a lot of ways in a limited sight-range scale to provide both a carrot and a bread crumb trail.

What is the role of the level designer when creating games for portable systems? Do they handle more or less of the artistic and programming needs for their environments than might be common in console or PC games? Does the smaller team mean fewer designers, or does it require fewer support roles to help flesh out levels beyond their gameplay requirements?

Portable game teams here are between 4 people at the smallest to 13 for a huge project (*The Sims*), with an average of 7–9. A level designer acts as game designer, as scripter, as inputter of data into code, as tester, and as adjuster of hotspots and collision boxes as needed.

The core role of the level designer is still to design levels. On all games, this requires papering out the levels, the basic architecture, storyboarding what events transpire. In some projects, designers will construct the map itself out of a tileset provided by a background artist (imagine a pile of LEGO®s, some with ground textures, some with walls, some with trees, some with chairs; and with those piecing together environments). Once laid out, the level designer then scripts the level, placing enemies and level logic using a simple scripting language, not coding really, but it's helpful to have a background. There are designers here with no coding experience or knowledge, and there are those with a lot. The more you understand what's going on behind the GUI, the better you'll harness it, and at best, you'll innovate. And we play through the levels. The coders and the artists are all drawing or coding and don't have time to just *play* through the game. This is no different from larger-scale projects, I imagine.

→

How do you go about planning for your levels and what sort of documentation do you generate? Can you explain the most effective ways you've found to prepare for a level and share the vision with other team members?

There's always one basic mantra developed at the beginning of the project that encapsulates the *heart* of the game. When starting a level, it's good to keep that in mind, though in the depths of production, it's also easy to forget.

The levels designed immediately prior affect a new design more than anything else. I just never feel like designing two open spaces in a row! People won't like playing it either, so that's just as good for the overall flow as for my enjoyment.

I'll just sit at my desk, leaning on my elbow, perched over a pad with the bottom of my palm pressed to forehead. I'll sketch ugly shapes (I cannot draw), and they won't make sense, but I'll start to conceive of the idea for the level, and as the scribbles and revisions overwrite themselves so much as to become unintelligible, I'll tear that page off, lay it beside the pad, and redraw it, only cleaner. In the redrawing it will change, and will itself demand scribbles and revisions, and then—another page torn and another cleaner version. Depending on the game engine, the process for entry is different, but I will essentially then build the architecture and collision and play it in-game. Once I'm satisfied with how it feels to move around, I will take a .jpg of the level layout in a simple paint program and type in my notes on what happens where. At first I did this solely for the benefit of the artist—door here, big statue there—but it became increasingly useful to me when, later, I've forgotten why it was *horribly essential* that this platform be shaped like a "W," and I can refer back to my paper layouts complete with labels and instructions. After that point, the difficult decision making is done, and scripting can be just following a blueprint. Decisions, of course, continue to be made during implementation, but the overall direction is there.

Can you give an example of a level that you worked on that didn't go as planned, and how you dealt with the problems?

Aside from the elephantine proportions of my initial levels, I find myself overextending particular ideas. I will have a very large idea, or series of events that I want to play out, and I try to lay out a map encapsulating all of them. Avoiding the early issues of rooms-too-large, sometimes this will become cluttered. Sometimes it will draw on too long. Letting go of the unified construct, and breaking the experience into distinct rooms, stretched over a *series* of maps, is helpful to the game. It's tough initially to crack an idea I'm proud of into smaller bits, but ultimately better off.

→

What inspires you when you begin designing a new environment?

GBA is almost all about licensed titles. I've been lucky to work on good licenses, so it is from there I draw my inspiration. Specifically, it is from the central theme that I've distilled during pre-production. Like a film director working on a gangster movie, making a scene he shouldn't lose focus on what it is that a gangster portrays, what is *gangsterism*. On a game like *Lemony Snicket,* for instance, I felt that the books (and film) were about children, due to a series of unfortunate events, forced to act in the world as adults, and all the adults in the world were suddenly acting as children. To me there was this whole idea of maturity—the books were written *for children* but under the assumption that it was going to presented as something more mature, so from the subject, to the style, to the *packaging,* the whole thing was very adult, and I wanted to portray that in the game. So the HUD, the controls, to the levels, everything was made to be totally accessible to the core audience of children, but to *feel* adult. Enemies were easy to kill, but looked and acted *mean*. Levels were simple to navigate but appeared grimy. Puzzles were laid out to appear as complex, as convoluted, as possible, but containing a simple solution. A kid who solved a puzzle like that, and got this huge mess of levers and machinery moving by his own guiles would feel adult and accomplished, even though the level *gameplay* would have been the same had there just been a door and a switch. Every game I've worked on starts with something like that.

What advice would you give someone who was thinking of taking up level design as a career, or who was considering moving to design from an art or programming background?

Well, play games. But more, concentrate on what you are playing. Millions of people play and enjoy games, thousands can discuss their favorite moments, but try to infer what it is that is going on there, what is it that makes one game better than another. Start from a very macrocosmic view of design decisions, the genre, the level flow, the special character abilities. Discern the differences and character of the games you're playing, then look closer. How do the microcosmic choices affect the overall direction of the game: how the player walks, the layout of the buttons, the look of the menus, the enemy reactions. A game is so much more than just the programming, or the art, or the designs within it. It's all these disciplines together in a whole greater than its constituents. For that reason, read, paint, see movies, solve age-old mathematical formulas, fall in love, write, construct origami. A well-rounded game is a strong game. As a designer, I think that's a great quality.

5 Refining the Player Experience

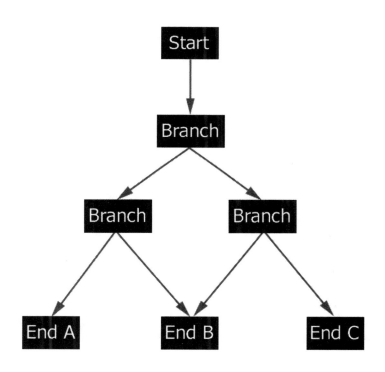

In This Chapter

By now, we have covered a great deal of territory about levels and what makes good ones tick. At this stage, you need to actually address these issues so you can develop your design. This book isn't a "how-to" that simply lays out a bunch of options for you to pick from and build a Frankenstein map. A truly fun level will come purely from you—the level designer—when all your instinct, creativity, and imagination are focused on making the map at hand. There are, however, many factors to be aware of, many pitfalls to avoid, and many approaches you can take. Before we describe the details of how to produce professional designs, this chapter will talk about design itself and the sorts of things that need to be considered by the level designer between creating the *abstract* and actually designing the level on paper.

CREATING A LEVEL ABSTRACT

The abstract is the first step in the design process. Literally, it is just a vague sketch of the level, and the most important things that have to be contained in it. Little detail is generally provided at this stage of the process, not because of laziness, but because of respect *for* the process. The craft of designing, and building, levels professionally is highly iterative. Things change constantly, and as the designer creates the level, on paper and in the editor, these changes result in a better and better level.

It's a process of evolution that allows mistakes to be seen early and corrected, or opportunities for new and greater player experiences to be discovered and added before the final product is delivered.

Even the most organic design process needs to start somewhere, however, and needs a few initial ideas to get the ball rolling and set the playing field for the next few months of work. This has many names, but in this book it will be referred to as the *level abstract*. In some cases, you, the level designer, will create the abstract. In other cases, the game designer might create it and hand it off to you.

A level abstract can be a text document, a folder of handwritten notes or even a collection of sketches and diagrams, depending on how many people will need to refer to it. On some teams, the levels designers are expected to type and maintain the documentation for their levels throughout the game's production. Other teams will roll the level data into the design document when the basics have been agreed upon. Others require no formal documentation, but you should assemble some kind of materials at this stage. You'll find it invaluable to have the basics of your level available for early team reviews, showing other people on your team what they might need to be building for or preparing for, or simply to refer to months later when you've forgotten why you made the last half so incredibly hard.

The case study in Chapter 12 demonstrates a level (or mission) abstract, but no particular format works better or worse—the key is to develop a document that contains the information needed by you and your team. The elements you will want to include, in general, are the following:

Player Character: Who the player will be, and what will he be at the start of the map?

Objectives: What does the player need to do, and what objectives does he have a choice in doing?

Difficulty: Where does this level fall in the overall game difficulty graph?

Location: Where in the universe does this level take place?

Environment: What's the weather, time of day, and geographic/architectural style?

Enemies: What characters will the player be pitted against, if any?

Gameplay elements: Broadly, what sort of gameplay will the level feature? Puzzle, stealth, action, driving, . . . ?

Position: Where in the game does this level take place—what level comes before and what comes after this one?

Having a mission abstract prepares you for the design process and will be a document you can always refer to when you want to ground yourself later if you forget what the core experience is meant to be. At the very least, the abstract will

allow you to begin to picture the environment and begin thinking of the kind of map you want to make.

WHAT HAPPENS NOW?

In the last chapter, we looked at the high-level theory of what makes a fun level. However, going from theory to an actual design is a long, and sometimes arduous process. The abstract provides a good platform to start from initially, but now more fundamental questions emerge about the level you are responsible for making and just what it should be. Before taking out a graph pad, consider the overall player experience, and all the elements that you will use to make it happen—the countless elements that will go into the playspace to challenge the players and reward them for success.

CONNECTIVITY AND DEFINING THE BOUNDARIES

The Big Picture

Look first at the "big picture" of the level based on the abstract you already have, and then work down to the details. Thinking of the level as a whole, how much freedom does the player need, how much *play*, or ways to interact with the level, will the player be allowed? Examples of everything from extremely focused linear levels, to wide-open environments full of possibility can be found in modern games. In a racing game like *NASCAR,* the tracks are built to constrain the player to the road, and rightly so. What purpose would a professional NASCAR driver have to drive out of the stadium and onto city streets? The design of that particular title has no reason to allow the player more freedom, or *agency,* than is needed for a top-class racing simulation.

On the other hand, a driving game such as *Midnight Club II* is all about letting the player go wherever he wants. In this game, the player roams real-world cities looking for other drivers to challenge. Where he goes and who he challenges are up to him, though linear sections do exist to allow the story elements to progress properly. The game relies on the player rewarding himself by exploring the maps at will and discovering and creating ways to use what he finds for even more interactions. Game designers often refer to this as *emergent gameplay. Emergence* is giving the player tools and toys in the level and letting him work out what to do with them, rather than very rigid encounters and puzzles that can only be defeated by a single solution—collecting the correct keycard, moving past a guard without alerting him, or triggering a scripted sequence, for instance.

Flow Versus Freedom

There are pros and cons to letting the player "off the leash" and play in his own way. If the game you are making is heavily story-driven, if there are many goals or tasks that need to be accomplished in a certain order, it is much easier to create a linear path through the environment that makes sure the player hits all the triggers and plot points needed to convey the storyline. On the other hand, people play games to have choices—if they wanted a linear story, they could as easily see a movie. Allowing freedom of movement and pacing of story is something that we as game designers can give our audience. The trick is in balancing freedom by ensuring that the players cannot get so lost in freedom that they forget what they were meant to be doing, or simply get bored with no real purpose or goal to keep focus on. Look carefully at the design of your game and the requirements of your levels. Ask yourself the pertinent questions that will give you some ideas of the level's big picture:

- How important is the storyline in the game, or the need to have the player in specific places at specific times to make the narrative progress? How linear does it need to be to keep the story moving, and the player interested?
- What amount of freedom will support and enhance the player? Is the game one about choices (tactical shooter, RTS, role-playing game [RPG], or adventure game) or is it about constantly moving forward, making fast decisions, as in a racing or fighting game?
- What are the project's restrictions on time and money? A wide-open level needs to be full of things to do—and these things take time and energy to create, not to mention art assets and code. Some games feature more linear levels as an efficiency measure, rather than as a design choice.

Different Flow Models

In between the ends of the spectrum—linear levels and open free-form sandboxes—there are many different "flow types" that a level designer can examine for his own maps.

Linear

Linear levels are the bread-and-butter of many action games. The player starts on one end and finishes at the other (Figure 5.1). Along the way he is forced to interact with the level—to shoot some aliens, unlock a door, use a gadget, solve a puzzle, or jump across some floating platforms. These obstacles break the player's progression to create an enjoyable and unpredictable rhythm in the level; however, it requires diversity in the sorts of things that the player will be doing; otherwise, boredom will set in. If the level is really just the player moving through beautifully

built spaces, occasionally either opening a door or shooting an alien, it will be pretty difficult to make a truly interesting experience. Linear levels are better kept short and interesting. Great-looking aesthetics will help to keep the player's attention, but the level designer must work hard to create major and minor encounters that test the skills and expectations of the player. You can find examples of linear levels in most games, especially shooters like *Half Life* and *SOCOM: US Navy Seals*.

FIGURE 5.1 A linear level progression.

Bottlenecking

A *bottlenecking* map progresses like a linear map; however, at various points in the level, the path will split, allowing the player to choose which way to go. Of course, all the splits keep the player moving toward the end of the level, but the experience along each path will be different. At some point later, all the paths will converge into a single linear route again—usually at a point where the player is required to do something special in the level (Figure 5.2). The beauty of this kind of level is that players will get the feeling that they have some freedom of choice—that they can take the elevator or the stairs, for example—when really the choice has no long-lasting impact on the flow of the level. Many games use these paths to give players a chance to engage in a particular activity that they enjoy more—the elevator shaft might indicate that jumping and climbing is needed to reach the top floor. The stairs may be the path that puts more enemy alien warriors between the player and the top level, thus would be a better choice for a player who likes combat and shooting.

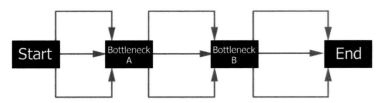

FIGURE 5.2 A bottlenecking level.

With bottlenecking, you can increase the player's feeling of making tactical decisions, but it can also be confusing if you don't make the branches clear, or if the player ends up at a bottleneck and isn't sure which way to go. For example, if the

level splits into paths A, B, and C, when those paths converge it has to be obvious that a doorway leads to the next section of the level, otherwise the players who arrived at the convergence via path A may (for instance) mistake the end of path B for the doorway they need to continue through. Going backward along path B and arriving where they started an hour before won't endear you, the designer, to them. A bottlenecked map allows the level designer to create a map with more diversity and choice, but also means that some players won't see certain areas or splits unless they go back and play it again. Unfortunately, many people think this is a waste of time; however, keep in mind that choice is what sets games apart from other forms of entertainment—if the players only see half of the level but enjoy every minute of it, is that a bad thing? Many examples of bottlenecking can be found in *Deus Ex,* a game that tried very hard to create meaningful choices for the player all the time.

Branching

Branching levels split several times during the player's progression, but each split leads to a different ending (Figure 5.3). The benefit of a branching level is that, like bottlenecking, the players are required to make weighty choices during play, and the experiences between players can be different based on how many splits there are along the way and how many different endings or exit points the level supports. The downside is that a level that branches a few times may end up taking much longer to build and create interesting encounters for than will a simple linear level. Also, the more branches there are, the more of the level will remain unseen by the player

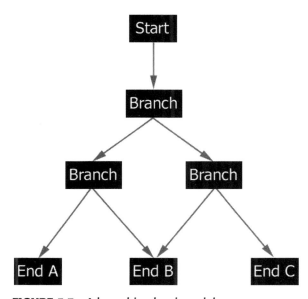

FIGURE 5.3 A branching level model.

in the initial pass through. Although many gamers will retry a level, taking paths they didn't choose the first time around, if they know there are unexplored options, it won't help make a better initial experience. Many teams avoid this route because it takes so many more resources to create a complex branching map than other models take. An example of branching can be found in the classic arcade game *Out Run,* which allowed the player to choose between two paths at the end of each track, making use of a branching system of levels.

Open

Open levels are very different than the models we've reviewed so far. Instead of pushing the player toward a physical ending, separated by encounters and obstacles, the end of the level is based on the player performing a certain number of tasks, earning a number of points, or simply finding a way out using things that are in the level environment (Figure 5.4). Open levels are often referred to as *sandbox* levels, meaning that they are walled-in areas where the user can play with the many toys and activities that the level designer has placed in the environment. *Grand Theft Auto 3 (GTA3)* uses the sandbox model extensively. The players start in a section of the main city with access to other areas blocked off until they have completed certain important tasks. Within that section, however, are all the tools that the players need to complete these objectives when and how they wish—an endless supply of various vehicles, weapons, and locations. The player may decide to do everything in the map besides completing the missions that will allow progression—or decide to only do those missions, allowing quicker access to other areas. In this way, open levels allow the players to control the rhythm and flow of their progression through the game.

The model of an open level often goes along with the concept of "systemic level design," where players deal with systems in the game that allow for more than one means to success. At end of this chapter, Harvey Smith discusses systemic level design in detail and what it means to the level designer. However, a quick example of systemic design in *GTA3* is any mission where the player is required to assassinate a character. Each person in the game has a health system, and anything that hits the character interacts with this system—a bullet causes damage, as does a baseball bat, but so does being hit by a hijacked tour bus. There are many ways to use the character damage system to complete a simple task, based on the tools and situations the players have available to them. Open levels support this kind of design by allowing free access to most of these tools at once. One of the first games to use this sort of game environment was the legendary space trading game, *Elite*.

Hubs and Spokes

Frequently, large, open maps are actually *hubs* rather than actual levels the player completes. A hub is a level, or part of a level, from where other levels branch off,

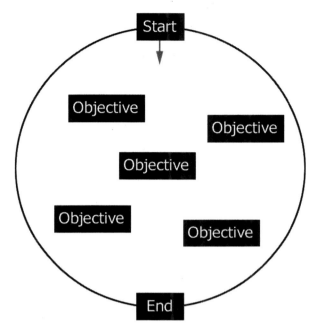

FIGURE 5.4 An example of an open level.

and return to. Rather than having a very specific end goal, or tasks to complete, hub levels are often the central area in the game and the player returns to it repeatedly again during play (Figure 5.5). An analogy for this is a train station. The hub level is the terminal, and the levels branching off are trains that take players to different locations and encounters after which they return to the terminal. Because the designers know the player will return to the hub level frequently, this is often where the item shops, training areas, help characters, and so on are. These aids are placed here for the players to use when they return from levels having collected money, or items, or information about the world.

The levels that extend out from a hub are often called *spokes,* as on a wheel.

This model of level design is quite efficient and folds in many of the benefits of models we have looked at until now, however, it is important to note that this is not a system for designing a single level but, rather, for grouping levels together efficiently. The hub could be an open, or branching level. The spokes could be linear, bottlenecked, or branching levels. Many games, such as *Jack and Daxter* and *Mafia,* use the hub-and-spoke system.

Hub levels often only unlock spokes a few at a time. This allows the player to see many of the areas that will be open later in the game, but not access them,

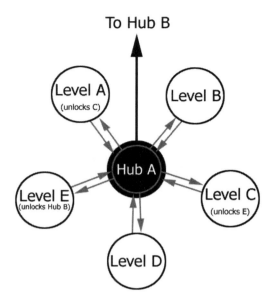

FIGURE 5.5 Illustrating the hub-and-spoke idea.

which is a great way to foreshadow future events in the game story. If the players get to a roadblock and see a lighthouse in the distance, they will think "I bet I can get there later in the game." It's even more enjoyable for them when they're right.

Dynamic Level Generation

It's worth mentioning a system of designing levels that is becoming popular as technology begins to support it—and that is the art of *not* designing levels. Well, not all of the levels. This technique allows the game engine to create a level "as needed" from pre-created snap-together sections (Figure 5.6).

Dynamic level generation works for games that can support more generic or repetitive-looking environments by having a greater number of encounters and interactions. It works very well for RPGs where the player is used to many random elements—random enemy types, random items left behind by slain creatures, random spells being cast by enemy mages, and so forth. However, dynamic generation doesn't mean completely random. In fact, it can often be several times more difficult to create a level in this way than simply building a traditional "fixed" level. This is because to create dynamic levels—dungeons, forests, canyons, villages, and so on—the game engine needs to have access to lots of different pieces that fit together properly and have rules that tell it what piece connects to what other pieces and how. These individual sections need to be planned out and built by designers and artists, and there need to be a lot of them, or the levels will start feeling very

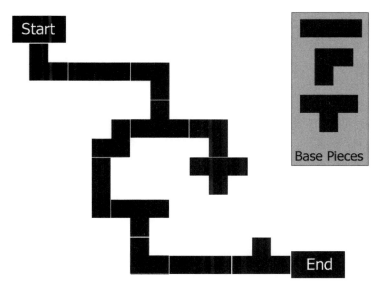

FIGURE 5.6 How dynamic level generation works.

similar very quickly (if all your pieces are crossroads and straight paths, your levels will all be grid-like and boring). Furthermore, the level designer needs to provide specific goals, encounters, items, and creature types that must be in the level regardless of the physical layout. In this way, the flow of the map, and to some extent the ergonomics (creating dead-ends is practically unavoidable using dynamically generated levels) of the level may change drastically, but the key elements will always be there. This means the level designer can rely on every player going through a specific level finding the Mystical Sword of Shish-Kabob, even if the location of the sword, and the path the player took to get it, is different every time.

It is not unrealistic to think that as on-the-fly calculation and rendering becomes more and more efficient, many games will feature dynamically built levels—racing games could feature unique tracks for each race (but a track that a player liked especially could be saved for return visits), and strategy titles could feature completely original, but still expertly balanced, playing fields to do battle on.

GAMEPLAY NARRATIVE

As players progress through a map, track, or game screen, they are telling a little story. This is the kind of thing you're likely to hear from friends and co-workers

when they are relating an amazing experience they had playing a game the night before: "So there I was, driving after the bad guys when a bus crossed the street in front of me—so I skidded around the bus, knocked down a streetlight and it landed in front of the truck I was chasing . . . which hit it, flew into the air and crashed on the roof of the burger place across the street!"

These are the stories we want the players to tell, but are generally unable to *force* them to experience. In essence, good game design, and by extension level design, relies on giving the player the right tools, the right components and challenges, at the right time. Sure, anyone can wow a player with a pre-rendered cut-scene of the story, but when it happens to the player in real time, unfolding before his eyes and under his control, it's a completely different level of experience. When considering your design approach, there are key things to identify, which we'll look at next.

INGREDIENTS

Ingredients is a term picked up from working with French game developers for several years. It is an excellent way to describe the parts of a level that make up the gameplay, rather than the parts that make up the obvious architecture and framework.

The ingredients of your level are all the elements afforded by the designer's vision. It might be creatures, it might be weapons available in the map, or other items. It might even be the *kind* of encounters the players are allowed to have. Some levels rely heavily on combat encounters. Other games require that a level designer create situations that allow the player to sneak by adversaries. Sound effects are ingredients, as are moving platforms and elements that the level designer can use in combination to create interesting variations on the same theme. Simply jumping from one platform to another can be fun initially but quickly gets boring if that's all there is to do. By creating twists on a theme—sometimes having a platform give way when the player lands on it, or having one or both platforms moving, or invisible platforms that only appear every few seconds, and so on. You can't be expected to come up with a whole level full of unique ideas, that's like writing a book with a completely original plot, an impossible task. On the other hand, you will be expected to think quickly as you design to come up with different and interesting ways of turning the raw ingredients of the game into exciting and entertaining encounters. In this way, level design is like creating a great soup—it's not simply the acting of adding ingredients into a container and heating. The different ingredients need to enhance each other, combine to create good flavor and texture, and come out much greater as one than they were alone.

Designing Ingredients

The elements of your level might not all be handed to you by the designer. Level designers frequently need to supplement the list of game ingredients, or make up new ones to make a game experience work properly. If you are responsible for creating the ingredients in your level—designing the kind of creatures the player will combat or the powerups available, you will need to provide the information needed to the art and programming teams. Common pieces of information for a map element you are creating are the following:

Purpose: Is this entity a character, a weapon, a piece of a puzzle?

Goal: What is the reason for the ingredient to exist? Is it to destroy players, or heal them? Is it there simply to be pressed so a door can open?

Visual Description: What does it look like in the game?

Special Animations: Is this the only enemy in the game that can headbutt the player character? If so, the animation team will need to create special animations for it.

Availability/Occurrence: Where will this ingredient show up? Is it just for one specific level, certain geographic locations, or anywhere in the game? It may be that something you design is useful to another level designer, so make sure you clarify restrictions on where it should and should not be used.

Placement Considerations: Where in a level should this go? Should it be grouped in pairs, or should it only be found alone? Is it rare or common? Is it contained in crates the player has to smash or can it be found in the street?

Attributes: Is this ingredient a character with health, armor, and ammunition that needs to be set? If so, how much of each? Is it randomly determined? You will need to outline the common game attributes that are used by this entity.

Special Properties: Is there something that it does that nothing else in the game does? If so, give a brief description and lay out how the attributes should work so that the programmers can set it up properly. For example, if you are designing a Mud Monster who needs to be destroyed with soap, you might need to give him a *cleanliness* metric instead of health. Normally, soap won't harm an enemy character in the game, but the Mud Monster is programmed specifically to detect when a soapy projectile hits it and increase his cleanliness attribute until it reaches 100%, at which point the monster is defeated. You might lay this information out as shown here:

Behavior	Variables	Description
Soap Allergy	Cleanliness (0)	When first encountered, the Mud Monster has a cleanliness metric of zero. When hit by a soap object, its cleanliness will increase by a random number between 7 and 11 points, until the metric reaches 100, at which point the monster is destroyed.

Items Used/Carried: If what you are designing is a hostile NPC, does it carry a weapon? Does it carry many, or is the weapon it carries randomly selected from a set specified by the level designer? Does the ingredient have an inventory, or items that it drops when defeated or destroyed? What are they?

Notes: Explain anything that doesn't fit into these categories, even if it is just a loose suggestion of how an ingredient should look, or act. If it's helpful in creating the entity, it should be stated.

It is good to keep ingredients that you create adequately documented, especially when it's to pass your designs on to the programming team for implementation. Included on this book's CD-ROM in the Sample Documents folder are examples of documents used to document level ingredients, as well as blank templates for you to use or from which to base your own.

PHYSICS AS INGREDIENTS

The use of real-time physics in games is almost a standard feature, with technology available that is able to efficiently calculate very complex predictions about how things in a game should behave when in motion. Some games use physics in a purely decorative way—the bodies of enemies using "ragdoll physics" to fall down stairs or over railings when they have been shot, for example. Other games use physics to enhance the core gameplay, especially for genres like car racing, where real-time physics allow the cars to behave realistically on the road and in collisions. The *Burnout* series of racing titles uses incredibly real physics to create intense multivehicle crashes.

Using physics-enabled ingredients in your levels can be a challenge. Until recently, games used animated geometry to simulate the real-world motion of ingredients. A giant rolling boulder to chase the player was set by the level designer to move between certain points or follow a prescribed path. It would behave exactly the same way every time the level was played.

With the same ingredient using physics, the results of its movements become much less predictable, and the boulder may careen off into a nether region of the level, or the player may be able to block it by throwing a large object in its path. If that boulder is needed to break through a wall to allow the player to access the next section, both these cases will result in the game being stuck. This means that any time you are thinking of using a physics-based ingredient for an encounter, you must plan very carefully for how to constrain the situation and control the outcome enough that the experience remains a positive one for the player. On the other hand, if you spend too much time building fail-safes for a physics ingredient, you probably would have been better off using a scripted sequence in the first place. Use physics carefully, and in situations where it is appropriate.

SIDEBAR

Susan is given the task of implementing a physics-based puzzle in a level for the action-platformer title she is working on. Knowing that the programming team has worked on the technology for more than a year, she wants the puzzle to show off the depth of the code, without creating bugs or a part of the level that might fail and stop the player from progressing. Her plan is to create a bowling mini-game, literally stacking up pillars at the end of a long ramp and giving the pillars real-time physical properties, so that when something collides with them, they will fall over, and into each other, creating a different set of events each time. She creates a simple script to detect when all the pillars have been knocked over and opens a trapdoor in the room at the top of the ramp when this happens. When players arrive in this room, they will find that they cannot go down the ramp, but that a hole in the wall allows them to see, and, more importantly, to throw things down the slope toward the pillars. Susan places small mole-like creatures to emerge from the floor of this room and attack the player. When the player whacks them with a weapon, the moles curl up into a protective ball—in this form, the player can pick up the moles and hurl them through the hole, where they will roll down the ramp and smash into the pillars. In this way, the player can use the unlimited supply of mole creatures to "bowl" with, until the pillars are knocked down and escape is possible. The player cannot interact with the pillars directly, and so can't break the gameplay, but the physics allow a fun mini-game that relies on the skill of the player and the luck of his throw to be completed successfully. As a safety feature, Susan makes the pillars' physical properties very light, and with a high center of gravity, so that the objects are very sensitive to collision and will scatter very satisfyingly when hit by another object.

ENCOUNTERS

Throughout this book, the term *encounters* occurs frequently. *Encounters* are the times in the level where the player is stopped from simple progression and offered an opportunity to interact with the game in a meaningful way. The example in the sidebar with the bowling challenge is an encounter. In a driving game, a simple turn or kink in the road is an encounter—approaching at high speed, the player needs to decide how to deal with it. Slam on the brakes, drift into it, or try to smash through the fence? That bend in the road is a planned encounter created by the level designer. A puzzle game designer may have different terminology, but when a new piece falls down into the play area in *Tetris,* that is an encounter—a new element has been introduced to the player and a decision or interaction is required to keep the game going.

Encounters are about challenging the player. Very literally, they are about you, the level designer, in a battle of wits with the player. Or at least this is how it looks from the eyes of a player. Encounters should test the player in a number of ways, for example:

Physical Reaction: How fast can players move the avatar in response to what is happening onscreen (*Defender, Project Gotham, Tetris*)?

Coordination: How quickly can players press different combinations of keys to survive an encounter (*Soul Caliber, Quake 3, Battlefield 1942*)?

Timing: How quickly can the player respond to an onscreen prompt or match an event in real time (*Pa Rappa the Rapper, Dance Dance Revolution, Amplitude*)?

Memory: How much information can the player memorize and recall later when needed (*Simon, Sam & Max Hit the Road, The Longest Journey*)?

Deduction: Using the tools and abilities available, how quickly or efficiently can the player solve a problem (*Myst, Where in the World is Carmen Sandiego?, Harry Potter and the Chamber of Secrets*)?

Naturally, combining different types of "base" encounters like these leads to even more complex, and difficult, encounters that the player will be prepared to face later in the game.

At a very fine magnitude, levels and the pacing that drives them are about balancing the time and distance between encounters. When not actively in an encounter, the player is generally in a routine activity—searching for ammunition, commanding peons to fetch wood, or resting so the character is at full health. This is valid gameplay, but the trick is balancing the intensity of a fun encounter with the player-driven elements of exploration and recuperation

At this stage of design, a level designer needs to think about the kinds of encounters—the situations, characters, challenges, revelations, decisions, or events that the player will come to while moving through the level. Later these will become the "bones" of the level, when it comes time to start designing the level on paper, as we will see later.

CHALLENGING THE PLAYER'S GAME KNOWLEDGE

When thinking about the sort of encounters you will be throwing at the player, it's essential to consider what they "know" at that point, what was explained as *intrinsic* knowledge early in the book. As players work through a game, they pick up knowledge about the game world and learn the rules about how to succeed. If they are unsuccessful in defeating an enemy with a group of units, they will (if the frustration level in replaying the encounter is not too high) change formation or tactics, or even attempt something drastic to test the game and find out the best way to accomplish the short-term goal. On another level, games often impart information to players explicitly. When the player character picks up a new weapon in an RPG, there is often a dialog box that explains what it is and how it works.

Given this constant learning of the game rules by the player, the levels themselves should provide opportunities to test the player's knowledge and skills developed along the way. If the player has discovered how to defeat Blue Robots, increase the number he has to fight. Once he has learned the technique to dispatching a Blue, he will enjoy the greater challenge of taking on two, four, or eight at a time. Then, just when he is becoming bored of fighting Blue Robots, introduce the Red Robots, which require a new level of reaction and timing to defeat, or perhaps are only susceptible to a new weapon just introduced in the level.

This may seem obvious—we have already examined the need for a steadily rising difficulty level after all. The more subtle lesson here is that the difficulty cannot simply be new gameplay encounters that require a player to face them blindly. Skillful level design is knowing, in general, what the player has learned to a point in the level and tune an idea for an event or puzzle there to make use of a rule or ability already known about. This will increase the player's enjoyment in any encounter, rather than having the player feel tricked, or cheated into failure. To repeat what was said in Chapter 2—as much as possible, the player should *never* be allowed to blame the designer for failure. If players feel that the level designer has in some way withheld information about how to succeed, they will quickly stop playing out of anger. On the other hand, the more that players know they have been given the tools to succeed, and just need to learn how to master them to progress, they will not blame the designer and will be more personally motivated to try again.

The other aspect of intrinsic knowledge acquired in play is that it's not as fun to learn something but not be able to use that knowledge. If the player is taught a new spell, let him use it, even if it means being able to go back into a level previously completed and using the new spell to access previously inaccessible areas. *The Legend of Zelda: The Wind Waker* uses this technique with incredible success—the player is often allowed to see the entrance to an area that is inaccessible until a special object is acquired later in the game. Once the player has the object and learns what it can overcome, suddenly he has a huge amount of useful knowledge—remembering all the places he had visited but could not explore further that can now be explored with success. Don't just give the players an item that replicates something they already have, or that they have already forgotten about by the time they can use it properly.

CREATING TENSION

A famous game designer once said that for a good level, "A gamer must be in constant fear." Although this is not the case for most games, tension (rather than fear) is a very big part of what makes games fun. The same can be said for most forms of human entertainment, where forms of tension are what keeps someone turning the pages of a book until the end, or keeps a concert hall full of eyes glued to the stage while watching an opera. In common usage, however, tension is something we tend to avoid, or talk about in a negative light.

Tension doesn't have to be negative however, and for the purposes of entertainment, it usually isn't. The kind of tension that is needed in a level is natural tension—like the tension on a rope that is towing a car. It is simply a "pull" in a direction with the possibility of failure, and as we have discussed, this is something the level designer needs to be conscious of all the time—how the player is being "drawn" or guided through the spaces and encounters in the map. Once the player has been hooked (by the visuals, or an intense opening encounter), the player is tugged through the level like a fish on a line. Gameplay is this act of reeling players toward their ultimate goal, or destiny.

Throughout this book, we will go into detail about how this line of tension is created and used correctly. However, while you are at the stage of coming up with the basic experiences and gameplay of the level, consider foreshadowing, lighting, paradigm shifts, and music and sound.

Foreshadowing

Providing vague or suggestive implications of a future event and giving the player partial information about the road ahead is a great way to seed tension in a level.

The player may see the shape of the end-of-level boss moving through the trees in the distance, or may read brief accounts of a terrible weapon scattered throughout the playfield. Although not enough information to be useful, it will begin to suggest something to the player. The more concerned players are, the more fearful an image may begin to form in their heads, even if the threat they fear doesn't really exist. Let the players use their own imaginations to make your life easier. Sight lines are also important. See if there are parts of your level that might support the player seeing a section that they will not arrive at immediately. For instance, if the player starts in a village, and must fight his way up a mountain to the evil vampire's castle—show the castle on the horizon. Make sure that the castle becomes a backdrop for events in the game—scripted encounters where the player can't help but notice the dark silhouette of his enemy's fortress getting larger and larger on the horizon. In coming up with ideas for the environment, consider the following:

- What elements in your level will support foreshadowing and sight lines? Are there windows to see into the distance, or cameras and television monitors that show rooms later in the level?
- Can you place dying space marines who will tell the player character about the nameless evil that lurks further into the dungeon?
- What format will clues and information come in? Character dialog, recorded crew logs, or transmissions from HQ?

Lighting

Good lighting is a key to a dramatic level. It also helps with guidance and tension. In Chapter 10, we will go into more detail about lighting, and how to use it in the level. For now, the properties to consider are more general. What sort of lighting will your level have? What kinds of sources are available? Certain effects and techniques transcend the technology that produces the light. A brightly lit area at the end of a dark room will guide the player to that spot. Likewise, a shadowy corner of a well-lit room will almost always invite curiosity—a great place to hide a secret item, or a trap. Draw the player through the map by highlighting areas with light and shadow, contrasting colors, or subtle changes that draw the eye. When you come up with gameplay ideas and encounters, think about the lighting conditions and effects that will be part of the experience.

Paradigm Shifts

When the player gets complacent, an extreme shift in the conditions or rhythm of the level can create useful tension. When the player has spent some time enjoying relative safety, it might be interesting to take it away, if only temporarily, or introduce a new

element that challenges the safety. Consider the state of the player when thinking of the level structure and try to embed some shifts and revelations that will cause the player to stop, think, and possibly even try a new item or skill for the first time.

Music and Sound

Audio affects the player very strongly but it is very easy to abuse. Less is generally more when designing in audio elements for the level. Think carefully about how you will use sound and music, and how it will affect the player. Audio can

- Enhance an encounter.
- Provide contrast to a visual element to increase tension (creepy music playing when the player enters a room that is decorated for a child's birthday party).
- Warn of an impending event.
- Become associated with a particular character or event (a recurring "theme tune").
- Generate emotion and unexpected reactions in the player.
- Help turn a visually dull space into a richer environment.
- Make mundane or repeated actions (firing a gun, giving a unit orders, flipping a puzzle piece) more exciting.

Remember also that the player may not—or may wish not to—hear all the beautiful sounds in your level. Unlike graphics, which are almost always essential for play, sound is very often considered secondary by players, especially music. Make sure that you don't create puzzles or encounters that rely solely on audio, by also providing a visual element (a switch that visibly turns, a light that changes color, etc.) that accompanies it, if it is an essential encounter or critical to progression.

RISKS AND REWARDS

Interactivity should mean choices in your level. The more the player has the freedom to decide a course of action, the better. To make this a pleasurable kind of choice (and not simply deciding between two near-identical options), you must balance the risks and rewards of making decisions while playing. Some examples of playing these two concepts off each other are the following:

- Monsters that drop powerful items (like repair kits or health potions) randomly. If the player is at full health and has the choice to either engage these monsters, or simply run past them, there is probably little risk either way. However, if the player needs health badly, attacking the monster might be a high-risk decision made worthwhile by the reward (an item that replaces lost health).
- The simple act of choosing between two different branches in the linear path. One corridor might be dark and spooky while another is warm and inviting. The risk might be that the inviting route is simply inviting the player to turn the corner and walk into an ambush.
- A system where weapons degrade over time, with use. The reward for using a special flamethrower might be increased damage and range, as well as impressive visual and audio feedback, but the risk is that it may explode after prolonged use. The player may never consider this until the odds get so high the potential repercussions outweigh the benefits.
- Allowing the players a choice if they need something badly enough to risk more than they would gain to get it is the basis for many gameplay systems and events in game levels. The judicious but intelligent use of different levels of risks coupled with large and small rewards can make all the difference. Consider how you will introduce this into the level, and in what forms. Certain once-off encounters or challenges might have some level of risk and reward. Alternatively, when designing ingredients for the level, or game, the player may have a choice every time he faces that particular entity in the map.

REWARDS IN GENERAL

What line will draw the player through your map? Games often use a "reward system" that allows the player to feel small degrees of accomplishment frequently in the level. The best example is the ubiquitous "coins" that can be found in many platform games. Collecting coins used to be the sole object of some levels or games back in the Dark Ages of game design. More commonly nowadays, the collectibles in a level are secondary—optional rewards—that the player can collect and when

he has enough of them, is given a larger reward or can use them to "purchase" a reward from a selection available.

Even if there is no ultimate purpose for acquiring collectibles in a level, the *act* of collecting them can often be a pleasurable experience. Some games litter levels with small rewards like emails to read, hidden areas to find, special characters to interact with, or fun elements to interact with.

The point here is that when thinking about what is rewarding in the level you are designing, don't just think about the large-scale rewards such as defeating a boss character or figuring out a major puzzle. Think also of the moment-to-moment rewards, and leverage what is fun about your game's overall design. If making the player character jump is satisfying and fun, create reasons to do so in the level. If shooting is fun, add many smaller combat encounters. If using an item is enjoyable, reward the player for doing so by giving him *reasons* to do so.

SCRIPTED GAMEPLAY

A common responsibility for level designers is the need to be able to set up simple "scripts," which are very simple programs written in a language that interfaces with the engine. Scripting allows you to set up complicated events that take what the player does, or other elements in the map do, into account and activate preplanned scenarios. Figure 5.7 shows a scripted event in the *Unreal Tournament 2003* Editor.

FIGURE 5.7 A scripted event.

By creating a script, you are creating what amounts to set directions for a movie—directing actors to go to specific locations and perform specific activities. Although very powerful, if incorrectly thought out or written, some scripts can allow the player to do something unexpected, which will break or confuse the script. Evaluate the technology available to you and begin to think now, of the sorts of encounters you would like to script, rather than what you want to happen naturally, or for the player to be able to experiment with. The loose opposite of a highly scripted level is a systemic one (as discussed earlier in this chapter, and later by Harvey in the interview at the end of the chapter), and the choice about how and when to use scripted sequences or scripted gameplay is usually determined by the team based on the needs of the game.

USING ARTIFICIAL INTELLIGENCE

A large part of what makes a dynamic, challenging level is artificial intelligence (AI). The actual study of AI is much more high-level and technical than in game AI, where the objective is to provide a flexible system to ensure fun encounters for anyone who plays—encounters with virtual opponents in the game world that can match the abilities and tactics of the players.

Some games need no AI, such as puzzle games or adventure games where most of the characters are static and pre-scripted to react to the limited number of options the player has in interacting with them. Conversely, some games rely almost completely on complicated and realistic artificial intelligence, such as racing games (where the computer-controlled drivers need to react constantly in response to the changing conditions on the track or road) or "sim" games such as *The Sims, Zeus,* and *SimCity*® where the AI controls populations of simulated beings that determine the random encounters that players need to face constantly. Most games, however, use AI to enhance the core gameplay or the feeling of being in a real environment.

States of Being

To better control and compartmentalize the behavior of game elements driven by AI, often these elements are given a number of *states* that they can be in at any one time. These states then determine the finer points of behavior, reaction to input, the kind of actions available, and so on. An example of states can be seen in *Thief: Deadly Shadows.* In this game, the player deals with opponents that have several states of being that are linked to their awareness of the player. When an opponent is patrolling the map, unaware of the player's presence nearby, the opponent will be

making no choices, simply following the path laid out by the level designer. This could be considered a *normal* state of being for the AI, one that it is in for most of the time. If the AI notices the player briefly, or sees an object missing or tampered with by the player, it may enter its *aware* state. In this mode, the AI begins to make independent decisions. It can break away from the patrol path and decide to look in the corner where the candle just went out, or it can decide that it didn't really see the player after all. If the AI receives more definite input about the presence of the player—if it sees the player clearly for X seconds or if it hears footsteps, it may shift into an *aggressive* state where it draws a weapon and attacks the player. Now the decisions being made are about eliminating the threat before it and self-preservation. The AI may attack the player until it takes enough damage from him that it decides to flee to safety.

Decisions, Input and Output

These decisions are the crux of AI. The character is only as intelligent as the designers have specified and the programmers have implemented. The AI in *Thief* cannot, for example, leave the player money to come out of hiding because it isn't possible within the framework of the game, nor does it help enhance the gameplay of the player hiding from opponents. Instead, the AI has a set of actions it can choose to perform based on what input it receives. The more decisions it has and the more input it is sensitive to, the more options it has—and to the player, the more "lifelike" its behavior will appear to be.

Input

As a rule of thumb, AI ingredients in the map should have clearly defined input. More specifically you, as the level designer, should be aware of what the ingredient will react to, and what types of input will trigger a change of state or a particular action. Common types of input are the following:

> **Sight:** What visual elements is it aware of, and what changes in the visual environment? How far can it see?
>
> **Sound:** Can the AI detect sounds as they happen in the level? To what distance? What sort of sounds will affect them?
>
> **Invisible input:** The game will often communicate certain events to an AI beyond its natural ability to detect them. A common case is a character "hearing" an alarm and reacting to it, despite being nowhere near it. This sort of input is often needed to force the AI to do something in relation to the player's actions, or to always perform a certain function even if players have by accident strayed

far from where they should be. You should be very careful about using this kind of input. Many players will be annoyed by AI that is obviously "cheating" by knowing exactly where the player character is, even though they are separated by a solid wall, for example. Many FPS titles will use invisible input to allow the AI to detect the player and pursue them more efficiently than having to constantly scan for them visually. However, it can lead to AI that outperforms the player in certain areas and must be tuned (or "dumbed" down to be a little more random or inconsistent to balance out this kind of obvious omnipotence on the part of the level ingredient).

Output

Good AI output is critical for a great playing experience. The player can't know what is going on inside an AI character's "mind" unless that character informs the player somehow. The more players are informed, the more they can make wise decisions about how to handle the character, or what actions to perform to avoid, defeat, or aid it. To use the *Thief* example again, the AI characters have a large number of "barks" or small dialog files that they use to inform the player of what they are doing or thinking. A NPC that is aware of a visual change but not aware of the player character may say, "Is anybody there?" A NPC that has seen, and is out to hurt, the player character may yell, "Come back here so I can teach you a lesson!" Barks are a great means to inform and update the player about the status and intentions of an AI character while maintaining a level of realism and consistency.

Other forms of output include the following:

Animation: The AI ingredient changes posture, or uses a different animation to indicate a shift in state or goals. This might even be a facial expression, or an erratic movement on the part of a rival driver.

Symbols: A character uses a specific visual cue to inform the player of an action or a decision being made. The most famous example of this is perhaps in the *Metal Gear Solid* series of games where enemy AI characters have an exclamation mark appear over their heads when they see the player, or a question mark when evidence of the player's presence is seen, such as a footprint. The use of symbols in games is borrowed heavily from comics and graphic novels where player emotions need to be captured and exemplified in static images, and symbols are often used.

Game messages: Sometimes it is easier to simply notify a player of a change in AI. This often comes in the form of a message from the player character's headquarters or an intercepted transmission

No matter how it is facilitated, AI must provide output to the player. In general, there should be a fairly equal balance between input and output. The more an AI ingredient is aware of, and can react to in the level, the more it should inform the player of its intentions and current state of being.

Pathing and Patrols

As a level designer, the amount of control you have over the AI in your levels varies. The previous sections should give you some guidelines about the most important aspects of AI and how it affects the player's experience. However, even if you don't have much input into how the AI is designed, you will no doubt have control of its movement through the level. This is a critical part of level design. There is a huge potential for things to go wrong in a map when care has not been taken to optimize, test, and refine the movements of the AI and the navigation elements it uses to get from point to point. Here are a few things to keep in mind when setting up the movement schemes for AI in your level:

Overestimate the Room Needed for NPC Movements

When you are laying out the navigation routes for your level, it is always better to give more room than you really think is needed—more room between individual nodes, between walls in corridors, between obstacles. Situations will always arise where congestion occurs in a "hotspot," or any areas where the player will encounter NPCs or other mobile AI. Keep a mental note of where you think these hotspots are and either make them roomy enough to handle multiple characters trying to move around the space, or confer with the artists to make sure the areas are built to the correct size to handle congestion.

Don't Use Too Many Nodes

If you are using a system that requires the placement of nodes or waypoints that the level's AI will move between to navigate the map, make sure you don't place too many all over the level. Even though the specific density of nodes will differ based on the system your AI ingredients use, or don't use, to supplant the main routes, it is always wiser to keep the density higher for tough navigation areas like staircases or corners and low for long corridors or open rooms. Games that use node-based navigation paths can suffer from having too many pathnodes as the AI character spends too much time picking between the numerous potential nodes for their next destination.

Avoid Patrols Crossing Each Other

You will often set patrols and scripted paths for AI when it is not directly interacting with the player character. Make sure that these paths are kept separate enough, and don't cross each other too much, to avoid characters running into each other and getting stuck, or avoiding each other only to get trapped in a corner or on a piece of the level geometry.

Random Movement

When given the option for an AI element to perform random actions, or choose randomly between several path branches, remember that it is good to have the player be able to anticipate the actions of an NPC to some degree. This is obviously more important in a stealth game, or an RTS where close observation of enemy units shows patterns and allows the player to come up with a strategy for defeating them. It is very tempting to have AI engage in random behavior to appear more realistic or give it more character. Remember that a player won't know something is scripted to happen repeatedly unless they see it happen at the same time and place over and over again. Random actions aren't truly necessary for making a character seem lifelike or that it is making decisions on the fly. It is better to have a character, unit, or group of AI ingredients that the player can feel more comfortable observing and engaging.

LEVEL GESTALT

Gestalt is an obscure word, generally defined as "a group of elements so unified that it can't be described as just a sum of all of its parts." In the context of a level designer being responsible for putting all the elements of the game together, it is a perfect description of what a level needs to be. A game level needs to be something greater than the gameplay, textures, props, and lighting within it. As these work together to support and enhance the critical encounters and tension in the level, they combine to create an experience that transcends just an environment with things to do—they become a world full of possibilities.

In practice, level design gestalt is about not focusing too much on one area, and knowing what the player will willingly ignore, and what they will not be able to resist. It is balancing the elements against each other to create a great level in the time, and with the resources, allowed. You almost never have time to give an equal amount of attention to everything in the level so seeing the environment as a player will and adjusting it accordingly will become a frequent obligation.

For now, just keep gestalt and the balance of ingredients in your mind as you think about the level and what you will be putting in it. As the process continues, it will become increasingly important to look at the level as the gamer rather than as the creator, and pay more attention to things the closer they lie to the critical path.

SUMMARY

In this chapter, we started by looking at the level abstract—the summary document that contains the key elements the level needs to have. Although this is a good starting point, the level designer needs to start thinking about the task in detail.

■ Overall flow and the critical path: will the players be given many choices and routes throughout the level, or will they move in a linear fashion from start to end?
■ Ingredients are the basic units of the level design. From enemies to powerups to props, the ingredients are the individual elements created by, or related to, a level designer for combination into gameplay and encounters.
■ Encounters are points in the level where the player has the option to, or is forced to, interact with the game. Encounters are made up of game ingredients combined to create interesting or challenging situations for the player.
■ Creating tension is how a level designer keeps a player interested in the level and wanting to play "just five minutes more." Level tension is akin to a fishing line or a conveyor belt—it is the practice of keeping the players moving through the space toward their next objective.
■ Gestalt is the fusion of elements so that they equate to more than just their total parts. The right combination of tension, encounters, visual environment, story, and interaction can produce an experience far beyond the sum of a level's elements alone.

If you haven't already done so at this stage, it's time to record your thoughts and ideas in earnest. No matter how silly or irrelevant a thought is about your level, it can help to write it down, or sketch it, in a journal. Buy a hardbound sketchbook, available at any bookstore, stationery, or art supply store, and an ink pen. The act of committing to an idea in ink tends to make the writer think a little more intensely about what is being written or drawn. By keeping this journal handy, you can quickly document sudden revelations or brilliant gameplay ideas immediately and refer to them again quickly when you need to. Archiving, documenting, and journaling are all skills beneficial for a level designer. You may have an idea that doesn't work for your current project, but a year later, you may come back to it and realize it's the perfect encounter for your new level.

INTERVIEW WITH HARVEY SMITH

As a leader, game designer, and creative director, Harvey Smith has been making games professionally since 1993. He worked at Ion Storm's Austin office from 1998 to 2004, acting as project director of *Deus Ex: Invisible War* and lead designer on the award winning *Deus Ex*. Before Ion Storm, he worked at Multitude, an Internet startup in San Mateo, California. There he was lead designer of *FireTeam,* an innovative multiplayer squad game that was one of the earliest video games to feature voice-communications between players. Smith started his career at the legendary game company Origin Systems, working there for almost four years. Over the last five years, he has spoken on these subjects and others at a variety of conferences and seminars in Hong Kong, London, Montreal, and the United States.

His projects to date include *Deus Ex 2: Invisible War* (project director), *Deus Ex* (lead designer), *FireTeam* (lead designer), *Technosaur* (project director/designer), and *CyberMage* (associate producer). He was also involved with production of *Thief 3, Ultima VIII, System Shock,* and *Super Wing Commander 3DO.*

Harvey, can you explain a little about how you came to be designing levels?

I got into video games professionally in 1993. When I signed on at Origin, I was a science fiction/fantasy writer with a recent publication credit and I felt like my writing was just taking off. (I'd just sold a story and had just finished a forever-unpublished SF novel.) I was also a major game junkie. I'd been playing video games since *Pong,* and I had been playing and designing pen and paper RPG's (as a hobby) since I was 11. I was also into MUDs (multiuser dungeons) and MUSHes (Multiuser Shared Hallucination) that allowed players to create their own content (like Illuminati Online's *MetaVerse*).

For six months I schmoozed at Origin, playing softball with the corporate team, playing in various RPG campaigns with the people who worked there, playing multiplayer games in the building with friends at night, going to lunch with members of various development teams, and finally even tagging along on a skydiving trip with Richard Garriot and about 30 other Origin staff members. All to no avail.

Eventually, I answered an ad in the newspaper that said, "Wanted: QA Tester with knowledge of video games." It paid $7 an hour, and I got the job immediately.

→

Within a couple of days, I was sitting at a folding table in the back of the QA Pit, flying *Wing Commander* missions on a 3DO.

I spent some time testing a few projects, then two things happened: I spent 10 months as lead tester of *System Shock,* working with the amazing developers at Looking Glass Technologies, and (without being asked) I wrote a detailed, aggressive report on what was wrong with *Ultima VIII.* I learned massive amounts working around Doug Church (remotely and for a while face-to-face), and I attracted the attention of Warren Spector and Richard Garriot. Eventually, Richard let me type up the "top 100 problems‰ in *Ultima VIII,* gave me the support of a programmer and a designer from the project, and we fixed a ton of problems before Origin released the CD version of the game (which was much more favorably received).

Having been in QA for a year and a few months, Warren Spector offered me a job as an associate producer and Richard Garriot offered me a job as a junior game designer.

After a couple of short projects with Warren, I pitched a highly innovative RTS called Technosaur to Warren and Richard, which I had been working on on my own time with a small team from the company. Origin let me pull together an official team, a demo, go through several stages of pitching, then enter full development.

After a year of formal production, however, the project was cancelled.

After that, I moved to San Mateo to work with Art Min and Ned Lerner on a game called *FireTeam.* It was a great move, like game design boot camp. I think I was employee #6, and I was the company's only dedicated game designer. Everyone there was a game designer, though, which was great.

During *FireTeam*, I worked closely with Art, Ned, Rob Fermier, and some of our "remote design compadres" (and game testers) were people like Marc LeBlanc and Doug Church. To say that I learned a lot is a massive understatement.

FireTeam was great—a multiplayer squad game with voice support, back in 1997. To this day, I am still very proud of that game and very happy with all that I learned. I built almost all the levels, refined them throughout test, wrote script code for the training missions, hand edited files that controlled animation playback, subbed in the game's sound effects, and came up with many of the game mechanics behind the sub-games, character classes, weapons, and powerups.

\rightarrow

It was the late 1990s, though, and the dot-com madness was beginning to end.

So, as Multitude started transitioning from games to voice tech, I left, moving back to Austin to work with Warren Spector on a new project that was shaping up to be what I instantly understood to be "like Underworld in the modern world." We created *Deus Ex* there in the Austin Ion Storm office with little attention from the more-chaotic Dallas Ion Storm office and little attention from our publisher, Eidos.

Once again, I was leading (parts of) a game team, designing game mechanics for character systems, weapons and tools, laying out interface elements, writing parts of the mission/story script and building (A LOT OF) 3D levels. It was great–very intense.

Still, the writer in me loved creating 3D levels (more so than the visual artist, which is pretty weak). I created most of the maps for the NYC and Paris missions in *Deus Ex*. I was inspired enough by my role to give a GDC talk called Systemic Level Design.

By the time *Deus Ex 2: Invisible War* came into production, I was too busy to work on levels, which made me sad, actually. I was project director, recruiting and leading the entire team, not just the level/game designers any more. I also was effectively lead designer for the first year of the project, writing the initial (ambitious) design doc.

So technically I was only a level designer on two games: FireTeam and Deus Ex.

In the future, the level designer role will increasingly be played by environmental artists, with the skills to create highly detailed and architecturally meaningful spaces. But of course these people will always need to keep things in mind like the map-flow, the dramatic rhythm of the encounters, technical issues like occlusion and line-of-sight, et al. That is, until "world creation" is an automated process—which it will be—driven by pre-arranged patterns related to architecture and gameplay.

At GDC (Game Developers' Conference) 2000, you proposed that level design would benefit from a systemic approach (where most often it is a series of special-case encounters). Can you explain the theory behind this, and the pitfalls of the special-case scenario?

A few years ago, much of level design involved very specific construction, based around the whims of whoever was working on a specific part of a level

→

or game environment. For instance, if a level designer wanted to create a trap or an encounter, he might create a unique object (like a table, a giant crane, or a door), add some unique scripted properties or behaviors to this unique object, then test out the scenario in the game and, if satisfied, move on. His areas might end up similar in appearance, but radically different in terms of functionality, from another level designer on the same project team, sitting at the next desk over. This was how game maps were created, in many cases, circa 2000 and earlier.

And while this was an okay way to construct levels, it had some problems:

Workflow Scale: This model is better for small teams, like one or two level designers, as opposed to 12 or even more that we might see today.

If you have 20 people working on environments, you don't want them all to be spending time duplicating the same work. You don't want 20 people creating identical doors; you want one person to create the door, then share it with the other 19. Similarly, if you've got to make a change to door behaviors at the end of a project, due to some physics system problem, for instance, you don't want to touch all 300 doors in the game. Instead, you'd rather open up the object browser, select the archetype instance of the door and change it there, once. This saves time, which equates to money or allows you to further polish and refine your game.

Gameplay Consistency: The more level designers "doing their own thing," the more variance featured with the behavior of the game's tables, giant cranes, and doors. The player has to re-learn how to use a door each time he encounters one, which is most likely frustrating, tedious, confusing, and less fun. (Player: "Oh, I got killed by this door because it crushed me. That's not fair; I learned from the doors in the previous level that doors pushed me aside, instead of crushing me.") In addition to decreasing the learning curve and making the game feel more intuitive or fair, the systemic level design approach also enables some high-minded game design aesthetic goals related to allowing the player to approach the game in a very deliberate, mindful, strategic way, rather than randomly stumbling from encounter to encounter. If the player can make some assumptions about the behaviors of things—due to their universal consistency—then the player can look across the game landscape and formulate a plan with intention.

\rightarrow

Ideally, under the systemic level design model, when the game team creates something, it matches the collective vision and is then "published" for the entire level design group to use.

Of course, special or unique objects are required for the game. Systemic level design was mostly a talk related to ubiquitous game objects—trying to make them more efficient to create and more unified in their behaviors. Unique or "special case" objects and behaviors are still needed.

Now most game development considers this, often courtesy of some object browser or mesh hierarchy tree. And even when I was giving the talk, some people were like, "of course." Some people already understood this concept, intuitively or because they had worked in object-oriented coding environments. But you would not believe how much resistance to this idea there was in certain areas, from certain people; some game developers were overtly hostile, implying that the systemic level designer was the death of creativity or something.

Do you see the industry moving toward systemic level design, and how does it apply to other genres than traditional action adventure games?

Yes, everything is moving toward global patterns. But we're going to move vastly beyond object-oriented level design in the near future.

As a player, over time, I have been drawn to a specific component of the interactive video game experience. I've crawled through airshafts, soared over battlefields, and swum in subterranean rivers. I love exploration, not only of environmental space, but also of system space. The thrill of your agency as a player—exercising your will over something and seeing the results, seeing the world change—is still fascinating to me. Part of the fascination is somehow connected, in ways I don't fully understand, to noting the existence of a system, providing input, and noting the reaction to your input. I believe this is what game designers like Marc LeBlanc mean when they talk about the explorable space of a system.

While playing *Underworld*, which is still one of my favorite games ever made, I had this experience: I fought a goblin, who was armed with a sling, on a bridge within an underground tunnel network. The goblin's sling stones damaged me and I was already wounded, so I decided to flee. As I was running, I fell off the bridge and down into the darkness. With a splash, I landed in a river very far beneath the bridge. In the gloom above, I could occasionally still glimpse the goblin. I swam along with the current (because swimming

\rightarrow

against it made my movement much slower), and finally I pulled myself out onto a muddy embankment. There, in a small niche set against the river, I took stock. I seemed to be in some crude place that felt "off the map" to me. I had deviated from the game's plot structure and quest goals. And that, in and of itself, was the most fascinating aspect of the game. To hell with saving the princess . . . I was now exploring the game world according to my own agenda. On the muddy river bank, I pulled up some plants and ate them, healing myself. About the explorable space of the system, I wondered intuitively, "Will the plants grow back?"

The future of "level design" (or game environment creation) is auto-generation. Someone will parameterize or seed things at a high level, and the system will create the world in ways that rely on lots of recognizable human patterns. Why do cities in Eastern Europe look *recognizably* different from cities in the United States? When I saw the game *Republic,* I was amazed at the art direction: the city in the game looked like a city from Eastern Europe. The elements that make such things recognizable can be quantified. Eventually, just by describing what you want in terms of terrain type, season, population, and culture, game developers will be able to provide world systems that generate themselves.

I think I first started thinking about this after talking to Doug Church late one night. He has so often inspired me with a single sentence that provokes years of thought.

But it's not the production efficiency, cost savings, world size, or whatever else that I find fascinating about this; it's the system space. I'm deeply (almost unconsciously) fascinated by the notion that greater levels of self-expression and exploration will be made possible by the removal of the human agent from the world generation process.

Auto-generating world systems imply to the player in me a very satisfying, tantalizing whiff of further explorable system space.

Are there specific examples of level design in past games that you think defined the craft?

If you think about it, in the distant past most game map terrain just represented distance and simple course-changing player-input with regard to four directions. Visualize the maze in *PacMan* . . . As more degrees of (3D) motion

\rightarrow

and movement modes (like crouching) were added to games, the map terrain got more complex in terms of requiring more complicated course-changing player-input. Visualize some of the very "circular" deathmatch levels in *Quake* . . . So, first off, I think you have to consider the time period (and the state of the craft at the time) in determining which work was defining.

In *Dungeon Master,* in 1987, the pits in the game's dungeon maps dropped the player down into the next map, into a deeper part of the dungeon. (Falling into a pit triggered a level load.) Given that the game was a level-progression RPG, where the player was generally around the same toughness as the monsters, this meant that the player could at times suddenly be facing weird, tougher monsters. I thought this was brilliant.

Underworld had the most gloomy spaces I've ever seen, in an age before advanced lighting.

System Shock taught me a lot about the value of internal consistency in creating spaces that feel plausible and "lived in." We applied this heavily to *Deus Ex.*

Duke Nukem will forever stand in my mind as an epiphany. The movie theater, with its bathrooms, were stunningly cool . . . I was literally giddy encountering them for the first time. It was as if the *Duke* team has tapped into some deeper form of catering to my "player expectation," which is one of the most powerful techniques in game design. (Sometimes games nail this and sometimes they thwart the player's expectations with dire results; an unfortunate counter example is the unrealistic unified ammo in *Deus Ex: Invisible War.*)

Quake taught me a lot about multiplayer map flow. The game showcased the value of nexus areas and demonstrated how to use vertical space in interesting ways.

There are often poor moments as well. In *Knights of the Old Republic* last year—a game I otherwise loved—there are levels that made me backtrack so much that I was angry at the game, cursing the tedium, but hungry for the next cool moment. Other players I've talked to mention the same problem . . . long, empty runs through spaces that have already been explored or cleared.

→

You have performed a number of roles in your development history. Often it seems what level designers do is unclear to other team members. Do you have thoughts on how level designers can foster communication with other departments?

Well, most of the positions on game teams are actually in a state of constant flux. New specialist positions emerge all the time.

A few years ago, I remember some people arguing that there wasn't enough full time work for an "AI Programmer." Now some projects have two or three people dedicated to the suite of tasks called AI.

Part of the problem with level design is that traditionally it has encompassed tasks in multiple disciplines: Game scripting is a high-level form of what, in the past, would have been game programming. Map/environment construction is a task that will, in the future, be solely the domain of environmental artists working with high-end 3D art software. Designing game mechanics for weapons, tools, enemies, and environmental objects will soon be the primary work of specialist game designers (along with other gameplay-related tasks).

I think two things will help game teams:

First, *before* any work begins, the exec staff should lay out very articulate job descriptions. This sounds like corporate fluff to some people, but it's increasingly important to clearly define responsibilities and boundaries. Starting a game project without the workflow process and roles defined is the game development equivalent of one of the major Hollywood blunders, starting to film a movie before the script is finished.

Either of these mistakes ups your chances of failing in some major ways.

Second, game teams need to continue to embrace a cross-discipline "strike team" mentality. As an example, imagine a temporary mini-team forming to solve a set of specific problems: An artist, a programmer, the team's audio engineer, and a game designer get together to go through all the maps and ensure that the sound volumes are set up in such a way that works well technically with regard to the AI, aesthetically with regard to audio/sound effects, and both technically and aesthetically with regard to the gameplay.

Not only does this solve problems very quickly, it also improves morale (by giving people a sense of accomplishment for completing mini-goals) and

\rightarrow

it forms better bonds between team members (since they have worked together in solving a problem and have learned to communicate better with one another); this breeds cross-discipline respect and eliminates some of the departmental us-versus-them mentality.

©2004 Harvey Smith

6 Common Level Design Limitations

In This Chapter

■ Technical Limitations
■ Environmental Limitations
■ A Final Word: Constraints in Licensed Games
■ Summary

I n this chapter, we'll discuss the sorts of boundaries you as a designer will need to make a game level. Almost as important as knowing what to do when building levels is knowing what *not* to do.

One of the things you shouldn't do is jump right into designing a level once you have a good idea. This might be okay for a quick test, or a small level you'll play with friends for your favorite multiplayer game, but not if you want the level to hold up to the scrutiny of the playing public. Even though it may seem faster to just dig in and start creating geometry, being part of a development team often means pre-planning and coordinating your efforts with others. The amount of planning and design work varies from company to company—in some cases a level designer never actually builds the level; he just creates extremely detailed documents from which artists can work to create the actual playfields and decorate them. In other studios, level designers are responsible for all aspects of a map or mission, from initial concept to finished product.

Regardless of the process, all game developers need to contend with constraints, limitations, and conventions when making a title. For level designers, the two most important areas to watch out for are technical and environmental limitations.

TECHNICAL LIMITATIONS

As software, all games run on hardware, commonly called the game *platform*. This simply refers to the device on which the games run, anything from a simple mobile phone, to a gaming console like the Xbox or PlayStation, to a cutting-edge home computer. The kind of platform your game is going to run on will affect the content you will be making for it. For a level designer, technical constraints don't really affect what a level is but do determine *how* it should be made.

Limitations from your hardware will come in all shapes and sizes. As a rule of thumb, the biggest factors are the following:

■ Memory
■ Processing power and frame rate

- Level performance
- Polycount and performance
- Level lighting
- Artificial intelligence
- Media format
- Target and minimum specifications

Memory

A machine's memory is the amount of data it can store before it runs out of room and needs to start overwriting some of it with new data. Frequently, the amount of memory in the average PC or game console isn't enough to hold all the data for a single level, and so every now and then, the game will load things it needs from the hard drive or disk drive. If this happens extensively, it can frustrate the player as the game pauses every few seconds, or even worse, stutters frequently, as the level tries to bring in all the new textures and models it needs.

Some games, such as *Resident Evil,* mask this process by showing a small animation between areas of a level where loading takes places. Frequently this is a logical separation of spaces like a doorway or a staircase. While the loading takes place, a small animation is played on screen to keep the player's attention.

Other games will simply try to combine the small loads into fewer—but longer—pauses in gameplay to keep the majority of the player's experience smooth. This can been seen in games where the player, unknowingly, crosses a threshold in the level and everything freezes. Other titles, such as the recent *Thief: Deadly Shadows,* mark where a load will occur with a special effect so the player is aware that the game will pause to load when they enter the area. Developers often include a small animating "loading bar" when a major level switch occurs to let players know that their machine hasn't crashed and that the action will resume in a moment.

Neither of these solutions is ideal, so many developers have been pursuing streaming content in an effort to avoid large pauses. This technique basically keeps the stream of data open, but small, allowing a constant flow of information into the level. This works if the player isn't able to suddenly enter a part of the level that uses completely different materials or actors—for example, going from the inside of a gloomy sewer into a bustling urban cityscape. Careful level design can allow gradual changes of environment, which makes streaming content much more viable as an option, and reduces the player's frustration and impatience.

Regardless of the final solution, part of your job as a designer of your game's environments is to make sure you work within the memory limitations. This means you need to be frugal in using assets in your level, and keep track of the transitions between locations and situations. As you work, ask yourself these questions:

■ Do I need a new art asset or actor here, or can I use an existing one in a new way?
■ If I do use a new asset, how likely is the player to notice?
■ What can I do to ease the transition between visually separate locations?
■ Should my level be broken up into smaller maps? Where is the best place for this? Where will it be least frustrating for the player?

Processing Power and Frame Rate

Interactive entertainment is an industry based on computers. The games all require massive amounts of computational power to create realistic spaces, challenging gameplay, and believable reactions from NPCs. All gaming platforms are constrained by their available computer horsepower, from the smallest handheld to the latest console.

The size of games and the limitations of the hardware don't always progress in parallel, however. Quite often, especially when a new graphics card or gaming console is released, there is a period where game developers scramble to take full advantage of the new hardware. Later, toward the end of the hardware's lifetime, games have often reached the capacity of what can be technically accomplished.

Modern gaming machines offer many flavors of processing ability—the CPU handles most of the mathematical calculations, such as calculating projectile movement, running the AI, or keeping track of all the objects in the world. Recently, graphics processor units (GPUs) have been introduced to take care of the increasing need for "eye candy" in games. The GPU is used to calculate things such as lighting and shading of the game characters and environment, displaying special effects and decompressing image files and textures from memory.

Just like film, or television, games are really displayed as a series of still images updated very quickly. For the most part, this is invisible to the player because of the way the human brain works. Called "persistence of vision," the principle is based on our knowledge that when presented with a series of images, the brain captures each for about one tenth of a second before processing the next one. If the sequence of images is slower than 10 per second, the viewer will see them as flickering and disconnected. Faster than 10 per second, and the brain begins to see them as a seamless series of movement. In games and movies, each of these still images is called a "frame" and the speed at which they go by is referred to as "frame rate."

Movies are filmed at a set rate of 24 frames per second. Games, on the other hand, have no standard frame rate. Each image is rendered individually and then sent to the television or monitor screen. The speed at which a game can render the images and display them to the player is controlled by the processors available.

Level Performance

Games have a variable frame rate that is measured as frames per second (FPS). As a level designer, you need to be aware of the impact your level has on your platform's

CPU and GPU and how that will affect the FPS during play. Of all the potential problems in a level, the frame rate is most likely to be the biggest. The average frame rate of a game, and the levels it contains, is often referred to as performance. A game's performance is tied up in many factors but as the most visible indicator of how well a game is running, most players consider a game with a higher frame rate as performing better. A game's performance is critical for fast-moving games that give the player a better edge over the competition the faster the screen updates. Players of first person shooters such as *Quake* and *Unreal Tournament* often value FPS more highly than anything when they are playing online against other players. For a hard-core action player, 10 frames per second more than your competitor can often mean the difference between winning and losing a confrontation.

In Chapter 4, we examined player ergonomics and the need to avoid frustrating the player. A consistently low frame rate will invariably annoy your players. In fact, if the FPS of a given level drops low enough, it will become unplayable, and probably no one will want to keep playing, even if the rest of the game is superb.

To keep the average frame rate of your level as high as possible, you need to be aware of how much strain you are placing on the processor. Everything that is being shown on screen will cause a small strain on the GPU. Every enemy or NPC that has to check for obstacles in its path is using processing power. The more of these elements that go into your map, the bigger the workload you are giving your hardware. As you prepare to build your level, you need to be aware of the costs of your decisions in terms of frame rate.

Polycount and Performance

For most 3D games, every object in the world is made up of polygons, or "polys." These are the simplest shape, geometrically speaking, that can describe volume. A polygon is really the space between three points that are called *vertices*. Every single object or surface in a 3D level is made up of lots of polygons all joined along their sides, and the more complex the object the more polygons it contains. When 3D assets such as character models and world models such as furniture or trees are brought into your map, they contribute to the overall polycount—the total amount of polygons in the level. The overall count is not usually the problem but, rather, the number of polygons that the player can see on the screen at once. If the game camera is pointing at an area with numerous, very detailed trees, the processor must handle all sorts of calculations relating to them, from working out what parts can be seen and what can't, to calculating lighting on their surfaces and the shadows they will cast on the ground and each other. A simple forest level can quickly become complex enough to slow the game to a crawl if you aren't careful (Figure 6.1).

You can also run into a bloated polycount from having too many characters in a single space in your level. Most game artists will use fewer polygons for secondary

FIGURE 6.1 Too many polygons in this forest.

characters because they will spend less time up close in the player's view, and it is often more important to have more on screen to give a sense of vibrancy to the game world. It is up to you to control how these characters move, where they will be contained, and how much affect they will have on the level's performance. Some games require a higher number of polygons for characters than in the surrounding terrain. For instance, many RTS titles need to support a huge number of units moving and engaging each other on screen at once, and use simpler, low-poly terrain models to compensate. Each game is different, and your concern must always be the enjoyment of the player, even if that means asking an artist to reduce the number of polys in a model already made.

You need to watch for more than just polycount, however. Many of the tools you have available to you as a designer can be overused. Special effects such as particle emitters (Figure 6.2), which can be used for anything from smoke to a black hole to falling leaves, are used more and more extensively and can help give the illusion of a much more realistic environment. However, emitters can quickly generate so many small images or models so rapidly, they can affect the performance of your map as easily as too many high-poly decorations.

FIGURE 6.2 A particle emitter in a map, using small images of flames in quick succession to look like actual fire.

Level Lighting

Lighting and shadowing is also a growing source of GPU strain, depending on the title you are creating and how realistic the environments need to be. All game engines and platforms have different ways of treating light and shadow, though there is always a memory and processing cost involved in adding more and more light sources to a map and expecting more complex lighting results. This is even more apparent as more games seek to add new techniques for creating more realistic and interactive lighting in their environments. Games like *Doom 3* began a new generation of "dynamic lighting" or lighting that is calculated constantly so that everything in the game will cast correct shadows, even if it is moving, and lights can be turned on and off in the level with appropriate results to the affected space. Until only a few years ago, most games had predominantly static lighting where the shadows and light values in the world were "baked in" as the level was compiled. These shadows then became a permanent part of the level, and even if you moved an object or a door that was casting a shadow, rarely would the lighting change to reflect it.

The cost of dynamic lighting is extremely large, however, and often you will need to limit the amount of lighting in your level to avoid processor load. This can be challenging as you seek to create visually appealing spaces with fewer light

sources than before. As the techniques evolve, the hardware limitations will lessen, but you should still make sure you don't plan for an extravagantly lit area only to be told by the programming team that it will be impossible to create with your engine's lighting tools.

Artificial Intelligence

All the processing costs so far have been for visual elements of the level. Increasingly, this workload is being handled by the GPUs that come with next-generation consoles and PC video hardware. However, it is important not to forget that much of what a processor does is handle things that the player doesn't ever "see." One major culprit is AI.

Video games have continually striven to give the player more realistic opponents, but at a cost. As the range and speed of computer decisions increases—giving game characters a better illusion of thinking for themselves—it means more processor strain. AI has several ways in which it uses the computational power of its hardware:

- Awareness
- Decision making
- Navigation

Knowing the relative performance hit of the actors you will be placing in your map isn't critical, but it can save you a lot of frustration later when the game slows down and you can't figure out why. Next, we'll examine why AI can cause performance problems.

Awareness

No matter what kind of opponents your game has, they need to have some awareness of their surrounding. How aware they are, and to what they are aware, determines the frequency of calculations they need to make. Even a simple object will most likely need to borrow the processor's time frequently to check against a list of conditions that will activate it.

SIDEBAR

A top-down strategy game features a "turret" actor that is designed to wait until an enemy unit comes within 200 meters, and then fire on it until it is either destroyed, or retreats to beyond the turret's range. Because the fastest

\rightarrow

units in the game move 100 meters per second, the designers decide to have the turret check for units moving within its range every two seconds.

Performance-wise, this means that each turret in the game will perform a check of its surroundings twice a second. One of these turrets in a map will produce no significant performance loss. After all, the modern processor can process millions of calculations in just half that time. However, if the level designer keeps adding turrets to the map, eventually there will be a noticeable lag in the game (every two seconds) as the CPU struggles to handle thousands of range checks simultaneously.

The example level in the sidebar could be smoothed by making sure the turrets don't all check for enemies at the same time. The engine could check each turret in sequence every two seconds, for instance, which would mean it was constantly working, but might avoid the noticeable frame rate loss of all turrets checking at exactly the same time, 30 times a minute.

The situation gets even more complicated if the actor needs to make more frequent checks. If it is decided that the turrets need to check for enemies within range 100 times a second, each of those actors you place in a map will have a greater drain on the CPU, and you will be able to use less of them before the level's performance starts to suffer noticeably.

The more complex the AI is, the greater awareness it needs. The example of the turret represents one of the simplest possibilities—it's not really "intelligent" at all, it's just reacting to a certain set of rules. If we were to take the example of one of the marine characters from *Half-Life*, we would find a much more complex awareness, simulating senses such as hearing, keeping track of the positions of its squad mates and registering the actions of the player so it can react accordingly.

However, as complex as an actor's ability to monitor the environment might be, a larger part of its computations are used in deciding what to do when it needs to react.

Decision Making

The core of an AI is the ability to choose an appropriate action to events it is aware of. This is really what makes it intelligent. Humans make an incredible number of decisions every instant—even while we sleep. To try to simulate this is still science fiction. So to create actors that seem to react realistically to the actions of the player, and events in the world around them, programmers need to set up special code that

allows a game's characters or units to react in specific ways based on predetermined conditions. Simply put, the more conditions, and the more possible reactions, the more the AI will need to calculate awareness around it, and keep generating a plan to react. All of these plans take processor time to work out.

To illustrate how an AI character might think, let's use the turret example again:

Deciding to make the turret a beefier unit in the make-believe strategy game, the designers decide to give it a greater degree of intelligence and several types of weapons to use against enemies—a rocket launcher, a machine gun, and a flamethrower for short-range combat.

The actor still checks around it in a 100-meter radius every two seconds. Now, instead of just attacking enemies until they leave the area, the turret will check against several conditions to present a much more difficult challenge to opposing units. When an enemy comes into range, the turret will now run through the checklist:

Step 1: Is the actor in range an enemy? If it isn't, then do nothing, but if it is, then play my "activate" animation and rotate to face the target.

Step 2: Is the actor between 100 and 75 meters away? If it is, fire a rocket. If it is 75 to 25 meters, then shoot my machine guns at the target. If it is 25 meters away or less, then use my flamethrower.

Step 3: How many rockets do I have left? If I run out, switch to machine guns and wait until the enemy is within machine gun range. If I run out of machine gun ammunition, switch to flamethrowers, which have no ammunition, but can only hit targets at 25 meters or less.

Step 4: Is the enemy still in range? If it is, return to Step 2 until it is destroyed. If it is destroyed or out of range, play my "deactivate" animation and go back to checking for enemies in range.

There are now four major calculations for the turret so it can make a decision about how to treat a unit moving through its territory. Now when a unit passes by, and the turret determines it must be destroyed, instead of simply firing at the unit until it goes away, the turret is constantly calculating distance and deciding what sort of weapon it needs to use. There is a constant stream of data that needs to be processed for each turret, and now the cost of each one added is much higher. The level designer placing these turrets will need to balance the amount of new multiweapon turrets in the map against other performance factors.

You can imagine, then, how many calculations an actor might have to make if it needed to act like a real human. The extent of conditions it would need to react to, the possible actions it could choose from, and the need to keep making decisions as things happen around it—all of these working tirelessly to provide a believable intelligence and a fun challenge for the player.

In single cases, or distributed lightly around the level, the noticeable impact on how a level runs may not be affected by this new, more complex turret (from the example in the sidebar). But enough of these placed around the map will noticeably drag the performance speed down as the calculations strive for the processor's attention.

Navigation

Navigation is the last major component of artificial intelligence that you will need to worry about in your game. Unless your game features a lot of static components and opponents (such as pinball), you're probably going to need to support actor movement and logical navigation through the map.

The worst possible case is that the AI uses some kind of constant awareness check to maneuver through the level. Most game technology allows for "raycasting," where an actor sends out a "beam" and then sees where and when it is interrupted. The actor then knows if there's an obstacle in the direction of that beam, how far away it is, and often what sort of object it is, similar to the way a bat uses echolocation. This can be extremely useful for incidental behavior, as when an NPC needs to line up a shot on another character, or in a driving game where an AI car is checking on either side to make sure it doesn't hit the curb. For general navigation, this is certainly not what you want your level's actors to be using.

There are more cost-efficient techniques for setting up NPC navigation in your level. Generally, however, most games allow the level designer to create invisible paths through the map that AI units or characters can use to travel between certain points. Often games call them waypoints or navigation points, whereas UnrealEd uses "pathnodes." These nodes exist as placeable actors in the game editor (Figure 6.3) but don't show up in the game.

Navigation Routes

By connecting a series of these nodes in a line, you make a path that the game's AI can follow. In this case, the AI can use this path to navigate easily. Like following a trail of bread crumbs, once the NPC reaches a pathnode along the route, the AI directs it to the next in sequence. This means that the AI doesn't need to make very complex decisions unless it has to leave the patrol route for some reason (like pursuing the player into a part of the level where the route may not go).

FIGURE 6.3 A series of pathnodes in an *Unreal*-based map.

Using patrol routes to guide your AI will release them from having to check their surroundings constantly and using the CPU too much. They will also allow your units to be much smarter in choosing ways through their environments and not get trapped behind bits of the scenery.

Routes, then, are especially useful for making the AI look like it has a destination in mind to the player and for making sure they go where you want them to go. Usually, however, you'll want the unit to break from a route when it needs to, to pursue an opponent, or to flee when hurt. To support free movement in the level space, you will need some kind of network or predefined spaces that tell the AI how to avoid obstacles and where important features are. These are often called navigation *networks*.

Navigation Networks

By connecting a group of points to each other within a space, you make a *network*, as demonstrated in Figure 6.4. There are advantages and disadvantages with using networks for NPCs to navigate. On one hand, a large, well-connected network that spans most of the level will allow NPCs to accurately travel through the map. On the other hand, the amount of decision-making for each NPC that uses the network will increase. On a route, there are usually only two places to go from any of the points along it—forward or backward.

FIGURE 6.4 A network of pathnodes.

On a network, however, an AI unit will need to decide where to go next at every point along the way. If it is a very complex network, the unit may be trying to decide between many possibilities every couple of seconds. In many cases, NPC units are coded to use routes when they are simply performing their normal or pre-scripted routines and then move on the network when they need to break from their defined paths, as while chasing the player or running to investigate an alarm.

Networks can then be considered *support* for an AI route because there is an expense for using networks all the time that would be pointless to have for performance's sake.

SIDEBAR

We can examine the turret scenario as an example of using a layered navigation system to provide flexibility without compromising too much CPU time:

→

In our fictional RTS, the lead designer has decided that the turret is too easy to avoid simply by moving just outside its field of fire. Thus, she has re-designed it to move around the map on tracks, making it a much more for-midable opponent, essentially a tank. The gameplay programmer goes to the level designers and asks them how they need it to move.

The design team realizes that the moving turret is still a defensive unit, and that mostly it will need to stay near critical areas and patrol around them to fend off enemy attacks. There's no need for intelligence on this level—the awareness level and distance checking of the previous examples are still in place. The unit simply needs to be able to follow directions that the designer sets up, and when it needs to, use a preexisting network of waypoints in the level to close the distance to an enemy. If the enemy is destroyed or outruns the turret, it will go back to its simple patrol again.

The beauty of this system is the designer gets to lay out the patrol points for the turret, making the turret flexible without needing to give it an actual brain most of the time. Once it detects an enemy, it needs to think harder to traverse the network toward its target, but eventually it will either be de-stroyed or destroy its prey and return to its simple, pre-planned patrol path that needs little CPU support.

Again, the sidebar describes a simplistic case, but one that demonstrates a rel-atively easy and effective setup for AI navigation. There are many emerging tech-nologies for handling the need for more realistic AI in games. However, the lesson remains the same—the more information you can give a unit in your level about its surroundings up front, the fewer decisions it will need to make as it moves and the higher your map performance will be.

Media Format

This aspect of technical constraint is less of a concern than those already discussed, although it does occasionally cause restrictions for the level designer.

This issue is one that affects console titles more than PC games. With PC games, even if a game is shipped on multiple disks, it is only segmented until the game is installed—most of the game information is generally written to the com-puter's hard drive. Internal hard disk drives are faster than portable media and the amount of storage is based on an individual user's machine, but often has much more room available for game data. It is rare for a PC or Mac user to run a game di-rectly from the CD.

For a console, even one with an internal drive like the Xbox, the game data is all stored on a disk and has to be read from the media when needed. This is where the specific kind of media (CD-ROM, DVD, mini-DVD, or hand-held cartridge for example) your game ships on will affect the size of the levels you will be creating and the quantity (and complexity) of the assets you will have available to make them with. These days, most games come on CD or DVD, which can be read fast enough by the game hardware to load in large levels in a satisfactory amount of time. On the other hand, a DVD data disk can hold more than five times the amount of information that a CD-ROM can. It's obvious, then, that if your game is shipping on a DVD disk that you can plan on larger levels, or at least larger levels broken into a greater number of loads. You will also be able to have higher quality textures, sounds, and models than if your game were restricted to playing from a single CD or mini-DVD (which the Game Cube uses, for instance). Every asset takes up memory on a disk, and a large texture with a lot of colors will end up being larger than a smaller texture that relies on fewer colors. The same is true for sound, as high-quality stereo sound will take much more disk space than will the same sound after a lot of compression and after detail is removed.

Target and Minimum Specs

One of the fundamental differences between a PC and console for a game developer is predictability. Every type of game console is a perfect clone of its siblings. A game that runs well on one Xbox, for instance, will run identically on another—on any Xbox for that matter.

On the other hand, almost every personal computer is different from the next. Even the same model and the same brand of PC may differ in drivers, internal components, and overall performance. If you buy a game for your computer that runs smoothly, it may be unbearably slow on your friend's machine. This is one of the greatest burdens PC developers have to bear—there is much less consistency with the hardware when making a PC game.

To address this, most publishers insist on "target specifications," which can be found on the back or side of most PC game boxes. The target spec is simply the ideal, average hardware setup required to play the game properly. If the player has a machine with better hardware than the target spec, that's great. However, a game running on a machine that does not meet the specific hardware demands may not perform well at all.

Along with the target specifications, most publishers will demand a set of *minimum specs* that tell the player the absolute lowest-end hardware that the game can be played on. If the player's machine does not meet these specifications, the game will often be problematic enough to render it unplayable. This system relieves the publisher of responsibility for someone who tries unsuccessfully to run the game on

a substandard machine. Conversely, it also sets large limits on the game for the developers. The minimum specifications for your title may mean you have less to work with, or that you need to be smarter in designing and building your level than a previous title demanded.

Before you even think about designing your map, make sure you know what the performance specs for your game are. The ideal you need to design for falls between the target and the minimum range, and it will affect everything we have talked about in this chapter so far. The lower the memory and processor requirements, the less you will have to work with.

Increasingly, game technology supports "scalability," which simply means the engine is smart enough to detect the settings and hardware the player is using and adjust the game accordingly. Most often this results in the purely decorative elements of the levels existing or not, or switching between high- and low-poly models depending on how much each player's computer can handle.

Performance Give and Take

If you are in a position where you have low hardware specs, you will need to prioritize the elements in your levels. Questions can arise such as these:

- Is it more important to have a more visually impressive environment than complicated actor AI?
- What elements can I remove without affecting the experience? For example, are there particle effects for torch flames where simple animating flame texture could be used instead?
- Have the artists given me models with the most efficient use of polygons?
- Can I get away with removing a particular texture, or having it scaled it down, without compromising the visual impression?

ENVIRONMENTAL LIMITATIONS

Some of the most direct constraints a level designer deals with are environmental. Every level is a location of some sort, and as such has decisions to be made about the kind of location and the impact on gameplay. Let's look at some of these pre-design factors.

Locations

We discussed in the first chapter that a level is a *container* for gameplay. As such, you need to know about the container before you plan to put anything inside. Just as the dimensions of a suitcase will determine what you pack, the location of your level is where you need to start because it will determine many important things about its development. Your level's environment will determine the kinds of resources available to you for creating gameplay. For instance, it will determine what sort of unique landmarks you might use, the quality of lighting, the types of characters that could be encountered, and most importantly, the physical scope that might be needed so it seems believable. There's a big difference in being asked to build a dingy drinking hole in Tokyo and the luxury of setting your level "in a Japanese bar." Likewise being asked to set a level on an open desert planet like *Dune* will probably require a greater size and scope than a suburban home will—even if it's just a matter of faking that scope, the workload in creating a convincing desert horizon will be heavier. How will you keep the player from wandering all over the desert, if your engine cannot render it? How will you make those constraints visible to the player without losing the open feeling?

It's a rare game where a designer can simply choose the location of his level based on personal preference. Factors such as the storyline, the number of different environments that can be supported by the art team, the type of game, and the difficulty involved in creating some types of spaces, for example, will all affect the final choices for a level's setting. Some level design teams must work out the settings themselves, whereas in other situations the basics are worked out by the game designer and handed to each level designer to flesh out.

Environmental Settings

Once a location is set, you have a number of factors to pin down, depending on the requirements and scope of the environment. If your level is going to be entirely underground, you probably won't need to worry about what the weather is like. However, if you have any exterior locations—even simply windows looking outside—you will need to determine the kind of weather, season, landscape, and lighting that the player will witness. Simply choosing a day or night setting will affect a number of things—the kind of lighting you'll need for exteriors, palette requirements for texture artists, special effects such as rain or snow, volcanoes, or space debris. Consider also that the environmental factors of your level are not isolated from each other. You will need to determine how they affect each other before affecting the level. For instance, if you are building an outdoor area for your game, the lighting will depend on the

weather and time of day combined. There are many examples of maps that feature overcast skies, yet everything is crisply lit by direct sunlight. These things will stand out to most players simply because they are unnatural representations of natural scenes (see Figure 6.5).

FIGURE 6.5 Example of unnatural outdoor lighting.

Although the specific location of the level will dictate the kind of environmental restrictions you'll have to work with (or around), there will always be some more common factors, for instance:

Local geography (desert, jungle, urban, volcanic, mesa, arctic)

Local architecture (common building materials, roof heights, construction styles)

Time of day (midnight, noon, 10 minutes before sunrise)

Season

Weather conditions (snowing, perfect summer day, calm before the storm)

Gravity (normal, reduced, or even absent)

Creating a Reference File

Regardless of where the decision comes from, the first order of the day will be to take what you have and begin a reference file. A reference file can contain anything that shows the flavor of an area, or that you think might inspire you for your level. If you need to build a map set in an Italian village in the 1940s, you'll want to hop on the Internet and begin looking for things that will increase your knowledge in that area. Photos and drawings are good for planning the construction and decoration of a level, but don't overlook things like regional music samples, articles written about the area, newspaper archives, anything that will allow you to get a better feeling for what you need to build.

You can keep these items in a folder on your workstation, pin them up on the wall behind your desk, or keep a loose-leaf binder with printouts.

A FINAL WORD: CONSTRAINTS IN LICENSED GAMES

If your game is licensed—if it is set in or uses concepts from a previously developed world—than you will have an extra layer of constraints to deal with. Many designers feel that working on a licensed title is automatically going to prevent them from being creative. In many ways, this may feel true for you too. Licenses have owners, and it means everything you propose for your levels will be looked at closely by more eyes to make sure you aren't overstepping a boundary, or creating a gameplay that doesn't fit the theme. Often great ideas will need to be shelved because they aren't appropriate for the licensed property. However, there are always positives to working with existing material. For instance, as a level designer working on a film adaptation, you may have access to an abundance of reference material from the movie—set photos, construction plans, models, and textures. All these things will help you create an environment that more closely resembles that which the player has already seen—or will see—in the theaters. Ultimately, you are still only restricted by your own creativity and ability to challenge the player. An original title can be just as restrictive as an existing license.

SUMMARY

In this chapter, we looked at the limitations imposed on level designers by the technology we use, the hardware involved in running a game, and the actual game design itself.

There are two common areas of constraint in level design:

Technical, which includes the memory and processing power of your game hardware, the kind of AI and active awareness of the level actors, and the sort of media the game will ship on.

Environmental, which covers the specific requirements your map must have or avoid, based on the story and the design elements featured in the level.

By identifying limitations in the setting of a level, you will be fully armed to go ahead and begin building a design.

7 | Designing and Documenting the Level

In This Chapter

- Game Metrics
- Different Metrics for Different Games
- Generating Gameplay—Brainstorming and Loose-Leaf ideas
- The Cell Diagram
- War Rooms
- Creating a Paper Design
- Choosing Your Design Environment
- Supporting Documents
- Conceptualizing Your Level with Visuals
- Reviews and Revisions
- Getting the Sign-Off
- Summary
- Interview with Ian Fischer of Ensemble Studios

Most levels tend to come in two parts—design and implementation. In this chapter, we will cover the design process from start to finish, looking at the sort of information you will need to arm yourself with, ways in which you can generate and link ideas together to create the right player experience, and how you can use the design process to evaluate the level before you commit to building it.

At this point in the process, you should know what sort of game you're making levels for, and what kind of level you'll be making, and have this information in the form of an abstract or design notes. You know what goes into a fun level, and you have thought about the scope, the flow model, the ingredients, and the kinds of player experiences that you want to have. Armed with all this, it's time to wrap it all into a design so you can start building.

To start the design process, the first thing a level designer needs to know is the nitty-gritty information about the game that will set the boundaries of what the player can reasonably expect to be able to do in your map, which we call *metrics*.

GAME METRICS

Before you can begin designing in earnest you need to know what "numbers" you're designing around. Most level design work comes after the initial properties and parameters of the game, what are called *player metrics,* have been defined. This is true for designing any kind of product—a car stereo can only be designed once the size of the dashboard slot it is meant to fit into has been determined, for example. Level design is no different; you need to receive many parameters before you

can really start designing gameplay or creating a navigable environment. For many games, 2D or 3D, the properties of the main character will be the biggest factor. For instance, if you are designing an action adventure, you will need to know the metrics for the player character's

- Height and width
- Walk and run speed
- Jump distance (the horizontal distance covered with a jump)
- Jump height (the maximum distance from the bottom of the character model to the ground during a jump)
- Interaction distance (how far away from a level or switch the player needs to be before he can activate it)

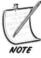

A word about character dimensions—the visual size of a character is often different from the actual *collision data for that actor. For the sake of simplicity and ease of calculation, many game characters tend to have collision primitives that block out where they are in the game world. An NPC may have a simple cylindrical collision mesh in the game that is slightly taller or wider than the actor's visual mesh, demonstrated in Figure 7.1 Thus, it's important that you know the real parameters and metrics before designing. If you are basing your designs on how big objects and characters* appear *in the game or editor, it's best to make spaces like doors and corridors slightly bigger than seems realistic in case the collision data is bigger than the actor looks.*

FIGURE 7.1 A game actor's visual mesh and actual collision mesh.

Before we describe this subject in detail, a word of warning: Beware the game designer or programmer who gives you a ballpark figure for vital game data. Game designers can easily fall into the trap of not giving the level designers concrete information. Be persistent in trying to get the real numbers. It's your job to create solid, fun environments for the game, and if you don't have the right information, you may find yourself suddenly working on obsolete data. Game development is a highly organic and iterative process, but the more you can solidify at the beginning of the design phase for a level the better. You can even put aside some aspects of a level like secret areas until you know more about certain avatar properties, rather than work with uncertain metrics.

DIFFERENT METRICS FOR DIFFERENT GAMES

There could be many more starting factors depending on what kind of game you are making. You can't make a doorway without knowing how tall and wide the character (or characters) in the game will be, but many games don't have doors, or characters for that matter. For an RTS where the player may be controlling many different types of characters or units, it may be more helpful to know the *weight* of a unit if there are elements in the level that react to that aspect of the actors. If there are elements like bridges that will crumble if the player tries to drive a tank over it, but are crossable by infantry, the level designer must know that data when creating the design for a map that uses bridges.

A variety of these special cases could affect the metrics of the player avatar and, consequently, your levels. Mostly, however, the things you need to worry most about fall into three categories:

- Powerups and temporary modifiers
- User-definable metrics
- Equipment and environmental aids

Powerups and Temporary Modifiers

In addition to common data, there may be special case information that you will want to know to build gameplay and create challenges in the game environments. In many games, the abilities and actions of the player character can be enhanced temporarily using "powerups." The player in the level often collects these items, which will give the player avatar a special ability, or change their normal properties in some way, for a short while. A powerup might make a character bigger or smaller, allow him to fly or to walk under water, or simply make him faster or slower. A lot of gameplay comes from having these items in a level. You might create a ledge that is only accessible to the player while he is under the effect of a jumping powerup.

These modifiers allow for a lot of gameplay. When players encounter areas that can't be reached using their normal metrics, they will know to look for something that will increase their abilities in a way that allows them to access it.

Powerups need to be quantifiable before you begin planning a level. You may not need the exact details of how they will work, but at a very basic level, you should know these properties:

- Effect (how will they affect the avatar?)
- Duration (about how long will they last?)
- Distribution (where in the level should you place these powerups?)
- Availability (how common are they?)

These four properties should allow you to start designing a level with the powerups in mind.

User-Definable Metrics

Some games will allow the player to generate a character's metrics manually, or use random allocations. Most typically, these are RPGs where players can tailor their avatar's visual properties such as height and weight, as well as their abilities such as jumping or running speed. A game that supports this level of customization will require the levels to be "water-tight" against the player possibly creating a character that can jump over the tallest walls or small enough to fit into areas the level designer had considered inaccessible.

The way to deal with these sorts of variable metrics is to determine their *ranges*. If players can alter the height of their characters at the start of the game, what is the height of the smallest avatar they can create? Likewise, what's the tallest size they can create? Knowing both ends of a variable metric will allow you to build solid geometry that keeps the players where they are meant to be.

Some examples of user-defined metrics are the following:

- Character size
- Character speed
- Character hit points/energy
- Character endurance (often affects inventory size)
- Character shot/activation distance

All these examples can drastically affect how a player is able to interact and play through a level, and you can probably think of a hundred more. These should be capped early in production—knowing the limits you will need to deal with in your level as early as possible will make the process infinitely easier.

Permanent Modifiers: Upgrades, Equipment, and Environmental Aids

Another factor to consider is the sort of permanent items that the player might collect during play that will affect how they interact with your level. Many games allow players to pick up new and more powerful items as rewards or ways to deal with increasing difficulty. These items often grant the player permanent advantages. A flamethrower weapon may allow the player to burn down obstacles instead of moving around them. A certain spell the player can buy may allow the player to float across a chasm instead of needing to lower a bridge like you had designed. Even elements within the level itself intended as decoration might be used to foil your best laid designs—some games have suffered from allowing the player to move environmental objects like furniture or crates and thus create ways to shortcut the level by hopping over a pile of chairs instead of finding the "correct" way through.

Much of this data comes from outside of your level specifically. Items introduced in earlier levels can affect your map depending on whether the player chooses to use them. Elements introduced in *later* levels may also affect yours if the player is allowed to return later. Games often disallow "backtracking" or letting the player move backward through a level, for this very reason. It becomes difficult to know what the player will be equipped with, or capable of, at any point in your level when they can come or go at will throughout the game. The lesson here is that the more you know about the design of the game as a whole, the better you can plan for problems occurring in your own level, and that's the real purpose of design coming before implementation.

GENERATING GAMEPLAY—BRAINSTORMING AND LOOSE-LEAF IDEAS

When it comes to putting your initial gameplay ideas down on paper, it is useful to think of situations and interactions without worrying too much about when or where in the level they will occur. Naturally, for most of your gameplay concepts you'll have an idea of where you want them to go, or have a general sense of where in the flow of the level they will belong. However, if you think of a great level gameplay idea but can't immediately think of where it would fit, don't worry. A good puzzle or battle will be fun no matter where the player encounters it. If you worry too much about the level structure and the specific placement of gameplay and game encounters at this stage, you are liable to end up with more contrived gameplay. Essentially, you will be putting the cart before the horse—letting the gameplay drive your level rather than the other way around. If you develop an idea that doesn't fit in the level you are making, you will almost certainly be able to use it in some other level later.

This is the concept of *brainstorming*—just letting your imagination loose and trying to come up with the best ideas you can for your maps. Brainstorming is a big

part of game development as an iterative process; you'll often find yourself sitting back, or sitting in a room with your colleagues, and racking your brain to come up with the best solution to a problem. For now, the only problem is how to create a fun experience from what amounts to a few sheets of paper containing the basic needs for your map.

Brainstorming requires that you open up your mind a little and put a check on your self-criticism. If an idea of a level element or a situation isn't immediately appealing, you can branch off and try a different version, or take part of it and use that to begin a new idea. The most important thing is that you record your thoughts. If it's a group brainstorm, use a whiteboard or hang up paper and nominate someone to take copious notes from the meeting. If it's just you sitting in the park or in your office, keep your sketchbook or journal handy and do the same thing. The more information you put down on paper the better.

At the end of a brainstorming session, you will have a better understanding of what you want from the level, and what the level needs. You will also have a wealth of notes or sketches you can choose from to build up the level experience. These are "loose-leaf ideas" because they're usually unorganized, loosely grouped, or sometimes simply written on the back of a diner napkin. These ideas will be what you fill in the holes of your level with—the small spaces between the major elements you already have like story requirements or key encounters or locations that have been set out by the level abstract. An example of a loose-leaf idea is shown in Figure 7.2.

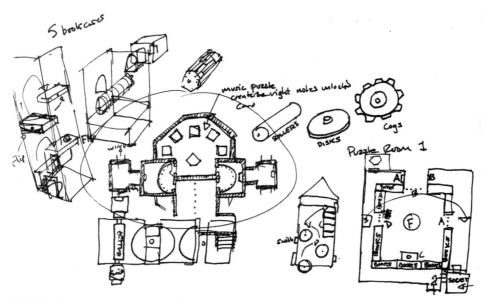

FIGURE 7.2 Loose-leaf gameplay ideas from a level early in development.

These ideas don't all have to be gameplay. They can be "wow" moments, scripted sequences, or simple locations for the player to restock and take a breather. If you are designing a multiplayer map, you may have an idea for some kind of cool crossover architecture, or a place where players can see each other but not be able to fire at one another, but at this stage only a rough idea of where it might go in the environment. Having a stock of these ideas and gameplays will help you as you construct the linear sequence of events in your level. Next we'll take a look at how putting these ideas together in sequence using a cell drawing forms the backbone of the level's design.

THE CELL DIAGRAM

Once you have a good collection of different gameplay ideas and situations, you can begin to string them together to create an actual experience. One way to do this is by using a cell diagram or "bubble drawing." In Chapter 5, we looked at using cell diagrams to pick out the rhythm points in a level, which is similar to what we will do now, on a finer level. Figure 7.3 shows an example of a rudimentary diagram for a level.

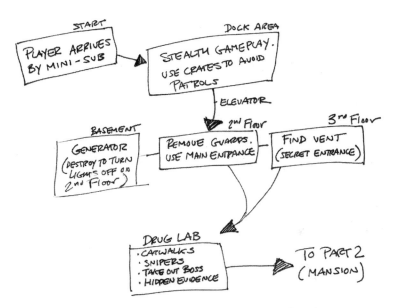

FIGURE 7.3 A cell diagram showing major gameplay elements.

With your loose-leaf ideas determined, you can begin to order them using a cell for each major gameplay, encounter, interaction, or event, joining them together with "connectors" representing smaller interactions or environments—corridors, staircases, elevators, clearings, teleporters, and so forth.

These basic studies are a great way to quickly lay out the whole user experience, and concentrate on the main areas of excitement and gameplay. Drawn roughly, you can easily cross out, replace, or re-link areas as you evolve the design.

WAR ROOMS

A great method for the level design team to distribute shared gameplay, ingredients, assets, or whatever they have at this stage, is to create a war room—a room set aside specifically for planning the game. Take a wall and divide it into areas that represent each level. Then write down all the loose-leaf ideas and elements on "sticky notes." As a group, you can stick these ideas up individually in certain levels, either marking where certain gameplays occur, or just marking the introduction of a certain weapon or item in the game (which level it's introduced in will affect the others).

War rooms are excellent for the level design process because they allow the maps to be designed iteratively, much as they will be built, but to include the entire team. Everyone has a chance to make suggestions to the team, to add or replace notes, to swap ingredients or encounters, or shift ideas a little. It also means that the entire level design team can leave a planning session all knowing exactly what has been decided. You should still have someone take minutes or keep track of decisions for those not part of the meeting, but the data can be left on the wall for other team members to look at, or for level designers to go back to when they need a refresher on the game as a whole. War rooms are really just giant bubble diagrams that can be accessed and modified by a group.

If for some reason you can't set up a war room (many companies don't have conference rooms to spare for long periods of time), you can still tackle this part of the design process as a team using computer collaboration tools such as Wiki or Microsoft NetMeeting®, which provides a virtual whiteboard that can be used like a war room wall and saved at the end of a session.

If you are simply designing a map for an existing game, or for yourself, it's still a good idea to create a cell diagram to solidify your level's basic elements—the flow, rhythm, difficulty graph, and so on. You will be able to see problems and conflicts much sooner if you take this step before you break out the graph paper and commit to a more detailed draft.

CREATING A PAPER DESIGN

Your paper design is the last stage of design before you're ready to go ahead and start building. In essence, this is the blueprint of the space you are about to make. Many problems may only become apparent when you begin building your level—the paper design is a static, 2D representation of your map (Figure 7.4) and, as such, will provide the starting point for the iterative process of creating a game environment. Still, paper designs allow you to present your whole level to the rest of the team and allow people to make comments and criticism about the level before you begin construction so that you can revise your design immediately. It's important to go through this last process for the sake of others as well as your own.

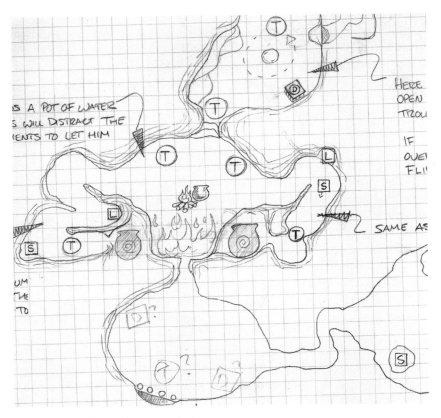

FIGURE 7.4 Part of a paper design.

Getting Started

Let's take stock of what you should have at this stage:

- A level abstract
- A reference file
- A collection of gameplay ideas for the map
- An overview or bubble diagram of the flow of events

Get some graph paper and a pencil and get ready to put all these things to use. Graph paper is ideal because it will more easily allow you to keep the scale and proportions of the different areas of the map true to each other. Pencil works better than an ink pen because it's erasable and will allow you to revise the map more easily.

You can find graph paper at most stationery stores or online office supply sites. Generally speaking, you'll want a few different sizes—8½ × 11 is good for smaller areas or for working out areas before committing them to the actual draft. Larger sheets are better for plotting out the main level layout and can be rolled up easily for transportation. If you run out of graph paper, the Mathematic Help Central Web site has printable graph sheets for every occasion—point your browser to http://www. mathematicshelpcentral.com/graph_paper.htm.

The actual process of drawing your design at this stage is generally up to you. You might want to go one area at a time, and draw some sketchy boxes to determine the size and relative position of the level's spaces, filling in the details later. Or you may pick a room—the beginning, the ending, or somewhere in the middle, and begin drawing more intricate detail. It can be quite useful to start designing somewhere other than the beginning. If you work your way back from the end, you will be less apt to pour all your creative juices into the first area of the level, and then be forced to fly through the rest of the map to get back on schedule. It's a psychological thing, but it works.

What you're doing right now is often referred to as *blocking in* or drafting the basic level. You are drawing the outlines and rough details of the level like a painter does a sketch on canvas before actually painting in the real thing on top of it.

Adding Details to the Level Draft

When you're happy with the basic draft and it contains all the spaces and places for your bubble diagram, you can start putting in the details that will make up the rest of the level. Level design is an *iterative* process. This means that you will continually find yourself moving elements, or adding ideas that you have as you design. This is normal, and expected, but others often complain about this skill of the level

designer. Much of the great gameplay of your level won't be the things you've put in your sketch book already, it will be the things you add when you realize that you can connect two areas in a really fun way you hadn't considered before, or when you have a brilliant idea for a puzzle where you had planned to put a combat encounter. Keeping things loose and sketchy in the drafting stage will allow you to add these details as you think of them, or change elements easily to accommodate revisions that make the level more fun. If you have an idea and then realize it doesn't work, add it to your sketchbook or journal anyway—chances are you'll end up using it years later in a level for a completely different game.

Regardless of whether you deviate from the original plan or engage in a completely organic process of coming up with the level draft on the fly, at this stage it's advisable to begin paying attention to the details.

One thing to make sure of before you proceed is how much detail you are *required* to include in your paper design. Some teams require only basic information—especially if the person creating the paper design is the same person who will build the level. Another factor is the overall experience level of a team. If your team is experienced, many "obvious" details can be left off the paper design. Some teams want only what they consider relevant information going into the paper design to avoid having the designers spend too much time before building. Although the benefit of the paper design is drastically reduced if the designer is rushed to complete it, it is a fact of life in game development. The lead level designer should be able to furnish you with this information, or it may have been decided communally among the level designers before the production process began. Knowing this requirement will reassure you about how much you *need* to include and will also give you an idea of what is too much.

Making a Marker Key

Without a key to the little marks and blobs you are putting in your map to represent all the stuff going in, chances are no one will know what anything stands for. If you are making a home-grown map, it still makes sense to use a key just so you will remember what everything is meant to be when you forget about the map and pick up the design a few months later.

The beauty of a design key is you can represent any element with a symbol of your choosing as long as it is used consistently. There is no industry standard for symbols, but the more you can make a marker symbol look appropriate to what it's meant to represent the better. As long as you put a translation key on the page somewhere stating the function of the various markers, other team members will easily be able to follow it. Figure 7.5 provides an example of a design key from an actual game level.

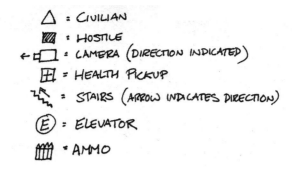

FIGURE 7.5 An example design key.

Characters: Patrols and Enemy Placement

Start finalizing your placement of enemies and opposing units. If they will be moving, plot out their patrol routes. If they *spawn* into the level or are created spontaneously by the engine in response to player actions, start deciding where those spawn points will be. If the enemies will be in the level from the beginning, mark them in on the map.

If it is important in your game to note which way things that can see or hear the player are pointing—living enemies, security cameras, heat-sensitive turrets, and so on—give them a direction indicator in the paper design that will tell your team members which way they are facing, or other relevant information about their sensory abilities.

NOTE

Moving enemies can have their patrols marked out simply by drawing a line, or series of lines with arrows that mark the points they will be moving between. This can get messy if you have lots of patrols intersecting, so consider using different colors to mark in overlapping or parallel patrol routes. You may also want to include other factors important for the enemy characters, such as the following:

- **Detection Range** (marked in as a surrounding circle showing how far they can see)
- **Initial behavior** (on, off, idle, searching, bored, playing cards, sleeping, etc.)
- **Special properties** (special weapon or carried item, blind, hungry, etc.)
- **Trigger conditions** (patrols after 10 seconds, activated by Trigger A, etc.)

Puzzles, boss battles, minigames, and triggered events

You'll need to indicate wherever something special is going to happen to the player, or where the player might activate a special situation in the level. If it's simply a

room with a puzzle, you can work out how much of the puzzle needs to be shown on the actual paper map. If the puzzle uses moving platforms that the player must leap on to cross a chasm, you'll need to mark in the chasm and the platforms, and indicate where the platforms will be moving to and from. However, if the puzzle is simply clicking on tiles in a wall to make them rotate to the same image, you may just want to indicate that with a star and a label reading "Rotating tile puzzle."

The same can be applied to *minigames*. Minigames are games-within-games and use simplified mechanics that force the player to stop and defeat a certain challenge before continuing. A minigame can be a logic puzzle that occurs halfway through a shooter, where the player needs to connect wires between different terminals to stop a bomb from detonating. For example, *System Shock* requires the player to solve a logic puzzle to unlock doors. A minigame may also simply be a diversion from the main objective in the map. *Legend of Zelda: The Wind Waker* features small minigames in several areas of the world as amusing distractions that the player can choose to play if he has enough money. The designer marks these sorts of games on the map and explains them in detail in the design document.

Boss battles are a particular type of minigame. Generally, the focus is on defeating one, or a handful, of unique opponents so you can progress to the next level. A boss should be used as a gateway between important parts of the level, and that's why they often come at the end, or midway through a map—a boss helps divide the experience into acts. On a more subtle level, a boss encounter helps you control the difficulty graph in your map by allowing you to increase the challenge level sharply, while giving you a chance to reward your player highly on completion. Just the act of defeating a tougher-than-usual enemy can be a hefty dose of accomplishment in itself. If you have a boss battle in your map, consider drafting it as a separate design. Chances are there is a lot of unique information about the encounter that will overload that area of your main map. Taking your boss battles or complicated minigames onto separate sheets will help you maintain order.

Finally, it's essential that you include in your map any kind of "invisible devices"—commonly called *triggers*, or *zones*—that will trigger events or activate components in the map. Many engines have different ways of handling player-activated scripts and events, but they often share common variables:

Effect: This is the most important factor you need to indicate on your design— what will the trigger *do*? How many doors will it open at once? Does it awaken a squad of tanks on the other side of the level? Usually the effect of the trigger is called the *event*. An event can be anything—playing a piece of music, starting a ceiling collapse, or causing the avatar to say a pre-recorded line. Using a consistent labeling scheme is an easy way to link triggers with their affected element in your design. For example, if you have a door that is activated by a hidden floor switch, mark the switch as TRIG_DOOR_A and the door itself as DOOR_A.

Keep this system consistent throughout your design (ideally your team will have agreed on a common naming scheme for level elements, but that detail is often oddly overlooked) so that *you* know where everything connects and other team members can easily see how everything is wired together in your map.

Visibility: If the player needs to physically trip a switch or pull a lever, that is called a *physical* or *visible* trigger. If the trigger is hidden from view or not part of the actual level geometry and triggers when the player or some other character enters its area, that's an *invisible* trigger. Either way it needs to be marked down on your paper design.

Activation Criteria: Will the player shoot this trigger? Pull it with his whip? Is the trigger set to go off when the player approaches it within a certain distance? For this you only need to mark in the relevant data. If it is a proximity trigger, draw in the boundaries of the activation area around it. If it is a building that needs a certain amount of damage to trigger a collapse effect, write in the damage number needed to activate it.

All games use some form of trigger/event system to tell the engine where the player is, what's he's done or where he's heading. Remember, it's your job to *simulate* a world for the player, and triggers and events are the shortcuts that allow you to do so. For example, we covered earlier how it gets very memory intensive to have all the NPCs or puzzles in a map present all the time, just waiting for the player to stumble on them. To counter this, level designers will often generate them when and where they are needed based on the player triggering an event. If the player is approaching the barracks of a castle, the guards can be triggered to appear inside as soon as the player opens the barracks door. The player won't know that they weren't there a second before, but the engine will have been spared in rendering and calculating the guards' AI while the player was still on the other side of the level.

At this stage, however, concern yourself with simply marking down only the information you need about the triggers and triggered events in your draft design.

Resources: Inventory Items, Powerups, and Expendables

Many role-playing, shooter, and platform titles require that the level designer place a lot of collectible elements, weapons, ammunition, powerups, bonus items, or other objects useful to the player through the level.

Earlier, we talked about difficulty and how a level's difficulty and tension can be controlled partly by the distribution of things the player needs throughout the environment. This is your opportunity to actually implement that before the map is even built. Even though much of the placement and fine-tuning of things such as health kits, spell scrolls, gold, ammunition clips, or save points will happen during construction and polish, you can get a good sense of how you need to distribute everything now.

Like everything else at this stage, be clear what all of your markers mean. You might also need to mark down how many of each item are in each location—many games have pre-set item counts. For example, your game may only have health potions that heal 10% of the avatar's total health. If you wanted to put a secret room in your map that would allow the player to recoup half of his health, you'd need at least five potions in that one spot. You'll want to mark this on the paper design as a numeral next to the potion symbol rather than drawing in five little potion symbols in the room.

Another consideration is highlighting the placement of unique items such as weapons, permanent upgrade potions, or resource locations for mining, rather than "expendables" or objects that the player will consume and encounter again such as health kits or ammunition. Using something such as a star or a different color reserved for unique items can help modelers and designers both pick out the important requirements in your map and the assets that may need to be created specially for your level.

Scripted Sequences, Cinematics, and Other Information for the Player

An important part of level design is knowing what to let the player discover by himself, and what to lead them to. There are many ways to give the player information for free. Many games choose to do this through noninteractive "cut-scenes," or cinematics, which are like mini-movies that the player watches to learn crucial data. Cinematics may be *pre-rendered,* meaning that they were created in an outside application and are played to the screen as video. *Real-time cinematics* take place *in* the level but take control of the game camera while they are playing. The handy thing about these scenes is that they can show the player almost anything—they can show events happening at the same time but half a world away, or show the player avatar's partner in trouble 40 stories above him. Time and location don't matter with cinematics. They also force players to watch what is going on, generally allowing them to skip over the scene if they don't think it is important or it bores them.

Scripted sequences are *interactive* story elements in the game. A player may encounter a scripted sequence when he hears two characters conversing in the next room, or when the player is able to initiate dialogue with an NPC without losing control of the avatar or game camera. The benefit of a scripted sequence is that it doesn't interrupt the flow of the level if the player doesn't wish it to. When overhearing two characters talking, the player may decided to just burst into the room, guns blazing, and the NPCs will stop talking and react appropriately (unless it's a particularly bad game) by shooting back or taking cover. Similarly, if the player walks up to a nonhostile character in the level and initiates a conversation as a scripted event, he can simply walk away if he gets bored, or continue to explore the environment while the NPC talks to him. *Half-Life* pioneered this method of giving the player information through interactive encounters, but many developers

have found that it is harder to do this in other genres. The drawback to scripted information tends to be that the character can often miss it (if he triggered the conversation in the next room but then needed to go into his inventory for something, as an example) by accident. Sometimes the player may not even realize he's triggered anything at all. You need to be very careful that the player is going to see or hear what he needs to if you intend to give him critical information by scripted sequence. Forcing the player through a doorway to trigger one, giving many visual or audio clues about what he has done, and including a way for the player to retrieve information he missed later in another form all help to make a more ergonomic experience for your user.

You can also include information for players to see in a level through traditional means—a note they find on a body, an email on an open computer terminal, or simply a warning written in a wall. There are countless ways to disseminate knowledge to the player in a realistic fashion but still make him feel like he has discovered it all by himself.

The important point here, however, is that these are all critical elements of the map, and you need to mark them down in your paper design too. Luckily, it rarely needs more than a simple box that states the purpose of the information. If your game uses a scheme to keep track of cinematics, such as numbering them or labeling them in a certain way, include that information too. For example, if you won't be scripting encounters in the level yourself, you can include a small star and box that says "Overheard conversation between Vampire and Zombie here" to indicate to your scripter where and what is occurring. The details of the encounter can always be worked out later or described in a *supporting document,* which we will discuss later in this chapter.

Earlier we discussed about marking triggers and events in the map—very often cinematics and scripted sequences are triggered by the player's movements in the map, so mark these triggers as you would others, and make sure the connection between a scripted sequence or cinematic and the trigger locations and conditions are clearly illustrated.

Doors, Elevators, Stairs, and Other Connection Pieces

Common architectural details need to be recorded just like gameplay elements, when they affect the player's experience beyond just looking cool. Commonly, these are connection pieces that take the player from one part of the map to another, or provide breaks between areas for optimization purposes (like the S-corridors covered in Chapter 9).

Often the parts of a map that simply connect relevant parts of the gameplay are added during construction. You may think, "I need to connect these two rooms, but their floors are at different heights now," and logically connect them using a

staircase that transfers the avatar smoothly between floors instead of the corridor you had originally envisioned. Many times, you will change major rooms or locations during construction and the parts that connect them will be forced to evolve to meet the new layout. It may be tempting to ignore these pieces in the paper design, but remember that the difference between even mundane-seeming parts such as a spiral or a linear staircase can be huge to the player. A spiral staircase is enclosed, mysterious, and will make players climb cautiously in case they round the corner too fast and run into a trap or enemy. Linear staircases will focus the player on what they can see at the end, often motivating them to move quickly across the stairs to reach the area beyond. The point is that on paper these decisions may seem trivial, but they are just as important as the placement of your enemies and encounters in creating an overall effect on the player. Resist the urge to use simple corridors and elevators when more appropriate (though time-consuming) connection pieces might be used.

For creating your paper design, you'll want to mark the following information about connectors:

- **Stairs** should be labeled and indicate whether they go up, down, or connect multiple floors.
- **Elevators** should be labeled as to where their final destination is (Elevator to B2), and if they aren't active from the start of the level, how the player will trigger them.
- **Corridors and passageways** should roughly indicate length, or if there's no room, use dashed lines for the walls to indicate that the space is longer than it appears on the page.
- **Doorways and openings** should be marked with relative size, and if the doors swing only one way, you can indicate that too by a small arc that describes the swing direction of each door in the frame.

Game-Specific Details

The last category of critical elements is the hardest to define—everything else that your game requires! Every game is different, and the types of elements required of each level are similarly unique. It may be important for you to put in light and shadow, if you are creating a stealth game. If you are designing a level for a space shooter, you may need to indicate the presence and direction of asteroids, orbital debris, or nebulae. Examples of common miscellaneous details in paper maps of varying importance include the following:

Light sources: windows, torches, lampposts, or luminescent snails

Tall obstacles: pillars, large rock outcroppings, skyscrapers, pylons

Traversable obstacles: hills, crates, single-story buildings, low walls

Mission specifics: HQ, fire bases, hostage locations, vendors

Easter eggs: Secrets, hidden rooms, or messages, a group picture of the level design team

Callouts and Supplementary Information

If an area becomes too cluttered, create a *callout* (Figure 7.6) to one side, that shows a more detailed view of the area where you can display the information with less clutter. Or create a separate diagram in your sketchbook or journal that shows the congested area more cleanly. The trick here is not to try to fit too much information into the main paper map, which will just make it less useful to anyone trying to read from it—everyone but you. Instead, use callouts on the sides for written notes, expanded diagrams, doodles, or anything that will decrease the visibility of the main map drawing too much.

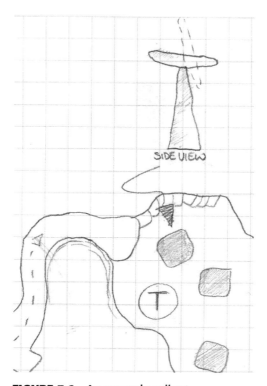

FIGURE 7.6 An example callout.

CHOOSING YOUR DESIGN ENVIRONMENT

When we refer to a paper design, it doesn't necessarily mean having to put pen to actual paper. Many programs allow you to create designs on your computer just as easily as you can on graph paper, sometimes even more easily. Although we refer to paper design as physically done on paper, using computer programs is convenient. The benefit of paper and pencils is that it's inexpensive and forgiving for the level designer on a budget.

Visio is a program that has gained popularity among some designers for its ability to handle the process of creating top-down draft designs for levels. It's actually a flowcharting program, developed by Microsoft for business applications. However, its ability to create and connect a wide variety of shapes and lay down text and icons easily makes it an ideal setup for paper designs. If you are more comfortable using a program like this to create and revise your paper map, and it's okay with the people you are working with, by all means go ahead. The advantages of a digital draft are that you can easily edit it, print out multiple copies at different sizes, and distribute it electronically via email or your local network.

Other programs also make good paper design environments. You can use Flash, Freehand, or Photoshop if you know those programs already, for example. However, make sure that you use a tool that's common among your team, so that other people can open the files easily. Not everyone will be able to open the "native" files that your application of choice puts out, so make sure you can export your designs into formats like .bmp, .jpg or .ai for distribution. If your lead designer is still using Windows Paint to open images (and you'd be surprised how many are), then a fancy Freehand file will be akin to handing him a design written in ancient Greek.

SUPPORTING DOCUMENTS

What are supporting documents? They are additional elements that will help others use your map, or help your producer schedule the time it will take to build your map and to create assets, finalize the look of it, script dialogue for it, and all sorts of additional tasks that go along with making a game environment.

Although you may encounter different, highly specialized support docs, by far the two most common are the asset list and the walkthrough, which we will cover in more detail.

The Asset List

When you're the artist assigned to help a level designer create a map, the last thing you'll want to do is have to read a paper design the size of a small car just to pick out

the special meshes and textures that it will need. You're going to want a list of all the special artistic requirements that you need to create, so you can get to work while the designer continues to plan and build the basic geometry.

This is an asset list, and although the format isn't important, it should contain as much relevance as you, the level designer, can give your supporting artists. More than visual artists will benefit from this. If your level needs special sound effects or music, you will want to include these for the audio engineers and musicians. A sample asset list (Assets.doc) is included on the CD-ROM in the Sample Documents folder, but it barely needs describing—simply write a concise list of the assets you predict you'll want, categorized by type.

ON THE CD

Naturally, you won't be able to predict everything you'll need for the whole level—a lot of that you'll realize later. However, even a small list with a few items can keep the artists busy for a week or two until you have a better idea of the sorts of objects, textures, characters, and sounds you require. Keeping a very brief list, in fact, is much better than trying to think of every single possible item you could want—potentially putting down a lot of assets that are doomed to change or be cut. Stick to what you're sure about.

The asset list can be a useful document throughout early production if it is kept "alive" by adding things that you need, and possibly removing those that you don't, so that your colleagues have a constant reference for what the level needs at any given time. However, you'll need to keep the artists aware of changes as they happen, and eventually you'll need to lock the document down—prevent any changes occurring—when there is no more time to make assets that haven't already been planned for. Remember, you can always walk over to a team member and request a new asset verbally too—but the list will help them not to forget.

The Walkthrough

Many people are not visually oriented, and even when they are, looking at a paper design or mission abstract for the first time can be confusing and non-informative if they haven't been a part of the level's evolution. That's why it is helpful to create a walkthrough document to allow others to get an immediate and clear understanding of what your design is all about.

A walkthrough can be a bullet-point list of the process the player will take to get through the map. If there are many paths through, or the level allows the player to do anything in any order, you might want to break the walkthrough up into paragraphs defining each major area and the gameplay it contains.

Generally, however, levels tend to have a somewhat linear flow, and you can create a good walkthrough by verbally walking the reader through (hence "walkthrough") your map using short descriptive paragraphs and the occasional sketch if you feel you need to.

Walkthroughs should at least outline the elements described in Chapter 3; where does the player start? What does he need to go? What is encountered on the way? What happens when he dies? And so on. It should also describe the experience of the player—when should the player be feeling tense, and why? Is there a trigger for creepy music at the top of a dark staircase? When should the player be feeling a false sense of security, only to be ambushed by enemy bombers?

With a document like this you can more easily explain, or *pitch* your design to the relevant people on your team, if you need to. You can also distribute it to people helping you create the level so that they have a better idea of the experience you intend the player to have. Even if you are not officially required to produce a walk-through as part of your scheduled design time, consider taking an hour to write one anyway. You'll find it a very useful tool both in allowing *yourself* to analyze how the level should feel, or how well it appears to deliver the experience you want it to. It will also allow others to see your vision more clearly than they would simply by seeing your paper design.

CONCEPTUALIZING YOUR LEVEL WITH VISUALS

We haven't talked about concept art yet. Concept art is really just drawings and sketches that allow you, and others, to see key areas of the level. Much like your loose-leaf ideas illustrate the gameplay elements and encounters that you will be putting into the level, concept art illustrates the visual style of your level, or at least certain areas. Unfortunately, this is something that many level designers don't feel they are able to do, or should do if there are artists on the team. Don't feel like you need to be a world-class illustrator to create usable concept art; sometimes all it takes is a few shaky lines to work out how high the columns in your atrium should be, or a simple pencil sketch to show a modeler what you want the crystals to look like in your cave map. Reference art can take you far in visualizing your level, but it won't substitute for your own imagination. If you have some drawing talent and time on the clock to draw out some concept images of your level they will most certainly be appreciated, even if it's just a happy player who stops to admire your well-thought-out visual style. Figure 7.7 shows an example of rough level concept art.

Even a few pieces of concept art can help you quickly determine a visual "theme" for your map when you are ready to begin building. We'll cover this in detail later, but rest assured the old adage is true: *a picture is worth a thousand words.* Or at least a thousand polys.

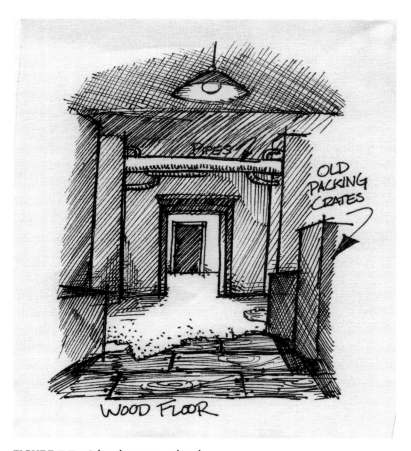

FIGURE 7.7 A level concept sketch.

REVIEWS AND REVISIONS

Okay, so you've been through the entire design process—from the bare seed of the level idea through increasingly detailed steps to now, with your paper design completed, a freshly printed walkthrough and asset list, a folder full of references and sketches, and an itchy editor finger. You're ready to go, right?

Well, almost, but not quite yet. If you're simply making a level for fun, you might understandably have skipped some of the more complex or team-oriented stages until now, feeling that they weren't needed for a noncommercial map. That's fine, but whether you're working on a Triple-A title, or making a deathmatch map

for your friends to play after work, you need a review. You need someone else's input right now because you simply won't be able to evaluate your own work at this stage, having been so deeply involved in it, and having spent so much time thinking about it. This is when you need the input of people you trust about the level and how it looks and feels.

If you are on a level team, this often comes in the form of a scheduled peer review where you will sit down with your fellow designers, or a selection of people from the team including leads, and talk them through your level so that they can evaluate it. This is necessary for several reasons:

- **The producer and leads** will want to know your estimates of how long you think it will take, the size and scope, the difficulty, and the general experience for the player.
- **The programming team** will want to know how much unique coding will be needed for the level, and how much existing work can be used. They will want to see the complexity of the map and hear how you will work to keep the frame rate up and the calculations down. They will also want to hear about how it will be set up for character navigation, AI requirements, and anything else that affects their work.
- **The art and audio team** will want to know about unique models, items, characters, textures, animations, special effects, sounds, and music needed for the level. They will need to know the environmental setting, locational information, the look and feel of the map, and the mood you intend to create for the player or players.
- **The scripting and cinematic team** will need to know how many cut-scenes there are, how many encounters or special sequences will be required, how complex the dialogue is, special characters, linear progression, and anything that could effect the way the story is told in both the level itself and the level's part of the overall game narrative.

Generally, you can expect one review of this type after you are done with the design phase, but sometimes more. After a review you will get feedback that you will need to decide whether or not to implement, and usually various members of the team will ask you further questions or bring up queries about parts of the level that concern them. You'll also get positive feedback too, about what your team likes in your map, and generally reviews are a positive experience. If you are working on a personal map, it's still advisable to get the opinions of a few trusted friends or colleagues about your design; the feedback from fresh eyes will almost always help you to evaluate your work better.

Depending on the results of a review session, you may need to revise parts of your design to meet suggestions or concerns from the team. You should never be

offended by criticism—it can only make your level better in the end. If a suggestion doesn't feel right you don't always need to act on it immediately, but in general if you break something down and rebuild it, it is going to be better because you have a clearer idea of what it needs to be. If you have an art degree, you will know how painful it can be to have to take a favorite piece of artwork down from the wall and redo it at the demand of a professor, but you will also know that it almost always improves in the process. The review and revision process is like natural evolution—it will force you to address problems that you didn't see (or saw but secretly hoped no one would notice!) and correct them, making for an improved level.

GETTING THE SIGN-OFF

Now you've had your review, you've implemented changes in your paper design, walkthrough, and asset list. You just need to get the final sign-off if that's required. Generally, this is simply a verbal agreement from your lead or the producer that you have finished the design phase satisfactorily and everyone is happy with the level. The best thing about a sign-off is every party involved is held to the agreement, and if someone comes back to you a few weeks later complaining about your incredibly hard demon in the last chamber, you can point out that you told everyone about that at your sign-off review.

It's best to get email confirmation that your level has a green light before starting. Just send out an email to your lead, or project manager and attach the level documentation. This way, if there's dispute over the level and its contents later, you can refer people to the email you sent out stating clearly what the level was going to be. It never hurts to have the evidence to back you up when people doubt your direction.

SUMMARY

This chapter described in detail the process for putting all your good ideas on paper—so you can remember them, and so other members of the team can understand them without your constant explanation. Although documentation and paper designs are important, it is also important that you don't try to get it all right up front. Let evolution work its magic on your level, and leave mental room for brainstorms, epiphanies, and revelations that naturally occur as you build and polish the level later in the process.

In the next chapter, we will look at how these designs get transformed into actual levels, and the lengthy processes, techniques, and rules involved.

INTERVIEW WITH IAN FISCHER OF ENSEMBLE STUDIOS

Ian, can you explain a bit about your background in games, and how your career led to designing RTS games?

I'm a lead game designer at Ensemble Studios. I started at ES in 1997, at the tail end of the development of *Age of Empires*. Most people don't count "companies" formed while they were in college and housed in the campus computer lab as professional experience, so this was my first real job in the industry. We've since done *Age of Kings* and *Age of Mythology*, plus three expansion packs.

Strategy levels—what's different about them compared with other major genres, and what elements do they share beyond the obvious? For instance, what are the areas a first-person shooter (FPS) level designer might need to know when moving to an RTS game?

I think the primary shift going from working on something like FPS levels to something like RTS scenarios lies in understanding where the experience takes place. FPSs are immediate—that's "you" in the game, running around with a shotgun, ducking behind crates, and blasting zombies. RTSs are distanced—"you" aren't really in the game as a unit, you're a "guiding spirit" of many units.

This fundamental difference has broad impact on how a level designer views making levels. In building a FPS level, you might be concerned with the location and properties of a light source in attempting to achieve a certain kind of shadow and mood in a room—you're trying to use the light to make the player feel a certain way when they get to the room. In a RTS, the lighting is generally global; your concern here is in picking a light set that makes the world look good and supports playability by keeping all the colors and units visible to the player. In a FPS, you need to watch the relative scale of objects because players will find a 10-foot tall door with a 2-foot radius doorknob beside a 3-foot-tall desk with a 16-foot pencil on it strange. In a RTS, you're only concerned with the way the scale of any particular object impacts the entire composition, not with uniformity of scale—some people notice that buildings in RTS games are generally a lot smaller than they should be but the experience is abstracted and distanced enough to make it not matter.

Gameplay-wise, your concerns follow the same pattern. There isn't anything stopping you from porting any variety of gameplay from almost any

→

genre into a RTS level. Technically, you could make a jumping puzzle scenario for a RTS pretty easily, for example. That doesn't mean that you should. The context that allows jumping puzzles to be whatever fun they are is found in an immediate, visceral game (say, *Prince of Persia*). In a RTS, you don't have the same context; nobody wants to jump at just the right time to guide villagers up a wall studded with conveniently placed outcroppings in *Age of Mythology*.

Are there specific ways level designers on an RTS game control the flow of events or the movement of the player when the actions can take place on huge areas of open terrain, and the player is controlling a wide number and combination of avatars instead of a single character?

With RTS scenarios, you generally make a decision on a level of player control to design for early on. If it's a wide-open scenario, the work can be done from a sandbox perspective—you're going to take a set of units and players, put them in an interesting space, wind it up, and let it go. If it's a tightly scripted scenario, the approach is a lot more of a director's perspective—you want to have a specific unit arrive at a certain location and be exposed to a set event at a known time.

The latter obviously needs more control of movement and events. Techniques that provide this in other game genres can generally be applied to RTSs too. A FPS might use corridors and one-way doors to funnel a player toward specific locations—mountains and ravines can do the same thing in a RTS. A FPS might not allow you to pass through a door until you get the key for it— a RTS where the player begins on an island with a boat hidden somewhere on the coastline is pretty similar.

What resources do you find useful when designing and implementing game spaces? Where do you go for inspiration?

Everyone does this differently. I'm pretty random about it; I'll read a book or see a movie or play a game or get involved in a conversation and some aspect of it will pop into my head as being something that could be cool in whatever I'm working on. I try to do a lot of analysis and "idea porting" with this—if I play a board game with a cool mechanic, I try to figure out how I could move something like it into a RTS space; if there's a popular movie out, I try to figure out why it's popular and how I could try to provide that in a game, and so on.

I'm one of those guys who has to write all this crap down, so I always have a bunch of napkins and torn box flaps and receipts with cryptic scribbles all over the place. My wife still thinks it's strange to find grease pencil notes all over the tiles in our shower too . . .

\rightarrow

What is the way Ensemble processes a level design through to completion? What sort of roles do level designers perform, or do you even have level designers in the traditional sense (handling both aspects of designing and building game environments)?

At Ensemble, all of the designers are generally involved with scenario creation at some level. We usually have a group of designers in charge of making the scenarios and one designer in charge of overseeing the single player game; anyone left helps with ideas and feedback.

Our scenarios begin with a "tear sheet." This is a one-page document put together by a scenario designer that provides the basic information: a simple sketch of the map, a few sentences on how the scenario will play out, and a hook. The hook is a sentence or two describing the unique gameplay the scenario is going to offer—"in this scenario, the world has cracked in half and the player can only help his ally by sending flying units," "in this scenario, the player starts with only a priest and has to convert all of his units," "in this scenario, the sun has gone out so blackmap reappears over places the player has explored," and so on.

Once we have a few tear sheets, the designers on the project get together to beat on them. Concepts that don't seem fun ("in this scenario, the player has to find his way through a maze. . ."), that require too much supporting work ("for this scenario, art will need to make 20 new unique monsters . . ."), or that have technical issues ("in this scenario, the player leads his army of one million high-poly units . . .") get modified or axed. The keepers are assigned to designers as "first pass" tasks.

A first-pass scenario is a rough version of the scenario from the tear sheet—no polish, no cinematics, no voice-over, no glitz, just a crude blocking of the scenario with whatever assets are at hand. Ideally, this should take no more than a day to put together. Essentially, a first-pass scenario provides us with something just one step up from the tear sheet—it's used to see if the game we had in our heads when looking over the tear sheet matches what we get when we see it in-game. The real purpose of this is to backstop and prevent us from spending a lot of development time on something that just isn't ever going to be fun.

Once first pass is complete, the process goes to the cleverly named "second pass." Second pass is an actual construction of the scenario, minus final polish. Ideally, it takes a week or two to get the initial version of this together. This version then is cycled into playtesting, where it will stay until the final

→

stages of the project. Once in playtesting, the scenario gets beat on by a variety of players who comment on what was fun or boring, difficult or easy. This feedback goes to the designers, who iterate the scenario and put the new version back into testing.

When a scenario has been tested enough and the game is in a stable state, the second-pass scenarios transition into final pass, where the designers add any finishing touches (custom art, voice-over audio, in-game cinematics) that didn't creep in while the scenario was being playtested.

Do you have any words of advice for designing and building strategy environments?

You can't make things easy enough.

By far, the most common mistake with the biggest negative impact on a scenario is the difficulty. Designers are gamers and they tend to be pretty good players. Plus, the opinions that they're generally most exposed to are those of the hard-core guys (because they're the ones who go out and post on forums). It's easy to start thinking of yourself as an average player or to assuming that everyone thinks the way the players on a certain forum do. It isn't the case. For every person who makes a post about a game being too easy, 20 stopped playing because they couldn't get past a level.

"Not easy enough" can also be "too confusing." I've played countless scenario submissions that were just bewildering. When you ask the designer what was intended, they'll often point out something you missed entirely—"oh, didn't you see the monk up on the hill, you were supposed to follow him. . . ." No, I didn't, and neither will 80% of your audience.

Make everything as simple as you can. If there's something players need to see, make sure there is no way they can play the scenario and not see it. If there is something they need to understand, make sure it's blatant (and engineer in safeties that remind them if they do things that show they obviously don't get it). Get as many new or casual gamers to playtest your stuff as you can—it's very difficult for people who work on games every day to put themselves in the mindset of a new gamer.

The enemy of "good" is "perfect."

(Thanks to O. Wayne Isom for those words of wisdom.)

You can block out a scenario in a few hours if you know what you're doing, but you can waste an entire week just trying to get the shrubs on a map

→

placed so that everything looks "perfect." Don't. Or at least don't until every-thing else is done. Build the minimum you need to test out the scenario con-cept to start. If that's fun, spend the time you need to revise the level until it's "good enough." Worry about "perfect" at the end, if at all.

Shooting for "perfect" is a great way to get a campaign with one awesome scenario and 29 messes.

"Different" can still be "crappy."

"But it's different" seems a common defense for scenarios that are unusual but not fun. Different is great. If you manage to put together a scenario that is different *and* fun, it'll be well received. But different cannot stand on its own. Pay attention to what is fun about the game you're working on and con-sider what different experiences you can offer that still support this.

At the end of the day, you can make the most different scenario ever seen by man and if I'd rather eat a handful of bees than play it, I'm not going to tell all my friends to go out and buy your game.

Start with a plan.

Starting the scenario development process with a rough idea of what you're targeting makes the job vastly easier than just sitting down and firing up the editor. Take the time to do a rough description of the concept, even if it's just to keep you focused.

Be merciless with your ideas.

Just because you've spent hours working on something (or will have to spend hours redoing it if you make a change) doesn't mean you have something worth shipping. Learn to recognize when a concept you've been working on isn't going to work out. Kill these ideas and move on.

8

Using a Level Editor: Building a 3D Space in UnrealEd

In This Chapter

- Installing and Opening the Editor
- Starting a New Map
- Undo and Redo
- Viewing the Level in UnrealEd
- Working with Level Geometry
- Placing Actors
- Testing the Level
- A Final Word on Grids, Snapping, and Clean Geometry
- Summary

Throughout this chapter, and the rest of the book, we will use the editor that comes with the *Unreal* engine as an example of a level editing environment. Among all of the commercially available level editors at this time, UnrealEd (the level editor application that comes with the engine) is one of the most popular, publicly documented, and user-friendly game editors available. Most of the techniques and procedures covered in this book, however, also apply to most other game editors.

ON THE CD

A fully functional version of the latest *Unreal* engine and UnrealEd are included on the book's CD-ROM. You can follow along with my examples and use it to experiment by making your own levels.

INSTALLING AND OPENING THE EDITOR

ON THE CD

First, make sure the *Unreal* Runtime Demo (included on the CD-ROM) is installed properly. An instruction file is included in the same folder as the installation file if you need help during the setup process. Once installed, open the editor by opening the engine directory (by default, this is C:/UnrealEngine2Runtime) and double-clicking UnrealEd.exe in the System folder. This will start the editor with an empty environment to work in.

When you open UnrealEd, you will be presented with a staggering array of icons and windows. Don't be put off; you will need to know only a handful of these buttons to create your first levels. Figure 8.1 shows a snapshot of UnrealEd after it loads.

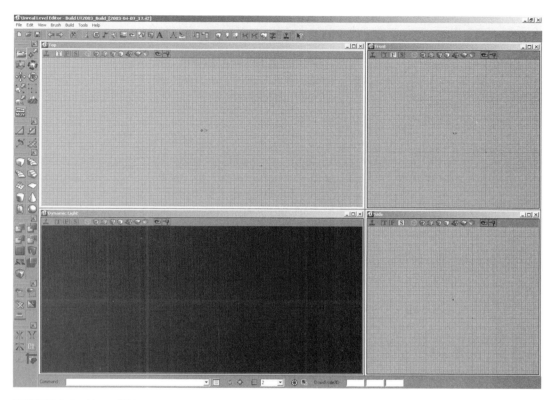

FIGURE 8.1 UnrealEd at startup.

STARTING A NEW MAP

When UnrealEd is launched, it begins by opening a new map. However, if you need to start over when working on a level, you can press the New Map button at the top left corner of the screen (the file group, as shown in Figure 8.2). If you wish to load a previously saved map, you can click on the Load Map button next to it. The last button in this group is a critical one, Save Map, which will save the map when you press it. If you haven't saved the map before, a save screen will open and allow you to enter a filename. Once the map has been saved once, pressing the save button will simply overwrite the previous version. The following keyboard short-cuts can be used instead of the icons:

Ctrl + O: Open Map
Ctrl + L: Save Map

FIGURE 8.2 The File
button group: new, load,
and save.

Clicking on File in the menu bar at the top will allow you to Save As (also available as the keyboard shortcut Ctrl + E), which will prompt you for a name every time (Figure 8.3). It's a good idea to save your maps frequently in iterations. For instance, if your map is called ElephantHouse, you should save your map as ElephantHouse_1, Elephant-House_2, and so on. This way, you will always have a recent map to revert to if something goes horribly wrong with the version you are working on. UnrealEd hates spaces in file-names, so make sure you use an underline (_) if you require a space in the filename.

UnrealEd automatically saves your map every five minutes. Each time it does so it will save it to the Maps folder with the name AutoX, where X is a number from 0 to 9. It will start with Auto0 and keep saving in increments until it reaches Auto9, after which it will save over Auto0 and continue the pattern. The best way to find out which is the most recent auto-save map is to check for the most recent save time in Windows.

New...	Ctrl+N
Open...	Ctrl+O
Save	Ctrl+L
Save As...	
Import...	
Export...	
1 C:\UnrealEngine2Runtime\Maps\Tutorial_1.urt	
2 C:\UnrealEngine2Runtime\Maps\lighting_and_texturing.urt	
3 C:\UnrealEngine2Runtime\Maps\Key_and_fill_example.urt	
4 C:\UnrealEngine2Runtime\Maps\Auto5.urt	
5 C:\UnrealEngine2Runtime\Maps\EM_Runtime.urt	
Exit	

FIGURE 8.3 The File menu.

UNDO AND REDO

Two other important features to know early are the Undo and Redo commands (Figure 8.4). Like most applications, UnrealEd allows the user to correct a mistake by clicking the Undo button and going back one step, or action, in the history of what the player has done. The editor supports multiple undo steps. If you accidentally click Undo when you didn't want to, the Redo button will move forward one step at a time in the action history, until it reaches the last action performed in the map. Keyboard shortcuts for these commands are as follows:

Ctrl + Z: Undo
Ctrl + Y : Redo

FIGURE 8.4 The
Undo and Redo
buttons.

With those essentials out of the way, let's look at how to move around the game environment in the editor.

VIEWING THE LEVEL IN UNREALED

The thing you probably noticed first is the area divided into four sections that dominate the editor screen. These four windows are called *viewports* and show the level in a variety of ways. The default windows that appear on loading are (clockwise from the top left) the Top, Front, 3D, and Side views of the current level (Figure 8.5).

This is not all that exciting at the moment because it's a blank level and all that is showing in the viewports is the editing grid (more on that later in this chapter). The gray windows with the grid showing are called the *orthographic views*. These windows only view the level along one axis, and have no perspective, which means that every object is viewed as if it were the same distance from the camera. This helps you edit the various level elements and make sure everything is the right size and shape. The fourth viewport is the *non-orthographic* view. This is the opposite of the other views in that it shows all three axes at the same time and has perspective so that objects further from the camera look smaller—it's a true 3D view. This viewport is harder to edit in, because sizes and shapes are all relative to the camera

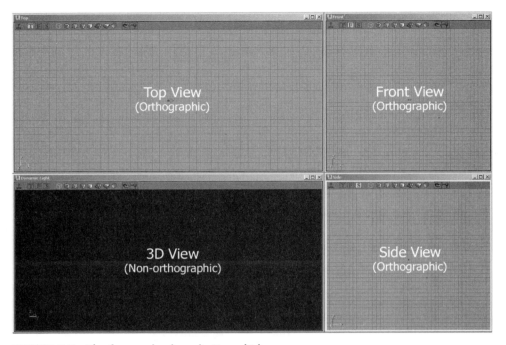

FIGURE 8.5 The four main views in UnrealEd.

and it is impossible to tell accurate distances as in the orthographic views. However, the non-orthographic viewport shows the level exactly as the player will see it, in motion if desired, with particle effects and animated textures playing in real time. This is one of the powers of UnrealEd, the direct feedback a level designer gets when adding something to the level and being able to see exactly how the map will look and feel without having to run it in the game first.

You can easily change the type of view shown in each viewport. An icon bar (Figure 8.6) at the top of the windows allows the user to select various particular modes.

The T, F, and S buttons represent Top, Front, and Side modes. The cube icons to their right all represent different types of 3D modes, mostly specialized views for optimization. For now, the only view we need can be selected by clicking on the checkered box with a shadow, called Dynamic Light mode, which shows the level in full.

FIGURE 8.6 These buttons will change the mode of a viewport.

MOVING AND WORKING IN THREE DIMENSIONS

Now that we've covered how to see the level, we need to look at how to move around in it. When you are building your level, you will be working in a simulated 3D space, much as the player will be moving through it. In general, we call each of the three dimensions in space the *X, Y,* and *Z* axes. The Z axis is height in the editor, and X and Y are breadth and width, respectively. As you move around the environment in the 3D view, it's easy to become confused at some stage about which way is the X, Y, or Z plane. Fortunately, UnrealEd, and most other serious editors, gives you a real-time axis indicator on screen so you can always keep track of your orientation and the orientation of the objects you are manipulating and placing. Figure 8.7 shows the axis indicator in the 3D view.

FIGURE 8.7 The axis indicator in a 3D window.

CAMERA MOVEMENT CONTROLS IN THE EDITOR

Each viewport actually represents the view from a virtual camera, and moving the point of view in these windows is often referred to as moving the camera. The Camera Movement mode (Figure 8.8) allows you to move the view in each of the display windows, as well as move and rotate objects and actors around in the level. This is the mode you will use for most of your session in the editor and is the default mode for general editing and changing properties of ingredients.

FIGURE 8.8 The Camera Movement mode button.

The camera can be moved using the following mouse movement and button combinations:

3D View

Rotate left/right: move the mouse left and right while holding either mouse button.

Rotate up/down: move the mouse forward and backward while holding the right button.

Move in/out: move the mouse forward and backward, holding the left button.

Move left/right: move the mouse to either side holding both buttons.

Raise/lower height: move the mouse forward and backward holding both buttons.

Top, Front, or Side Views

Move left/right/up/down: move the mouse in the desired direction while holding the left button.

Zoom: move the mouse forward and backward while holding the left and right buttons. Alternatively, you can use a scroll wheel if your mouse has one.

Try opening the map that comes with the Unreal Engine Demo, *Em_Runtime.urt in the Maps folder. Use the controls just described to navigate around the environment in the orthographic views, and in the 3D view, until you feel comfortable with the controls.*

WORKING WITH LEVEL GEOMETRY

Before we get into the details of starting to build an environment from scratch, it's a good idea to talk about the elements that go into creating the basics of the level geometry. When we talk about geometry in the book, it really refers to the 3D sur-

faces that make up the levels and everything in them. The word is used in the field of mathematics to describe the relationship of points, lines, and angles. These points, lines, and angles allow us to create a 3D level and the engine to give it life.

Different Geometry Types in UnrealEd

The engine supports three major types of geometry—three different ways to make the surfaces that define your level:

- BSP
- Static mesh
- Terrain

BSP

BSP is short for *binary spatial partitioning*. Roughly speaking, BSP is a way for the game engine to work out what in the level is visible to players as they move through it, and what it doesn't need to bother rendering (areas behind walls or other solid obstructions, around corners or behind the player's range of vision, etc.) Rather than try to go into technical details, we can talk about the basics of its purpose in a level. BSP generally makes up the bulk of the *hull geometry* or the geometry that makes up the basic surfaces of the environment. In most interior maps, BSP is used for surfaces like walls, floor, ceilings, stairs, and so forth. It's sort of like virtual wood or plaster. One benefit to using BSP for surfaces is that it uses *lightmaps* to show the effects of the lights in the level hitting its surface. We'll talk more about lightmaps in Chapter 10, but for now, simply remember that BSP has nicer-looking light and shadow effects than do other types of geometry in the editor.

Creating BSP is like using building blocks, with the added power that you can generate whatever size and shape building blocks you require, at any time. In the engine, these blocks are called *primitives* because they are all very basic shapes—rectangles, cylinders, cones, and the like. You will create many separate BSP pieces that fit together to define the shape of areas or objects. These pieces of BSP are called *brushes* in UnrealEd. Generally, brushes are kept as basic shapes and grouped together to create more complex forms. For instance, you can make a sealed room using six cubic brushes—four for each of the walls, one for the ceiling, and one for the floor (Figure 8.9)

BSP can also be used to create simple decorative elements that don't require too much detail, such as stairs, railings, window frames, or crates (Figure 8.10).

Later, we'll look at how to create BSP brushes in the editor, as well as edit and move them. The important thing to learn now is that BSP is used for low-detail and structural geometry, or for surfaces. For more detailed and fancy decorations, you'll want to use static mesh.

FIGURE 8.9 A room made from six BSP brushes.

FIGURE 8.10 Decorative or semi-decorative objects in a level made with BSP brushes.

Static Mesh

This form of geometry is different from BSP in that it is not generally created in the editor. Static meshes are made in external 3D modeling applications such as Maya or Max, and then *imported* into the editor as an object you can place, move, and perform simple procedures, such as scaling or duplicating it. Static mesh does not allow more complex operations such as those available to BSP or Terrain.

You may be wondering what the "static" part means. Well, the *Unreal* engine has two kinds of imported mesh—the static, decorative type just explained, and *skeletal mesh,* which is the kind of geometry used to make NPCs and objects that move and have animations in the world. The "skeletal" part comes from the fact that animators use a special kind of virtual skeleton to move the mesh around and get it to look natural. These are special kinds of decorations that usually come with AI programming and code that makes the mesh move and animate based on what the actor is doing.

So a static mesh is an object with no animations or special code—it is simply an object that is meant to sit in your level and look pretty. Objects that require fine detail or more surfaces, such as trees, chairs, cars, door handles, or lighting fixtures are made by artists as static meshes and placed wherever they are needed, or simply look cool. Figure 8.11 shows some examples of static meshes in a map.

FIGURE 8.11 Some examples of static meshes by the Epic artists.

Unlike BSP geometry, static meshes do not use lightmaps, instead they use a simplified system that shows what lights are hitting it and how hard, called *vertex lighting*. A simple rule of thumb with vertex lighting is that the more complicated a mesh is—the more polygons it has—the better the lighting looks. Generally, however, static meshes shouldn't be used for level elements like floors or walls that will be illuminated by many lights. It won't look as good as BSP. We'll examine this more closely in Chapter 10.

Terrain

Terrain is a very specialized form of geometry used to make . . . well, terrain. It is a flat plane that you can raise and lower, flatten, and generally shape to make any kind of natural terrain you need—from flat fields to rolling hills to Alpine slopes, and everything in between. Terrain can be created in two ways, either in the editor, or by using an image program such as Photoshop to form a *heightmap*.

A heightmap is a convenient way to create a 3D form using a simple 2D image. Using your image editor, you can create an above-view of the terrain you want using pure black, pure white, and shades of gray in between. When UnrealEd reads the image and applies it to a terrain mesh, there will be high areas wherever white shows on the image, the deepest or lowest parts when there is black, and different heights in between depending on how light or dark the gray is. This may sound confusing but if you refer to Figure 8.12, you will see the way that the heightmap is transferred to the 3D terrain geometry. Now that the terrain is using this image as its guide to what it needs to look like, you can simply draw on the image to edit the terrain geometry using the same color-to-height rule.

The other way to create or edit terrain in UnrealEd is to create a flat surface first (using a neutral gray heightmap) and then form it to the shape you want using the editor's special tools. This allows you to select different areas of the ground and manipulate them in real time, seeing the effect in your editor. It's a much more powerful method of creating a landscape or outdoor area. Terrain, like static meshes, is vertex lit. The number of polygons and their size compared with the player will determine how realistic and sharp the lighting is on the terrain's surface. Terrain cannot be used for anything other than naturally forming, organic surfaces. It can only go up and down, you cannot create overhangs, or tunnels, and it certainly shouldn't be used to make anything like a building or a manufactured object like a crate or a vehicle. However, it's invaluable for creating large outdoor spaces, or simple but natural-looking indoor spaces like courtyards or walled gardens.

FIGURE 8.12 A 2D heightmap and the resulting terrain geometry created by it in the editor.

BUILDING THE LEVEL HULL IN BSP

The detail needed to create a full level would take an entire book by itself. For our purposes of examining the use of a level editor, the task will simply be to build a room, add a light, wall coverings, and a static mesh decoration. Doing so will get us familiar with the basic operations, menus, and procedures used to make levels for the *Unreal* engine.

Okay, the first step is to make the actual room. This is done very simply. We need to select a shape and give it dimensions to make a builder brush. We will use this brush—or shape template—to "carve" the shape of our room in the level.

What Is a Brush?

We know now that a level is made up of many individual 3D shapes, called *brushes*. Brushes are the foundation of the level in *Unreal*-based games, the primitive geometry used to create the level hull.

One very important thing to know about using BSP in UnrealEd is that it is based on the concept of making *subtractive* geometry. The easiest way to explain

this is that most game editors are *additive*, which is to say the level starts as an empty void, to which the level designer adds walls, floors, and ceilings to create interior spaces. These pieces could be made by artists and snapped together by the level designer. The level designers might also use simple BSP shapes to build the level hull.

UnrealEd levels start as complete *solids*. Instead of building up rooms and spaces, the designer actually subtracts them—or "carves" them out of the world. Simply subtracting a cube from the world will create a room—the inside of the cube is now a space carved out of the solid. By further subtracting these spaces using BSP brushes, a level of many different interior connected spaces is created.

Subtraction allows the level designer to build a level with many fewer brushes. Consider it—to create a room additively the level designer needs to use six BSP brushes, as explained earlier. To create the same room subtractively, the player simply needs one brush, shaped to the required dimensions of the room, and then subtracts that from the level solid (Figure 8.13).

FIGURE 8.13 A room made from a single subtracted BSP cube. Compare this with the identical room in Figure 8.11.

However, BSP can be added easily in UnrealEd too. To work additively, a level designer can simply subtract a massive space for the level to take place in, and then add brushes in to create the level hull. Subtracting in UnrealEd instead of adding

BSP does save memory and reduce the occurrence of errors caused by "leaks" in the level where brushes don't completely touch each other and open the level to the void outside. In editors for games such as *Quake* that use additive brushes for the hull, leaks can cause many visual problems in the map.

What Is the Builder Brush?

Before a brush becomes part of the level, it exists as a kind of "ghost image" with dimensions based on the numbers that you set in its properties. This shape is shown as a red wireframe outline in the level, but does not exist until you add it or subtract it from the level. Once it is the correct shape and size, the level designer can move it into position in the level and click the Add or Subtract button to make it a permanent brush. The phantom brush is called the Builder Brush, the name it will be referred to throughout this brief tutorial.

Creating a Builder Brush

We need to pick a primitive shape for the builder brush so we can make the room. We can do this by going to the builder primitives group (Figure 8.14) and right-clicking on the icon of the rectangle to open a dialog box, where we will set the properties of the room we want (Figure 8.15).

FIGURE 8.14 The brush primitives button group.

FIGURE 8.15 The cube brush properties window.

Right now the only properties that we need to set are height, width, and breadth. Type the number 1024 for all three (we'll go over what this number means later in talking about units of measurement), and click the Build button when you're done. A red wireframe box will appear in the corner of the 3D view. This is the builder brush—the shape that will be added to or subtracted from the world depending on what you want to do with it. The dimensions are exactly as you typed in the previous menu. To turn this "ghost" cube into a real piece of BSP, we need to select the Subtract button (Figure 8.16) located below the primitives group.

FIGURE 8.16
The Subtract button creates a subtractive BSP brush from the builder.

This will result in a box appearing in your level. If the box isn't centered in the 3D view, move the camera until it is. If nothing seems to have happened, be sure the top of the window says "Dynamic Light" and not "Wireframe." If it doesn't, click the little checkered cube button on the right of the mode icons to return the view to the Dynamic Light mode. You should have something that closely resembles the room in Figure 8.17. We will be working in this room for this chapter. You'll notice in the 2D views that the box has a yellow wireframe. This denotes that it's a subtractive box—it's subtracting space from the level's solid mass. Brushes that add mass back into the level are colored blue. There are different colors for other types of brushes, but for now, we just need to recognize these two colors.

Now you have an empty room. The greenish texture on the walls, floor, and ceiling is the default image (or *texture*) that the editor applies to surfaces when the user has not specified a specific image to use. This is often referred to as the "bubble wrap" texture. Not much to look at, but this is where all levels begin—the first element in a blank level. Next, we're going to add an actor to the map to test it.

FIGURE 8.17 The subtracted cube brush.

PLACING ACTORS

An *actor* in this engine is terminology for pretty much anything that has code behind it. More simply, this means almost any object in the game is considered by the engine to be an actor because it has some kind of programming involved or properties that can be set by the user. For example, a light in the level is an actor because it has settings and properties that allow it to be modified. A BSP brush is an actor, of a sort, as is a static mesh. At runtime, the player sees these visual elements in the map.

Other types of actors, those that provide functionality for the level but aren't seen by the player or explicitly in the world (a trigger may exist as an actor but players may not know they have triggered it) are *invisible* actors. They can be seen and manipulated in the editor, but when the game runs they are unseen in the level, working in the background without the player knowing anything about them other than their visual or audible effects.

Most actors can be placed in a map extremely easily. All you need to do is open the Actor Browser by clicking on the button at the top of the editor window (the icon of a chess pawn). This will open a new screen with a number of tabs on the top. This is the Asset Browser, which accesses much of what is created outside the editor and placed by the level designer. For now, we just need the tab labeled "Actor Classes."

The PlayerStart Actor

Every map needs a place for the player to start from. To add this to the map, and be able to test it in the game, we need to place an actor called the *PlayerStart*. Using the Actor Classes window that is open, click on the small "+" symbol next to the word *Actor*. This will expand the actor category list. Next expand NavigationPoint by clicking the "+" next to it, and do the same for SmallNavigationPoint. These names may seem obscure, but don't worry, it's not important to understand what they mean for now. You should now see a line that reads *PlayerStart*. Don't expand this. Simply click on the name itself and it should highlight, as in Figure 8.18.

FIGURE 8.18 The PlayerStart actor selected from the actor class browser.

Now that the PlayerStart actor is selected it's easy to place it in our room. In the 3D view, move the cursor over the center of the subtracted cube's "floor" and click the right mouse button. A menu will appear with a number of options. One of these is "Add PlayerStart Here," shown in Figure 8.19.

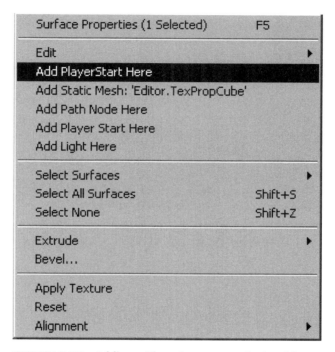

FIGURE 8.19 Adding a PlayerStart sector via the right-click menu.

Click this option to add the PlayerStart actor. The menu should disappear and the screen will show the subtracted room as before, only now with what appears to be a small joystick sprite on the floor (Figure 8.20). This is good—that joystick is the PlayerStart visual representation in the editor. As an invisible actor, it won't appear in the map, but it will tell the engine where to spawn the player when the map is run in the game. Zoom in to the PlayerStart until the room fills the window, and next we'll add some light.

FIGURE 8.20 The PlayerStart actor successfully placed in the room.

Adding Lights

Before we "build" and test the map, we need to place some form of illumination in the room to see by. Placing a light is much easier than placing the starting point. To do so, hold down the "L" key and left-click with the mouse on the floor of the room near the PlayerStart actor. You should see a little lightbulb sprite appear near where you clicked. If it doesn't immediately show up, repeat the procedure again and it will (the editor can be finicky about this sort of thing). Once it's placed, you should have something that looks like the scene in Figure 8.21.

With the light in place, we can build the map. Building is the process of the editor compiling all the information about the map into a digestible form for the engine to run. It also means that all the elements and ingredients in place at the time of building are calculated. For our little level, this means the PlayerStart will become functional and the light will be applied to the room's interior surfaces as a lightmap. There are a number of options for building different aspects of the map individually. All the buttons in the Build icon group control the specific build processes, but the Build All button (highlighted in Figure 8.22) will perform a complete operation, rebuilding the lighting, geometry, and AI paths all at once.

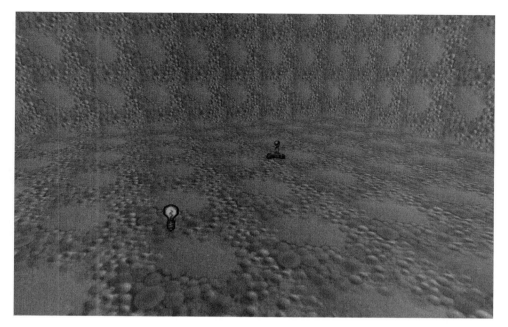

FIGURE 8.21 A Light actor added to the scene.

FIGURE 8.22 The Build All button highlighted.

Press this button now. You will see some progress bars quickly fill up (a map with only one room and one light is built extremely quickly, but full-detail commercial levels can take considerably longer, especially on older editors) and then a window will pop up that looks like Figure 8.23.

The Map Check dialog box shows any errors in the map that the editor detected when building. The only message now should be about a "NULL reference material," which is fine. The editor is just pointing out that you still have the default bubble wrap texture on the walls, which we'll fix in a minute. Close this box and you should see the effects of your build operation. Now, instead of flat green walls you should see the effect of the light you placed in the room (Figure 8.24). The floor will be brighter nearer the light while the corners further away are dark, as are the walls.

FIGURE 8.23 The Map Check dialog window.

FIGURE 8.24 The room after lighting has been applied.

TESTING THE LEVEL

Let's take a minute to actually test the level in the game engine now. This is simple, just a matter of clicking the Play Map button (Figure 8.25) at the top of the screen next to the Build buttons. Clicking this the first time will create a log window that

will generate a lot of text and then the screen will go black momentarily before the game shows up. Don't worry if it takes a few seconds the first time you test the map, the engine needs to create support files the first time it is run.

FIGURE 8.25
The Play Map
button.

Once the level has loaded, you should find your creation there, a bare room with one light. You can use the mouse to "look around" and the W, A, S, and D keys to move around the level. When you're done, press the escape (Esc) key on the keyboard, and select the exit option to return to the editor.

LOADING TEXTURES

Now that you have seen the level closely you probably want to improve the looks of your modest map. Lighting is a good beginning to make a better-looking environment, but another key factor is texturing—applying 2D images to the level surfaces to give them depth and context. To apply texture, we need to load some appropriate textures into the Asset Browser to choose from. Looking to the button group where we selected the Actor Class browser earlier, we can find the Texture Browser button (Figure 8.26).

FIGURE 8.26
The Texture
Browser
button.

Clicking on the button will open the Asset Browser window with the Textures tab selected. There will be a few random images in the main window and the package name, "Editor" appears in a drop-down box above. These aren't suitable for decorating the room, however. In the browser, go to the menu bar and click on File, then select Open. You will need to navigate to the book CD-ROM and find the folder labeled "Demo_Level." In this folder, you will see the texture package file named "Book_Demo_Textures.utx."

ON THE CD

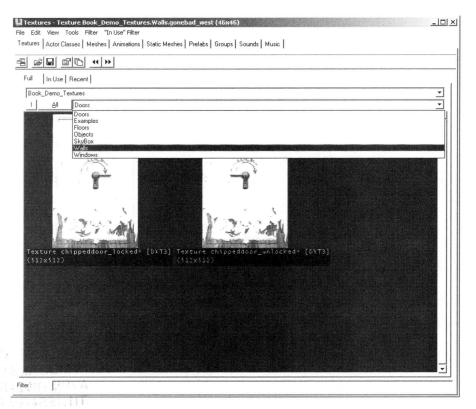

NOTE

The editor requires that assets be saved in "packages," which are collections of files that are grouped together for convenience. You might create a package that contains all the wall textures for your level. Or you might put all the textures for the level into one single (and massive) package.

Click on this file and select Open to load the texture package into the editor. Now you should see some different images in the Texture Browser, two textures that look like doors. Above the images is a drop-down box that simply says "Doors." Click on this and scroll down until you see a line that says "Walls" and click on it (Figure 8.27).

FIGURE 8.27 Selecting the Walls category of the demonstration package.

This will open another part of the texture package, where all the wall images are kept.

All the textures have names listed below them as well as sizes, for example (512 × 512), in pixels. In UnrealEd, textures are by default mapped at a ratio of one pixel to one unit of measurement in the editor—simply called *units*. When we created the sub-tract brush for the room, we made it 1024 units to a side. This means that a 1024 × 1024 texture will fit on a wall perfectly. For a smaller texture, such as the 512 × 512 pixel wall textures open right now, the image would be mapped on a 1024 × 1024 wall four times. This may sound excessively complicated; however, being able to create a working level hull depends on your ability to understand and stick to the game's units of measurement. Let's leave the textures aside for a moment and examine the concept of measurement in a level editor.

UNITS OF MEASUREMENT

First and foremost you will need to agree as a team about what sort of universal units you will measure the game in. Generally, there are two types of units—*real* and *abstract*.

Real measurements in a game follow a system used commonly in the world. For instance, you might build your game environments using meters, or feet, or inches. This is convenient for artists because it allows them to make some general assumptions about the scale and size of objects before you even build the level. Assuming your game is using centimeters as its basic unit of measurement, you can simply go measure a doorway, or look up average door heights on the Internet, to know how high to build it in the game. The problem with real-world measurement schemes is that often they create complex numbers, especially for level designers. If you're building an area using feet, and then need to subdivide into inches (such as 3' 4") when something needs to be between three and four feet, it can get complicated. When you find yourself measuring things in fractions of inches, it can get down-right ugly.

Another disadvantage is that most game textures are made at specific sizes that don't really relate to real measurement. Most textures are measured in pixels, which don't have an exact fixed ratio to any real unit of measurement. Textures also re-quire very specific increases in size. Textures use "power of two" sizes, meaning that a legal texture can only have an edge of 2, 4, 8, 16, 32, 64, 128, and so forth. Each size larger is simply the previous size multiplied by two. Convenient for graphics programmers and Photoshop artists, but it means the bigger the texture the bigger the jump in size, and that can cause headaches when you're creating large spaces in your level.

This is why many teams use abstract measurement units to make things easier for the developers. Because the textures have a specific measurement system, Epic decided to mirror the same unit system in its engine, as we'll find out later in the book. The *Unreal* engine uses the same measurement scheme as the textures, allowing designers to create walls that perfectly match their texture sizes. A wall 256 high will receive a 256 pixel high texture with no squashing or stretching of the image. The advantage of an abstract unit is that it can be customized to the needs of the game. If you need a lot of fine detail in a 3D shooter, you might have a very "granular" system of measurement similar to centimeters or millimeters. If you're making a map for a tile-based game, you might only need to measure by the squares that determine where each piece goes.

Abstract measurement is always a hard concept to explain. Generally, the chess analogy helps illustrate this concept. Chessboards come in many different sizes and shapes, and the actual size of each square in inches or centimeters is actually not important. You can play chess on a board the size of a soccer field, or you can play it on a board the size of a beer mat. What is important is that there are eight squares to a side. The number of squares rather than their actual dimensions in relation to anything except each other is what needs to be calculated when making a chessboard. Thus, you can say that chess uses "squares" as an abstract unit of measurement.

If you don't have a unified measurement system for the game you are building levels for, take it as an early danger sign. On at least one commercial title (that shall remain nameless), every level designer was working with a different measurement system, and all the environments had to be rebuilt later in the project when it became obvious that nothing was a standard size, not even the doorways.

APPLY THE TEXTURE TO THE LEVEL

Now that we've covered the concept of measurement, let's go back to the Texture Browser and select a texture for the walls of the room. What we need is a texture that will tile well across the surface of the BSP brush. This excludes anything with a specific detail on it that will obviously be repeated. A good candidate then, is the texture named "runnergreen." Select it by clicking on the image in the browser. You will know it is selected when its background turns from black to gray. There can only be one texture selected at a time, and when you choose to apply a texture to a surface, or when you build a new brush from the builder, it will use whatever is selected in the browser at the time for the surface texture.

With the texture selected, you can now apply it to the walls of the room. Hold down the Alt button on your keyboard, and use the left mouse button to paint the

wall with the image. It's as easy as that. Go ahead and do the same to the other three walls in the room. You should end up with something that looks like Figure 8.28.

FIGURE 8.28 The room with a proper texture applied to the walls.

Now that the walls are textured, it becomes obvious that the lighting is extremely rough. The first step to fixing this is to place a few more lights and move them to better positions in the room for a more natural, and pleasing, effect.

MOVING ACTORS IN THE LEVEL

Moving actors is similar to moving the camera view around in the environment. First, you need to select the actor you want to move. If you select a piece of geometry like a BSP brush in the wireframe view, it will become brighter than the others. Other actors turn green when selected. You can select more than one actor in the 3D view by holding the Ctrl key and clicking on as many as you want. Deselect any selected actors by pressing Shift + N. Once you have the actor(s) that you want to move selected, there are different mouse button combinations for the 2D and 3D views.

Moving Actors in the 3D View

Move actor on X axis: Move mouse left and right while holding the left button.

Move actor on Y axis: Move mouse left and right while holding the right button.

Move actor on Z axis: Move mouse up and down while holding the left and right buttons.

Moving Actors in the 2D View

Move actor on X and Y: Move mouse in any direction holding the left button.

Try adding another light, in addition to the one already in the room, and moving both to opposite sides of the room, about a third of the way up the wall. As you move the lights, you will see their effect on the surfaces of the level. If a lightbulb icon disappears, it has gone through the wall of the room to the other side. You can switch to a top view if this happens and drag the light back inside the square of the subtract brush. After you are finished, your room should resemble Figure 8.29.

FIGURE 8.29 The room illuminated by two wall lights.

ADDING A STATIC MESH ACTOR

This room is bare. Let's put something in it to give it a sense of scale. In the asset browser, click the tab labeled Static Meshes. Just as you did with the texture package,

ON THE CD

open the "Book_Demo_Staticmesh.usx" file from the CD-ROM in the Demo_Level folder. When the file loads into the browser, it will show a chair in the small 3D preview window. This is the only mesh in this package, and it is pre-selected by the editor. Adding it is the same as adding the PlayerStart—right click on the floor of the room in the 3D view and choose "Add Static Mesh: 'Book_Demo_Staticmesh.Furniture.chair'." Where you clicked, an instance of the chair will appear. If not, click on an area that is fairly clear on all sides and add it again. The editor will not add a static mesh actor somewhere it will not fit. You can rotate the chair on the floor by selecting the Rotate Actor button (Figure 8.30) at the top left of the editor.

FIGURE 8.30
The Rotate
Actor button.

When you are happy with the chair's position, go ahead and rebuild the map. You should end up with something like Figure 8.31.

FIGURE 8.31 A newly placed static mesh chair.

CHANGING THE BUILD PARAMETERS

One thing you may have noticed by now is that the lighting in the map looks good until you rebuild it, and then it looks splotchy and generally bad. That is because the engine is, by default, rendering the lighting at a low quality. You can easily change the quality of the lighting by using the Build Options button (Figure 8.32) in the Build group and changing a few settings in the menu. For now, open the Format settings and select RGB. Then uncheck the box labeled "Dither?"(Figure 8.33) and click the Build to rebuild the map with better lighting.

FIGURE 8.32
The Build
Options
button.

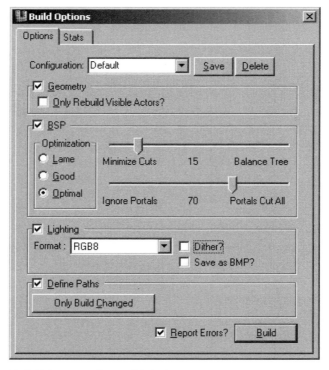

FIGURE 8.33 The Build Options menu.

ADJUSTING AND DUPLICATING BSP

To finish the room, we can make a better floor and ceiling by applying textures to them and removing the last bubble-wrapped surfaces from the map. The only problem remaining is that the ceiling is awfully high, lost in darkness. Also, the texture on the wall is tiling vertically, and looks a little unusual with a second baseboard running around the middle of the room. Let's bring it down to a more normal height by going into the Side view and using the Vertex Editing mode. You can enter this mode by selecting the button to next to the Camera Movement button at the top left of the editor (Figure 8.34).

FIGURE 8.34
The Vertex
Editing mode
button.

In the Side view, we can see the yellow square outline of our room, the chair, and the two lights inside. The first step is to select the brush so it brightens, indicating that it is the active selection. Now we can drag a *selection box* around the top edge of the square. This is done by holding the Ctrl and Alt keys, then clicking *and holding* the left mouse button. Moving the cursor down and to the right should create a box shape that encompasses the upper half of the yellow square (Figure 8.35).

Letting go of the keys and the button will make the selection box disappear, but now there are two white dots at the upper corners of the brush. In fact, there are four of these dots, but without perspective, it looks like only two.

These white dots tell us that the vertices—the four upper corners where the lines of the brush meet, can now be moved. Using the same controls as moving an actor in a 2D view, carefully move the dots down to half the original height of the brush. Make sure that the sides of the brush remain perfectly straight on the background grid (we'll talk more about the grid in a minute), and you will have a scene that looks like Figure 8.36.

FIGURE 8.35 A selection box encompassing the upper vertices of the room.

FIGURE 8.36 The room's height cut in half by lowering the upper vertices.

Rebuild the map and go into the 3D view and you should see a room similar to Figure 8.37.

FIGURE 8.37 The reduced ceiling in the 3D view.

That's it—you made a room from scratch. You lit it, textured it, adjusted the height, and gave it a PlayerStart so it could exist in the game. These humble beginnings are the start of learning a level editor. You may now appreciate the huge amount of time and effort it takes to design and build a full level for a commercial title. Using this editor is a start, but there are many games with many different editing tools available. The more you can expose yourself to new ways of thinking and building, the more robust you will be as a designer. If you are ready to go on, the next chapters of the book will cover the more advanced procedures and theories involved in creating complete levels. If you want to keep using the editor, Go to Epic Games' own *Unreal* engine site (*udn.epicgames.com*) where a complete set of tutorials, from basic to advanced, is available for free.

A FINAL WORD ON GRIDS, SNAPPING, AND CLEAN GEOMETRY

Every computer application where you will be placing separate elements together provides a grid, from low-cost 2D illustration programs to high-end 3D modeling packages. A grid provides a basic way of making sure everything lines up and connects smoothly. Why a grid? Well, for the same reason that you use graph paper when you want to plan a level—it allows you to make sure that all the edges and the corners of things line up. Graph paper allows you to make sure lines and edges are the same length—that the walls of a room are all the same size, for instance. It also allows you to compare sizes easily—a square room that uses four-grid squares is half as big as a square room with an interior composed of eight-grid squares. That's exactly why we use a grid when creating a 3D object or environment; it keeps things neat and tidy and allows us to make quick comparisons and judgments of relative scale and scope. Usually, a grid can be scaled up and down to support smaller and larger objects. It will also support "snapping" where a part of whatever object you have selected will snap to a point on the grid. This allows you to move selected objects around in increments, but still link them correctly to other objects. The editing tools you use will always have a grid of some sort, and taking advantage of it will make your life a lot easier when you are building the level hull.

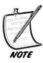

Remember that you can change the "size" of the grid—meaning how many units each grid square represents—by selecting a number from the Grid Size selection box at the bottom center of the editor screen.

In Chapter 6, we covered the concept of polygons and how a polygon was the shape described by a series of points. Each of these points is called a *vertex* (or *vertices* for more than one), and each is a unique point in your virtual space with its own X, Y, and Z coordinates. A quick demonstration of this would be to take a pen and begin dotting your face with pen-marks. Apart from looking like you have bad skin, you will have a bunch of points that represent the boundaries of your face in 3D space. If you took one point, say the tip of your nose, and measured from that point to each dot on your face, you would get a different distance for each. This is how the engine calculates shapes. The point on your nose is called the *origin* and often represents the very center point in the world. By comparing the X, Y, and Z values of a vertex with the origin, the game knows where each vertex is. By adjusting the numbers, the engine can move the vertices around in space, and this is how everything moves and reacts in the game.

This is the also the concept of how 3D objects are made—the vertices are all points on the surface of a model that when connected describe a shape in the world. The line drawn between two vertices is called an *edge,* and when two polygons are put together, their outside edges will describe a four-sided shape.

You can use all of these elements on the grid to make sure everything is flush with its neighbor. UnrealEd works best when all the vertices for BSP brushes are on points of the grid. For instance, if you are creating the walls in the corner of a room you'll want to make sure the edges where the walls meet each other leave no gap—the player might be able to see through it, or the engine may consider the gap an error and cause all manner of problems. For static mesh and terrain, it is less important, but for "clean" building purposes and tidiness, it still makes sense to keep things aligned with the grid as much as possible.

Another important aspect of building on a grid is that art assets or level assets that you import from other people should also be built with the grid in mind. Most modern modeling applications support a "pivot point"—a point around which the model rotates. This pivot point can be used as the part of the model that snaps to a level grid. In this way a modeler knows that if an object needs to sit on the ground—such as a chair—placing the pivot point at the bottom of one of the legs will allow a level designer to quickly line it up correctly at floor-level using the grid.

Some game editors keep all the various parts of the map separate (what we discussed as BSP brushes) but snapped together to *look* like seamless surfaces and corners. Other programs, especially high-end modeling packages such as Maya, allow you to actually *weld* vertices together to join them permanently. In this way, you can place the floor, walls, and ceiling of a room into a level as separate squares in their basic positions relative to each other, and then weld the three vertices at each corner so that the six squares are now joined to make a sealed cube.

Generally, however, when you're making your level you won't be welding verts, you'll be snapping them together to make it look like everything is really joined up. The player doesn't know the difference, if your artists have provided you with clean-snapping level elements and you have placed them correctly.

If you learn to just place objects and build the maps by "feel" it will be harder to break the habit and learn to build everything correctly on a grid. The ability to build "clean geometry" is one of the basic abilities all level designers should have, and this is often the difference between an amateur map and a professionally built game level.

SUMMARY

This chapter gave a brief overview of how to create a simple environment in the *Unreal* engine's level editor UnrealEd. The basic elements of a 3D space were created—the space itself first was made out of BSP, then a starting point was added for testing, two lights for ambience, textures for context, and a prop for scale. These elements provide a foundation for the next chapters, which will explain the process of designing, documenting, and building a professional level from start to finish.

9 Building the Level Part 1: Basic Building Techniques

In This Chapter

- Restrain Yourself
- The Difference Between 2D and 3D Levels
- The Whitebox Process
- Whiteboxing the Level Hull
- Popular Level Building Approaches
- Customizing Your Building Process
- Optimization Techniques
- Test Your Work Constantly
- Summary
- An Interview with Lee Perry of Epic Games

Seeing your two-dimensional paper design take shape into a fully realized environment is one of the most fun parts of being a level designer.

There are as many techniques and tricks to building game spaces as there are level designers. This chapter will outline some of the most useful techniques for you to use when the time comes to go from design to implementation. As you go on to build each level, remember that you are engaging in a creative endeavor—there's no *right* way to create a fun experience, there are always choices to be made and options to be weighed. Some will be right the first time and some you'll need to go back and fix. Your vision will come from your experience, instinct, and your talent for making great spaces. Learn from your mistakes. It's a different process every time, and making a mistake when building a part of your map just means you have a chance to make it twice as good.

In this chapter, we will cover a lot of ground. We will go over the different ways to build the level, and the sort of information and tools you will need to construct the basic level structure. Specifically, we will also cover the part of initial level building we often call *blocking, roughing,* or more commonly, *whiteboxing.* It's the process of creating the level to see how it feels to play, without worrying too much about how it will look. Whiteboxing is a term borrowed from stage design and architecture, where a designer builds a mock-up of a project using plain white materials. For level design, it simply means making the basic space, without all the bells and whistles of fancy textures, lighting, or final decorative models.

The chapter will also cover two common ways to approach the construction of your level, creating functional geometry first and adding the "icing" to it later.

RESTRAIN YOURSELF

At this stage in production, level designers are champing at the bit to jump into an editor or modeling program and begin building the level. You may see clearly how the level will start, you might even think you have a perfect idea of how the entire level is going to be. The planning is done, the documentation finalized, and the vision of the level is burning an image in their brains. But it is important not to tackle everything at once—simply building a bunch of rooms, throwing textures on the walls and floors, and placing lights all at once is rarely the recipe for a successful level, especially if you end up realizing you need to make a room bigger to fit a puzzle, or that your corridors are too narrow for the enemy soldiers to fit through. You need to first build a functional space, and then you can add the gameplay and decorative elements, test and tune your creation, and finally polish it for delivery. In level design, form follows functionality for the most part—remember that even a great-looking level will soon grate on the player if it's not fun to play.

At the start of this book, *level* was defined as "a container for gameplay." Now is the time to build the container—you can worry about decorating it later.

THE DIFFERENCE BETWEEN 2D AND 3D LEVELS

At this point we reach a critical junction. Until now, it hasn't really mattered if your game is a 2D side-scrolling action shooter, a 3D role-playing game, or even a text adventure. Design and planning is a universal requirement, no matter what genre or platform you are making your level for.

Implementation, on the other hand, is going to differ based on several factors—the type of game, the number of people on the team, the pipeline, and more. A fundamental difference in approach results from whether you are building a 2D or 3D level. Generally, the biggest difference is in realism. 3D levels are built with an element of realism in mind—even those that set out to be stylized. This means that close attention needs to be paid to texturing, lighting, and making sure everything works in three dimensions. Even a game like *Legend of Zelda: The Wind Waker* that goes to great lengths to keep a "Saturday morning cartoon" look uses very complex lighting techniques and the element of 3D space to create vertical drops, high mountain peaks, and vast ocean panoramas.

A 2D game, however, is limited by depth—the most noticeable limitation for this is the game camera through which the player sees the world. In a 3D game, you can generally move the camera on three axes—sideways, up and down, and *into* and *out of* the screen. A 2D game allows the player to only see one side of the game world at a time—from the side, from the top, or from the back of the main character. Think of any 2D game, such as *Super Mario World* or *R-Type*. In these cases, the

camera is set at a fixed axis and distance from the player's avatar and the environment. Some games even try to mimic a 3D camera, such as *Warcraft 2*. However, these sorts of games use an *isometric* viewpoint to simulate the look of three-dimensionality. The characters are still just flat sprites on screen that are limited to being viewed from only a few set angles—it's still not a real 3D game. Some 2D games have tried to include limited movement into and out of the screen. *Oddworld: Abe's Oddysee,* for example, allowed the player to use occasional doorways to move between the foreground and the background. Though it was a nice visual effect, it wasn't vastly different. Beyond these gimmicks, 2D games are mostly relegated to flat levels that the player only sees part of at once time, with the camera scrolling around in the direction of movement.

Instead of creating surfaces, applying textures, and then placing simulated lights to create dramatic lighting, 2D levels are often large background paintings drawn as flat graphic pieces that are snapped together edge-to-edge to create a linear environment. Items that the player interacts with, such as platforms, enemies, or switches, are placed on top of this background to create the parts of the level the player can use to progress. Light effects and textures are painted directly onto the level background. In this respect, the next few chapters about building your level are more focused on making 3D maps, especially the information dealing with the visuals of lighting, texturing, and placing decorative meshes. Although 2D games are still being made, they are becoming much less common for commercial release. Even game genres traditionally founded on 2D levels, such as RTS or adventure games, are now using 3D environments.

THE WHITEBOX PROCESS

In level design, the *functional construction* is the level "hull" or the basic geometry needed to create a space for the gameplay to happen in. The simple definition of a whitebox level is one where the only visuals are those needed to test the gameplay—basic rooms and spaces, a few lights thrown in, and one or two textures (Figure 9.1).

The reason for thorough whiteboxing is that levels are primarily about the user's gameplay experience. By waiting on the decorative or visual parts, the level designer builds the functional parts of the map—keeping the level down to the basic components needed to be able to play it and evaluate whether it's fun, or if there are any glaring problems with the design that won't be noticeable until you start to build it. Even more importantly, having a whitebox level allows you to test it, or get others to test it, and work out design problems, modifications, or simply areas that need to be cut, before you spend any time decorating, or requesting art assets from the art team.

FIGURE 9.1 A whiteboxed area of a level.

In a game I was designing levels for, I created several puzzles that required the player to jump across platforms that would fall a few seconds after the player landed on them. The puzzles looked good on paper, but when production started, we noticed it was very hard to predict where the player was going to land—a mixture of the game camera's restrictions and little "air control" (air control is the control a player has over his character while in the air after jumping—can you jump forward and then end up moving behind where you started by holding the reverse button? That's air control!) meant that the platforms would need to be a great deal bigger so the player could land on them successfully. Luckily, the level was just whiteboxed—the platforms were simply mock-up geometry at this stage and the room was bare except for the pit the player needed to jump across. The artists modeled larger platforms and the pit was made wider to keep the difficulty level consistent. If I had already had the artists build actual finished models for the platforms, and I had decorated and lit the room already, I would have had a lot more work to implement the changes when we discovered them. The artists would have had to go back and create new models, as well as reapply the textures, and I would have had to expand the room to encompass the new pit, then repair the textures, lighting, and prop placement around the new room.

The process in which you build your map will show the hierarchy of elements in the average level. In order of importance, to build a finished level you will need to add the following:

1. **The Level Hull,** or the basic geometry of your map that allows the player to navigate from end to end. This is basically walls, floors, and ceilings, outdoor terrain, doorways, stairs and elevators, walkways, and the like. This is most of what we'll be reviewing. Whiteboxing also includes basic optimization. We'll go over this aspect of level design later in the chapter, but optimization is one of those tasks that never seem to go away—you should constantly look for better ways to improve the performance of your level, through all phases of building.

2. **Gameplay elements** that will create all the interactive encounters in the level, such as enemies and the navigation networks they will use, switches, puzzles, items and upgrades, traps, and important secret or hidden areas. If the player needs pillars to shoot from behind, add them, otherwise those elements are considered props and can go in at stage 3. This phase also includes the scripting you need to do to give life to the NPCs and environment, and to set up interactive sequences and encounters.

3. **Decorative elements** that will set the mood and atmosphere of the map, as well as complement and enhance the gameplay. This covers textures; lights and special effects; props such as columns, railings, door frames, and trees; interactive decorations such as breakable glass or exploding barrels; pedestrians; mood pieces; and sound effects and music. You can add scripted events here that aren't necessary for the level to work—bonus encounters, overheard conversations that give the player clues about the unfolding storyline, little scenes to enhance the mood or scare the player, and so on.

4. **Polish items** such as nonessential secret areas, additional props or audio elements, and the like all go in last. Generally, this stage is strictly governed by how much time and memory you have left to work with after you've finished the previous phases completely. Don't be fooled into thinking this phase is unimportant, however. Many of the best-received games were popular because of the high degree of polish their levels showed. Schedule polish time in whenever you can.

WHITEBOXING THE LEVEL HULL

The level hull is your responsibility and determines the important factors in the level, such as flow, rhythm, difficulty, and ergonomics. Even more important, it determines the *quality of the player's experience.* This is essential to remember. Before

you start to think about how a level is going to look, you need to make sure your building is up to code. Just like a house that's built with bad materials, if you don't take care to make sure you build good geometry, the player might find the game collapsing around him. To build an enjoyable level you must address the following:

- The *scale* of the level elements
- The *volume* of the spaces
- The *quality* of the construction

Scale

When creating game environments, scale is a loose concept at best. The scale of your level will need to change depending on several factors. In a third-person game, the distance between the camera and the player avatar will make things in the world look smaller. Games are generally played on a 2D screen, and humans are used to having natural 3D vision. This means that the sense of scale in a game often comes from comparing things with each other, or comparing the avatar with a piece of the world, to work out general sizing and distance.

Scale Problems in Third-Person Titles

First-person games are a little bit easier to design levels for because the camera simulates seeing the world from the eyes of the avatar, meaning that when something is higher than the avatar you can't see on top of it, when it's lower than the height of our eyes, we can. For a third-person camera, we can't use these visual tools. Even though we, the player, can see on top of a box, because the camera we are seeing the game from is floating above the main character's head it might still be higher than the avatar's eyes if we were to see from that point of view. The higher and further back a camera is from the avatar, the more confusing it becomes. This also means we can see over obstacles or around corners that the player's character cannot, which can give the player an advantage in the game whether you want it or not, shown in Figure 9.2.

To deal with problems like this, a level designer needs to be able to scale the level to suit the game's needs, by instinct rather than mathematically. It is very important not to fall into the trap of trying to scale everything realistically. This will almost never work because a game character has elements that will affect movement through a virtual space more than a real person has moving through an actual building. For instance, most engines use simplified methods to determine if a game actor is colliding with parts of the world. Even though the player avatar may visually look like she can move through a doorway, the actual invisible structures—the collision mesh—that calculates this may prevent it, causing no end of player frustration as the character refuses to enter what appears to be a legitimate opening.

FIGURE 9.2 An obstacle as seen from first- and third-person views.

Likewise, when creating a top-down 3D game, creating things in the world to scale may simply take up too much of the screen. If you're controlling a tank, and you scale everything in your level realistically from the tank's real-life measurements, it may end up that a single house takes up half of the camera's view. In this case, you may need to make everything in the world a little smaller to allow the player to maneuver around the spaces. Figure 9.3 shows an example of scaling common in an RTS ,where many of the buildings are scaled smaller than the vehicles the player is controlling, which in turn are scaled differently than the human characters. However, having an accurate scaling is much less important to the gameplay than fitting as much as possible onto the screen without having a camera so far back it's impossible to click on a single tank.

FIGURE 9.3 Scaling example common for a Real-Time Strategy game.

Scale is secondary to ergonomics. Remember that you are the world's most knowledgeable expert on your own levels. It's especially important to remember this in areas such as scale where you may be tempted to think a level is playable simply because *you* can complete it. When you're testing your level, you probably aren't trying to see how easy it is to get stuck on pieces of geometry. Try playing with your other hand, or have a co-worker who isn't a level designer play your map. Often you'll notice that others get stuck in areas or have trouble getting through doors or corridors that you don't because they aren't aware of the best way through. If you suspect that this is the case, you probably need to scale these spaces up, to make sure your players don't get stuck either.

SIDEBAR

Frank is building the ever-present sewer level for a FPS. He does his research and finds out that the sewer system in the area of the world in which the level is set uses conduits barely big enough to fit a small adult. He faithfully re-creates this system of narrow tunnels in his map, being as close as possible to the real-life dimensions of the sewers. He runs through a few times from end to end, and the player avatar just fits, creating the kind of cramped, claustrophobic atmosphere he wanted. Pleased, he sends it to the QA department for initial testing. An hour later, he gets a phone call from one of the testers:

"Frank, what the heck were you thinking? These sewers look great, but they're so narrow I can't turn around when I have a gun in my hand! The collision on the main character expands to encompass the gun so that it won't go through walls. Every time I get into a fight I get backed into a corner and die—did you even play this thing? No player is going to get past this level unless you widen all of the passages."

The rule of thumb here is that players are more willing to forgive slight exaggerations in scale—whether it be increased or decreased—if it allows them to play the game more easily. You can be sure that a map that is perfectly to scale with the avatar isn't going to win over a reviewer if he can't get through a door without resorting to a cheat code.

Volume

Related to scale is *volume.* In this case, *volume* refers to the amount of space you actually create rather than how much you really need for the final area, or, more important, how much you will be able to fill until a room stops looking empty or flat and starts looking real. For instance, when fleshing out your design as basic geometry, you may realize that a space simply looks too big. It may also be tempting to just bring in the walls and lower the roof to make it seem like a more realistic space for what the function of the space will be. However, if you don't consider fully how many decorative models will be added later, how many characters will need to move in the space, how big the textures will be for the walls and floor, and so on, you may be making a mistake that you will need to address later, when you don't really have the time. The concept of measuring volume is a tough one to illustrate clearly. Even in real life, volume is incredibly difficult to estimate by sight alone. If someone showed you a cardboard box, you could probably guess how much it would hold by example—it might be refrigerator-sized. But actually determining the exact volume in units of measurement is much harder. Unfortunately, many of the people creating assets for your level are working on exact measurements and may be justifiably irate when you play with the numbers of your level without letting them know first.

SIDEBAR

In another fictional example, Ben is creating a medieval town map for a brand new first-person murder-mystery shooter. During whiteboxing, he is irritated by how empty and huge the interior of the town's church feels when he playtests his work. Bringing the walls in makes it feel a little better, and he continues building the surrounding town structures based on the new measurement of the church.

A week later he gets an annoyed call from Linda, the modeler tasked with decorating the map Ben has handed off to her. She reminds him that his original documentation called for a much larger church interior, and that the props she has made don't fit properly any longer. As a result all the ambient characters are getting stuck in the aisle and between rows of benches, and either Ben or Linda is facing a few long days of rework.

Sometimes, however, you will feel that the areas you are working on don't seem big enough, or impressive enough, and you are tempted to enlarge them to make a more imposing atmosphere. This is also jumping the gun, and not allowing yourself or the artists' time to achieve atmosphere through aesthetic means. A small space can be made impressive or grand by lighting and texturing, or special effects like fogging and reflectivity. Size, as they say, is not everything.

This is not to say that you shouldn't use your instincts while building a level's basic spaces, but you should always keep in your mind a mental image of everything that needs to go into the map. When you feel the urge to mess with the dimensions of a room or a hillside, make sure you know why you want to change it. Changes in the functional phase of level design can cause repercussions all the way down the line if you aren't careful to communicate your decisions.

Quality

It may strike you as premature to talk about the quality of construction when you're dealing with the skeleton of a level. On the other hand, not only are you setting a precedent when you build the functional geometry, you're building a foundation on which everything will be built. The best materials money can buy won't save a house built on a rotten foundation. It makes sense then to build the hull of your level as stable and sound as possible when you begin.

The process that you use to make your basic level architecture will depend a lot on the tools you will be using. If you use a BSP-based editor, you'll use brushes or geometric primitives to carve the hull of the map. If you use a modeling package, you might be using more complex means, moving faces and vertices in a more organic manner.

Either way, there are ways of keeping your work tidy. Allowing small overlaps of shapes, floating vertices, or duplicating objects on top of each other can create visual artifacts and in many cases affect the performance of the level or stability of the map, crashing the game when the player enters an improperly built area. Every engine is different but some common examples of bad geometry include the following:

- Z-fighting
- Floating geometry
- Structural holes
- Complex shapes

Z-fighting

The "Z" in Z-fighting, also known as Z-buffer fighting, refers to the depth or distance between a surface in the level and the game camera—the distance on the Z axis. When two or more surfaces overlap, 3D engines often don't know which one is meant to be "on top," and so it tries to draw both simultaneously. This results in

an annoying flickering or saw-tooth effect as the different surfaces compete to be seen, as in Figure 9.4.

FIGURE 9.4 An example of Z-fighting.

Occasionally you might have surfaces that are very near each other, but not sharing the same space. In some game engines, this can result in flickering when seen from a certain angle or distance. These sorts of problems often show up later in the testing phase when a lot of people are playing through the map; however, it pays to take some time and walk through your map after long periods of construction to see if you can spot special-case glitches.

Luckily, these problems can often be caught by error-checking map tools. Most editing technology will warn you when two objects are overlapping, or occupying the same space, either automatically or when initiated by the designer. Unlike more general problems, checking the locations and size of objects in the environment for errors is easy for a computer to do.

Floating Geometry

Being able to work in virtual space has amazing benefits. One of these is that most level designers don't need to worry about the influence of gravity until the game is actually running (unless they wish to specifically see the effects in the editor). Often, elements in a map that would be attached to things in real life, are placed as floating objects in a game. For instance, a fire extinguisher in a level is placed flush against the wall in a level to give the appearance that it is bolted there, when in fact it's just hanging there—with the player never being the wiser. However, this leads to a very common problem in 3D maps—elements in the environment that seem to hover unnaturally just above the floor, walls that don't quite reach the ceilings, or windows that float a foot away from the walls they are meant to be set in, such as in Figure 9.5.

FIGURE 9.5 A window detached from the wall.

Detached architecture like this is usually is a simple mistake. Frequently, the viewpoint you have in your editing tools can affect how often you misplace something. A top-down view can't show object's heights above each other. And although

the window in Figure 9.5 is obviously floating from a side view, everything seems normal from straight ahead (Figure 9.6). Not only does this look bad, and remind the player that he's looking at an artificial environment, it can also cause problems where the avatar or game characters might get stuck in small, unseen gaps between props, and so on.

FIGURE 9.6 The same window, from the front.

Floating geometry is a tricky problem for designers. Often people besides you who notice it may not mention it, assuming you know, and have plans for the objects in questions. Other people may play through without noticing it themselves, which can happen if the gap is in an awkward place to see. This is why in many levels, you can crouch or lower the camera to discover all manner of furniture or props levitating above the floor.

It's also tricky to build tools to detect these problems when they happen or at compile time. In general, most objects need to be touching at least one other object in the level. Very few things exist that can defy gravity—and most of those are flying

vehicles or creatures that aren't part of a level decoration. That being said, a light switch needs to connect to a wall, not the floor. A chandelier needs to be attached overhead to a ceiling or a beam, not a wall. Detecting what object needs to be fixed to what plane or neighboring prop is probably too hard to calculate automatically. If your engine warns you about disconnected elements, that's a big help, but human vigilance is always your best ally when making sure your geometry is tight.

Structural Holes

A generic sort of problem with many engines is the appearance of holes or corrupted surfaces in the level when geometry is created incorrectly. These unstable areas can have two common manifestations for the player—those problems that simply affect it visually and those problems that affect the stability of the map.

Visual Problems

Commonly called a Hall of Mirrors (or HOM), a hole can appear on a face or over several surfaces, through which the player can see either what's behind it, or a blurry strobing mess if nothing exists on the other side. On larger surfaces, it is obvious that there's something wrong, but it's easier to overlook small holes when the surface that has a hole is in deep shadow.

In some engines, the editing tools may not show a hole in the geometry; you must be in the game with everything running in real time to spot them. Commonly, you'll get testers notifying you about "corrupted graphics" when holes occur.

Stability Problems

Sometimes a hole can occur as a more serious problem than a funky-looking wall. Depending on the technology used, and the severity of the corruption, holes can cause collision problems, freeze actors that try to move through the area, or in extreme cases, crash the game. These are results of the game engine trying to deal with the bad geometry and failing.

These surfaces can be visual, which makes them easier to track down, or they can look perfectly normal on the surface, which means you (or the testers) will notice them only when the problem occurs. Tracking down an area of corrupted geometry that is crashing the game can be difficult, requiring that you run through it several times until you get consistent results of where the problem begins, at which point you can take steps to correct it.

Fixing holes in a map is usually a matter of tracking down the bad geometry that's causing them. For some editors, this is easy. In BSP-based maps, the designer can see the cuts made by the various primitives used to create the level and follow the cutlines (the lines where the BSP is automatically cut by the engine for optimization purposes) from the hole to where the conflict or corruption occurs. In

other applications, such as Maya, the designer may need to zoom in closely to the problem area and see if he can identify the cause—it may simply be a vertex that isn't welded to the rest of the geometry, or it might be a face that is inverted. If in doubt, simply rebuilding that section of the map is always an alternative to the detective work of solving the engine's issue with what you have constructed.

Complex Shapes

Overly complex geometry tends to be a problem like those mentioned above, rather than be a problem itself. However, it is a factor in the quality of a level construction too, even if it isn't halting gameplay. Complex shapes with curves or faceted surfaces can often slow down or cause problems in game engines that rely on simple shapes to perform well. It is also a healthy habit to step back sometimes and see if you are making things complex when the player won't know the difference in the final level. In Figure 9.7, you can see a simple door as basic geometry, and the same door textured. The texture actually handles most of the detail—the geometry just needs to be a rectangular hole in the wall allowing the player through.

FIGURE 9.7 A simple door as flat geometry versus textured.

It can be similarly tempting to assume your level isn't detailed enough when you're looking at it as geometry without any texturing or lighting. When does a shape go from being fine to being too complex? That's something determined by factors such as the polygon limitations of your game, the complexity of the geometry around it, and the expense of other map elements you will be adding later.

Make sure you use good judgment when creating your geometry, but don't short-change yourself on areas that need polygons, such as curved surfaces, bevels or pipes, that might require more complexity of form to look as realistic as possible.

POPULAR LEVEL BUILDING APPROACHES

We've gone over the concept of whiteboxing and paying attention to the functionality of your map before you begin actually decorating it. Now we can talk about ways to approach putting together the basic map structure.

No matter what environment you will be building your level in, it's likely that you will have access to all the tools you need to put together a finished map. Modern level editors and 3D art applications contain all the methods of building, editing, decorating, testing, and releasing your work as a finished level. The problem is that it is tempting to start using all of them at once. In this section, we'll look at two common, but very different methods of building a level from start to finish. We can call these the *section* and *layer* techniques. A level is really made up of several distinct ingredients—the basic geometry, the decorative geometry, the lights, the textures, the navigation paths, and so on. "Sectional building" is where you will create you level in a series of completed chunks, adding a little of each building phase to the mix at a time. "Layer building" is where you will add most of one phase, then the next, and so on, building your level in passes, from start to finish each time.

Building Your Level in Sections

If your level is quite large, or you really don't have the attention span to build the basic structure of your map without stopping every now and again to decorate key areas, then sectional building is probably your preferred method for level building. For smaller levels, it may not be as productive to build in this manner.

Look at your design and see if you can break it up into separate areas that can be tackled one at a time. Start by building the first few sections as basic whiteboxes. Create the functional geometry, add in the gameplay elements that you need; if there are puzzles, place them in the level, or if there are patrolling enemies, set up their routes and place the enemy characters where they need to go. You're making sure that all of the gameplay is in place enough that you can make sure the first section plays as it should. Now you can begin to place textures and lights in this section, building the decorative elements to a more finished product. At this stage, you may only have a small portion of the art assets you need for the finished level, but you can always go back and replace some elements with their finished forms, or leave room for objects to come later. If some sound assets are ready to go in, you can think about placing those as well. Whatever hits you about the first few sections

you've built—changes that need to be made, places that seem perfect for secret passages or chambers, new encounters you hadn't thought of before—add them in. You're basically trying to get this section of the level as finished as possible before moving on.

Once you're happy with the section, move on to the next area and repeat the same process: get the structure built, the gameplay set up, textures and lighting applied, and then move on. Figure 9.8 shows the workflow for sectional building.

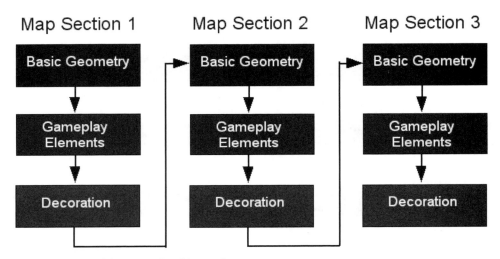

FIGURE 9.8 Building your level in sections.

Advantages

Building by section gives you the ability to have a relatively finished map at any stage of production, even if it's only half of the actual level. If you're only 50% done and your lead comes and tells you the game needs to ship early and you only have five days left, you can probably stop where you are and use the remaining time to create a new ending and polish up the map. It also allows you to build on and fine-tune the visuals as you work. If you realize the neo-Mayan theme you've chosen needs all the rooms to be bigger, you can adjust the current section and build the rest of the level hull accordingly. It will also allow you to quickly build a full prototype of your map for the team to see, with examples of gameplay, architecture, lighting, decoration, and general atmosphere early in the process.

Sectional building is also ideal for creative types who need to jump around from area to area to keep their concentration.

Disadvantages

Sectional building can be problematic because it means you are skipping the pipeline too much. By starting to place decorative models and textures early in the map's production, you may only have a fraction of what the art team has been able to create. This means you will often be going back to previous sections and adding any new art assets that have become available since you last visited. This process is chaotic and can lead to areas that are neglected for a long time, or to the level designer focusing too much attention on one area of the map.

Building in Layers

An alternative to sectional building is to use the layer system (Figure 9.9). In this case, instead of breaking up the level into manageable chunks that you will work in completely, it involves going through the level, from start to end, in a series of passes or layers that represent the "phases of construction" explained previously. Start by building out the level's hull completely, or as best you can given everything you know at the start of production, from beginning to end, creating all the spaces you need for the gameplay to happen. It's not important to address truly secondary elements like secret areas or purely decorative spaces like areas outside of windows that are just there to give the player a view.

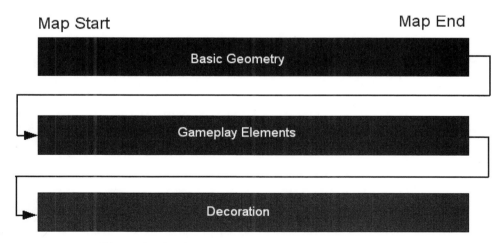

FIGURE 9.9 Building a level in layers.

When the level hull is laid out, you should be able to navigate completely (barring areas that require a puzzle to be solved, or a scripted event to happen). At this stage, you might be able to export your level data out to the art team who can begin

working on props and textures with a much better idea of what's needed and the specific sizes and areas involved in your level.

Now that the hull is done you can go back to the beginning of map and work on the gameplay layer. Implement your puzzles, encounters, and triggers. Drop items in and create temporary geometry for critical decorative pieces that don't exist yet, like a table the player needs to jump up onto to access a vent. Put in the NPCs that will populate your map, add the navigation elements that will allow them to move about the map. Set up patrols and scripted sequences. This phase is about creating the gameplay and seeing how it works before you put any substantial time or effort into decorating. Once your gameplay layer is complete, you should have a pretty good whitebox to test your level with, and to allow other people to play and review how it feels. Naturally, you will be missing most of the visuals so you won't be able to impart the atmosphere of your level to others yet, but the important part—if it's fun or not—can be seen and problems corrected quickly. Test, review, and update.

Once you are confident that the map is playing as you want it, you can go on to the third layer, the addition of visual and atmospheric elements. By this time, most of your level's assets have been created and made available to you by the artists. The decorative layer should just be about making your level's mood and aesthetics fit the chosen theme, as well as adding features that enhance the visual quality of your gameplay. Change your ugly placeholder water textures to the beautiful, rippling materials your texture artists have made. Replace your BSP cars with the final static mesh equivalents.

Advantages

The major advantage of building up your level in beginning-to-end layers is that the people supporting your map time have time to do their work. By concentrating on the basic hull geometry and gameplay mechanics, you allow the modelers and texture artists to create the assets you'll need by the time you are ready to decorate. It also allows you to test the level's gameplay earlier and more completely than sectional building does, which in turn allows you to determine how fun it is, what sort of things you need to fix, and in general, how well the level does in meeting the goals set for it at pre-production.

Disadvantages

You may ask yourself "why wouldn't I bother to create my level in layers? It seems like it has the more advantages overall." This is technically true; however, the human factor can't be ignored. It is a very hard thing to concentrate solely on one task for weeks at a time, which is what layer-building requires. To avoid burning out or becoming so involved in one single process that you begin to lose sight of what you are doing, you'll want to switch between tasks just to give yourself a breather. Honestly, it's no fun to have to create untextured, visually uninteresting whitebox geometry

day after day. The urge to decorate a room and use all the fantastic art assets that have been building up in your level's folder on the server will be high. This is one benefit of sectional building—it allows the level designer to maintain enthusiasm and keep a fresh perspective on the different aspects of the map.

Another disadvantage is that, using the example again of your game's deadline suddenly being shortened by several months, by building in layers you might suddenly need to ship a level that has all the gameplay done, but none of the map decorated at all. Sectional building allows you to try to cut off the level at the point you were building, but with a layer-built map you will need to accelerate the remaining phases to get the map finished—there's no good point to cut the decoration process if all the hull and gameplay is done.

CUSTOMIZING YOUR BUILDING PROCESS

The examples outlined in the previous section were two very common and different ways in which level designers work. These are by no means, however, the only ways to approach building your level. As we examined in Chapter 3, there are many different approaches to building levels and missions for a game. These examples contain general techniques to help you; however, the best way for you to build your levels is just that—your own. Find a system that works for you. Maybe you are able to work better by concentrating on each task one by one until your work is done, working down through a list of objectives for your level. Perhaps you keep yourself interested by flitting from one area to another on an hourly basis. You are confined somewhat by the pipeline your team uses, by the power of the tools you are using, and by how much design and documentation you started with. In the end, however, level design is an iterative, creative, and often personal endeavor, so find the method of working that allows you to produce the best results and modify it to whatever demands your team setup imposes.

OPTIMIZATION TECHNIQUES

Although optimization is not always a "phase" of building your level, you must always keep the performance of your map in mind as you work through the stages of creating your work. Optimization and keeping the frame rate high in your level will mean not only designing with the available optimization techniques of your engine, but also keeping an eye on how much geometry you are using in a given area, as well as how many textures and lights you are placing. These all contribute to the overall workload of the processor and part of your job is to make sure your level never bogs down the machine it is playing on. A single game level might contain a staggering amount of data. Forcing the machine to cope with rendering all this is out of the question.

If you are lucky, your engine is intelligent enough to know when a wall cannot be seen through and won't render what is on the other side. This is not usually the case, however, because having the engine constantly trying to calculate the occlusion or how each surface of the level will hide what's behind it, would take enormous energy. Most game engines require that the level designer manually tell the engine what should or should not be seen as the player moves through the level. At the very least, the designer often has to give the engine hints about what the player needs to see or not in certain areas of the map. Let's now look at common ways to keep performance high in your level:

- Zones and portals
- Occlusion objects
- Spawners

Zones and Portals

Many games allow level designers to break their maps into smaller sections that get shown to the player only when the engine determines he should actually be able to see them. These areas are called *sectors* or *zones*. The basic theory behind a zone is that the level designer tries to divide up whatever map he is making into largest number of sections that visually divide each other from the rest of the map. At runtime, the engine then turns zones on and off based on data that gets generated automatically when the level designer compiles the map, such as what zones need to be visible from every point in the map, and what direction the player character is facing, as in Figure 9.10.

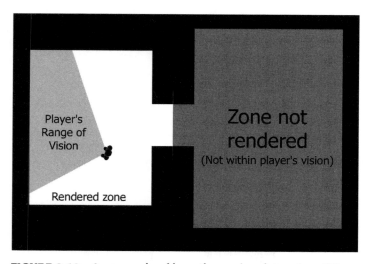

FIGURE 9.10 An example of how the engine determines if it needs to render a zone or not based on the avatar's location and the direction it is facing.

The theory of sectoring your map can be confusing but it is really a very simple concept. Two rooms, A and B, on either side of a doorway can be flagged in the engine as different zones. When the player stands in room A and looks through the doorway into room B, both rooms need to be visible. However, when the player turns the character around and the doorway is no longer visible on the screen, room B stops being rendered because the engine knows that

a. It is a separate zone, and thus, it doesn't need to be on all the time.
b. The player can't see it anyway.

The same would go for the player standing in Room B and looking through the doorway—Room A is visible and the engine is rendering everything in it. Once the player turns the game camera away from the door, room A disappears. Simple but effective.

The system of using "S-corridors" also takes advantage of zoning. If you separate two zones with a transition zone shaped so that the player cannot possibly see the zones on either end, like a right-angle corridor or s-shaped tunnel, you can be sure those separated zones will never be rendered at the same time.

How you break up your level will differ depending on what engine you work with. The *Unreal* engine uses the concept of "zone portals" to literally seal off different parts of the level into zones. The level designer places special sheets, called "portals," of geometry that fit snugly into doorways, vents, open windows, or chimneys, etc., essentially making that section of the map airtight, and the game engine knows from this that the area sealed in by the portals is a separate zone from the rest of the level.

Using the previous example, to build rooms A and B in UnrealEd as separate zones, you would first create the geometry of both rooms and the doorway between them. Then, adding the portal sheet into the doorway will mean that the next time you rebuild your map, the rooms will be different zones.

TIP

You can see how many different zones your map is divided into in UnrealEd by clicking on the Zone View button in a viewport, as seen in Figure 9.11. This will show the level in 3D with each zone in a different color. Be careful, though, the engine randomly determines the color of each zone and if your map has a lot of them, sometimes two zones can be very similar colors, making it seem like your portals between them aren't working.

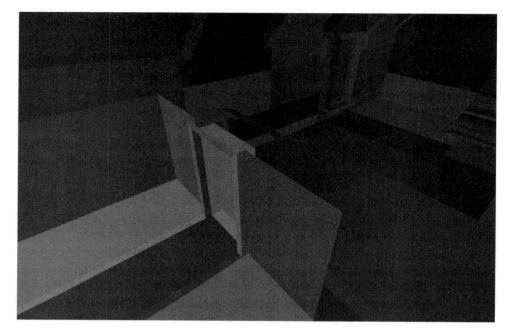

FIGURE 9.11 The Zone View in UnrealEd. Each color represents a different zone.

Sometimes, your engine won't do as much work as you would like. When working as a level designer on a project, we had to build all the maps in a commercial modeling and animation program, with no real editor to speak of. To break the level into zones, we needed to group all the geometry where the zone was meant to be, and then link it to a dummy object elsewhere in the map. The engine would look for the dummy objects, and then know what each zone contained by following the links from dummy to level geometry. Then, in another program, the level designer manually told the engine which zone was visible from every other zone—a visibility web. Sound tedious? It was, and often led to mistakes and late-night rework. Thankfully, the level design tools generally available today are much more user-friendly and powerful when it comes to zoning.

Occlusion Objects

Zoning is a very fast and easy way to optimize your map in general. However, you will find that sometimes it is either impossible or undesirable to use zones, especially in outdoor areas where sealing off the outside environment is difficult. Another technique can be used in these cases, often in *addition* to zoning, with objects known as *occlusion objects* or simply *occluders*. Occluders are objects that tell the engine not to render *anything* that blocks the player from seeing it, as in Figure 9.12.

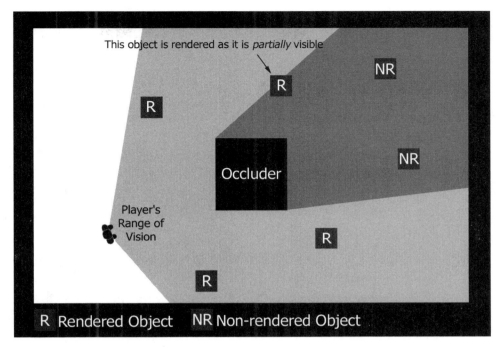

FIGURE 9.12 An occlusion object and how it tells the engine what part of the level doesn't need to be rendered based on the position of the player character.

Occluders should be placed after you have zoned the map. Consider them the second tier in the three-tier system of optimization, with zone sectoring being the most important, and occluders coming after. In the *Unreal* engine, these occlusion objects are called *anti-portals*. In the previous section, you learned that portals tell an engine that when a player looks through a portal whatever is on the other side needs to be rendered. In the same way, an anti-portal tells the engine that whatever is on the other side should *not* be displayed or calculated by the processor. In UnrealEd, the level designer can place objects that are invisible to the player, but define spaces in the level and the special properties they need. Anti-portals are placed as these volumes—they can go anywhere in the level—in the middle of pillars, in the walls or floors between rooms, or inside doors—to prevent the rooms beyond being rendered when the doors are closed. Wherever they go, the engine knows that whenever the anti-portal gets between the player and a part of the level, that part doesn't need to be there. Essentially these objects are the hint to the engine about what parts of the level are actually blocking the rest of the level from the player and what can, or should, be seen through.

Care must be taken not to place these occluders in areas that don't have solid geometry or something in the level that explains why the player wouldn't be able to see it. Placing a tall, narrow antiportal in the middle of an open field will result in a narrow slice of the screen showing "nothingness" when the player looks across the field and his view is intercepted by the occluder. The engine doesn't know whether you are placing an occlusion object in the right place or not—it simply does what you told it to. If the walls between the rooms in this example were semi-transparent, you would not want to use occluders because the player would expect to see something of what's on the other side of the walls.

Spawners

The last tier of performance optimization is called *spawning,* and it should be considered if you have zoned your map well, and placed occluders, and still are having performance issues. Spawning doesn't deal with the visual limitations of the map—too many polygons or lights, for example—but, rather, the limitations of AI and calculating too many moving objects at a time.

Generally, the player will be working through the map section by section, and won't see everything in the map at once. Given this, it may not make sense to have all your map's NPCs walking around and doing things if the player cannot possibly see them. These are actors that you can *spawn* in whenever you need them by placing a marker that tells the game engine "when the player activates a certain trigger, create an enemy NPC where I am." *Spawning* is a term coined in the dark and distant days of games and refers to the act of a level generating an element out of thin air when triggered. It's most useful for generating generic enemies or level elements that don't require a pre-set patrol, special behavior, or other unique attributes. Most game spawners are simply markers in the map, in whose property attributes you set the number and type of actor to create and when.

SIDEBAR

To illustrate the concept of spawning as an optimization enhancement, consider again the two rooms we have used for examples previously. Now there is a door between them that starts closed. The player starts in room A and the design calls for an enemy soldier to wait in room B for the player character to enter, and then attack him. There's no real point to the soldier being in the next room until the player opens the door—for the sake of argument, we can say that the player can't hear him or detect him in any way other than visually.

In this case, we could simply spawn the soldier into the room as soon as the door opens. We can set the door to send out a message to a spawner actor in room B. We set the spawner to generate one generic machine gun soldier facing the door as soon as it receives the trigger message. Then, when the main character actually moves through the door, the message is sent, and the soldier instantly appears in the next room. By the time the door opens, the player sees the soldier there waiting, and upon seeing the player's avatar, the soldier attacks. The benefit of this setup is that *until* the player opened the door, the soldier didn't exist, and thus the game engine didn't need to spend time or resources calculating his AI or rendering his model.

Although it's safe to assume that most games support some level of "on-the-fly generation," your specific engine might not. There are other ways of using this principle, however. You might be able to have some of your NPCs remain idle until triggered to keep from too many simultaneous navigation calculations, for instance. Or you might simple place your characters in a "green room"—a box far away from the main level and teleport them in when they are needed. It doesn't take too much to figure out how you can use the tools your editor gives you to optimize the map—get creative.

TEST YOUR WORK CONSTANTLY

No matter how you build your level, eventually you will get to the point where it is time to play through and test it against the design. It plays like you want it to, it looks and sounds like you want it to, and evokes the kind of mood and ambiance that you were aiming for. There will have been big changes, small sacrifices, and content you added at the request of others, but it's to a point where you could include it in the game if you needed to. At this stage, the level is referred to as "feature complete."

SUMMARY

Laying a good foundation for the rest of your level is vital, and part of being able to do this is to learn good construction practices for building the functional parts of the level—the parts most likely to cause the player problems. After a solid level hull is constructed, you can worry about decoration and lighting.

Some lessons brought up in this chapter were

- Use a good measurement system and the tools provided by your technology to make sure everything is kept clean. Intersecting geometry, floating or detached objects, or malformed shapes can cause a variety of problems during the level's production period.
- Keep a cool head when dealing with scale and volume issues this early in the life of your map. Sometimes making sudden aesthetic decisions at this stage will create a headache for you or someone who is working on the map externally. Wait until the decorations are in and the lighting is placed before you make a drastic decision on the impact of a certain space on the player or gameplay.
- Different games require different scales and size relationships between the player character and the environment around them. Take time to work out what feels right given the camera and control settings, and start from there when dealing with scale, rather that trying to build something that is realistic above all else.
- Pick a construction method that suits how you work, but allows you to stay within the schedule of your game. Balance the speed of construction with having playable levels as early as possible to allow for playtesting early in production.
- Optimize your map constantly. As the hull changes, you will need to check how those changes affect how the level runs. Take time frequently to update and separate the map into zones, place occluders, and see if there ways in which you can improve the performance of the level.
- Test your map often. Get other people to play it and watch what they do and don't do. The more you test, the sooner you will find problems. This seems obvious but it is too often overlooked.

AN INTERVIEW WITH LEE PERRY OF EPIC GAMES

Lee, can you explain where you work and what your position is?

Currently, I am lead level designer at Epic Games. This involves working with the team to create the environments and game situations a player encounters as they progress through the game, and working closely with Cliff Bleszinski, our lead designer to find the best ways to implement the story and gameplay he's trying to create in our title.

Also, a large chunk of my work is tied up in trying to hone the process into a manageable workflow, trying to find the techniques that best allow us to create the assets we need.

You have been vocal in the need for level artists to create level assets with modularity in mind—creating fewer but more robust interlocking pieces for designers to use while building, rather than creating many one-off decorations in later art passes. Can you explain the advantages of this production method for both designer and artist?

Absolutely. I believe efficient planning of your assets is key to producing the amount of assets you need for a title, without sacrificing quality of visuals. Creating and using modular assets, such as tiling walkway geometry, or wall details, or even modular decorative statues that function like 3D paper dolls in your level, these approaches will save you a world of work later in the process.

I have no doubts that many people can sit down and model and texture an entire large environment in beautiful, full-blown, custom detail. But I also have no doubts that most of those people won't feel like doing it a second time, after they realize the insane amount of assets that need to be created for a full level of unique models and textures. Ultimately it comes down to a question of efficiency, and once you embrace working efficiently and professionally, you can quickly see that there are many hidden benefits that come along with using a good process.

In short, the idea process breaks down to creating artwork that can be re-utilized later in different circumstances. One could simplify it to simply modeling a mesh as they normally would, and then carving it up into subsections to allow the designers the ability to lay out the sections differently, thereby creating new variations of the original mesh. But ideally, once you're sure the asset you're working on will be part of a modular system, you can take it

→

much farther than that by keeping modularity in mind as you start construction at the earliest stages.

The primary technical rule here is "Grid Grid Grid." Break your objects down into pieces that will snap together easily when placed on a reasonably coarse grid setting. You can always deviate from your grid in your level once your pieces are made, but you'll find it much harder to align meshes later in the game if they're not built to match up early on.

From an initial glance, the approach may seem like it's limiting your creative ability, but nine times out of ten the modular nature of an environment will work in your favor and save you many headaches when the technical difficulties of level design rear their heads. And the advantages are many; memory savings, consistency in style, ease of modifying a feature throughout your level, ease of construction management within your level, and there are so many more.

That's a cursory overview of our design goals at Epic, and as always, there's always exceptions to the rules and custom centerpiece meshes to get built . . . but in general, work clean and you're avoiding major hassles for yourself and those who will work with your assets.

The above is one part of a greater pipeline; can you explain further your ideal production scheme and how level design plays a part in it?

I wish I had an answer that worked for this is all cases, but if there was an instruction manual that came with the game industry, well, I didn't get a copy.

Every project has different design goals and different approaches to how they want to accomplish that design. Moreover, every team is made up of people who work under very different guidelines and preferences than any other team. A management hierarchy and workflow that works like a dream at one company is often the bane of another company's existence.

For the rare multiplayer-focused projects like Epic's *Unreal Tournament* series, there's creative freedoms that you simply couldn't extend to a group creating a single player title.

For a single player project, the layout and events contained within the environment are more important than ever. People aren't creating their own fun within your sandbox anymore. Once you know what needs to occur within the scope of your level, and you've verified that possibly with some loose game flow sketches, get something in there as quickly as possible. A blank canvas is scary, and the quicker you get something down to start iterating on, the better off you'll be. A good rough blocked in environment is a great place to start.

→

At some studios, if your environment rough gets flushed out enough to become a "level shell," it gets handed off to artists and scripters to fill with life. At other studios, a level never leaves a designer's death grip clutches. Everything is realized and centralized back at the designer's desktop, and the designer carries something of a management cap.

For my ideal scheme, I strongly believe a team of people must be involved. A single designer burns out quickly on an environment they're solely responsibly for. In the past it may not have been an issue, but with current visual trends the goal of a one-man level is more and more the ghost of gaming's past. And for my 2 cents, I say "good riddance." You need artists involved, you need sound engineering, you need scripting input, you need input from fellow designers, you need the help of testers, and often you need the help of a good producer if you plan on creating an experience that will put you in the fond memories of gamers worldwide.

A healthy knowledge of all those areas will help you, but don't fall into the trap of insisting you know better than the specialists around you.

What part of the level design process do you think is commonly short-changed (pre-design, visualization, whiteboxing, tuning, etc.)?

I believe interactivity is currently the golden element people are clamoring to improve as players' expectations soar. A few years ago you could get by with a static cash register on a counter, but more and more people want to be able to throw that register through the window, pry it open with a crowbar, retrieve the quarters from within, and cram them down the barrel of their gun to use as improvised ammunition.

Interactivity is the area that you'll see more and more people and companies scrambling to innovate with, now that visuals are becoming more and more accessible and competitive simultaneously. People will need to ramp up this facet to stay competitive.

As both an artist and designer, what skills have led to your success in game development?

Working well with others, adaptability, and trying new approaches to problems of development has been what's kept me on my toes for years now. More than ever, if you want to be a designer, you need to be flexible in what you know. If you don't know how to script, at least learn enough to communicate with those who do. Gather as much knowledge as possible from the people around you and keep an eye on what's coming down the technology and design pipes. That's served me well.

\rightarrow

What can level designers do to work harmoniously with artists on their team?

Accept that the days of levels having your names publicly stamped on them are gone. Realize that the actual content that you require to design a really cutting edge environment is most likely being created with many other people's assistance, and they all deserve credit. Accept that and work with it, get tightly knit with the people you're now depending on, and learn more about what they do in order to improve your respect for them as well as your communication abilities.

Do you think level design is a viable career path for someone with little artistic sense? Can the design be removed from the aesthetic entirely?

I believe there's room for all kinds of designers. I've worked with designers that come from every discipline now, and they all bring something great to the table. The variety of design talent and scope that works on a team is what will give you a well-rounded game as a whole.

Art is something that is easily judged, and therefore is often judged as a primary skill. You can drop something that looks really solid in front of someone, and it sells itself even in the form of a printed screenshot. If you're weak aesthetically, but strong in another department such as scripting, you'll need to work harder to counter that process and break through the front door; you'll have to convince the studios that you've got other skills to compensate. But, keep in mind, that often the most critical and accomplished designers are the ones that learn the new tools, create the interactivity, step up to pushing the world of design itself, and more than anything, create the FUN that goes into the environment, not the lens flares.

We don't play art, we play games.

10 Building the Level Part 2: Visual Design

In This Chapter

- In a Fight Between Graphics and Gameplay . . .
- Structure and Beauty, Perfect Together
- The Style Guide
- Texturing
- Lighting
- Placing Props
- Additional Visual Elements
- Summary
- Interview with Mathieu Bérubé of Ubisoft Entertainment, Inc.

Generally, a player sees the level before he hears or even plays it. Many games will begin with a cinematic or introduction sequence that illustrates the impressive technology and immersive graphics behind the game, giving the player a taste of what's to come. This is call *aesthetics*. The visual impact of a game is usually what hooks a player in at the beginning. After that, the gameplay has to take over and keep him playing, or all the graphics in the world won't help. That being said, part of your responsibility is making your level look good, and there's so much atmosphere and emotion you can create in your maps through graphics and sound alone, it's a huge responsibility. It's also a tremendous amount of fun, like wallpapering your apartment, if you could change the pattern and color of each wall in the blink of an eye. The best levels are those that play well and *feel* good, so this chapter will describe everything you need to make great aesthetics.

IN A FIGHT BETWEEN GRAPHICS AND GAMEPLAY . . .

Who would win in a fight between graphics and gameplay? It's a trick question—the answer is neither. It used to be, in the long distant past of game development, that a game could have the worst graphics in the world and still go on to sell a huge number of copies. This is almost never the case anymore. Gamers are maturing and have grown up on a steady diet of eye-candy and next-generation graphics technology, and they expect great-looking games for what they pay. This doesn't mean that a game with less impressive graphics won't be popular—a fun game will sell despite the lack of eye candy, but certainly there are benefits to having a player pick up your title's box at the store and drool over the in-game screen shots on the back panel. It may very well be why he decides to buy it.

Graphics aren't king, but neither is gameplay the end-all-be-all for the modern player. A good mix of both is needed for a video game, and the levels therein. This is

similar to modern cinema. When people go to the movies, they may not be going to see the latest in special effects, or to see whole cities wiped out by computer-generated tsunamis; they may simply want a good story, or to be distracted from their worldly woes for a few hours. On the other hand, they still demand an artful director, believable acting, and sets and backdrops that don't look like they were painted by a three-year old. People want to be entertained, not just amused. Most movies that are all special effects and little substance don't get repeat viewings. Movie goers want a *balance* of exciting visuals, acting, and compelling narrative, much in the way that gamers require you to deliver a compelling mix of aesthetics and gameplay in the levels you make.

STRUCTURE AND BEAUTY, PERFECT TOGETHER

The geometry in your level isn't simply there to sit and look pretty, it's there so the player has something to walk on, stuff to hide behind, or things to move out of the way, it's a structural element with a specific function in the world. However, not all geometry has to be structural—a lot of it needs to be decorative, to make a visually pleasing environment and not a bunch of concrete walls and lightbulbs hanging from sockets. The visual aspect of designing game spaces is very similar to the practice of architecture, though obviously on a much smaller scale. Building a game environment requires balancing the two fundamental elements of spatial construction, the *Functional* and *Aesthetic,* just as architects have done since the earliest days of human culture. For instance, visit any well-known Gothic cathedral like Notre Dame in Paris and you will discover it is not only visually stunning, it is also a marvel of structure. Flying buttresses, columns, vaulted arches, and tapered wall thickness are all used to create an overwhelmingly spacious interior that affects every visitor who enters, but more importantly are used to distribute the enormous weight of all that stone above. This careful balance of both strength and beauty translates directly to your need to balance the geometry of your level in ways that provide a smooth-running map that looks just as good as it plays.

In level design, you must always be aware of *why* you are placing a decorative element in your map. Do you need it, or are you simply bored with the space you are working on? It's all too easy to start throwing crates into a room because it looks too empty. After a while, you may have so many crates that the player won't be able to see the exit anymore. There is always the danger that you will be sacrificing the structure of your level—ergonomics, flow, or difficulty, for example, by over-attention to decorative details. It doesn't even have to be visual to affect the flow of the game—sound effects and music can also result in a negative experience if used inappropriately.

Neil is creating a map where the player must sneak through a theme park gone wrong, patrolled by deadly robotic monkeys. The monkeys have a limited vision distance, and make a lot of noise when they walk, giving the player ample time to avoid or hide from them when he hears the clanking of their gears. One day, Neil decides he's going to try to give the player an immersive audio experience, and meticulously places hundreds of sound-emitting actors around the theme park to play random cricket sounds. The result is definitely impressive—at any point in the map, the player can hear the sweeping chorus of crickets all around him. So much so, in fact, that it's almost impossible to hear the robot monkey assassins until they have drawn their swords and are running noisily for the main character. As cool as the crickets are, it's not worth having to raise the volume of the monkeys' movement, or use another method of alerting the player to their presence, potentially breaking someone else's map. Reluctantly, Neil pulls out the sounds so they won't affect the stealth gameplay of the level.

The lesson from this sidebar is that you must always make sure the level plays well and provides a consistently immersive experience for the player, even if that means sacrificing an aesthetic component. If your modeler insists on placing his scaffolding model in your map, despite you telling him that it is too narrow to let the player pass through easily—you need to put your foot down. Balancing form and function is one thing, but the interactivity of a level and the frustrations of the player are still paramount, and decorative elements that jeopardize the player's ability to use the level should be prevented from appearing in your work, whether you or another team member is responsible for decoration.

If you are making a map by yourself, it's both easier and sometimes more difficult to gauge how much decoration and aesthetic treatment your map needs.

THE STYLE GUIDE

The amount of control you have of the look and feel of your levels is largely based on how much of that information has been decided already. Some teams insist on a *style guide* for the levels. The creative director or art lead, in conjunction with the art and design teams, creates this document to outline how everything in the game should look. Often, the style guide contains general information and rules for the level designers about the kind of assets that can be used in the levels, the relation-

ship between specific elements (for instance, the style guide may determine the exact light settings you need to set for a street light in your level, or it may limit your choice of ground textures to a particular set of concrete materials). The style guide may also include basic themes and settings for your levels, with examples of preferred lighting, architectural elements, character costumes, and such. More detailed information is given for artists in creating the game assets such as precise palettes of colors, naming schemes for textures and objects, and how different components will go together (are the pots and pans rendered and placed separately, or are they modeled as part of the stove object?).

If you have a style guide, many of the following pointers will be determined somewhat by the information it contains. Get the most current copy of the style guide when you begin building your level and keep it updated when you start decorating. Regardless of whether you have a style guide for the team or not, you will still need to make many aesthetic decisions as you beautify your levels.

TEXTURING

Textures are flat images (Figure 10.1), often produced in 2D image programs like Photoshop , and sometimes taken from real-life photographs or scans, that you place on the surfaces of your level. Textures give form and add detail to flat surfaces. A drainpipe made as level geometry will start as an *untextured* cylinder, meaning it is created without any kind of visual indication of what it is meant to be (other than shape), just as in a modeling program. You can then apply an image of, say, rusty metal, to the surface of the pipe. The image will wrap around the cylinder, and although it may not look *perfect*, it now tells the player a lot more about what that round thing sticking out of the ground is. If you add a series of rivets to the texture, the pipe is now rusty metal with rivets running down it. Even though the rivets aren't really there in 3D, it will look like it to the player, or at least pass all but a close examination, creating another layer of realism. When it comes to making a truly stunning environment, the biggest factors are the texture and lighting choices you make. The basic geometry that you have created is really just like a blank canvas—it gives shape to your creation, but no matter how complex the geometry is, adding textures and lighting to it will turn it into a living, breathing world with a visual history of its own.

Textures are measured in pixels, by height and width. Texture sizes are in the (width) × (height) format. This is why people will often refer to a "64 × 32 texture." They aren't scoring it; they're just referring to its dimensions. Because of the way computers prefer to store information, textures come with their dimensions in factors of two, and so common sizes for a length and width follow the "by two" rule— 2, 4, 8, 16, 32, 64, and so on, which we covered in Chapter 8. In the *Unreal* engine's default scale setup, each pixel is equivalent to a unit of measurement in the map,

FIGURE 10.1 A level texture.

making it easier to match up or *map* textures perfectly to surfaces in the level. If you create a wall in UnrealEd that is 256 units high and 256 units wide, you know that a 256 × 256 texture will map perfectly onto it with no rescaling necessary.

Textures, Shaders, and Materials

Throughout this chapter, we will refer to the images you apply to your level as textures. However, fewer and fewer games are using 2D textures for levels. Generally, games now also use *shaders,* which are best described as special properties that describe how the surface they are applied to should look, or react to the surrounding lighting. Some examples are "self-illuminated" shaders that can make a surface glow in the dark, or "bump-map" shaders that make the image you apply to your level look like it has depth—parts that are "bumpy" or meant to stick out of the surface have highlights and shadows cast by the level lighting as if they were really there, instead of simply being drawn onto a flat image. It's all just trickery, however, created by the graphics hardware of the machine the game is running on. Shaders, textures, and the results of combining both for complex surface effects are often referred to as *materials.* In UnrealEd, anything you apply to the level geometry is called a material, whether it is just a flat texture, a shader, or many of each combined into a single material. Materials can be used for many special effects that give extra life and a much greater sense of realism to the surfaces they are applied to

(Figure 10.2). However, even though the process of creating materials is generally more complex than simply making a square image and slapping it onto a surface as a texture, how you will apply them in the level will be the same, and the following information applies to both.

FIGURE 10.2 A standard 2D texture and the same images as a self-illuminated shader.

Applying Your Textures Correctly

Most editors make applying textures to the surfaces in your level quite simple. You select a single material from a list of what's available, and click on a surface to apply it, or simply drag the texture from the list to the surface you want it to appear on. Once it's on there, you can manipulate it to some degree.

Textures have a special coordinate system they use to refer to the surfaces they are applied to. We already discussed how in 3D space, the three dimensions are called the X, Y, and Z axes. Because a texture is a 2D image, however, it doesn't work well to give it XYZ coordinates. The universal system for "mapping" or applying textures to a 3D surface is to use what are called the U, V, and W axes. Generally, you won't need to deal too much with the W axis in simple level texturing, unless you are rotating a texture on it. However, the U and V axes you will use constantly because these tell the engine the height and width of the texture compared with the surface on which the texture is placed. When you alter the texture on the U axis, you are altering the *width* of the texture on the surface. When you alter the V coordinate mapping of your texture, you are basically adjusting the *height*. This is a simplified explanation but will serve you well most of the time.

Common ways you can alter the appearance of a texture are using the following:

- Rotation
- Scaling
- Moving
- Flipping

Figure 10.3 provides some visual reference about what these manipulations look like.

FIGURE 10.3 A texture applied correctly, rotated, moved, flipped on an axis, and scaled.

Often, you will need to make slight adjustments to a texture once you have applied it. This is especially true when you want textures applied to different surfaces to match up correctly—for example, in the corner of a room, you apply a wall-covering texture to each wall, but they might not line up automatically. You will probably need to adjust the alignment or the UV information, so it looks like both walls are continuously covered.

Using Photos as Textures

If you are making your own textures for your level, consider the relative merits between using an actual photo of a real-world surface and creating a new texture specifically for your needs. Using a photograph has many difficulties; for instance, when you take a photo, generally there is some sort of lighting in the scene. If you take a picture of a window at noon, there may be a strong shadow on the wall be-

neath the window's sill. If you simply slap this image on the wall of your level, that shadow cannot be manipulated. It may not look right unless the lighting in your level is meant to look like noon, with the sun very high and casting shadows straight down all around the map. You can imagine your map set at sunrise, with long shadows being cast over the faces of buildings—except for this one window frame with a shadow that seems to be defying the direction of the sun. It sounds like a trivial thing, but don't be fooled. This one element significantly affects the illusion of a real or consistent space. Players may find themselves noticing that shadow even if they aren't aware of what's wrong with it. It's much easier for the brain to pick out what's wrong in a situation than what's right.

Hand-painted textures, on the other hand, can be created with the specifics of your level in mind. You can add specific elements (rust, rivets, wood grain, or blood splatters) to a texture that you create, or modify in an image-editing program, that will reflect the environment the texture goes in. For instance, you might create the same window frame we used in the previous example, but now remove the shadow and replace it with a sunrise-appropriate shadow that slants along the wall below at a sharper angle and looks darker than the noontime one. You might also add more appropriately colored highlights to the frame, or a reflection of the level's sky in the window glass. Now you have tied the texture into the environment so that it looks like it belongs. The rule of thumb here is *never* apply a digital or scanned photo directly to a surface in your level without first modifying it appropriately. It is virtually impossible that the photo will match the conditions of your map completely.

Tiling and Nontiling Textures

Your texture artists will generally create two kinds of textures: surface textures and model textures. You can apply surface textures on different parts of your level. Because you won't really know beforehand the exact dimensions of your level, possibly not until you actually ship the game, it's impossible to have the texture artist make textures that fit all of the various surfaces of your level. Some textures would also need to be literally thousands of pixels to a side just to cover the larger surfaces in your map. Because of this, most of your level textures will *tile.* This means that the textures can be repeated over and over again, edge to edge, across the surfaces of your level without any obvious breaks. Much like wallpaper, the artists need to make sure that the edges of the tiling texture line up correctly so that seams or little inconsistencies where the texture meets the edge of its neighbor don't occur. When you are applying tiling textures to your level, let the artists know if a texture has visible seams, or there is a very obvious spot that can be seen to repeat across the surface, and they should be able to correct the texture so it works.

Nontiling textures are usually those created to add detail to a surface without having to use polygons, such as a texture for a window, a door, a stony patch on the

ground, or a burn mark on wood. Although you can still try to tile these across a surface (the game engine doesn't know whether a texture is going to tile or not), they will look bad.

Nontiling materials are also created for specific objects and characters in the game. Texture artists create these kinds of textures (also called *skins*) by breaking the various bits and pieces of the model into flat planes and then creating textures to fit them, as demonstrated in Figures 10.4 and 10.5. The real estate the texture artist has to work with on the image is often limited, so artists play a sort of puzzle game, trying to fit all of the model's parts into one 128×128 pixel texture, for instance.

FIGURE 10.4 A flattened texture for a game model.

FIGURE 10.5 The same texture applied to the model.

This results in a texture that cannot be used for anything but that model. Applying it to level geometry will look like Figure 10.6, which is only useful if you're making a level to demonstrate how horrifically wrong things can go when texturing.

FIGURE 10.6 The misuse of a nontiling model texture.

The Dangers of Stretching Your Textures (and Your Relationship with the Artists Who Made Them)

In Chapter 8, the need for a good system of measurement to be able to match up textures to the surfaces of the level was discussed. Often, you will need to scale a texture to meet the exact dimensions of a wall or floor. If this means only a few units of measurement, and barely noticeable, it is an easy fix, but it is quite easy to keep nudging the scale of a texture on a surface until it becomes *stretched* beyond what is visually acceptable.

Often artists are more picky about the correct scaling threshold of a texture, but that's their job. You may think something looks fine, but get a good deal of criticism or comments back that a certain wall looks stretched. In this case, you can either make, or request a new, larger texture from the art team that will fit the surface you are trying to apply it to, or you can rework the geometry to make the surface fit the texture. Both are valid options—it just comes down to which is the easiest or quickest solution.

Breaking Up Geometry to Support Texturing

It's easy to go ahead and block out your level without any heed to the decoration, but it's a shortsighted way to build. Chances are your texture artist has some ideas about the best way to apply his work to your level, and working with the art team as you build, or at least creating a set of guidelines about the use of textures, will help you to get your map decorated much faster. One common example of this is breaking up a wall to support *trim* textures. Trim is considered the sort of architectural or decorative flourishes that are common in human structures. Molding along the top of the wall where it meets the ceiling, or floor, is trim. Elaborate door frames, chair rails, brickwork, or window casements are all trim.

These elements could be included in the wall texture itself—throw it on a vertical surface and voila, you have a wall complete with trim. The trouble happens when you have a wall that is too big or small to fit the wall without stretching the texture to fit. It makes more sense for the artists to create the trim textures separately from the base wall texture so that you can tile the wall image as much as you want and still have properly sized trim around it. To do this your level needs to be broken up or *split* to accommodate the different textures that will share the plane.

ON THE CD
This may sound complicated, but in UnrealEd it's a very simple procedure that can be performed in a number of ways. The CD-ROM for this book contains a link to the Unreal Developer Networks in the Resources folder for online tutorials and guides that cover this aspect of the editor. Make sure you talk to your artists about how they would like the level's surfaces broken up before you start building. It may be that they don't care so much, or it may be that they want every wall split at a height of 256 units so that no stretching occurs.

Keeping Your Texturing Consistent

We have already discussed the importance of keeping a theme throughout your level. This is the same on a smaller scale for your texturing and lighting. If you have literally hundreds of textures to choose from when it comes time to decorate your map, it may be tempting to use all of them, just because they're all so great-looking. Not only this a nightmare in memory use, but it probably also won't look very good if the textures are meant for different levels. The use of a handful of textures creatively is often much more impressive and thematic than simply going for the "Most Number of Rock Textures in a Single Level" award.

For instance, in a level set in an underground mine, you'll need certain types of textures—smooth rock for the sides of the tunnels and areas that have been drilled by machine. Rough rock for naturally formed caves or side-passages. Wood textures for support beams, braces, and trusses, and metal for iron bands, rails, and metal deposits. Within each of these categories, you don't want to use too many different variants. Using four or five different wood textures is going to be unnecessary

given how few of the level's surfaces will be using it. Variances within this category may also be noticeable—you don't want to use a hardwood flooring texture. Neither do you want to use a wood texture with detailing like nails or rivets, from a palette model, or wood that is polished or decoratively stained. You want natural-looking timber textures all with similar grain and color consistency to maintain the look of a real space.

Consistency Within Texture Sets

Another form of consistency is making sure you don't mix and match textures too wildly between texture "sets" or collections of textures that are intended by the art team to be used together and not combined with other sets. This is often seen in games that have wildly different environments. For instance, *Half-Life* features mostly industrial, corporate, and military-themed levels for most of the game, and everything is very firmly routed in earthly environments. At the end of the game, however, the player is transported into a completely different dimension, for which Valve's artists created extremely "alien" textures. Although some of these textures were used in earlier parts of the game (the player encounters laboratories that feature alien creatures under study, and some of the alien textures are used here to "foreshadow" the player about where he will end up later in the game), using these alien textures more frequently in the earlier levels for trim, ground textures, or simply as replacements for normal structural elements would have looked dramatically out of place.

If you are making your own levels for fun or for a noncommercial project, you might be downloading many of the excellent textures and materials available for free on the Internet. The same caution applies here, however—it's easy to go crazy and use as many textures as you can. You will be better off picking one or two collections of textures by the same artist that meet the needs of your map and stick to using those, and keep a consistent style in your map, rather than simply downloading textures singly by how they look on a Web page.

Colors Within Textures

Most professional texture artists will work with you to find out the kind of lighting conditions and environmental elements that will indicate the palette of your level and the lighting it will require. This is because you might get some peculiar or even downright ugly results in your level when a vividly colored texture meets a vividly colored light and the two blend to create an extraordinarily ugly color. For instance, if you make, or use a deep blue carpet texture on the floor of your spaceship corridor, and then use a red "emergency" lighting scheme to illuminate the level, those floors are going to become purple. Even though this realistic, it might not be the kind of color you want for your map.

Consider how your textures will react to other level elements. Even the audio in your level may need to tie into your textures. Having large, echoing footsteps when the player walks through a room is appropriate when you've used metal textures, or flat, reflective surfaces, but not when you have tapestries or walls lined with books.

LIGHTING

Dramatic lighting is critical to the look and atmosphere of your levels. You may not be the one who decides the final placement of lighting, but certainly a level designer who understands the basics of how spaces should be lit, and the effect of different kinds of lighting on the player can design better maps with mood in mind.

The advent of 3D technology has allowed the creation of extremely realistic lighting in game environments. At first, these environments were pre-rendered affairs, with scenes and levels created in high-end programs and then presented to the player as flat backgrounds. Later, with games such as *Doom* and *Duke Nukem 3D,* mapmakers were able to create basic lighting effects that simulated real-world conditions and effects.

Typically, the kind of lights you will work with are very similar to real-life lighting used in movies and TV shows. However, lighting in 3D virtual environments has one great advantage over film and television—the lights don't actually need a source to come from. Light can be generated where and when needed, which is a powerful feature when it comes to a game environment.

How Light Works

In real life, everything we see is actually light bouncing from an object into our eye (when we see an apple on a table, it's really the light reflecting from that apple and hitting our eye that we perceive), or shining directly from an emission source (like looking at the sun). Light has always been enigmatic to those trying to explain how it works. At best we know that it is a form of energy, that it radiates, and that it has electromagnetic properties. It behaves like a wave, but also has properties of particles in travel.

Luckily for us, visual lighting is about knowing how light behaves in the real world, and is less about the scientific phenomena behind how we see. We can look to examples all around us, in movies, photos, or even written descriptions, to learn how to simulate a realistic and visually impressive lighting scheme for a level.

Although we will talk about the need to simulate certain effects of light, when we talk about level lighting, we are generally just placing sources—the engine handles how the light bounces around and simulates the effect of our eyes "seeing" it in the world.

RGB Versus RYB

The primary colors of light are different than that of physical pigments, such as paints. When you learn your primary colors in school, you learn that the three primaries are red, yellow, and blue. However, the properties of light colors are slightly different. You create colored lighting using red, green, and blue instead. Although not incredibly important to know, it can often throw new level designers off when it comes to specifically picking a color for a light, or trying to replicate a color scheme from reference.

Game Lighting

In games, every year technology improves game lighting techniques, allowing for increasingly realistic lighting effects. A decade ago, the process of "ray-tracing" allowed computers to simulate how light bounces around an environment, allowing for effects such as reflectivity or creating objects that looked like they were made of glass-like transparent materials. More recently, a technique called *radiosity* gave 3D content creators the power to simulate light bouncing off different sorts of surfaces and materials, as well as how the color of light travels and blends in lit areas. Already the experimental processes being used for cinematic lighting of 3D environments for film are creating scenes that cannot be differentiated from real-life pictures. It won't be long before lighting within game levels will be comparable to that of photographs also.

The tools that level designers are given to light environments are similar to that of commercial 3D rendering packages, but much more basic. Generally, the cost of lighting a game environment is high, and at the time of this writing, games cannot support the kind of lighting movie artists enjoy because of realistic performance factors. For this reason, designers need to light within the bounds set by the platform and engine that will run their game. This is not to say that game lighting is crippled in any way—amazing-looking maps are being made every day, using the same basic lights and techniques that have been used since *Doom* wowed a generation of gamers.

Level Lighting

Calculating a single light's effect on a level is simple. A handful of lights in a map can be computed by most engines with ease. However, modern-day games have levels that can contain hundreds, if not thousands of light actors, each contributing to the environment, and each requiring the game hardware's attention to do its work. For this reason, there are several standards in which light effects are handled in games. The two most important, and the two we will cover here, are *lightmaps* and *vertex lighting*.

Lightmaps

For most of the level's surfaces, there is no need to calculate how the light looks repeatedly during play. Although real-time lighting, where lights act realistically and cast real shadows, is becoming more prominent in high-end games, most games currently are still using basic lights that are placed by a level designer and rendered once to create the effect of that light as a permanent feature of the level.

Most of the geometry used in a game level is *static*—it doesn't move, or change form. Because of this, the lighting doesn't need to change either. Each light is calculated once, and its effect is added to the overall lighting conditions of the map. Once the lighting is fully rendered, the engine builds a set of unique textures, called lightmaps, automatically and applies them to the surface geometry of the level. Depending on how much detail the level designer sets, and how much the engine can handle, these lightmaps can be very smooth, very high-resolution textures that give the effect of crisp lighting when seen in the level. The process is easy as long as the lightmaps are applied to large surface areas. The smaller the polys are on a surface—if it is very complex, or organic—the more a lightmap needs to be faceted and the longer it takes to produce, and the risk of errors or visual glitches appearing increase dramatically. In UnrealEd, only BSP can use this kind of lighting, as it is generally very low-poly and easy to create lighting maps for. For other types of level geometry, terrain, or static mesh for example, *vertex lighting* is used.

Vertex Lighting

This method of showing light affecting the level geometry is extremely fast for the engine and hardware to calculate, so it can be done "on-the-fly" and is used extensively when lighting game characters. An NPC can't use lightmaps because the game never knows how that character will be oriented to, and its distance from, any of the lights in the level. So vertex lighting is used to make sure the effect of all the surrounding lights converge on that character as he moves through the environment. Anything dynamic that will (or could) move in the level, and anything that uses very complex geometry is generally a preferred candidate for being vertex lit.

So now that we know why it gets used, let's go over *how* it works.

We know that everything in a game that has physical form uses polygons to define its shape. We know that those polys are the spaces between vertices, each being a point in the game world. Another property that each vertex can store is a color value. The engine can then look at the color value of each vertex in an object, or in the level, and *blend* between those colors to create smooth gradients of color and shading on each polygon. So if the light hitting the vertices at the top of a wall is much brighter than those at the bottom, the color of the entire wall will blend from light to dark, top-to-bottom. Figure 10.7 shows the difference between an object using a lightmap, and the same object using vertex lighting.

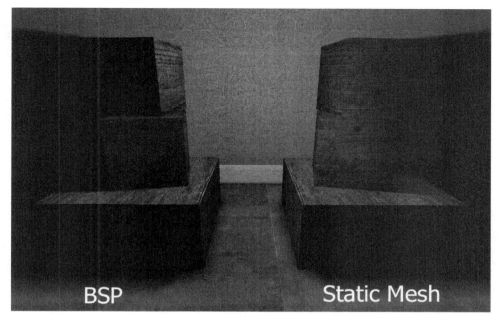

FIGURE 10.7 A BSP object using a lightmap, and the same object as static mesh using vertex lighting.

You can probably see the difference—the vertex lighting is a lot cruder, and the fading between light and dark areas is more drastic. The level designer generally does not choose the kind of lighting that each type of geometry uses; however, it is important that you know the difference between the various lighting techniques and how to use, and abuse, them.

Generally, the more verts a 3D mesh has, the more lighting data it can support. In plain English, this means that a higher-detail model will light much better, and more smoothly, than a low-polygon model will. In some cases, vertex lighting can look as good as a lightmap if the mesh has enough vertices in the right places. This is important to remember if you have a model that isn't lighting very well. If you can, increase the number of polygons, or ask the artist responsible to make it a more complex model, and see if that improves the visual quality when lit. In other cases, you may simply need to have the vertices moved to an area where they are exposed to light better.

Other Lighting Systems

As game graphics get better (seemingly exponentially), these artificial methods of lighting are becoming increasingly obsolete. *Splinter Cell* and *Deus Ex 2*, for example,

have both used methods of trying to calculate light *dynamically* and shade everything in the level as it affects everything else (we will cover this in more detail in the section on *real-time lighting* a little later in the chapter). However, these games used this kind of lighting sparingly, and in conjunction with lightmaps and vertex lighting, to maintain a high performance. As this book was written, *Doom 3* had just hit the shelves and its big claim to fame was that it uses real-time lighting extensively, creating an unparalleled level of lighting that reacts realistically to what happens around it. Lightmaps and vertex lighting will be around for a while, but as time moves on, level designers will need to familiarize themselves with the ever-increasing demands, and complexities, of emerging lighting techniques.

Lighting Parameters in Games

How lighting is controlled differs from technology to technology. Different game platforms are more or less likely to support different types of lighting based on their internal hardware. However, the basics remain consistent enough. All lights in games are emitted from an actor or object you physically place in the map. Parameters that affect the light are set on this object, and the physical location of the light object is usually called the *origin*. Lights in games generally have the following properties:

- Brightness
- Range
- Tint
- Direction

Brightness

The brightness of a light indicates how much energy it is emitting. For a level, the brightness is how bright the light is at its origin. Brightness also determines how much the light will affect nearby surfaces, how strong the shadows it casts will be, how much it will dominate nearby lights, or be dominated by them, and so on.

Range

A light's range is the distance the light travels from the origin. In reality, a light source's range is often determined by the brightness of the light and the surrounding atmospheric conditions. A bright light on a foggy day won't travel very far, for instance. Games are virtual environments, however, and the designer can choose to have extremely bright lights travel only a short distance on a clear night, if that's the desired effect. Range is generally measured in regular game units, or expressed as a discrete numerical property. If the latter, you might need to experiment which how much or how little to adjust the range property to get your light to travel the correct

distance. The range of a light works hand-in-hand with brightness. If you have a light that is set to shine for 100 units, beyond that number of units from the origin, the light will stop illuminating things. However, if the light isn't very bright, the noticeable effect between ten and a hundred units might not be so noticeable. Conversely, if the light is extremely bright, the fade from light to dark will be obvious, as shown in Figure 10.8.

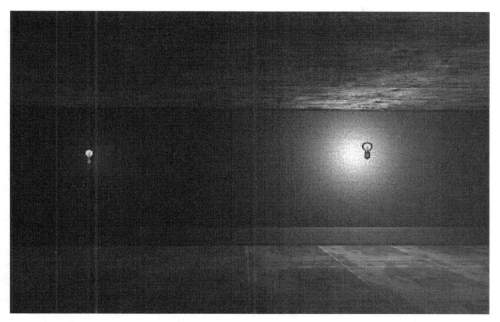

FIGURE 10.8 Two lights with identical ranges but very different levels of brightness.

Tint

In everyday life, every color has some kind of tint or color to it. Light can be emitted from a source that gives it a particular tint—a blue flame, for instance—and then it can be further changed by conditions between the source and the viewer, such as the way that earth's atmosphere affects the color of sunlight as it passes into our eyes. In game levels, color is used to match lights to the sources they are meant to come from, and to evoke certain emotions and concepts, which we will look at further in this chapter. You will usually be able to pick the color of a light from a palette in the editor or type a numeric variable that determines the light's tint in the level.

Direction

Light travels in a straight direction until it is interrupted by something that reflects it. Light will be cast from a source in all directions unless it is constrained or focused by something—a shade, a cover, a screen with holes, or a lens, for instance. In game levels, you will often want to direct light to a particular area of the environment. In such cases, you will be able to determine the direction for a particular light in the engine by rotating the direction of the light. In UnrealEd, each actor can have an arrow that indicates what direction it is pointing in, if direction is important. Light actors use this arrow to show where they are focused if they are set to be directional.

Common Light Types

Common level lights (Figure 10.9) can generally be classified in the following categories:

- Point
- Spot
- Fill
- Ambient
- Celestial

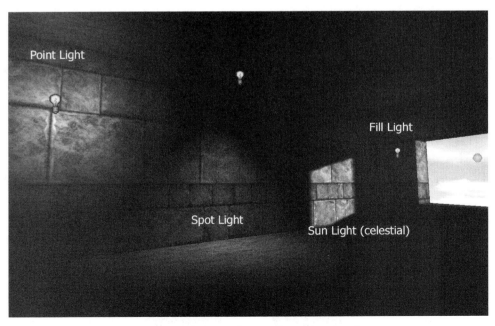

FIGURE 10.9 Common styles of lighting shown placed in a level.

Point Lights

Point lights are the workhorses of level lighting. Generally considered to be nondirectional, because they shine out in all directions from their center (or point, which gives them their name), you can use a point light to represent the effect of a light bulb, fluorescent light, torch, or gas lamp in the level. When you are whiteboxing the map, it is easy to throw a few point lights around the room to illuminate the space and start visualizing how the lighting will take shape.

Spot Lights

When you need to direct your light to one particular place, or have the effect of a directed light, using a spotlight is the best way. Just like a stage spotlight, these types of light actors are directional and cast a circular spot of light where they are pointed.

When a spotlight is cast at an angle on a surface, it results in a triangular beam of light on that surface, like a light shining down along a wall. This effect is often used to bring out wall textures in otherwise dark areas.

Fill Lights

Fill lights are very dim point lights that are used to *simulate* the reflection of light onto a surface indirectly. For instance, in a dark room with sunlight coming through the window, the ceiling may pick up some of the light reflecting from the floor, or a wall, even though it isn't being lit directly. With a radiosity lighting engine, this sort of effect can be achieved automatically; however, in an engine like UnrealEd, with a more basic lighting system, you can use fill lights to simulate this sort of effect, as demonstrated later in Figure 10.15.

Ambient Lights

Ambient lights affect entire regions of the map, or even the entire map, by raising or lowering the overall level of light. This kind of lighting affects all the surfaces in the area regardless of whether they are receiving any other illumination. Ambient light will also add or decrease the intensity of existing lights in the map within the area of effect and can also affect the color of the map's lighting, which can be useful for creating outdoor effects such as the orange glow of a sunset, or indoor effects such as the cool blue mood of a mortuary at night. In UnrealEd, the ambient light is controlled by zone. A special object within each zone called the *ZoneInfo* actor has a property in it that the level designer can adjust to control the brightness and color of that zone's ambient lighting.

Celestial Lighting

Sun, moon, and star light are common forms of creating ambiance in a level, as well as being useful for lighting whole outdoor areas uniformly. Celestial light is

commonly called *parallel lighting* because light from the sun and moon hits all of the earth from one direction—all shadows cast by the sun are uniform in angle and length relative to what is casting them, as shown in Figure 10.10. In some engines, celestial lighting is created by setting special properties in the level (as in *Quake 3*), whereas in *Unreal,* the designer places an actual light actor called a *sunlight* in the environment and uses it to direct the light and set the strength and color. Although the actor is called a sunlight, it can easily be used to simulate moonlight (low intensity, blue-white light), starlight, or light from an alien sun on a distant planet.

FIGURE 10.10 Sunlight in a game environment.

Dynamic Lighting

The light types mentioned previously are regarded as *static* lights. Their effects are calculated once—when the level designer builds or compiles the map, and the engine uses that calculation for everything that it lights in the game. Dynamic lights, on the other hand, move or have some kind of animated effect. A siren effect, for example, is a colored dynamic light, that rotates its focus in circular motion around its origin. A strobing fluorescent bulb in a level is commonly created by a dynamic light that is set to flicker on and off.

These lights can be expensive to render because they require a constant or regular recalculation of their effect on the level.

Real-Time Lighting

As rendering technology for games becomes more advanced, we are seeing more and more games using real-time lighting. These lights are actually calculated constantly, generating realistic shadows (often referred to as *dynamic shadows,* which simply means they are created on-the-fly by whatever moves in front of them) instead of using lighting that is baked into the level at the time it is built. Real-time lighting can create amazingly real levels, and interesting interaction possibilities. If a lightbulb is emitting such a light, and it moves, the shadows it casts will lengthen and shorten as it swings back and forth, for example. Many games use a combination of real-time, dynamic, and static lights to create the level lighting, to keep performance high. Static lighting is usually the least taxing on the game hardware, and real-time lighting is the most expensive, requiring a great deal of hardware acceleration to render. Figure 10.11 shows an example of dynamic shadows in a game.

FIGURE 10.11 A room with dynamic shadows cast by a light calculated in real time.

Self-Illuminating Objects

In some cases, you won't need to place a separate light object in a level near the object to be lit. Some game engines allow light-emitting objects to use "self-illuminating" shaders. In these cases, light can sometimes be calculated as emanating from the lit parts of the object. For instance, if a computer screen prop in a level is textured with a self-illuminating material, the screen might cast light on the desk it is sitting on, the keyboard and mouse, a wall nearby, and so forth. To control the light settings of such objects you will need to adjust the settings in the properties of the illuminating material. These forms of lighting crate a much more realistic effect than does trying to simulate with basic static lights; they often come at a greater performance expense, however, and should be used sparingly. Don't texture whole walls in self-illuminating materials, unless you're prepared to deal with the wrath of your low-spec player.

Level Lighting Techniques

Placing lights in your level is easy. Making them work for you is harder. The principles of lighting your environment are similar to other visual media such as stage set design or lighting in film. The fundamental rule is to use as few as possible. Too many lights, too many colors or intensities, and the viewer becomes confused. Although not always applicable, a general rule of thumb is that fewer lights are better. See how little you can get away with and still have the effect that you want, instead of saturating an environment unnecessarily.

Traditional Lighting Methods in Levels

In traditional lighting, two main types of light are important to know—the key light and the fill light (we already described what fill lights are—they give the subject "form" by defining the shape, volume, and density of the subject). The key light is what directly illuminates the subject, highlighting it as something of interest to the viewer. This is the general formula for, say, lighting an actor in a toothpaste commercial, but it can also be applied to game environments. Looking at Figure 10.12, you can see that the central light is the key light, shining down into the focus of the room. Around it are fill lights, casting a softer ambient light that gives a sense of depth to the scene.

Not every scene can be lit this way. Having a single key or fill lights in the area may be unrealistic in the game's setting. However, in level design, we often use the term "key lighting" to describe the critical lighting for gameplay, much in the way a film director uses key lighting for critical elements in the frame. Level designers or environment artists will place key lights in areas that are important to the player—highlighting entrances and exits, at the end of dark corridors to show the player there is something beyond. Key lighting in levels can be subtle too; for instance, in

FIGURE 10.12 Key and fill lighting. Notice how the spotlight picks the box out as the focus of this room.

a dark street, light shining from an open window several stories above the player may indicate an alternate entrance into a house other than trying to sneak past the guards at the front door. A very weak glow near a vent will draw the observant eye to that part of the level.

In this way, the traditional sense of fill lighting in levels becomes more about decoration and giving depth to the environment. Fill lighting is incidental or decorative lighting—torches lining a corridor in a tomb, or the glow of computer monitors on the command deck of a starship. Fill lighting has a practical side—the player needs to be able to see where he is going, and fill lights show the way, but they should not interfere with key lighting that is informational, or indicative.

Colored Lighting

The use of color in a level is an important part of setting the mood and creating a sense of atmosphere. Like lighting in general, less is usually more when it comes to picking the colors for your level. The first thing you must decide when you begin to light is how the setting of the level will affect the colors you have to choose from, and what the most effective schemes will be. For example, if you are making an

adventure game level with a volcano theme, you will want to restrict your main palette of colors to fiery or hot colors—reds, oranges, and yellow or white where temperatures are extreme. A color scheme doesn't need to be complex, it just means you are picking a few colors that are relevant to your level, and sticking to them more than others, avoiding sources or objects that would require you to place many different and clashing colors all in one area—unless your game happens to be the *Attack of the Rainbow Creatures from the Planet Psychedelika*, in which case, go nuts. It's often unrealistic to expect one color scheme is going to be enough for an entire level. Many game levels encompass very different environments. A level set in New York City at night might feature different color palettes for outdoors, inside an apartment, outside a club, and inside the kitchen of a fancy restaurant. Keeping each of these environments consistent within itself is the important part.

Color Contrast

Human brains see contrast exceptionally well. Our minds are tuned to seek relationships in what our eyes perceive, and contrasting colors are a great way to shake the player's brain and shout "Wake up!"

A level with lots of different colors fighting for space in one area can be distracting and often ugly. However, choosing some contrasting colors for your lighting scheme can have a powerful effect on the mood of your map. The cold blue light of the moon streaming into a room from an open window on one side, and the warm glow from a dying fire on the other can create a very realistic and pleasingly colorful effect. Red light streaming from a doorway in a corridor lit by soft green can really pull a player's attention to that area , but it can also make a player feel ill, if the colors are too vivid or too wildly contrasting. As always, use subtlety and restraint when placing contrasting or dissonant colors in your level. You may think the effect isn't powerful enough, but the player may get the message quite clearly. Level designers can lose track of how an environment looks to someone seeing it for the first time and seek to intensify the colors and lighting in the map to compensate. Take a step back every now and then, or even better, get the opinions of other people on your team to make sure you aren't going overboard.

Consistency of Lights and Sources

As you place lights in the level, make sure that they are kept consistent with the sources they are supposed to be coming from. It sounds like a simple thing, but every year games ship with levels that feature tiny bulbs casting massive pools of light around a room, or searchlights that barely register on the environment or characters. The source of the light in the level—a window, a streetlight, a burning tank, or a glowing mushroom, will indicate what sort of settings you need to apply to that entity's lighting. Figures 10.13 and 10.14 show the difference between a consistent and an inconsistent light-to-source relationship.

FIGURE 10.13 A realistic lighting relationship.

FIGURE 10.14 An unrealistic lighting effect for the object supposedly emitting the light.

Lighting should be consistent throughout your level. Sunlight should not be different from one courtyard to the next unless there is a rational explanation—time has passed, or the weather has changed, for example. Likewise, once you start placing streetlights, keep them pretty much the same. It's okay to have the occasional

burnt-out, flickering, or damaged streetlight, but if every one in your level has a different intensity or range, it will look very odd indeed.

To keep your lights consistent, consider "grouping" an object with the appropriate light actor and then duplicating that group whenever you need to replicate the light effect elsewhere in the level. In UnrealEd, you can combine elements in a map as "prefabs" that can be saved and reloaded as a group. In this way, you can place a spotlight actor under a streetlight prop, and once the spotlight is correctly tuned to get the effect of the streetlight shining down, copy and paste the two together around your level as needed, instead of setting up multiple lights and having to tune them all individually. It also means that if someone else takes over your map before you have finished lighting, he has a working example of the streetlight to use.

Contrast and Shadows

Light is only one part of what makes level lighting important. The creative use of shadows is also part of your environment's unique atmosphere. There are two kinds of shadows in a level. The first kind is shadow that is simply the lack of light—the dark corner of a room, or a dark passageway. The second, and more useful, is the shadow that you "sculpt" by placing something in front of a light source to make an interesting mix of light and dark on a surface. Just as the contrast of colors gives depth and complexity to your map in a pleasing way, the contrast between light and dark is something humans find particularly fascinating. Just look at the photos by Ansel Adams or watch a classic black-and-white movie like *Casablanca* and see how the use of light works to create rich scenes without the need for color at all. Contrast is a fundamental way in which we see, it allows us to make sense of a visual image and use our pattern-loving brains to quickly assimilate information.

In Figure 10.15, we see three versions of the same scene—one with flat, ambient lighting, one with simple lights, and a final version with complex shadow patterns. Which seems to create the best sense of space? It's number three, the shadowed hallway. Notice too, how the shadows pick up certain areas of the wall texture and leave others dark. This effectively masks the tiling texture used on the wall, which is obvious in the first two versions. Another feature of shadows is that they allow the level designer much more freedom in showing parts of surfaces to the player and reduce the problem of a texture tiling across a surface immediately looking artificial.

A common way to add dramatic shadows to a level is to place lights behind a "screen"—anything with holes in it that will create shadow patterns where the light hits a part of the level geometry. There are countless examples of this technique in games—lights behind rotating fan blades, torches in cages, or sunlight behind louvered shades. In general, this is the best way to "shape" shadows to your liking. You can have lights shining through where bricks have fallen from a wall to cast a series

FIGURE 10.15 Three versions of the same corridor featuring successively more complex shadows.

of rectangular lights across a room. Other methods include placing lights behind existing geometry that will result in a broken light area (placing a light on the ceiling above clusters of pipes) or using projected textures, which we will discuss next.

Projected Textures

When a level needs very crisp, well-defined shadows, it can be beneficial to use a *projected* image of a shadow instead of trying to create one using an actual light. Projected shadows are black silhouettes textures that are literally projected, or applied, onto surfaces in the level. In the UnrealEd, the level designer can drop a projector actor into the map and assign it an image to project. This can be almost anything chosen from the material browser. Once chosen, the actor will project that image out into a cone for a specified distance. When something interrupts that cone, it picks up the projected image. This is exactly how projection works in reality, when you put something between the projector and the screen. The direction of the actor can be altered as can certain ways the image is projected, what will take the image, and what will remain unaffected. The benefits of projectors are obvious—but they come at a price because they are relatively expensive to calculate when compared with simple shadows.

Allowing the Player to Affect Lighting

As we have seen, games truly differentiate themselves from other forms of visual media by their interactivity. This is especially true with lighting. In a movie, the viewer can't force the main character to turn the lights on in a dark room. However, we can certainly give the player the option to do that in a level. A trigger object like a switch, linked to a dynamic light, is all that is really needed to have the player control whether an area in the level is lit or not. This is the basis for many stealth or tactical combat games where the player is trying to make enemy territory more traversable. Shooting out searchlights, cutting the electrical power to a building, or throwing water on a torch,—all allow the player to create a better environment in which to skulk or hide. Inversely, throwing on the lights in a dark warehouse and blinding the enemies inside wearing night-vision goggles, or simply being able to see opponents better with the skylights open, is a very powerful way to let the player control lighting and becomes a type of gameplay all to itself. When creating your lighting, think about this, and ask yourself where the player might benefit from—or simply enjoy—control of the lighting in an area of the level.

Lighting in Multiplayer Levels

When creating a single player level, you need to think about the theme of the map, about creating an atmospheric space through believable and decorative light layouts.

For multiplayer maps, however, the level designer must think of other concerns. As we have seen, lighting can be used to pick out certain areas or objects in space as important, or used to draw the player to look in a certain place. In multiplayer maps, the player needs to be informed very clearly about what an area is or

what it contains. There isn't much time to stop and think about the function of a space when someone has you in his sniper sight.

Consider the use of color, common associations with certain colors, and how those colors are used in the kind of game you are making a level for. If you are creating a "capture the flag" map where the level is divided into thirds—neutral territory and each team's home turf—you might want to adjust the lighting in each team's base or home area to make contrasting team colors. Players on the Blue team will know the enemy flag is near when they are in a red-lit and textured building. Likewise, the absence of specific team colors indicates to them that they are in a space between team territories, without having to consciously think about it.

Consistency also helps a player determine where critical areas are in the map as they pass by. If the level designer places all the weapons in that map in alcoves or on pedestals that produce a green glow, the players will look for that color when searching for a new weapon. They will quickly associate colors with items or area functions if you give them consistent clues through color.

Common Lighting Mistakes

Lighting is a powerful tool, and it is all too easy to make mistakes. This chapter has covered many lighting issues that can work against a level; here are some of the bigger mistakes that are found commonly in levels of all genres:

- Over and under lighting
- Using too many lights
- Not all lights need sources, not all sources need lights

Over and Under Lighting

One difficulty with developing computer and video games is that there is no control of what sort of device the player is watching on, or the quality of the image. There are differences between different brands and ages of televisions and monitors, and there are differences between two monitors of exactly the same model and lifetime. Make sure your monitor is relatively consistent with your co-workers' when developing the levels. If your studio hasn't calibrated all the team's monitors or production televisions, some people may come to you claiming your level is too dark, too light, or just right, and they may be incorrect. Check your sources and test your level, or watch it running on other people's monitors to make sure you aren't steering your lighting in a bad direction.

When it comes to being over-lit or under-lit, a level will usually look better on the darker side of things. However, it will also be harder to play. An over-lit level will look less appealing, but the player will clearly be able to see where he is going. Make sure that no matter how dark a level gets, the player can always make out the

basics of his surroundings. In a dark room without lighting, there should be enough ambient lighting for the player to find the door without having to just move in random directions until the door opens. A good rule of thumb is that you should just barely be able to see the texture on a surface when playing in normal lighting conditions—if the level's base lighting gets any darker than that, the player will quite easily become muddled.

Using Too Many Lights

There's no point in using three lights where one will do. Instead of manipulating the settings on a single source, a level designer or environmental artist will often duplicate an existing light several times until the light reaches the desired intensity.

A big problem with this is that more light sources in the map will (depending on the engine) affect performance, and it will *weaken* the shadows in your map. Why is this? Well, consider that each source of light in a room casts a shadow. The more points from which light is being emitted, the more light and the more shadows. Shadow definition will weaken and soften. Essentially, you begin to lose control of your "dramatic" lighting.

The same can be said for using a few light actors for a single torch—they will all cast light from slightly different positions, creating several slightly different sets of shadows. To the player this will look like one blurry shadow coming from the light bulb. Clear shadows and lighting, as well as improved performance, come from being frugal and smart with lights.

Not All Lights Need Sources, Not All Sources Need Lights

One of the best parts about lighting in a virtual environment is that you don't always have to have a logical source for a lighting effect. Many companies that make 3D computer-animated movies take advantage of this to create "fake" lights for reflections on shiny surfaces or to brighten areas that realistically would have insufficient means to create enough light. Remember this when you go to put in a moody glow in a space and think to yourself, "How would that be there?" Sometimes an effect looks so natural that no one will notice that there aren't any real reasons for the effect to be there. A common theme of this book is that part of the level designer's talent is being able to judge what the player is likely to accept or not. Sometimes aesthetic features outweigh the need for logic, which is useful to remember when lighting a dull space or part of a level with little "real" source for lighting.

In the same way, it is very tempting to always place a light actor near parts of the map that *look* like they should be illuminating everything around them. However, it is rare that everything in the map needs an actual level light. A good example of this kind of "overly enthusiastic" lighting can be seen in maps set in urban areas at night. If there are windows high up on buildings, textured to look like the

rooms beyond are lit—it is not always necessary to place a light by that window. Lighting is best served where the player will interact with, or at least appreciate, it. It is also a valuable resource for how the level will run. If you don't need to use that light, let the texture do the hard work in convincing the player that there is a real light coming from that window.

PLACING PROPS

Just like texturing and lighting, placing decorative props in levels is not something all level designers do. However, it is very common that a designer is given a set of objects, or given access to the assets being made for the game, and allowed to place them in the map for atmosphere.

Prop placement generally happens in waves. You might go through and place props here and there while you are whiteboxing, or put in as many have been completed already by the artists. Invariably, though, more will be made, approved, or edited as you work, so you will want to go back and place new objects in the level before it is done. Placing non-interactive objects and props usually comes with a great deal of tweaking and fine adjustment as the level evolves and the designer revisits areas after a period of time to see what is working and what isn't. On the other hand, there are some good rules to work by when adding detail and clutter to a map.

Adjustments for Character

Very subtle changes between identical meshes can help break up the sense of monotony that comes from a series of identical light sconces along a wall, or a room full of perfectly parallel desks. In reality, furniture gets bumped, carpets get rumpled, maintenance workers hang light fixtures badly, and everyone has a personal preference on how they position their keyboards on a desk. Give the environment some life and take the time to adjust each prop you place so that it has a character of its own. Twist a few desks just a little in an office so they aren't all in line, for instance. Small adjustments in rotation, positioning, or even scale can create a much more natural-seeming environment.

Anecdotal Placement

Clutter is a term used by level designers and artists to describe filling up the empty spaces in an area of a level with static props to give it a lived in or real-world appearance. It doesn't necessarily mean clutter in a negative way. For example, a blank wall in a room might have a few bookcases placed along it, and though it doesn't affect the player's navigation or look untidy, it breaks up the monotonous look of a tiling wallpaper texture—this is level clutter. Like the concept of character adjustments, it is also

a waste of polygons and texture memory to simply throw junk around a level and consider it clutter.

When adding this kind of prop, try to think of the anecdote behind it—how it got there, what purpose it serves, why it wasn't removed, and so on. Even the smallest of props can tell a story. A teddy bear on a basement step. A still-steaming coffee cup on a table in the mortuary. By creating mini-narrative behind what you place, it will look less random and more integrated into the environment. You can't go through this process with every prop you add, but concentrating on the decorations along the critical path, or that the player is likely to see, is a good idea.

Clutter Without Collision Problems

When creating good visual clutter in an area, always remember that the main character, and the NPCs, need to move through the level unhindered by badly placed objects. Sometimes if a level designer places an object far enough away from a wall that a gap is formed, a character can get stuck between the object and the wall permanently, forcing the player to have to restart or load a previously saved game. Likewise, some objects have collision boundaries that don't quite match their physical appearances. The cabinet that *looks* like the main character can pass by might have a collision object that sticks out further than the visual mesh, and the player may catch on it as he passes by. Player ergonomics comes before visual decorations, so make sure your clutter isn't affecting the flow of the map.

ADDITIONAL VISUAL ELEMENTS

Other visual effects available to level designers and artists don't quite fit into the realm of texturing and lighting but are still essential parts of the visual design process.

Skyboxes

When you look out over the rooftops of a level, or out of a window at the distance, you are usually seeing the *skybox* (also referred to as the *skydome*). This is the technique of creating a fake horizon to simulate a world beyond the confines of your level, making the world feel bigger and enhancing the mood and theme of your maps. Almost all games use a skybox system if they require the player to see outdoor areas (Figure 10.16).

Basically, the skybox can work in two ways. The easiest way is just to cover the entire map with one giant dome—like an inverted salad bowl—which is textured with an image of sky, clouds, a giant alien moon, and whatever other details are needed for the level environment's setting. The disadvantage with this feature is that unless this dome is massive, the dome will skew as the player gets nearer to one side or the other. This is to be expected—if something is visible but far away, like a

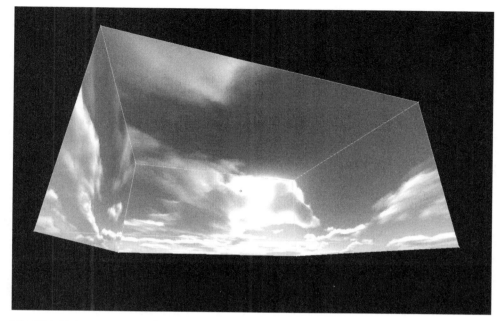

FIGURE 10.16 An example of a skybox.

mountain, walking a few paces won't make it noticeably larger on the horizon. However, closer objects like buildings, or a phone booth in the midground, will grow in relative scale as you approach by only a few steps. Thus, this method of simply pasting a sky around the entire level doesn't work exceedingly well (though a surprising number of games attempt it).

The second method, which is almost universally adopted by commercial games, is creating the sky environment in a separate area and then allowing the walls of a level to "see into" that environment. Imagine if the horizon of your level were really a box made up of movie screens that were projecting a 360-degree view of another place. Now say that no matter how far you walked in any direction, those movie screens would never get any closer—that's the benefit of a skybox. By painting the walls of your level with a special texture that allows it to show a view from the skybox, the game engine does just that, allowing a very detailed skybox environment, with a sky color, fog, clouds, terrain, and other visual effects to be seen "over the horizon" in the actual level by the player.

Fog

Fog is a simple but amazingly effective visual effect that also has performance benefits in most engines. In real life, when water vapor or fine particles gather in a

dense cloud, it obstructs your view as a cloud. When you're *in* the cloud, it only allows you to see a short distance before the view fades into a single color. This is what fog does in games, allowing the level designer to set a value in the environment that tells the engine to create a "mass" in the distance into which the view disappears. Three factors generally determine the fog in the map:

Start distance is how close to the camera the fog begins to affect the player's view.

End distance determines at what distance from the player camera the effect ends.

Color tells the engine what color the fog needs to be—a designer could make it blue-gray for smoke, or light grey for morning fog, for example.

The less distance between the start and end, the less subtle the effect generally is, and the longer the distance, the more natural it seems for general atmospheric fog. The player should rarely be allowed to feel claustrophobic or have the view restricted too much unless it's a special (and brief) requirement for the level—a burning building or falling through murky water, for instance.

In real-life conditions, there is always a haze in the air—it comes of having an atmosphere on our planet. The haze may be heavy, or it may be light, but it has the effect as described earlier. Earth's atmosphere will often begin to occlude very distant objects such as mountains or skyscrapers, eliminating detail and color, eventually leaving them as muted silhouettes against the sky, and finally eliminating them from view. As a natural condition, adding fog to a level will often give it a much more realistic feeling. The difference between a map with and without fog can be quite dramatic. Figure 10.17 shows the difference before and after fog is added in the same level.

FIGURE 10.17 Notice how fog enhances the scene (right).

The technical advantage for fog occurs when engines are intelligent enough to realize that when an object in the level is completely obscured by fog, it doesn't need to be rendered anymore. This means that if a level has a lot of detail, fog can be added, and brought in close to the game camera, allowing the player to only see a little of the detail at a time. This won't work in a level that is meant to be set in—and subsequently textured and lit like—a sunny meadow, say. However, for preexisting conditions where fog would limit the view—rain, snow, a sandstorm, San Francisco in the morning, or London at night—fog can be used for visual *and* technical benefits.

Ground Fog

Some engines allow a level designer to set fog on the Z axis—up and down—to create the sense of water vapor collecting low to the ground. This is a great effect for cold or damp environments such as cemeteries, cold storage rooms, nighttime deserts, or tacky nightclubs. Although the benefit of culling distant geometry isn't very useful here, the effect of ground fog can add a great deal of dimension to a map. This effect can be simulated easily, however, by layers of flat planes mapped with semi-transparent mist textures and stacked low to the ground instead, with collision turned off so the player avatar can pass freely through them.

Particle Effects

Particle effects are probably *the* most useful type of special visual element in games today. Essentially, a particle effect, or emitter, is an entity in the map that creates actors, gives them a direction and a velocity, allows them to interact with the world for a set period, and then "kills" them by removing them from the level. Think of sparks being generated by a welder's torch. The sparks are short-lived points of light that spray out from the point where the torch hits the metal, and die out very quickly. The shower goes for as long as the torch is held there, generating more and more sparks. The number of sparks at any one time is fairly consistent, however, because the new sparks are being created at about the same rate they are dying. Sometimes the sparks fade out before they hit something. Those that fall on a nearby surface may bounce off or lay on the ground before they stop glowing.

Now think of the sparks replaced with sprites (small 2D images that always face the game camera) or models, and you have the concept of a particle effect. Literally any kind of moving effect or "mass" can be made with an emitter. An emitter can be set to generate large sprites of storm clouds that float across the top of the level, with very long lifetimes. A particle effect can be used to generate fast-falling sprites of raindrops all over the environment, giving the impression of heavy rain.

Using actual 3D models, emitters can generate "debris"—a collection of small 3D meshes that represent chunks of masonry, parts of cars, shards of glass, whatever needs to be ejected when something is hit by a bullet or blown up. These effects

can be used when needed—called up by the engine when a bullet hits a window, for example. However, in the hands of a level designer, an emitter can be set to use models for environmental features such rocks tumbling down from a cliff, meteorites, chunks of ice floating down a river . . . the list is endless.

SIDEBAR

An example of using an emitter in a creative way can be seen in *Harry Potter and the Prisoner of Azkaban* for the PC. In this title, the first level is set on a train moving through the country side. To get the effect of motion, the train remains static and all the elements outside of the train's windows in the level are set to move. The ground textures pan across the map opposite to the direction the train is meant to be traveling, for instance. To enhance this effect, particle effects generate trees and make them move in the same direction and speed as the texture on the ground, then destroy them when they are out of view of the train. From the outside the level, this looks like trees appearing on one edge of the level and racing across the ground to the other. However, from the *inside* of the train, the effect is very effective—it really seems like the trees are zooming by because the train is in motion.

These effects can often be attached to other actors in the level—a smoke particle effect to a car's exhaust, or a small emitter that generates "ripples" around a character when it enters water.

As useful as they are, particle emitters aren't great for everything. They can be a resource drain on the hardware because they generate lots of geometry at a high rate, which can be taxing to calculate. Particles don't generally have collision, so that the engine doesn't need to work out how each single particle needs to interact with the level surfaces it hits. Some engines do have the option of particle effects using real-time physics to calculate collision, but this should be avoided unless the effect really depends on it.

To keep performance high, restrict emitters to where you really need them. Don't try to replicate visual effects that can be done more easily, but might take longer, using less costly techniques. The numbers of particles generated, how complex each one is, and how long it will remain alive in the level—all affect the engine. Keep the numbers low and work up if more detail is needed, rather than starting with a complicated effect and trying to strip the numbers down, which will take a lot longer.

SUMMARY

The look of a level is important, not just to hook the player at the beginning of a level, but to support the aspects of the level that aren't just gameplay. The atmosphere, the theme, and the uniqueness of the environment are all enhanced by attractive visual design. Visual elements also create a better play experience for players, as we have explored in this chapter. The use of lighting and textures to enlighten players, guide them, and warn them, without forcing the information, is part of the level designer's talent for telling a story without words.

We looked at many different visual techniques that are available, but it is important to remember that they don't all need to be used. Picking the right visual treatments and carefully applying them to your level will result in a product that players talk about for years.

INTERVIEW WITH MATHIEU BÉRUBÉ OF UBISOFT ENTERTAINMENT, INC.

Mathieu, if gameplay is the immediate challenge before the player, how do you go about planning a level? Do you generate a pool of experiences on paper and string them together to make a level? Or do you plan a basic level flow and identify "beats" where you will go back and create immediate experiences on a later pass?

This question is a bit personal, in the sense that I don't think there's one better way to do it. Each LD has his favorite way of level planning, though we're being asked more and more to put everything on paper before building anything.

My own way of doing things is that when I come onto another project, I take a few days to build a document I call the Gameplay Ideas doc. In there, using all the game ingredients, I try to combine them in the most interesting manners to come up with the most gameplay ideas possible. Doing this, what happens is I find way too many ideas for a single level, so the doc becomes a general reference tool for anybody starting his level planning.

Then, using the doc as a tool, I enter level planning. On paper, in a document I call the Level Design doc (LDD), I create the level structure: what kind of areas are in the level, how are they connected, what objective are there, how are they accomplished, what kind of enemies will you be facing, etc. But most importantly, for each area I list what the intended gameplay is: what is the

→

obstacle, and in what way can the player overcome it. This is really important because it's the best way the rest of the team can understand your intention, and having them understand it means that the tools you need from them to be able to build your gameplay will probably come sooner and in better shape than if they wouldn't have had any paper reference.

So yeah, I guess it's safe to assume that I do generate a pool of experiences on paper and string them together to make a level. But this generalization lacks a few important details. A lot of factors come into the equation of choosing the right gameplays and building the right sequences of them. Things like level theme, how far in the game is it, does it teach a new skill, has it been used already, if so can it be made harder, etc.

So when the LDD is complete and approved, its time to start building the level.

Does this mean the creative part of the job is over, that everything that needed to be thought about is done? That for the next months, your brain can go on a vacation while you do the grunt work? ;)

Nope. Certainly not.

You mention planning a basic level flow and identifying beats where I would go back and create immediate experiences on a later pass . . . This is appropriate too, because the LDD can never cover more than 80% of the player experience. A lot of the small things in the level will not be covered in the LDD, like where does this guy take cover after a firefight? Or how lit is this hallway, etc. You need to stay focused as you go about these small details, and if stuff gets cut because of different reasons, you need to be even more creative in finding solutions that keep your level's quality high. Going back into your level on a later pass, like a few months after, can also help you find weaknesses to your initial design and react accordingly, something that often allows huge leaps in overall polish of a level.

With the amount of creative energy needed to design, build, and decorate a level, often a designer can be burned out by the time it comes to actually creating gameplay. How do you overcome that sort of block when you're designing play spaces?

The answer actually lies in your question. First, you mention level designers "decorate a level." This is something that is slowly going away in our industry, as it should. We want level designers to work as much as possible on the minute-to-minute gameplay of the game, and to leave all the aesthetic aspects to other persons, often called "level artists." By removing all graphical responsibilities from level designers, save from the very rough basic geometry,

\rightarrow

we give them more time to experiment with the engine, to work closely with game and AI programmers, to work with the designers and scriptwriter, to tweak their gameplays, etc. Which in the end, makes for a better (and prettier too) game.

You also mention that "often a designer can be burned out by the time it comes to actually creating gameplay." That should never happen. Creating gameplay should be the first step to anything the level designer does. Before actually sitting down and building a level, he should have taken the time to think on what his intentions are for the level he's building, what kind of situations he wants to put the player in, and write all of this down on paper. It's a fact that this process is too often overlooked still today. Building gameplays shouldn't be about where do I place this guard, how high is this platform, how far does this enemy patrols, etc. It should be about the immediate challenge. What is the current obstacle the player is facing and how is it possible to get past it, and what makes the situation unique and fun. Once the basic gameplay ideas are found, then you can start thinking about how you want to build your environment around them.

11 Building the Level Part 3: Theme, Investment, and Atmosphere

In This Chapter

- Dissonance Strikes Back
- The Elements of a Great-Feeling Level
- Theme
- Player Investment—Believability and Consistency
- Atmosphere
- Summary
- An Interview with Rich Carlson of Digital Eel

As we examined in the previous chapter, having an attractive level makes for great screenshots. However, when the player is actually in the level, able to explore his surroundings, investigate interesting areas, and feel real feelings based on encounters, looks alone do not create a compelling experience. A level needs substance—atmosphere, ambiance, and a theme to tie everything together. In Chapter 4, we discussed the need for "water cooler" moments in a level. This can often be through the atmosphere alone. Given enough tension, emotion, and believability, players may rave about a level simply because of how good (or creepy, empty, exciting, and so on) it *feels* rather than how well it *plays*. So, without further ado, let us explore these concepts further.

DISSONANCE STRIKES BACK

As a level designer, you are responsible for the visual impact of a level to some degree. While your artists or creative director may be making sure the high-level looks are catered to, you need to make sure the small things aren't forgotten. Players are much more likely to notice something out of place or blatantly incorrect in your map than they are to notice how realistic or pretty the shrubbery looks.

Say your level is set in ancient Egypt. Don't put medieval tapestries in, or a room full of nuclear detonators. This is because the way humans think is based on patterns, and when everything is flowing along smoothly visually, the player is "invested" in the game world, but as soon as something weird pops up the player's brain will shout "Whoa! What's that doing there?" On the other hand, you can add some elements that are slightly dissonant but less likely to jerk the user out of the experience. For example, Biblical and Egyptian folklore have many tales of magic. Placing magic-wielding temple guards or platforms that float above a deep abyss with no apparent method of suspension—these elements may just be accepted as "mythical Egypt" by the player who so far has seen nothing historically inaccurate.

If you are creating a futuristic level with an Egyptian theme, try to tie the more dissonant elements into the theme. If you need to place a flying vehicle in a medieval level, make it look like it is made from rough-hewn timber, crudely sewn leather and furs, and held together with iron bands and nails. Just because it *didn't* exist in a historical era doesn't mean you can't make it look like it was. For example, in the film *Stargate,* the main characters travel through a dimensional portal and find themselves under attack from a technologically superior enemy with an Egyptian flair—their powered battle armor looks like statues of Egyptian gods that we have all seen in museums. The architecture on their spaceship is made to look like space-age materials with mysterious internal lighting, but it still conforms to a real sense of Egyptian art and architecture. This is a thematic approach to the design of the film, much in the way you should apply your theme to the visuals in your map.

SIDEBAR

Experienced level designers can often get away with limited forms of dissonance, when they *intentionally* want to shock the player or make him feel like something is out of place. Placing nuclear warheads in an Egyptian pyramid may feed a story element—perhaps your game is driven by a conspiracy theory of ancient aliens who built the pyramids returning to reclaim the earth. The warheads may be placed there by a secret government agency intent on wiping out the returning alien craft.

Until now we have talked about thematic dissonance as being undesirable because it causes the player to question his surroundings, or our attention to detail as level designers. However, for many storylines, making the player question himself, his surroundings, his motives, or his purpose is desirable. A game where the player is stuck in a dream or a nightmare, for instance, can break the theme every now and again to remind the player his surroundings are not stable. A soda can in the middle of a Victorian bathhouse level might stir paranoid feelings in the player and prepare him for the revelation that he's stuck in some kind of failing virtual reality. This planned form of dissonance allows the careful level designer to create specific emotional states in the player—wonderment and realization, which we will examine later in the chapter.

Generally, if you aren't familiar with the theme you have chosen, or has been chosen for you already for your level, start researching it. The more you know about the architecture of the period and place, especially, the more believable space you will create.

THE ELEMENTS OF A GREAT-FEELING LEVEL

The laundry list of critical aesthetic elements needed for a great level experience differ as wildly between level designers, as levels do between genres. Here, however, are common if not critical elements you'll need to address when building the level:

- Theme
- Investment (believability and consistency)
- Atmosphere

THEME

We touched on the theme of your map in Chapter 7. However, it's one thing to simply pick a keyword or simple theme concept when you first begin to design, and it's an entirely different feat to make sure your chosen theme is represented fully and completely throughout the level.

The theme of your map will help *ground* your player in the environment and create a sense that he is in a real space—even if that space could not possibly exist on earth, or within the bounds of our own reality. The theme you choose will determine different things in your environment, such as the following:

- Architectural style
- Natural elements
- Sound and music
- Character accents and costume
- Lighting
- Puzzle components
- AI behavior
- Weapons and items

Style

Keeping things continuous, architecturally, will help the player's belief that he is in a real place. Avoid sudden transitions to completely different-looking areas or forms of architecture. Although the player may not be a scholar in historical architecture, mixing different decorative periods, such as Art Deco (lots of geometric shapes and bold colors), Gothic (gargoyles, narrow arches with pointed tops, tall columns), and Megalithic (large stones with spirals carved into them, stacks of flat rocks piled to make shelters, standing stones) will simply confuse the player and make him wonder if he skipped to the next level by accident. Mixing architectural styles can, how-

ever, be successful if it is used consistently across the whole game. For instance, if your game is set in an alternate version of the future where the Roman Empire never collapsed, you might have a theme across the levels that uses a blend of historic Roman and modern-day materials and building styles (skyscrapers built with Roman columns going all the way up and round-arched windows, for example). Conversely, mixing architectural themes in-level is only useful if you *want* to make the player feel uncomfortable. Otherwise, stick to the elements of your theme, and try to make nonthematic elements fit as well as you can. If you need an elevator in a medieval castle, explore how you can pull it off using technology and materials of the day. For instance, in modern-day Thailand, they use bamboo scaffolding instead of steel because bamboo is strong and flexible, and grows naturally in that climate. That's an appropriate thematic take on an architectural element.

Natural Elements

Much as the architecture in your map should reflect a time, period, and culture, the naturally occurring elements, such as trees, plants, rock formations, and so forth, should also remain consistent with what you have chosen for your map. For instance, if your theme is a post-apocalyptic desert, placing a leafy oak tree on top of a sand dune won't go over well with the player. Nor, in fact, will a large lake of crystal blue water, even if *technically* clean water could be found in such an environment. You need to restrict yourself to the palette of your theme—cacti, cow skulls, the wreck of a long-dead automobile, and endless rolling sand dunes will all work nicely, however.

Sound and Music

Generally, you will be provided with sound elements by your audio department or sound artists, or you will be using sounds that shipped with the game you're making levels for. You will probably also have access to the sounds and music made for the other levels in your game, or a pool of common effects that is open to all of the level designers to help make more atmospheric maps.

The theme of the map should be reflected in what the player hears, just as much as in what he sees or feels. Avoid overt conflicts in theme, such as using country music when the player is sneaking through an Aztec religious ceremony. Avoid using sound effects that evoke hollowness or echo for characters walking through the corridors of a cruise liner. Try also to avoid well-known stereotypes. If your level is set on a spaceship, don't have your doors hiss when they open. *Star Trek* has a corner on the "hissing door" market. Go for something meatier instead, like a whine of electrics, the gurgle of fluid being transferred, or the clank of ratcheting gears. Meeting your theme never means you have to pander to stereotypes.

Character Accents and Costume

If your theme has no real basis in reality—if it is some kind of futuristic earth society, or set in a completely alien dimension, you can pretty much choose whatever cultural elements you want for the way your characters talk and what they wear. Why do the high-ranking officers of the Empire in *Star Wars* all speak with highbrow English accents? Because it's cool, that's why. There's no way we can argue against that decision because the characters are all part of a completely fictitious universe.

However, if your level for a horror game takes place in a Lovecraftian New England town in the turn of the century, having a character talk like a cartoonish Italian pizza chef will do nothing for your mood. You want mumbling fishermen or drawling small-town policemen. There is a lot of debate about realism and game dialogue. Many people feel that if a game is set in a real-life area that speaks a language other than English, then the game audio for that level should reflect that, and use subtitles to translate the speech for the player. On the other hand, many other designers feel that this is too distracting, and characters from places like Russia, China, or Morocco should speak in an *accented* form of whatever language the game is aimed for. So for a game released in the U.S., all the characters would speak English, but using the accents of where they are meant to be, allowing the player to hear the dialogue without reading titles, but also feel more immersed in the culture of where the level is set.

Either option is valid, and in general, you won't have much control over the specifics of who does the voice acting for your level. But you can try to make sure that you don't end up with dialogue for your map that doesn't fit at all. Make sure your producer or creative director clearly understands the theme of your map so they can plan to work with the voice actors in achieving an appropriate characterization.

Lighting

Outdoor lighting differs by location, weather, time of day, and season. Indoor lighting is affected by light source, temperature, the amount of dust or moisture in the area, or the surfaces of the space (painted, concrete, natural rock, wood or rusty metal?). We talked at length about contextual lighting in the previous chapter, but the sermon here is the same. Make sure your lighting sources are continuous with your level's theme. Don't use halogen light fixtures in your 13th-century cathedral. Open-flamed torches in wall sconces look good against wood or brick, but they will look out of place against metal walls not only because a metal wall covering suggests a fairly modern building, but also because the player is simply used to connecting torches to medieval or pre-industrial locations. Candle flames won't stay lit in exposed conditions outdoors, unless the player can safely assume they are magical, or in someway not *normal* candles. Let your instincts and research guide you in placing proper lighting elements.

Puzzle Components

Often, you will have moving elements and pieces to puzzles that need to show respect for the level theme. For instance, cogs and clockwork tend to work in indoor areas, even areas where one might not traditionally expect it. An Incan temple or a Tibetan fortress, for example, can easily support a puzzle where the player has to jam the workings of a complex mechanical machine. On the other hand, in a futuristic setting like a battle cruiser, having mechanical puzzle elements will look out of place. Better to represent the same puzzle as hacking a computer terminal or trying to short the power on a panel full of colored, glowing cables.

SIDEBAR

While working on the *Harry Potter* series of games, we found that level designers were often tempted to create very "realistic" puzzles using mechanical pieces or moving elements that were suspended by chains, posts, and so forth. In keeping with the theme (a magical school for young wizards and witches), we had to keep reminding ourselves that the puzzles didn't *need* explanation. In fact, we could have floating bridges, magically activated stairs that slid out of walls, or floors that simply fell away to nothing, because the player was *expecting* supernatural encounters and things that couldn't be explained easily. Oddly, despite having license to do whatever we wanted, it was a constant battle to *not* make rational obstacles and encounters. If your level's theme is a fantasy, be prepared to try to push back your natural need for rational spaces and structurally realistic encounters!

AI Behavior

The way your characters and enemies behave should be determined in part by theme. SWAT teams fight in tight, coordinated units. Militia units tend to be more disorganized and prone to flee. An experienced pilot may not attack an enemy he knows he cannot win against, but in a WWII flight simulator you would expect a Japanese fighter pilot to be a fierce opponent, no matter what he is up against. When you are choosing or scripting the behavior for the NPCs in your map, think about how it will affect the theme, and the player's sense of belief. Don't have your elite troops fleeing as soon as they get hit by the player, and likewise, don't have civilians calmly wait on street corners when giant robots are attacking New York City. Almost every level has AI of some type, and it is a big part of what gives your level flavor, so use it wisely and have it fit the theme of your map, even if it isn't interacting with the

player. Have your Egyptian priests light fires in the temple. Or if your theme is "Clear a rebel base located in a South American swamp," have the patrolling NPCs mimic human behavior by walking around puddles and pools, and stopping and using their flashlights to scan the undergrowth when they hear branches breaking around them. Have them swat at giant mosquitoes landing on their arms and necks, and give the player the feeling he's watching someone traverse a real patch of jungle. We'll examine this later as "life beyond purpose" for making the player believe that an NPC is a more complex individual rather than just a simple AI routine.

Weapons and Items

This one is pretty obvious. Roman legionnaires didn't use machine guns. Aliens tend to shun cleavers (unless they're all out of laser cannon ammo) and flint knives. Use your brain and choose an appropriate metaphor for your weapons and gameplay items. The Ancient Celts may not have had medical kits, but they had common plants they used for healing injuries. A great example of a thematic health item can be found in *Max Payne,* where the player finds bottles of painkillers to restore lost health points in relatively appropriate areas of the levels—bathrooms, locker rooms, kitchen cabinets, and so on. If your theme is a "steampunk" fusion of Modern and Industrial Age, maybe your weapons will be mechanical, rapid-firing flint-lock pistols, and powerups are special science books that can be found on desks, shelves, cabinets, and podiums. There's almost always an appropriate thematic metaphor for gameplay items that will fit your level, if you think hard enough.

PLAYER INVESTMENT—BELIEVABILITY AND CONSISTENCY

Chapter 1 described level designers as responsible for the *illusion* of reality in levels. This can seem like a tall order to new level designers. How will the players truly believe that they are in a real space when they are always, to some degree, aware of being in their living room holding a controller and simply watching events play out on TV? Well, really it's no different than someone getting "lost" in a book or at a movie theatre and forgetting where he is in the real world. They are *invested* in the experience, and the events unfolding before them. Luckily for you, the level designer, games are capable of much more intense forms of investment because the player isn't simply watching a predetermined series of outcomes. Your players have real-seeming choices and goals in the game that only they can accomplish. People's (simulated) lives or world events hang on their actions, and the plot doesn't move forward until the player wants it to. This experience is from a combination of all the games parts—the script, the game design, the code, and the art. However, to keep the player invested, your responsibility as a level designer is to keep the player believing in what he is seeing. This doesn't mean you need to create a world so de-

tailed that the player can't help but feel immersed and sucked in—far from it. Trying to go that route will only lead to failure—there's no way you can ever build a level that is on par with the real-world in choices or level of detail. However, you have the unique power to capture your audience just as intensely as any other form of entertainment.

This is *believability,* the process of making your audience believe in the experience you provide. Stage magicians have been doing this for centuries. When your girlfriend goes up on stage and gets sawn in half at a magic show, you know it isn't real, but it doesn't stop you from feeling anticipation, fear, excitement, and finally relief when she steps out of the magician's box unharmed. The art of stage· magic has perfected the art of believability.

You can use your own sort of magic when you build levels. The main way to do this is keeping the illusion of reality *consistent.* Don't give your player a chance to question the validity of the environment he is moving through. The more you can give a reason for things to exist—or not to exist—in your map, the better. Following are some techniques you can use for consistency.

Provide Real-Life Services

Is your map set in a restaurant? If so, it should include areas and services that the player could reasonably expect from a restaurant in real life. It should have a kitchen, or at least indicate that there is a kitchen that the player can't access for some reason. It should have restrooms, with toilets, sinks, and hand driers inside. It should have areas to store dishes and cutlery and preparation machinery, and the people inside should be either customers or restaurant staff. All these things will be what the player will *expect* to find. You don't need all them to create a realistic environment, but the less you have the more it will be obvious that this is simply a generic environment that has been half-heartedly dressed up as something like a cafeteria. The player may not consciously *miss* seeing bathrooms in environments that might have them in real life, but having them, and making them open for the player to enter and confirm that they exist, will create a much more comfortable and consistent feeling of an actual restaurant. Bathrooms, kitchens, break rooms, and lounges, in fact, are all great ways to give a space a "human" dimension. Almost every building has some form of restroom or facilities in or near to it for the people who live or work there. It might not be the most glamorous room you build, but the benefits of a well-built bathroom in your map are appreciable.

Give Your NPCs Life Beyond Their Purpose

How many times have you waited and watched an enemy character simply sitting in a chair, not moving more than the slow up and down motion that indicates breathing in a game character? How often have you seen an NPC pass by a television set on patrol without even glancing at it? One way you can create much more

believable world in your level is to give *life* to your characters. Make them feel like real people, that there are actual minds behind their movements and actions when they are not simply shooting or fleeing from the player.

SIDEBAR

In *Splinter Cell,* the player is meant to sneak through the maps without being seen much. This means that the NPCs spend a lot of their time doing relatively mundane things, especially those characters that aren't armed and simply walk the corridors of a map acting as simple moving obstacles that the player would need to avoid or risk alerting. To make sure the character seemed more realistic, I tried to include elements in my maps that would allow the NPCs to interact with the environment, or at least have something that would break up very obviously looping paths. Vending machines are great for this, especially if you can get your animators to provide animations that support an NPC using them. In one of my levels for the game I was able to have an opponent walk up to a drink machine, insert some money, wait a few seconds, and then begin pounding on the front of the machine when he realizes that it took his dollar. Players can relate to this sort of scene—it adds humanity to the denizens of the level.

Simple, real-life acts occur around us all the time. You might have a character stop and look at a hat in the window of a clothing store as you follow him. You might have a jeep unit guarding a resource on the map, and every so often have another jeep drive up, and the first one drive away, giving the player the impression that they were taking shifts. It doesn't matter if the player never sees it—those that do will feel a great deal more immersion in the environment, which is worth a little of your time to set it up.

Don't Mistake Realism for Immersion

Game levels rely on illusion. When a level is set in an oil refinery, the whole complex is not built down to the last closet. The level provides the areas that the player needs to access to further the story line or meet his objectives, with a few side areas or less relevant areas often thrown in for the sake of making the level look like a bigger environment than it really is. The reason for this is simple—it would be lunacy to try to create an entire building's worth of space if the player just needs to get from the basement to the roof. That's like building a car every time you needed to drive to the grocery store—it's simply not worth the effort.

However, the temptation is always there when building a level. Putting a blank doorway in an office building can sometimes feel like cheating the player. It may seem like a trivial thing to simply put a small room behind the door with a desk and a chair, just in case the player decides to open the door and go in. What's the problem with this? Well, there are a number of problems:

- Weakening the critical path
- Causing render bloat
- Wasting scheduled time
- Confusing the player

Weakening the Critical Path

Levels are generally linear, if not spatially, at least in the way the player needs to complete certain tasks one after the other so he can progress or finish the mission. This is often referred to as the *critical path*—the route through the level that the player needs to take for success. Part of the level designer's job is to lead the player through the environment, making sure he does not get distracted so much that he wanders off the critical path and has trouble getting back on it. By including too many secondary areas purely for the sake of making a more real-seeming level, you risk diverting the player off the path and potentially causing frustration once he gets to the end, or explores the environment and finds nothing worth having gone there for. Unless your game allows you to place reward items in every office, you should consider using fake doors to line corridors and give a *sense* of many more rooms than there actually are to explore and avoid feeling like you have to create them all as explorable areas.

Causing Render Bloat

Say you build an entire factory for your map—every office, every machine room, every toilet stall and broom closet. Chances are the player won't have the time or patience to see it all—but the engine will. The engine will need to render everything you add to the environment, and you will need to try to optimize the entire thing in defense. This is render bloat—causing the engine to render things needlessly and risking performance problems by including more data than it can handle at once.

Wasting Scheduled Time

When your producer is setting up your schedule for building a level, he isn't expecting you to build a 100% accurately modeled space. Game development is a race against the clock, and unnecessary areas of the map take time and resources to create but don't add anything to the critical path. If you are found to be wasting time building superfluous areas, structures, or paths, you might be putting your schedule

in jeopardy. You can only build so much in a reasonable amount of time. Concentrate on getting the vital spaces built, and return to creating additional areas if time permits once your scheduled tasks are complete.

Confusing the Player

Say the player has been walking through a level set in a hospital. As he moves through the first floor, he finds that each door opens to reveal something beyond—operating rooms, offices, wards, and so forth. All are modeled completely, and the player stops to explore each one in case there is a clue, or a pickup lying around somewhere. As he moves upstairs, there is a similar layout, but now none of the doors will open. Are they all locked? Are some of them open? Where is the key? Checking each one reveals that it is nothing more than blank image of a door, rather than a moving piece of geometry. Actually, the map's creator simply ran out of time and wasn't able to give the second floor the kind of attention he gave the first. The *player* doesn't know this, however, and will simply be confused by the situation. Players are used to doors opening when they lead somewhere useful, or for a reason. Going against this convention can prove confusing, or worse, extremely frustrating to the average player. Simply creating some explorable spaces in one area but not in another is even more unbalancing. Be consistent with the reality of your level and make things ergonomic for your player. Avoid creating too many areas that are irrelevant to the player, that confuse the critical path, or that will waste time you will need later for an important part of the map.

Balance realism versus practicality when creating, building, and decorating. Naturally you want to make your space seem like it could be real, or to have a sense of purpose and function beyond what the player might immediately have access to. However, a hyper-realistic map isn't always going to be fun to play, whereas a fun map can always be made more realistic.

Directing the Player with Consistent Clues

Players don't want to be told how to play a game. They play because they want to be in control and make their own decisions. It is still important for a level designer to lead a player through an environment, using hints and prompts that allow the player to make informed choices without feeling like he is on the designer's leash being led to each item of interest. Some of these clues can simply work by tapping into a player's own brain, by using elements in a scene that will attract attention, like using subtle lights to highlight important items in a dark a room (a ray of light from an overhead window being cast onto a particular row of books in a case for example). These techniques are often used in movies, in books, or in paintings to draw the audience to certain conclusions or part of the framed image.

In games, a technique used frequently to let a player know if something is worth pursuing is to develop a consistent difference between how elements of interest and things that are simply props or static decorations are represented. Take the case of doors, which, as we explored in the previous section, can often present a problem if the player isn't sure it's a real door worth trying to open or not. It's best to teach the audience early that a door that cannot be opened has a simple image of a door handle, while a door that the player can open—at some stage during the level—is represented by a more fully modeled door with a 3D handle. The difference is subtle, but if it is consistent, then the player can begin to see quickly while playing which doors need to be tried and which doors can be ignored. The system could be simply that metal doors, for instance, are always locked, and doors with other texture types have space behind them to explore. Many games use this clue system for doors. Consistency, not the actual difference, is the key to informing the player about what is "live" in the level and what is not.

ATMOSPHERE

When someone describes the *atmosphere* of a level they have played, they are really talking about how they felt while playing it. Part of this feeling comes from how immersed in the environment the players were—how real it seemed, how much the level reacted in ways they expected and how many things they were able to do without being reminded they were just playing a game. The other part comes from the way in which the development team was able to create *emotions* in the player by using dramatic elements such as sound, light, architecture, and textures.

Together these two experiences create atmosphere, and mood, in a level and make something that isn't just a series of encounters with NPCs or room after room of puzzles, but an actual living environment where the player feels fear at what is growling in the next room, elation at moving a bridge into place, anxiety at riding a rickety gondola over a boiling, lava-filled crater. Atmosphere is the glue that binds the fun of the level's gameplay and the work of the art and programming team into an *experience*, allowing the designer to tell a story about the level through visual elements.

Letting the Player's Imagination Do the Work

One thing to note is that atmosphere isn't about jamming as much cool stuff in your level as possible. In fact, very often atmosphere can be created by the *absence* of things. For instance, in a game where the player is used to hearing the moans and groans of monsters, a level where suddenly there is no noise at all, except maybe the very low, very faint sound of a ventilation fan high above—will make the player feel that something is wrong, that something bad is going to happen, or that something

is waiting for him. Let the player do some of the hard work and *suggest* things in your level. Suggestion can be made as audio or visual clues—a bloody footprint, the sound of tapping behind a locked door, or simply the sudden silence in what should be a noisy, crowded environment. These all suggest certain themes or situations to the player. Even if they aren't the thoughts you had intended the player to have, they are still enjoying your level on an atmospheric level. Let's look more at the kinds of emotions and reactions over which level designers have control.

Fear and Anxiety

Fear is a fairly easy emotion to evoke in the player. In *Resident Evil*, a game all about scaring the player, early in the first level the player enters a well-lit corridor with nothing out of the ordinary. With no warning, however, two zombie hounds burst through a window behind the player character as she passes by it, which is a universally recognized "heart stopping" moment in game history. Fear can be created by any kind of drastic, sudden, tipping of the balance against the player. Having all the lights go out, having an elevator drop without warning, or the ceiling begin to collapse—these are all proven methods of scaring the audience, pioneered by Hollywood horror movies decades ago.

Anxiety, on the other hand, is a more subtle and complex emotion that needs to be built over time. The player also needs to feel some attachment to his character for anxiety to take root. If the main character is disposable, what's the problem with having him die? Conversely, the more time and effort the player has put into evolving and progressing his character through the game, the fewer chances he will want to take with a dangerous situation. Anxiety, then, is implanting the idea into a player's mind that his character may be about to run into some kind of lethal situation. Think about the opening scene of the movie *Raiders of the Lost Ark,* where Indiana Jones is swapping a bag of sand for a priceless gold idol that is resting on a pillar in a trap-infested temple —the slow movements in the scene, the music, and the close camera angles all create a stressful, anxious feeling in the audience. There are many great ways for this in games, and often audio comes to the fore in levels where the player is meant to feel nervous or anxious. *System Shock 2* used ambient effects and subtle incidental music to create an almost tangible feeling of dread. Slow, eerie music, the silence of a shopping mall that seems like a massacre has taken place, and the occasional announcements of an insane computer for a crew that has all been killed—these are ingredients for a high level of anxiety in a level. The longer the level designer can stretch the *feeling* that something bad is about to happen, without having it broken, the stronger it will become. Eventually it will become boring, however, and needs to be resolved in an actual encounter. No one single emotion can last for the whole level. Going back to the concept of rhythm, as a level designer you need to create a roller coaster of emotions with your level's atmosphere, balancing drawn-out emotions with sudden changes in emotional tempo.

Revelation, Realization, and Wonderment

Game levels frequently can be predictable. The player has already guessed the critical plot-twist or secret long before he encounters it in the map, and when he does, it's more of a reason to wonder why he paid good money for the game instead of being a jaw-dropping moment of enlightenment.

The emotion of *wonderment* is tied closely to the "Wow factor" in levels. Although the player may be stunned by a revelation that a friendly character has really been trying to kill the player, or that the spaceship he has been fighting through is really just a set on an alien reality-television show, these are more often related to the game's script or narrative. To create wonderment through atmosphere, you need to do so using the tools at your disposal as a level designer. When the player emerges from a dark and cramped prison interior into a lush, sunlit valley, or when a growling monster the player just killed turns to the main character and recites a Shakespearean sonnet with his last breath, that will cause the player to wonder if it was really a monster he just struck down. As mentioned at the start of this chapter, using dissonance in a carefully controlled situation often creates wonderment. At the end of *Half-Life,* the player sees things in the levels that make him wonder if all the fighting he has done up to that point has actually furthered the cause of the people he thought he had been fighting against—the remains of a human soldier on an alien world, for example, is a powerful form of realization or *revelation* caused by seeing dissonant elements in a map. Surprising the player with situations he was not expecting is the key to wonderment. When the player realizes that what at first glance seemed like a simple puzzle turns out to be the critical element in the level— fixing a broken control panel on a derelict spaceship and suddenly having all the power return to it, lights flaring up all over the craft with the sound of the engines firing up—that is a key emotion a level designer has the power to create through atmospheric elements.

Relief, Satisfaction, and Joy

A controlled atmosphere can also be used to create many positive and fulfilling feelings. This feeling naturally comes naturally when the player completes a difficult encounter or puzzle, or simply finds a well-hidden exit. Timed events can amplify this sort of relief by increasing the stakes for the player.

SIDEBAR

Say you have a room that the player falls into. It is a wide circular room with a single door to exit and the floor is covered with a foot of water. When the player initially falls in, he suffers some degree of panic—what is this place,

how does he get out? Finding the door, the player quickly enjoys a small degree of relief at escaping what first appeared to be a dangerous situation.

If you had created a problem that needed to be solved before the door opened, say a logic puzzle in which an exposed panel in the door reveals several terminals that need to be connected by the correct wires. Now, completing the puzzle and opening the door to freedom allows the player to feel satisfaction—he didn't simply activate the door and walk through, he earned his freedom by rising to the challenge and beating the internal mechanism.

However, if you had introduced a timed element, such as an environmental danger like outflow pipes coming on and flooding the chamber, then you have introduced a strong element of urgency and fear into the encounter.

The player is now racing against the clock, trying different wires and connecting them to terminals. The threat of drowning will probably affect his decision making and each mistake or disconnection will be a painful error. Eventually, the door engages and the player spills out beyond with the floodwater. What is he experiencing now? Satisfaction and relief, which together form a sense of joy at beating the odds and not succumbing to the trap.

Relief is when the player drops the controller and breathes a long sigh, as adrenaline pumps through his body. *Joy* is when he drops the controller and dances around the room, shouting. If this seems impossible for a simple video game to produce, consider the many games that rely on this emotion as reward for playing well. Racing games such as *Mario Kart* rely heavily on the player crossing the finish line just ahead of his opponents, coming first by a nose after three grueling give-and-take laps. This needs the AI behind the other racers to be good, but not so good that the player cannot win against them. Well-executed plays and game wins in sports titles have the same effect on players. These emotions are all about build up, risk, and ultimately, the feeling of beating the odds. Part of this is the player's investment in the game or game characters, and part of it is creating a sufficient illusion of danger.

Loss and Regret

Earlier in the chapter we examined the idea of the player being able to *invest* in the game by belief in the surroundings and seeing the result of hard work and long hours in the player character or units.

Through the introduction of plot elements, we can also have the player become attached to other aspects of the game—characters, weapons, vehicles, or what have you. When a player is attached to something, he is then capable of feeling *loss* when that elements is removed, destroyed, or perceived to no longer be accessible to the player. A common example is a trusty sidekick NPC that the player relies on in the game that is suddenly killed with the player being helpless to stop it. Or the player reaches a point in the game where all of his hard-earned weapons are removed, and he starts the next level with nothing but a piece of pipe as a weapon. These are classic, if not overused, design elements engineered to create a sense of loss in the player. The former example is simply borrowed from Hollywood movies, where lovable sidekicks or secondary characters die needlessly by the hour. The latter example, however, is more of a game convention, because it directly affects the player's ability to interact with the game. In a shooter, the main way a player can express himself or interact with the world is through his weapons. Take those away, and the loss is tangible. Both are valid, but take more than clever level design to achieve. Working with the game's scriptwriter and design lead, you can, plan carefully crafted encounters that will strengthen the player's perceived relationship with certain game characters, and then the final showdown event (or events) in a level where the loss will occur. These events should not be cutscenes, if possible. Simply watching a friend get gunned down by a gang of outlaws in a pre-rendered movie is much less compelling than seeing an ally go under as you race to his or her aid, ultimately in vain. Even better, create encounters where the player *can* save an ally. Branching narratives (where the game's story can go down different paths based on the actions of the player) and emergent gameplay is improving to support this sort of life-or-death decision by the player. If there's no real connection between the player and an NPC, there may be little incentive to save the NPC from harm. On the other hand, in the same game a different player may seek to protect the same NPC at all costs.

Silent Hill 3 is a great example of player attachment (and loss, later in the game) using branching narrative. In this game, the player meets a mysterious woman, Maria, who is both appealing and yet incredibly acerbic at times. Soon after, the player finds he must protect her from the creatures prowling the town, and the game not only notices how well the player protects Maria but also picks an ending based on that protection. The player's own sense of attachment and fear of losing Maria (or not, as the case may be) as a fellow living being in an otherwise lonely world, determines the final outcome, but the game never forces the player either way.

Relative to atmosphere, it is quite possible to keep the *threat* of loss current to the player by making sure the environment is dangerous in a way that is threatening to what the player is trying to protect.

Atmospheric Audio

Our ability to hear is actually much more powerful than our ability to see. This means that players will often notice subtle audio hints more often than subtle visual ones. For one thing, human sight is directional—it needs to be focused on something to register it. The ears pick up sound from all around, however, and the brain can focus on and filter out a large number of sounds at once.

All of this is really to say that audio plays a major part in creating atmosphere in games. As you seek to infuse flavor and ambiance in your map, add layers of sound. Music can enhance almost any mood if it is consistent with the encounter or on-screen situation. It is useful to watch different types of movies and analyze how the music is used to create emotions and give the viewer a better feeling of the environment in the scene without actually being there. A musical score is such a powerful stimulant for the imagination, and yet viewers rarely actually notice the music—it just becomes part of the scene. Remember that a player probably won't have time to stop and admire the game's musical score, it will go directly into his brain without his realizing it, making it a useful and elegant way of controlling the atmosphere.

Similar are ambient sound effects. In a dark cave level, a few *drip-drip-drip* sound effects playing in the darkness will suggest a huge amount of subconscious information to the players. It suggests water nearby; an echo suggests the cave system is huge and hollow; it might subtly suggest footsteps; or that what is dripping isn't water, but maybe something far less wholesome . . .

When building, make sure your sound assets are up to date, and don't be afraid to approach the sound designers when a brilliant idea for an atmospheric effect hits you—that's what they are there for, after all.

SUMMARY

The need for eye-popping graphics and in-your-face gameplay is growing in games, with each new generation trying to differentiate itself from an increasing number of competing titles. Don't necessarily let this steer how you will bring the player in and keep him interested in your levels. More subtle techniques need to be employed—the level designer needs to think of all the little details that will make players of the game feel immersed in the map and that the game world is actually much bigger than the level they are restricted to. Atmosphere, believability, consistency, and keeping a theme running through the level will all help enfold the player in realism and grounded in whatever rules the designer sets.

AN INTERVIEW WITH RICH CARLSON OF DIGITAL EEL

Rich, you've been involved in designing levels for quite a while now, can you tell me a little bit about your career and how you came to be a designer?

A long time ago in a galaxy far, far away, a nasty hard drive crash put me out of the music business for a few months. Suddenly I had more time on my hands than usual. While I was recovering work and trying to hustle new music gigs, a friend showed me *Doom* and gave me a freeware copy of WadEd, a .wad file editor. He said something like "You run D&D games. You might like to make levels." I was skeptical because I wasn't into games with guns, but the engine was so cool and whoa, the sound was in stereo. You mean, I can add my own midi files and SFX too? Neato . . .

Turned out he was right. I ended up making a couple of dozen free levels for *Doom, Doom 2, Heretic, Hexen,* and *Quake* right away, like within a period of six, maybe eight, months. I really enjoyed that time. It felt like rock and roll did in the '70s. LAN parties were just starting to happen. There was this funky community, an undeniable coolness about it, and the technology was hot. You're right where you want to be.

Anyway, *Quake* was the game that got me my first legitimate job in the game industry. I'll always credit *Quake* itself before any other factor. Steve Rescoe (id), John "DrSleep" Anderson (not involved with the game industry anymore), and I had been trading *Quake* levels and emails via this wonderful new thing called the "Internet." (The *Doom* community started out on BBS so this was a pretty big deal.) By the way, I was the newbie always looking for criticism and Steve and DrSleep were really mentors to me.

Meanwhile, John Romero and his pals were setting up Ion Storm although I wasn't really aware of this at the time, or interested the game biz at all. It was about levels, not getting a job. DrSleep had Id connections having worked on the "Master Levels" add-on for *Doom.* Soon, Romero got Sleep on board and they started looking at user-created levels to find new blood to staff up Ion's two brand new level design departments.

What it boiled down to was that if Romero liked your levels, you were pretty much in. Steve and I got offers, which was totally amazing and we both eagerly accepted. And, you know, quite a few level designers working in the industry now got their first jobs during that '97–'98 boom time.

By the way, my Ion interview consisted of a five-minute long-distance call from John Romero.

\rightarrow

Do you think different game genres yield very different level requirements, or is there a fundamental set of rules that all levels share?

The basics, things like paying attention to details or understanding the tools and operating them correctly, are always pretty much the same, but each genre offers unique challenges and surprises.

Actually, with enough research and a little careful thought it isn't too hard to cop a genre, broadly speaking. What's tougher is handling each "flavor" within a given genre. That's what separates the men from the boys. Is it semi-serious science fiction like *Star Trek*? Is it geek-funny, like *Hitchhiker's Guide to the Galaxy*? Is it kid-funny like *Jimmy Neutron*? Is it fantasy like *Star Wars*?

Understanding flavors, which requires a broad familiarity with a given genre, and being versatile enough to execute them has got to be one of the most challenging aspects of level design, especially in these days of licenses and mass market (as opposed to niche) games.

Could you elaborate on the concept of "flavors" and how level designers can go about absorbing them (and understanding them) into the critical-thinking areas of their brains?

I use "flavors" because of my aversion to technical sounding words. "Sub-genre" isn't quite right. "Variations on a theme" might be closer. Varieties of ice cream. Varieties of rock 'n' roll. Like, punk isn't country rock even though they use the same chords.

If you play in a variety band or a wedding band, you know dancers want to hear the songs "just like on the record." If you can't pull this off, you won't please them, you won't get rehired, and your group will go broke. You absolutely have to know all of the flavors of "rock 'n' roll," and the flavors of other categories too. Quite a chore. (Fortunately, if you really like music, getting there is half of the fun.)

If you understand the flavor you stand a better chance of being able to execute or recreate the flavor authentically when asked to do so. The more flavors you understand, the more styles (hey, style's a good word for this) you can pull off. Studios need versatile level artists who can switch flavors without too much trouble to suit the style (yeah, I like that better) of each game that comes along.

How do you get this? Wow. You spend a long time collecting information, details, trivia. If you want to be a jazz guitar soloist, you listen to jazz guitar records and cop everything you hear, and this takes years. You can't understand punk, country rock, art rock, heavy metal, folk rock, jazz rock, and grunge by next week. There is no crash course. You have to pick it up bit by bit, and you have to take the time to absorb it.

→

So hopefully you find a nice broad category or two that you like, like science fiction. You decide you want to work on science fiction games. Why? Because you always liked science fiction. You are insatiably curious about it. It entertains you. You care about it. You know you do because years have now gone by, and you have never stopped being surprised by it.

Even if you don't like Flash Gordon or Dune or Doctor Who, certain aspects of it, you can appreciate them all because they're "in the realm" of your interest. And meanwhile, you're absorbing all of the juicy details you can.

If you don't come to the table with a lot of background like this in a couple of genres, it's not the end of the world. Most shooters, for example, are pretty clichéd and their settings, architecture, and encounter types are well known and relatively easy to emulate. But just as you get cozy, your studio signs to do a *Star Trek* game, or a game based on the new *Hitchhiker's Guide to the Galaxy* movie, or maybe something from Pixar or Nickelodeon, yow!, and you've got a whole different level art style and vibe to deal with.

If you're an empty slate and unprepared/inexperienced, it's not like you'll lose your job. There's a lot of support on a team and lots of different things for a level artist to do. But, you may not get very close to being involved with core level design issues. The folks with the most familiarity with the particular flavor of the game and its presentation will be taking care of that.

In this book, I talk about the importance of planning and documenting a level design before building anything. Can you describe to the readers how you go about designing your level and the kinds of techniques you use to turn ideas into actual gameplay?

Graph paper and pencil. I may draw a Zork map (a flow chart with movement directions) or I might draw an area-by-area layout to scale but it all starts with a good old #2 pencil.

Since a story obviously has a beginning, a middle, and an end, and since I think of each level as kind of a short story, I try to make sure that I have those three plot points covered first. Start with a bang or begin with a dramatic or mysterious event. Put a decisive event or a twist in the middle. End with a bang, a cliffhanger, a cool transition, or something like that.

Then I try to think of a couple of fun encounters to put in between those three points. If you're working from a design document, these might be the opportunities when you can wing it and stretch out a little.

Meanwhile you're asking other designers and testers if the ideas you've implemented are interesting and fun to play. You go on feedback and tweak or replace until the whole thing runs smoothly and satisfyingly (and is challenging and fun).

\rightarrow

Where do your encounters come from when you work? Do you keep a notebook of fun encounters, or is it more of a metal bank? Or do you simply generate gameplay ideas on the fly as you come across "holes" in your level?

I believe in chance, trusting your subconscious, and having tricks up your sleeve.

Chance is easy. Keep randomly smacking different things together and something cool will eventually occur, assuming you know a good thing when you see it.

Having faith that your subconscious will provide good ideas from time to time seems like betting on chance but, as a friend of mine once said, it's amazing what your brain can do when you're not looking.

A bag of tricks is an absolute necessity. It's full of all of your favorite ideas that you have collected and saved, that have, to the best of your knowledge, never been done before. It's also your chops, the serious skills you possess. Very important because (a) who you get to work with depends on your chops, and (b) if you don't have any chops, "you can't play."

Of your many levels, what stands out as the one you are most proud of, and why? What makes it different, specifically?

There are a couple of free levels I've made, or collaborated on, for the various *Doom* and *Quake* engine games that I think represent my best work. *The Doom That Came to Dunwich,* Iikka Keranen's Lovecraft-themed *Quake 3 Arena* level—he allowed me to add a couple of rooms and "co-direct." "Dungeons of the Doomed" for *Doom 2.* "Oblivion" and "Fane of the Diabolist" for *Quake.* And then there's the chicken level I made for *Heretic* but we won't go into that.

I also made a few *Morrowind* mods that I'm happy with, particularly "Three Shades of Darkness." You can find all of these levels on the net in the usual places.

"Oblivion" has kind of an interesting story (pictures too) at *http://digitaleel.com/blog/ob.htm.*

I like these the best, even over the professional level work I have done, because each one has features that are unique or personally interesting to me. "Dunwich" has Dali, Escher, and Ernst paintings hanging on the walls of a secret underground sanctum. "Dungeons" is an immense D&D-styled dungeon fortress layout; it's a dungeon crawl for *Doom 2.* "Oblivion" is all about small Roger Dean-like sky islands floating in a black void. It's a jump puzzle level that's actually fun to play. "Fane of the Diabolist" was the level that got Romero's attention at Ion. It has some really weird stuff in it, "arty" stuff, a couple of very obtuse (awful) puzzles and outside areas with uneven "natural" ground, which was actually kind of an innovation then.

\rightarrow

"Three Shades" is too complex to talk about here but it's large—three very detailed dungeons connected by a story thread from an earlier mod I made. I created a ton of content and Iikka modeled and skinned a couple of nifty new weapons for the mod, including the now infamous Pandemonium Parade Baton. Throughout these levels, I'd add original art, sound effects, new writing, and even original music compositions. I put my heart and soul into them.

I've never been happy with a single pro level I've made. They all were rushed and really suffered for that. Many had to be remade several times due to lousy, incomplete, or nonexistent game design in the first place. After too many cooks had their way with them, the finished versions never looked as good as I knew they could look and never played as well as I knew they could play. Continuity was missed or ignored. Trendy gimmicks were added to "spice them up." Areas were re-lit or re-textured and botched. Jump puzzles were added. Switch and floor plate puzzles were added. Etc.

After a couple of years of this I got pretty frustrated because I knew that nobody was ever going to see my best work with that kind of arbitrary atom-smashing design process going on. Still, I tried to be optimistic. I switched companies and forged ahead. Three years later, after much more of the same, I had a revelation about what my role should really be, but I had become very jaded and I was too burned out to really act on it. That whole wonderful yet frustrating period of level design was coming to an end for me.

Given current advances not only in rendering and display technology, but also in processing power and maturity of gamers, what would you have done differently if you were creating those levels now or in the future?

Free levels? Honestly, nothing except incorporating any new features that might enhance the level. It's much more likely that I would just build brand new levels with new features to experiment with.

Pro levels? I'd try harder to tie Wow! features to Wow! gameplay elements instead of trying to be so subtle all the time. Every gamer deserves a clever level with a well thought out and logical underpinning, but what they really want is to be entertained!

You know, I don't really think about gamer maturity because the average gamer today only knows games from the last couple of years. They haven't seen a fraction of the cool things computer games can do.

\rightarrow

Can you illustrate the major pitfalls that you have overcome in your career, and those that you still see new generations of level designers falling into?

Be honest with yourself and identify your real strengths. Then focus on them and make sure your boss knows what they are.

Although I can usually whip up a fun playable level, my most authentic abilities are in aesthetic areas, like lighting, accurate and creative texturing, colors, detail work in general, dressing, artistic composition and balance, visual continuity, etc. In other words, I should have been working in the art department.

By the time I figured that out, I was already burned out from five years of full bore heavy crunch dying company level design. And, dang it, I had to stop doing it for a while.

Any parting words of advice for the up-and-coming generation of Level Designers?

If everything is wonky, and you can't seem to get your level working or playing smoothly, it may simply be suffering from obesity. Flabby levels are easy to fix though. Highlight generous areas of geometry with impunity and hit delete. Generally, I think that intense tightly focused short levels are more fun to play than padded-out long levels. Make more short levels and less long ones.

Maybe that's just a personal preference. I like short economically written chapters in novels, and short scenes and quick cuts in movies. I grew up watching too many Tex Avery and WB cartoons.

Do detailed work and take pride in that but don't get stuck on one thing for too long. From the midpoint on, once the level has taken shape, do light passes and finesse the level a little each time. If you get hung up trying to perfect one thing at a time, valuable days will pass, other parts of the level will get shorted, and you'll probably have to change it later anyway.

Do you merely get impatient with long levels, or do you think there's really a problem out there with too many level designers trying to stretch out the length of their environments too far?

I do get impatient with long levels although there have been exceptions, like some of the mission areas in *Thief: The Dark Project* which were huge but also very focused and tactically fascinating. You had to kind of live in them, so to speak, to survive. But usually it's the old all-American "big is more" thing. People think bigger is better, and they become overambitious, until they realize they have to fill even more square footage with interesting details and things to do. When a level designer chumps this, you know it, players know it, testers know it, because you end up wandering through large areas with absolutely nothing to do. Yeah, I think this is a fairly common design mistake.

12

A Case Study: The CIA Level from *Tom Clancy's Splinter Cell*

In This Chapter

This level is chosen as an example to illustrate several aspects of previous chapters. On one hand, the CIA is an example of how good planning can pay off. Much of the level was done on paper before the editor was even opened, with several phases of documentation, sketches, and layouts building to the initial whitebox stage. On the other hand, we didn't plan for the kind of performance hits we started to see once the level began to take shape, and so some drastic cuts and optimizations had to be introduced to make it perform better on the Xbox.

AN INTRODUCTION TO *SPLINTER CELL*

At the beginning of *Splinter Cell*'s pre-production, there were only a handful of us designing the game. It was the first game Ubisoft produced at the Montreal studio that would break the tradition of family-oriented and casual games by bringing in the kinds of things fans of Tom Clancy love from his books—firefights, political intrigue, and a strong sense of realism. Because this was new territory to the studio, we found ourselves laying tracks as we went, and many of our ambitious ideas about the scope and complexity of the levels were tempered over time as the game began to gather steam.

The Team

The level design team consisted of a lead level designer and six level designers, each responsible for two to three maps of their own design. Each designer varied in experience and background, some of them coming from other projects at Ubisoft, with the rest hired from the extensive community of *Unreal Tournament* amateur map-makers. While we were planning the team, we thought that having seven level designers might be excessive, but we quickly realized that we had completely underestimated the workload. In the end, an entire section of the game, a set of four levels set in Siberia, was dropped to allow the designers to concentrate on their other levels. Although painful for the people who had put a great deal of work into their Siberia maps, as we have discussed in previous chapters, the ability to quickly adapt to change and move on is a necessary quality in level design given how fast external pressures can build up.

The Pipeline

Splinter Cell was one of two titles at Ubi Montreal being developed with Epic's (at the time) cutting-edge *Unreal Warfare* engine. On previous titles, level designers at the studio had mocked up levels in 3Ds max, and then handed off the maps to artists for all the final geometry and beautification. With the new engine, the designers would be responsible not only for the gameplay but also for a good deal of the final architecture and geometry. Much of the decorative work was done in Max by artists and then imported into the map through the *Unreal* editor. This method of producing levels meant setting up a different pipeline for the company. Each level designer was paired with an artist. Designers would be given the basic information for their level—environment, key story points, main objectives, enemy types, and allowed equipment—and then would build the level on paper themselves. The artists working with them would be involved in the construction stage, providing textures and environmental models to decorate the levels with, including unique set pieces. Level designers were also responsible for creating scripted events and in-game cinematics using a custom scripting engine.

CREATING THE LEVEL DESIGN STRUCTURE

All the levels in the game started as long columns of paper tacked onto the walls of a meeting room—the "war room" technique worked extremely well for us to be able to break the game into logical chunks and outline the necessary details for each one. Critical level components were written down on sticky notes and moved around as we struggled to balance the initial flow of the game. After we were happy

with the level structure, the distribution of items and equipment, environmental factors, and story elements, all the data was typed into mission abstracts—one for each level—and these became the starting point for each level designer creating the finished design.

Mission 2.1–The CIA

Splinter Cell was designed to push stealth gameplay as much as possible. At its inception, the game was designed by a core team of four, all of us big fans of the *Thief* series by Looking Glass Studios, and the aim for our design was to take the tightly focused gameplay of the most successful stealth games currently available and bring them into a contemporary setting with real-world locations and situations. One of the highlights of the sneaking gameplay was the Central Intelligence Agency level, which had the player breaking into one of the most heavily secured installations in the world and do it without causing a single casualty.

The CIA level was created as part of the first pass of mission abstracts. The initial level documentation, once it had been written up from a sheaf of paper covered in scribbled notes and Post-Its, is shown in the sidebar. As you can see, the details at this stage are slim, and most of the document is just bullet points and one-line objective summaries.

2.1–CIA HEADQUARTERS, LANGLEY, VA

LEVEL SUMMARY–Find the leak

Someone inside the CIA is leaking information to the Georgians. Fisher must find the leak so that Third Echelon can follow it toward Kombayn Nikoladze.

Objectives

1. Access the CIA's internal server. Any information leaving the CIA would have left an imprint on their server. If Fisher can infiltrate the CIA and access that server, Third Echelon can trace the imprint to its source. *(Use Object)*
2. Access Dougherty's Computer. The computer belonging to a CIA employee named Mitchell Dougherty is the source of the leak. Fisher must access it so that Third Echelon can trace it to the Georgians. *(Use Object)*

\rightarrow

3. Kidnap Dougherty. Third Echelon wants Dougherty alive so that he may be interrogated. We must know whether or not he was consciously giving information to the Georgians. *(Find Person)*
4. Extract Dougherty. Fisher must carry Dougherty out of the CIA and to Jr. Wilke's truck. *(Extraction)*
5. Escort the Truck. Fisher must clear a path for the truck to get out of CIA headquarters without being detected in a restricted area. *(Escort)*

CHARACTERS	NPCs
Sam Fisher	CIA Agents
Irving Lambert	CIA Police
Vernon Wilkes, Jr.	CIA Technicians
Jack Baxter	CIA Bureaucrats
Mitchell Dougherty	

ENVIRONMENTS
Autumn in the American South
Night
A storm is brewing above
Sheet lightning, distant thunder

This sidebar is good example of a first-draft mission abstract. As scant as the details are, the skeleton of the level is there, the basic location elements, the must-have game objectives, and the kind of ingredients available. This is just enough of a framework to begin hanging a design from.

From this information, an overview document was formed, using an aerial photo of the CIA complex found on the Internet, to mark out rough locations the level would take place in and fleshed out with some text descriptions beneath it. Often you won't be able to have an actual reference photo for your level, and in such a case you might need to provide a sketch map or simple diagram to illustrate the scope and locations of the level visually. The overview draft is reproduced in Figure 12.1 in its original form.

OVERVIEW DRAFT—MISSION 2.1 CIA HEADQUARTERS

FIGURE 12.1 The CIA complex with rough indications of where the player will go.

©2002–2004 Ubisoft Entertainment. All Rights Reserved. Splinter Cell, Sam Fisher, Ubisoft, the Ubisoft logo, and the Soldier Icon are trademarks of Ubisoft Entertainment in the U.S. and/or other countries.

Section 1: Entrance and Basement

The player starts in a small wooded area by the main entrance. Low decorative hedging provides shadows for movement, and a lake area provides water to hide in when K9 patrols get too close. The Main CIA entrance is, obviously, a bad place for Sam to enter, but it's doable with enough ammo and a lot of luck. Instead, Fisher will be informed that 3E is shutting down the A/C system for a few seconds allowing him to enter the building through the blades of a large fan. The player can from there use a security corridor to bypass the entrance post and get to the main elevator lobby where he can catch a ride to the basement, and the server room.

\rightarrow

The basement is alternately well lit in busy areas, and dark in the areas that are shut down or inactive at night. Some scripted events such as people crossing Sam's paths, as well as patrols and such will keep the player on his toes.

The gameplay in this section is mostly stealth and timing based. There will be some small shortcuts, mainly through a cramped cable run branching from the backup battery room, that will make the player's life easier if he finds them. Once the player enters the server room and does his thing, he'll make his way further into the basement where he'll reach a small lobby and head up stairs to the courtyard.

Section 2: Courtyard and Cafeteria

The courtyard is a wide paved area in a quadrangle between looming CIA office blocks. Across a small wooded area is the cafeteria, a modern three-arched tent-like structure that contains the main dining room, cafeteria, and kitchens. The player will need to work though this structure to access the paper disposal complex behind it, where a disposal tube will lead to Dougherty's office area.

The gameplay here is split indoor/outdoor. There will be activity outside— a higher state of security with a patrol car, and various cops and maintenance guys walking around. Inside the cafeteria, most of the seating sections are closed. The kitchens are manned by a skeleton staff catering to the CIA overtimers working tonight. The paper disposal section will be a loud place, with some technicians working on machines and such. There will need to be a lot of vertical components that Sam can use to get up to the level Dougherty is on.

Section 3: Information Retrieval Department

This section will be busy. Some areas will be dark, with motion-sensitive lights. Lots of locked doors, and offices. Some will be open and there will be a good deal off foot traffic, agents and pencil-pushers walking around trying to deal with the current crisis. One of the cooler ideas here is for Sam to make his way through a few sections of tape carousels with robotic arms moving around filing tapes, to get into a sealed off area, Dougherty will need to be followed and knocked cold when he goes to smoke, If not, the player will need to carry him to the smoking lounge and out onto the building's super-structure. Still carrying Dougherty, the player must maneuver across building facades and rooftop to slide down to where the van is waiting. Physical stealth gameplay rules here. With the bulky body on his back (alliteration) Sam is unable to fight or use geometric events to move, and must remain unseen at all times.

\rightarrow

> **Section 4: Clearing the Path**
>
> In this section, Sam will need to scout ahead of the van. There will be cameras, patrols, and a few security stations with guards in bulletproof huts where Sam will need to take them out and switch off the tire-slasher roadblocks that stand in the van's way. Lots of stealth and timing. This is still just at concept stage right now.

Although not always necessary, this sort of overview documents are useful when you're pitching your design or trying to explain the basic concept to someone else. Even if you don't ever end up showing it, it can help to write down your vision of the level to solidify it in your own mind. The example in the sidebar might be a little wordier than necessary, but remember it can often help to paint a clear picture in someone else's head to use a good description when you don't have time to make diagrams or track down extensive photo references.

ASSEMBLING REFERENCE

After a presentation of the infant level to the team, and all of the issues at this stage resolved, the next step was to track down references for the map. Several sources proved useful for digging up good references. Simply typing "CIA" in Google's image Web search came up with a variety of images from official and unofficial sites.

Several Internet search engines support image-only queries. Google is a great place to start looking for references, or even quickly find sites that might contain many relevant pictures. Just point your browser to http://www.google.com *and click on "Images" above the search bar.*

We also had access to a few television documentary videos, which provided visual references for some interesting areas in the complex, as well as a little about how the facility operated. For instance, one documentary showed document disposal tubes that employees would use to destroy sensitive documents. These tubes were used in the original design to allow the player to climb up onto the floor where Mitch Dougherty worked, though they were removed during production. It was important to try to find good reference for this level in particular because as far as we could tell, the Central Intelligence Agency was really just a glorified office building.

It would be hard to create a rich visual experience, exciting physical gameplay, or intense stealth situations like some of the other maps provided, unless we could justify them with appropriate spaces. In searching, we tried to find as many "cool" locations with atmospheric or gameplay appeal as possible.

Ultimately, the following areas of interest stood out as good strategic additions to the level design:

Lobby

The lobby in the level (Figure 12.2) is a combination of the old and new entrances of the actual CIA. We wanted to keep the grandeur of the real-life location—the marble tiles, inset CIA logo, and the exhibits dotted around the room—but make it more suitable for moving around in shadow. I placed a fictional element in—a long glass ceiling to provide an overhead light source, and then created pillars beneath it to cast pools of shadow the player could move between.

FIGURE 12.2 The CIA lobby. ©2002–2004 Ubisoft Entertainment. All Rights Reserved. Splinter Cell, Sam Fisher, Ubisoft, the Ubisoft logo, and the Soldier Icon are trademarks of Ubisoft Entertainment in the U.S. and/or other countries.

Basement Corridor

We had one rather fuzzy image of a corridor with a curved ceiling and dark panels on each side with recessed lighting behind them that we took from the TV documentary. It ended up being used as reference for all the corridors in the CIA basement area where the main server was kept. It was very sci-fi looking, and we thought it made a nice transition from the "high governmental" style of architecture of the lobby area to a more subdued and clinical look below. It also paid to represent the popular public image of the CIA as being a high-tech environment rather then a regular workplace. An early construction is shown in Figure 12.3.

FIGURE 12.3 An eerie basement corridor modeled on actual CIA reference. ©2002–2004 Ubisoft Entertainment. All Rights Reserved. Splinter Cell, Sam Fisher, Ubisoft, the Ubisoft logo, and the Soldier Icon are trademarks of Ubisoft Entertainment in the U.S. and/or other countries.

Battery Room

One of our accumulated reference images was an image of the CIA's rather large emergency power facility. It had racks and racks of what looked like giant car batteries that would power the vital systems of the agency if the main power sources were interrupted. This not only seemed like a good visual area to include, we also thought it would be amusing to add a technician walking through the stacks of batteries trying to count readings and forever having to restart. The tall rows of batteries made it possible for the main character to execute a special move where he would jump up and wedge himself high up between two walls.

Cafeteria

The cafeteria is a large tent-like structure sitting at the center of the campus. It's quite visible in aerial photos and has been the backdrop for a number of movie scenes taking place in the CIA. We thought it would be a significant way to "ground" the players in the CIA by having them traverse a well-known part of the facility. One of the best things about using extrinsic knowledge—or knowledge from the real world outside the game—like landmarks is that it allows the player's brains to feel that the spaces are more real.

Rooftop Fans

Another external feature is a building shown in aerial photographs behind the cafeteria with large vent in the roof. Because the player needed to move an employee out of the complex using the rooftops of the CIA, this seemed like a relevant obstacle they might have to face on their way out. It should be said that we *assumed* that these large disks were fans. It was an educated guess on my part, but even if I guessed incorrectly (and they are actually UFOs) it's a great example of a simple reference image inspiring a level design decision—the fans turned out to be a very cool visual experience in the final level, regardless of whether or not they exist in real life.

THE DESIGN PROCESS

Originally, the map was intended as a four-segment map, but soon after beginning the design phase, it became clear that the map would really need to be divided into five sections instead, for convenience and for optimization. The opening part, the CIA entrance, was split into two separate maps, one for the above-ground portion and one for the underground areas. At this stage, there was enough information to begin the process of actually designing the level—a time and place, goals and objectives, a general idea of the level flow, and a folder full of reference images. I could begin to put pen to paper and start sketching out a level layout, starting out with

some loose sketches of a few key environments—the server room, sneaking past a security station by crouching under the shelf, a room with a turret that the player would encounter later in the game. Usually at this stage, as discussed in Chapter 7, a more abstract flow sketch is recommended: just putting down some gameplay ideas and key locations and linking them to form a series of events. In this case, however, I felt I had a strong sense of the level and moved right ahead on the first pass at a full layout, which is illustrated in Figure 12.4

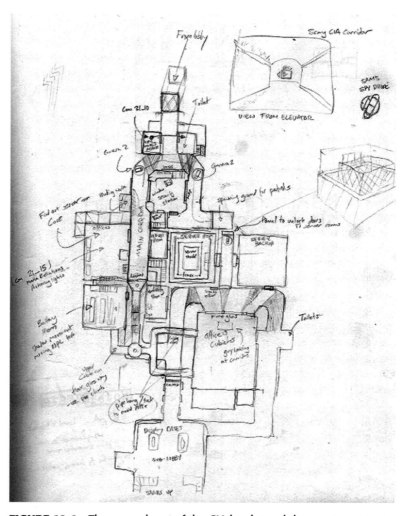

FIGURE 12.4 The second part of the CIA level, rough layout. ©2002–2004 Ubisoft Entertainment. All Rights Reserved. Splinter Cell, Sam Fisher, Ubisoft, the Ubisoft logo, and the Soldier Icon are trademarks of Ubisoft Entertainment in the U.S. and/or other countries.

 Each of the main sections from the draft overview became a layout sketch in this manner. Roughed out in pencil, it's easy to erase and redraw the level in small sections. The first parts that you solidify on paper tend to be the areas that are most delineated by the level's needs—rooms that house the level objectives, the points of interest, the areas that provide the most gameplay interest all get filled in at the beginning. Then come the connectors—the elements that connect the gameplay areas, like corridors, staircases, hidden vents, maintenance tunnels, and the like. This is the system of building content from the most important areas—those that are likely to be fixed in place or time —to the most generic sections that can more easily be changed to fit changes in the level.

In parallel to creating the floor plan, we began adding in the gameplay ingredients. The level was to be about stealth, not combat, so there needed to be some diversity in ways to detect the player as he moved through the map. In addition to patrolling employees, agents, and CIA security patrols, we added many cameras and alarm panels to ensure that the player's mistakes would have serious consequences. Cameras were designed to see the player, or unconscious bodies, and raise the alarm. Alarm panels allowed NPCs that saw the main character or witnessed something wrong to run to the panel and alert everyone else in the area to the presence of an intruder. To balance this, the level needed a lot of shadows to let the player slip by these obstacles, and more importantly, to always have somewhere nearby where he could hide and wait out a search when he was spotted. Lastly, we needed to put in markers for every scripted event, cinematic, objective—any event that would need to be placed within the map and would require the support of an artist, scriptwriter, modeler, and so on.

Photoshop was used to create the basic floor plan from my layout sketch and thenseparate layers were set up to separate all these elements for easier reference. Figure 12.5 shows the lighting layer, which indicates the preliminary areas of light and shadow for Part One of the level. Figure 12.6 shows the layer that includes the event information for things like computers with information, NPC conversations, and the like.

It's important to stress here that this level of detail stems from the fact that *Splinter Cell* has a few gameplay systems that overlap all the time. Giving the player the choice to shoot opponents, sneak by them—or simply bypass them—means that the levels had a higher gameplay load to support than would, say, a straight combat game or puzzle adventure title. In a traditional RTS or platformer where the route and pattern of gameplay may be simpler, this level of detail in your design documentation may not be necessary. On the other hand, your game might support even more systems and possibilities. The only real rule of creating support documents is that you need to make the level clear to the other members of your team and to keep a record of your design decisions. If you can do this through a simple line drawing or a single Word document, there's no need to make more work for yourself.

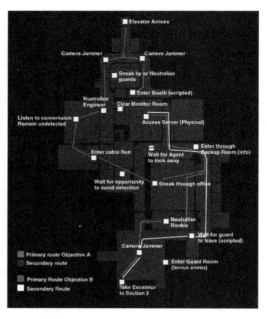

FIGURE 12.5 A map showing the rough locations of light and shadow. ©2002–2004 Ubisoft Entertainment. All Rights Reserved. Splinter Cell, Sam Fisher, Ubisoft, the Ubisoft logo, and the Soldier Icon are trademarks of Ubisoft Entertainment in the U.S. and/or other countries.

FIGURE 12.6 The same area as Figure 12.5, but showing information about in-game events. ©2002–2004 Ubisoft Entertainment. All Rights Reserved. Splinter Cell, Sam Fisher, Ubisoft, the Ubisoft logo, and the Soldier Icon are trademarks of Ubisoft Entertainment in the U.S. and/or other countries.

With the layout complete, we now had

- An overview of the exact size, complexity, and scope of each part of the level
- The number and type of enemies, their position, and their reason being there
- Positions for cameras, alarms, and computer terminals, shadows, scripted events, and surprise encounters

I could now go ahead and open the editor to start building the geometry.

BUILDING THE CIA FROM SCRATCH

The CIA was one of the first levels made for *Splinter Cell*, and construction began without much in the way of anything but what could be constructed in the editor. There were no real models or textures to use extensively, and many that were available were just placeholders or tests. However, there was plenty of basic geometry to build, so the

first early drafts of each section came into being in 3D quite quickly. One of the advantages of doing a lot of design groundwork before you start building is that you anticipate problems early in the process and the actual finished level remains true to the plan. Building from sketchy information will often result in a level that looks and plays nothing like the original plans called for—you start to second guess yourself or fill in details as you go, which can be a detriment if you don't have the will to fight feature-creep. Figure 12.7 shows a comparison between the initial geometry for the lobby location, and the finished environment from the retail version. Very little has changed except for the addition of decorative elements, which is mostly because of how extensively it had been planned before whiteboxing.

FIGURE 12.7 The progression of work on the lobby area. ©2002–2004 Ubisoft Entertainment. All Rights Reserved. Splinter Cell, Sam Fisher, Ubisoft, the Ubisoft logo, and the Soldier Icon are trademarks of Ubisoft Entertainment in the U.S. and/or other countries.

Each part of the level was quickly assembled from BSP geometry as a whitebox in the editor so we could get a feel for the physical space and suitability for the kind of stealth gameplay we wanted.

As each area was created, we put whatever textures were available on the surfaces and added in temporary lighting to rough out the conditions we expected for the final product. After all of the areas had been built out in rough, a copy of the level file was given to a modeler to begin making art assets, while I concentrated on turning a bunch of empty rooms and corridors into a playable level. The CIA was a level built in "sections" so each section would get built out a little, NPCs and game ingredients would be dropped in, gameplay in that area would be mocked up or implemented in rough, and then I would move on to the next section. In this way, each finished section could then be reviewed for level of difficulty and gameplay effectiveness, resulting in quick changes if it didn't seem up to par.

THE DANGER OF UNKNOWN METRICS

One complication during production was that the metrics of the game were still in flux. Things like the main character's jump height, crouch height, and so on were set, but the position of the camera during these moves, the amount of clearance needed, and the proximity at which guards would detect the player were all still being determined when the first levels started production. This meant that when something was changed, I had to go back and identify problem areas, correcting them for the new metric. Although not a source of incredible frustration, it did add up to a surprising amount of time spent reworking the map.

SHIFTING TECHNICAL LIMITATIONS

Another complication was technical limitations, and the little that was known of them at the beginning of the project. *Splinter Cell* was designed as an Xbox title from early on; however, the actual technology that went into the console was being developed in parallel. The team was also using an engine that was itself undergoing major technological revisions, and it became clear that much of what we built needed to be. This led to situations where some areas of levels needed to be heavily optimized—reducing the amount of geometry or ingredients that used lots of system resources—to keep an acceptable frame rate throughout the level.

For the CIA, it was apparent that that level was too big to fit in one map file. To relieve the console of having to keep all of the data in memory, the level was broken into several parts that would load one after the other. A side effect of this was that the

player could no longer be allowed to go back and visit a part of the CIA once the next was loaded. Mission objectives had to be set so that a player could only leave the map once everything he needed to do in that section had been completed. Secondary goals and optional objectives were removed or made mandatory to avoid players getting frustrated when they weren't allowed to return to a previous section and complete a bonus goal they had forgotten about.

REDUCING THE SCOPE

Splinter Cell was a title that envisioned multiple choices throughout each level early in the process. The design team had been impressed by the multiple paths in *Deus Ex*, released a year earlier, and so each level was initially conceived as having many routes to completion, each taking advantage of a particular type of gameplay. The categorizations for these were the following:

Stealth: avoiding enemies and detection equipment

Athletic: jumping, climbing, and shimmying to navigate the level and avoid detection

Combat: quickly taking out enemies before they could react or raise the alarms

We quickly realized once production started, however, that we wouldn't have enough time to complete the levels in their proposed form and ship the game on time. It would be necessary to cut down the scope of the levels, and possibly remove some maps entirely. Looking at the CIA critically revealed some weak spots that were suitable for cutting to reduce the overall size and complexity of the mission.

CUTTING BACK ON CONTENT

The cafeteria section as shown in plan form in Figure 12.8, still just at whitebox stage, could be removed entirely without affecting the flow of the level too much. Originally, it had been included more for its visual impact and recognizability. There were no critical objectives in that section, nor was there any particularly special gameplay. Removing it would reduce the CIA by one-fifth in volume, but the impact on the level as a whole would be negligible.

The next target for removal was the last part of the level—escorting the van carrying Dougherty out of the CIA grounds. This was a slightly more painful amputation because work had already started on some elements. The animations of the van

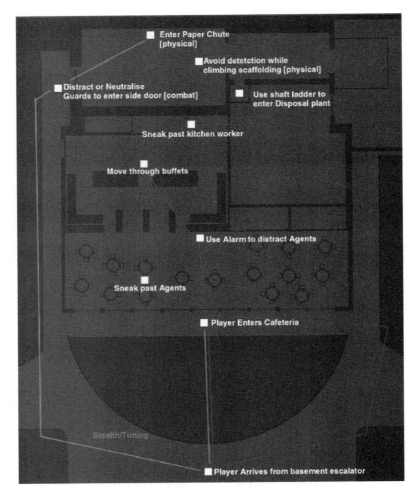

FIGURE 12.8 The original design for the cafeteria section. ©2002–2004
Ubisoft Entertainment. All Rights Reserved. Splinter Cell, Sam Fisher, Ubisoft, the Ubisoft
logo, and the Soldier Icon are trademarks of Ubisoft Entertainment in the U.S. and/or other
countries.

along the winding exit road had been started, but nothing had gone beyond the first
pass for geometry or lighting. We also knew from the design that the level would
need some unique textures and models created for that section. Removing this sec-
tion would bring the level from five parts to three, reducing the physical size, but
not severely affecting the flow or coherence of the mission.

A lesson learned here is that really scouring your designs for feasibility early in the process can be useful in identifying parts of your level that might be at risk of removal later down the road. For some teams, it's acceptable to have expansion joints in a level design—areas that are identified from the beginning as removable if needed, but that will help the level be more fun or immersive overall if allowed to remain. For most teams, however, parts of a level not strictly necessary for play are not a good use of time or energy and are axed during the design phase.

RESUMING PRODUCTION

With the reduction in scope and size and a more manageable workload for the artists and programmers assigned to support the level, work could continue in making the CIA a living environment. By the time the level was whiteboxed sufficiently to prove out the gameplay and player navigation, many of the art and code assets for the level had been started and were available to be put in the map. The next stage was a combination of placing gameplay elements like keypads or computer terminals and decorative elements like vending machines and furniture in places like the break room shown in Figure 12.9.

The CIA continued to grow, bit by bit, according to plan. Surprisingly, much of it remained true to the first paper designs. The first sections to receive attention were those that housed important components of gameplay or specific challenges that would show off the stealth system. Because the original multipath ideas had been resolved into a straight stealth path throughout the mission, it was more important to put in as diverse a collection of sneaking game plays as possible to keep the player interested and the pace intact. Some of the most ambitious shadow-based scenarios showed up in the CIA, including the rear lobby where the player was allowed to shoot out a sequence of lights above him in a relatively well-lit space to create a shadow-path to move across the floor without being seen by cameras. Because of the mundane nature of the CIA in reality, the entire level was quite dark. Partially this was explained away by the fact that the player was sneaking into the facility at the dead of night. However, many players wondered why the level seemed to be so inadequately lit. The truth is, when a choice has to be made between gameplay or realism, there can really be no choice for the level designer—and keeping the shadows ever-present meant a more usable space for the stealthy player.

Gradually, the level approached an alpha state. Most of the elements that defined the level were in place and working well enough to play through. The main server room, where the player would find out who the CIA mole was, was complete. The placement, behavior, and conversations of the night-shift employees that the player would encounter was solid. Computer terminals and keypads throughout the maps had been set up with the proper codes and information to allow Sam to pass through the CIA unhindered.

FIGURE 12.9 A decorated CIA break room. ©2002–2004 Ubisoft Entertainment. All Rights Reserved. Splinter Cell, Sam Fisher, Ubisoft, the Ubisoft logo, and the Soldier Icon are trademarks of Ubisoft Entertainment in the U.S. and/or other countries.

CLEANING UP

Most of the changes in geometry stemmed from issues not apparent during the design phase. Most common of these was that in 3D the level presented some problems that weren't obvious in the 2D paper maps. For instance, there were occasions where a room needed to be lowered, or widened, or a staircase lengthened to make all the pieces fit, especially when it was apparent that the player would be confused by the layout, or unable to move around properly.

A few more serious occurrences came in the form of actual performance problems. For instance, the original plan for the CIA lobby called for a bank of sliding

glass doors at the front of the building that would connect the interior with the grounds where the player started. However, it soon became clear that when players faced the doors from the exterior, they not only saw the lobby, they also saw straight down it into the room beyond. The amount of polygons involved was causing the game to slow down too much. The result was the partitioning of the lobby and the room behind with a short right-angle corridor.

Lastly, there was the removal of extraneous areas. In any game there needs to be a balance between the realism of the space and the toll of rendering too much in a scene. In the initial design, there were many offices with no significance in the CIA, to make it seem less empty, or full of obviously fake office doors. However, in production the logical decision was that these be removed, as is the norm in most games. As we see constantly in level design, reality doesn't always make the best model for designing a realistic space.

SCRIPTING

With construction either completed or under control, it was time to turn our attention to some of the critical scripted events that were still in a basic or temporary form. A good example is the events surrounding Mitch Dougherty, the "mole" that the player must track down, immobilize, and smuggle out of the CIA for questioning.

Mitch was written by JT Petty, our resident scriptwriter, as an obsessive-compulsive night-shift clerk who would leave his office when the player reached it, and meander down to the smoking deck—the only way out of the level to the outside. The player had to check his computer to make sure it really was the source of the leak, then follow Mitch out of the building without being seen or detected, and then haul him down to ground level alive.

The actual script behind Mitch was quite complicated, involving many pauses for washing his hands at water fountains, taking to a fellow employee, and entering codes into security keypads on his way to smoke a cigarette. Creating a realistic sequence would require many custom animations for Mitch, a complex path network for him to follow and a large script to control his movement and reactions to the player. The actual space in which he would move was set and so the work needed to make a watertight scripted scene was next. Without going into too much into detail, the entire sequence took the close support of a programmer and animator to getting running to a point where Mitch would not react unexpectedly, and often amusingly, to seeing the player or hearing a gunshot. In the process, his script became simplified to a point, while keeping the best parts of what we had planned—stopping to chat to a co-worker, washing his hands in a water fountain, and generally seeming like he had a real purpose in his actions.

Other scripted events, such as conversations or even simply having an agent walk to a vending machine and bang on it after losing his dollar, were worked on in order of importance. Even though many of these events were all ways to have NPCs move about the level, they also often provided entertainment for the observant player. In one case, the player needs to cross through an auditorium (shown in Figure 12.10) with a briefing in progress. Although not vital to the missions, it worked to create a huge amount of tension as the player moved silently amongst the chairs and oblivious agents in the heart of the CIA, and was meant to be one of the Wow Factors in the level.

FIGURE 12.10 A view of the auditorium. ©2002–2004 Ubisoft Entertainment. All Rights Reserved. Splinter Cell, Sam Fisher, Ubisoft, the Ubisoft logo, and the Soldier Icon are trademarks of Ubisoft Entertainment in the U.S. and/or other countries.

TUNING

The fine-tuning of a level is often overlooked in the process of building it. However, with the CIA, there were many small additions and adjustments necessary to create the optimal experience for the player. Luckily, there was time budgeted for level designers to create ambient and functional changes to enhance the level while they created the spaces.

One of the simplest things a level designer can do near the end of the production process is to go through and make sure the small things are given due attention. By small things, we mean making sure computers are sitting perfectly on top of desks, that doors fit squarely in frames, that decorations aren't partially embedded in walls or floors, and all the myriad of small graphical glitches that occur when putting a map together.

Another tuning task for the CIA was creating deposit points for players to stash the unconscious bodies of employees to hide them from being seen by other NPCS on patrol or when searching for the player. Even though the design had specified a few broom closets and bathrooms in perfect locations for hiding bodies, there was a greater need for dark corners, overhangs, and shadowy dead ends that would accommodate each player's stealth tactics.

ADJUSTING THE DIFFICULTY

Of the NPC types in the CIA, half were armed, with agents using pistols and security officers using lethal automatic machine guns. Instead of using their firepower and the number of enemies in an encounter versus the player as the main tools for creating different levels of difficulty, we used the physical spaces of the level and the opportunities that came about from combining stationary opponents with moving characters. Often, the player could wait until a group of opponents dispersed after talking, or could watch a moving character to see how long it took before he returned, allowing the player to sneak by or neutralize the isolated character.

In a level where there is a lot of tension, you need to give players frequent pauses or "sanctuaries" where they can catch their breath and plan their next course of action. The level of difficulty in *Splinter Cell* comes partly from the frequency of safe areas compared with the number of exposed areas where the player is in danger. Individual levels within the game used this ratio to control how easily the player could progress and how often the player was at risk of alerting the NPCs or taking enemy fire.

In the end, the CIA fell on the low side of average in difficulty for the game as a whole. Although there were many areas of danger in the map, and the overall restriction on the player of not harming any NPC was always present, there was also a huge amount of sanctuary space and very few large teams of enemies the player needed to deal with. Careful planning and observation by the player would ensure that even less experienced gamers could enjoy a high degree of success.

WRAPPING UP

The CIA ended up being finished by a fellow level designer, Mathieu Bérubé, but it was completed to the original plan and remained one of only two levels in *Splinter Cell* that required a zero-casualty environment. Response to the level from the fan community was extremely positive. Even though some players felt that the level was too restrictive in not allowing lethal force to be used, an overwhelming number relished the challenge, and CIA found it's way into many top-10 lists on *Splinter Cell* forums.

From a designer's perspective, the CIA was an unusually compliant level. Very little of it differed drastically from the original design, and someone who had never played the level could probably use the initial paper layouts to navigate by. Though large parts were cut, they were all somewhat secondary to the mission as a whole and resulted in a leaner level overall. This speaks volumes about the need for substantial pre-design and design time before building a level.

SUMMARY

In this chapter, I talked about the process of making a level from scratch for a stealth-based console title. Your game may be a different genre, or for a much different platform, but many of the points brought up here will be applicable.

What Went Wrong

- The team didn't have enough prior experience with the engine to be able to predict the technical limitations for the title. Thus, many parts of the map had to be visually sealed off from the others, and the level was broken into more loads than originally planned for, which affected the flow somewhat.
- We underestimated how long it would take to make each level. In the case of the CIA, this led to almost half of the level being cut midway through construction.

- The scope of the gameplay needed to be brought down as the map went through production. The early design called for the level to support multiple gameplay types including stealth, action, and combat, but all these would have specific requirements from the environment. In the end, any work not involving stealth needed redesigning, sometimes involving a significant amount of time, as the focus became solely on making the player sneak through the entire level.
- Limitations for the amount of AI in any one area meant that the CIA seemed a little deserted, even for the late-night setting.

What Went Right

- A lot of time spent on sketching and planning meant that many of the problems with the initial design were caught early, sometimes even before building had started.
- Good references helped to create a realistic (or passably realistic) environment for the interior of a building the public has rarely seen.
- A clear design and a solid mission abstract at the beginning of the project meant that we could design in greater detail in the planning stage knowing exactly what elements were to be used, what was happening in the story, who the vital characters were, and so forth.
- Assets made for other levels were easily reused in the CIA, such as computers, seating, vending machines, and so on. This meant that during the building of the level we could place decorative elements instead of waiting until the end to place them all as polish work.

13 Final Word

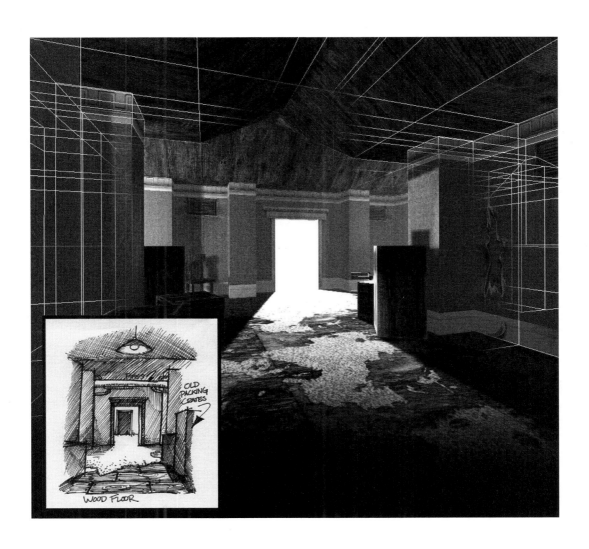

In This Chapter

■ The End of the Beginning
■ Where to Go Next
■ Thanks to You, the Reader

THE END OF THE BEGINNING

Even in a book this size, it is only possible to cover many of the subjects briefly, leaving a great deal to explore about the topics we have touched on. Architecture, lighting, history, geography, psychology, sociology, and on and on—level designers never stops learning to be better at what they do. So, although you have reached the end of this particular book, it's really just the beginning of what's available on the subject—there are countless avenues to explore from here.

WHERE TO GO NEXT

For continued research on game design and related fields past, present, and future, investigate the following resources:

Books

Andrew Rollings and Ernest Adams. *Andrew Rollings and Ernest Adams on Game Design.* Indianapolis: New Riders, 2003.

Terry Byrne. *Production Design for Television.* Boston: Focal Press, 1993.

Steven L. Kent. *The Ultimate History of Video Games: From Pong to Pokemon.* Roseville, CA: Prima Lifestyles, 2001.

Tom Meigs. *Ultimate Game Design: Building Game Worlds.* New York: McGraw-Hill, 2003.

Matthew Omernick. *Creating the Art of the Game.* Indianapolis: Pearson Education, 2004.

Andrew Rollings and Dave Morris. *Game Architecture and Design: A New Addition.* Indianapolis: New Riders, 2003.

Katie Salen and Eric Zimmerman. *Rules of Play: Game Design Fundamentals.* Boston: MIT Press, 2003.

Herbert Zettl. *Sight, Sound, Motion: Applied Media Aesthetics.* Belmont, CA: Wadsworth, 1990.

Web Sites

There are many, many places to visit on the Internet to learn more about game and level design, from fan sites to professional journals. Here are some great places to start:

- Gamasutra (*www.gamasutra.com*) is a dedicated site for articles and features about all aspects of game development. It is also the Web presence for *Game Developer* magazine. Gamasutra also has the best posting boards for jobs in the industry.
- The International Game Developers Association (*www.igda.org*) is a large organization of game makers and enthusiasts, with an extensive and active discussion forum for almost every related topic.
- The Unreal Developers' Network (*udn.epicgames.com*) is the central repository for news, tutorials, and information about the *Unreal* engine and related projects. If you want to learn how to use the engine that comes with this book like a professional, the UDN has everything you need.
- GameDev.net (*www.gamedev.net*) is another Web site dedicated to game development and packed full of news and information.

THANKS TO YOU, THE READER

Finally, thanks to you, the reader, for purchasing and reading this book.

Appendix ▨ **About the CD-ROM**

This book includes a standard PC format CD-ROM. Figures from each chapter are included in the figures folder for each chapter. As you read the book, you may want to look at the same figure on the CD-ROM as the one referenced in the chapter; the figures are full size and in color on the CD-ROM and are named with the same reference number used in the text.

The Folders

The CD-ROM contains the following folders and files:

- Chapter 1 through Chapter 10 each contain a subfolder with the name figures that contain full-size, color copies of the figures referenced in the text. No figures are provided for Chapters 11, 12, or 13 because of copyright issues or because none were used in the chapters.
- Sample Documents contains several design document templates you can examine and use.
- Resource contains an HTML file that has a list of links to useful Web sites. Double-click it to open it in Internet Explorer's browser.
- Software contains the following:
 - A free trial version of Adobe Photoshop CS, the leading digital imaging and editing application used in game development.
 - A copy of Terragen, a free 3D landscape creation program, excellent for creating skybox textures.
 - A copy of Open Office, a completely free, open source office suite that was used to write this book and is compatible with Microsoft Office.
 - A fully functional demo copy of the *Unreal* Engine, used for most of the in-game illustrations in this book.
- Demo_Level contains the following files:
 - DemoMap.urt, a small explorable level used to create many example screenshots for the book, which can be loaded and run within the Unreal Engine Demo included on the CD-ROM. Copy this file into the *Unreal* Engine's /maps folder after installation.

- Book_Demo_Textures.utx, the textures needed to view the demo map. Copy this file into the Unreal Engine's /textures folder after installation.
- Book_Demo_Staticmesh.usx, the objects needed to view the demo map. Copy this file into the *Unreal* Engine's /staticmesh folder after installation.

SYSTEM REQUIREMENTS

System Requirements for Included Software

System requirements for all of the software included on this CD-ROM can be found in the Readme.txt file in each individual folder within the main Software folder, but you will at least need DirectX 8.1b3 or higher; 250 MB available hard disk space, Java Runtime environment installed (free at *http://java.com*), 256 MB RAM, 16 MB NVIDIA TNT2-Class or other DirectX version 8-compliant video card, Windows-compatible sound card, and a 33.3 Kbps modem.

Minimum System Requirements

Viewing the figures included on the CD-ROM requires the following:

Windows® XP / 2000 / 98 / 95

Intel® or AMD processor at 300 MHz

192MB RAM

Graphics card and monitor supporting 1024×768 viewing resolution at 16-bit color minimum

Windows-compliant pointing device

CD-ROM drive

Internet Explorer 4.0 or higher

To use the UnrealEngine, you will need DirectX 8.1b3 or higher. Please also read the Unreal Engine Runtime demo End-User License here and on the CD-ROM.

UNREALENGINE2 RUNTIME DEMO VERSION END-USER LICENSE AGREEMENT

Document Summary: This document contains the latest version of the end-user license agreement you are required to accept if you want to download and use the UnrealEngine2 Runtime software. It will link to version-specific pages if licenses differ between versions, and those pages will contain the latest versions.

END-USER LICENSE AGREEMENT

PLEASE READ CAREFULLY. BY USING OR INSTALLING THIS SOFTWARE, OR BY PLACING OR COPYING THIS SOFTWARE ON YOUR COMPUTER HARDWARE, COMPUTER RAM OR OTHER STORAGE MEDIUM, YOU ARE AGREEING TO BE BOUND BY THE TERMS OF THIS LICENSE. IF YOU DO NOT AGREE TO THESE TERMS, PROMPTLY DISCONTINUE THE INSTALLATION PROCESS AND CEASE ALL USE OF THIS SOFTWARE.

1. **Thanks.** Congratulations and thank you for licensing our software. We're sorry to cramp your style, but our lawyers tell us that if we want to keep control and ownership of the cool stuff we're developing, we have to make sure you understand and agree that you are just getting a right to use it and that that right is limited in certain ways. So here's what you need to know and agree to.

2. **License.** The Unreal Engine 2 Runtime: DEMO VERSION and the related documentation (the "Runtime Software") is licensed for your use, subject to terms and limitations in this license agreement.

3. **Commercial Exploitation.** You may not use this Runtime Software, or any content created with it, or use the tools provided with this Runtime Software for any commercial purpose whatsoever

4. **Use Restrictions.** We want you to enjoy our products for years to come, and we want to be able to continue to release awesome stuff, so you need to be aware that there are some things you cannot do with the Runtime Software. The Runtime Software contains copyrighted material, trade secrets and other proprietary material. You may not decompile, modify, reverse engineer, prepare derivative works based on the Runtime Software, or disassemble the Runtime Software. You may not rent, sell, lease, barter, or sublicense the Runtime Software. You may not delete the copyright notices or any other proprietary legends on the original copy of the Runtime Software. You may not offer the Runtime Software on a pay per play basis or otherwise commercially exploit the Runtime Software or use the Runtime Software for any commercial purpose. You may, however, use the Runtime Software for non-commercial and educational purposes. You may not ship or export the Runtime Software to any country that would be in violation of the U.S. Export Administration Act (or any other law governing such matters) and you will not utilize and will not authorize anyone to utilize the Runtime Software in violation of any applicable law. The Runtime Software may not be downloaded or otherwise exported into (or to a national or resident of) any country to which the U.S. has embargoed goods or to anyone or into any country who/which are prohibited by applicable law, from receiving it. YOU MAY NOT USE THE RUNTIME SOFTWARE TO DEVELOP GAMES. YES, I KNOW THIS SOUNDS NASTY BUT LET'S FACE IT, EPIC'S PRIMARY MEANS OF INCOME COMES FROM GAME SALES AND ENGINE LICENSING. WE WOULD BE SHOOTING OURSELVES IN THE FOOT IF WE ALLOWED AN ENGINE WE GAVE AWAY FOR FREE TO TRAMPLE OUR PRIMARY MEANS OF INCOME. SORRY, BUT IF YOU WANT TO DEVELOP A GAME PLEASE DEVELOP IT AS A MOD FOR ONE OF OUR EXISTING RETAIL GAME PRODUCTS OR CONTACT US REGARDING A PROPER ENGINE LICENSE. (More information on the Unreal Engine 2 licensing can be found at: *http://www.epicgames.com/licensing.html.*) THANKS FOR YOUR UNDERSTANDING AND SUPPORT. (FYI: Our desire to release Runtime Software for future versions of the Unreal Engine will diminish if folks blow us off and develop or release games using the Runtime Software in violation of the above terms.)

5. **Termination.** This license is effective until one of us terminate it. You may terminate this license at any time by destroying the Runtime Software and related documentation. In the unlikely event that you are naughty and fail to comply with any provision of this license, this license will terminate immediately without notice from us. Upon termination, you must destroy the Runtime Software and related documentation. Please don't wait for us to come after you; it would not be pleasant for either of us. If we do have to come after you, we're going to expect you to pay us for our troubles, including the cost of our lawyers.

6. **Disclaimer of Warranty on Software.** You are aware and agree that use of the Runtime Software and the media on which it is recorded at your sole risk. The Runtime Software, related documentation and the media are provided "AS IS". EPIC EXPRESSLY DISCLAIMS ALL OTHER WARRANTIES. EXPRESS OR IMPLIED, INCLUDING BUT NOT LIMITED TO, THE IMPLIED WARRANTIES OF MERCHANTABILITY AND FITNESS FOR A PARTICULAR PURPOSE. WE DO NOT WARRANT THAT THE FUNCTIONS CONTAINED IN THE RUNTIME SOFTWARE WILL MEET YOUR REQUIREMENTS. NO ORAL OR WRITTEN INFORMATION OR ADVICE GIVEN BY US OR ANY OF OUR AUTHORIZED REPRESENTATIVES SHALL CREATE A WARRANTY OR IN ANY WAY INCREASE THE SCOPE OF THIS WARRANTY. SOME JURISDICTIONS DO NOT ALLOW THE EXCLUSION OF IMPLIED WARRANTIES, S0 THE ABOVE EXCLUSIONS MAY NOT APPLY TO YOU.

7. **Limitation of Liability.** UNDER NO CIRCUMSTANCES, INCLUDING WITHOUT LIMITATION, NEGLIGENCE, SHALL EPIC OR ANY OF THEIR RESPECTIVE OFFICERS, EMPLOYEES, DIRECTORS, AGENTS, LICENSEES, SUBLICENSEE OR ASSIGNS BE LIABLE FOR ANY INCIDENTAL, SPECIAL OR CONSEQUENTIAL DAMAGES THAT RESULT FROM THE USE OR INABILITY TO USE THE RUNTIME SOFTWARE OR RELATED DOCUMENTATION, EVEN IF SUCH PARTIES HAVE BEEN ADVISED OF THE POSSIBILITY OF THOSE DAMAGES. SOME JURISDICTIONS DO NOT ALLOW THE LIMITATION OR EXCLUSION OF LIABILITY FOR INCIDENTAL OR CONSEQUENTIAL DAMAGES SO THE ABOVE LIMITATION OR EXCLUSION MAY NOT APPLY TO YOU. In no event shall our total liability to you for all damages, losses, and causes of action (whether in contract, tort or otherwise) exceed the amount paid by you for the Runtime Software.

8. **Controlling Law and Severability.** This license is governed by and construed in accordance with the laws of the State of North Carolina, USA. The exclusive venue for all litigation shall be in Wake County, North Carolina. If any provision of this license is unenforceable, we will cross it out and the rest of it shall remain in effect.

9. **Complete Agreement.** This license constitutes the entire agreement between the parties with respect to the use of the Runtime Software and the related documentation. However, Epic reserves the right to modify the terms of this license from time to time and will post notice of material changes somewhere within www.epicgames.com.

10. **Copyright.** The Runtime Software and all copyrights, trademarks and all other conceivable intellectual property rights related to the Runtime Software are owned by Epic or Epic's licensors and are protected by United States copyrights laws, international treaty provisions, an army of clones, and all applicable law, such as the Lanham Act. You must treat the Runtime Software like any other copyrighted material, as required by 17 U.S.C. section 101 et seq. and other applicable law.

11. **Enjoyment Requirements.** We are aware that there are rumblings and grumblings within the software community about heavy handed, legally onerous license agreements. You have our word that this one is as fair and even handed as it gets and, as you have read this far, you know it to be true. Now, be gone from this screen and enjoy the Runtime Software!

12. **EULA Modifications.** You agree that Epic reserves the right, from time to time, to modify the terms of this license agreement and that you will abide by the updated terms as posted at *http://udn.epicgames.com/Two/UnrealEngine2RuntimeEULA.* You also agree to remain up-to-date and in compliance with the most current license terms.

Index